THE GERMAN WERKBUND

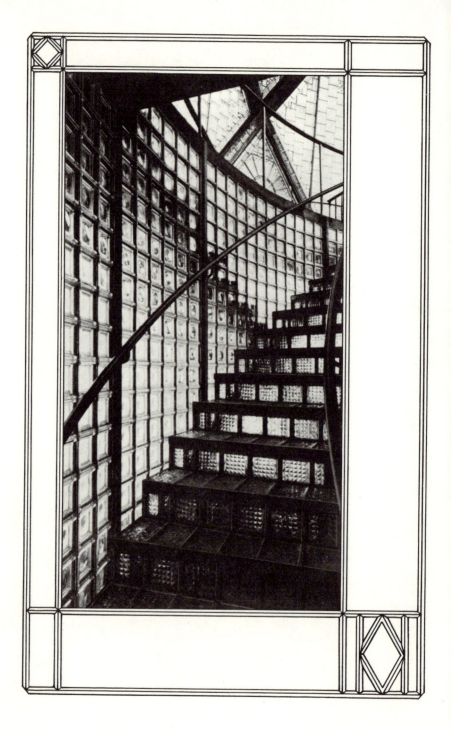

THE GERMAN WERKBUND

The Politics of Reform in the Applied Arts

BY JOAN CAMPBELL

PRINCETON UNIVERSITY PRESS

Copyright © 1978 by Princeton University Press

Published by Princeton University Press, Princeton, New Jersey
In the United Kingdom: Princeton University Press, Guildford, Surrey

All Rights Reserved

Library of Congress Cataloging in Publication Data will be
found on the last printed page of this book

Publication of this book has been aided by a grant from the
Paul Mellon Fund of Princeton University Press

This book has been composed in Linotype Primer

Printed in the United States of America by Princeton
University Press, Princeton, New Jersey

To my husband

CONTENTS

LIST OF ILLUSTRATIONS

Following page 170

WERKBUND FOUNDERS AND PRESIDENTS
1. Friedrich Naumann (1860-1919)
2. Hermann Muthesius (1861-1927)
3. Henry van de Velde (1863-1957)
4. Theodor Fischer (1862-1938)
5. Peter Bruckmann (1865-1937)
6. Hans Poelzig (1869-1936)
7. Richard Riemerschmid (1868-1957)
8. Ernst Jäckh (1875-1959)

WERKBUND TYPOGRAPHY
9. F. H. Ehmcke, poster, Cologne Werkbund Exhibition 1914
10. *Die Form*, October 1925, title page

COLOGNE WERKBUND EXHIBITION 1914
11. Walter Gropius, Administration Building and Model Factory, from G. A. Platz, *Die Baukunst der Neuesten Zeit*, Berlin, 1927
12. Henry van de Velde, Werkbund Theater, from *50 Jahre Deutscher Werkbund*, ed. H. Eckstein, Frankfurt, 1958
13. Bruno Taut, Glass Pavilion staircase, from Deutscher Werkbund *Jahrbuch* 1915

THE CHAIR
14. Karl Arnold, cartoon from *Simplicissimus*, 1914
15. Ludwig Mies van der Rohe, tubular steel chair, Stuttgart Exhibition 1927, from *Innenräume*, ed. Werner Gräff, Stuttgart, 1928

ACKNOWLEDGMENTS

IN addition to the staffs of the archives listed in the Bibliography, I should like to thank the following libraries and institutes: the Interlibrary Resources Division of the Douglas Library at Queen's University; the Royal Institute of British Architects, the Warburg Institute, and the Wiener Library in London, England; and the University Library in Stuttgart, Germany. I should also like to thank the individuals mentioned in the Bibliography under the heading "Interviews and Personal Communications" for their contribution to this study, and the following for providing information, stimulation, and encouragement: Professor Rayner Banham, London; Frau Dorothee Nehring, Munich; Professor Jacques Paul, London; Sir Nikolaus Pevsner, London; Professor Eberhard Pikart, Munich; Frau Gabrielle von Pfetten, Munich; Professor Julius Posener, Berlin; Mr. Walter Segal, London; Dr. Klaus-Jürgen Sembach, Munich; Professor Heinz Thiersch, Munich; Frau Irmgard Tschich, Berlin; Herr Erich Wenzel, Düsseldorf; and Dr. Hans M. Wingler, Berlin. None of the above will agree with all my judgments, but I hope they will regard this book as worthy of a subject whose importance they recognize.

I should also like to thank Professor R. F. Hopwood of Queen's University, Kingston, Ontario, for patient supervision of the thesis on which this book is based; and the Government of Canada (Canada Council) and the Province of Ontario (Ontario Graduate Fellowship) for financial support of my research. Above all, I must thank my family for their understanding during these last years when they were forced to compete with the Werkbund for my attention.

xii

The illustrations for this book were made available to me by the Neue Sammlung in Munich and the Werkbund-Archiv in Berlin. I should particularly like to acknowledge the assistance of Dr. Wend Fischer and Frau Renate Planitz of the Neue Sammlung, Frau Dr. Günther of the Werkbund-Archiv, and Dr. G. B. von Hartmann of the Werkbund-Berlin.

For preparation of the photographs I am indebted to:

Jan Beenken of Munich for numbers 1, 2, 3, 4, 6, 7, 8, 9, 10, 11, 12, 13, 14, 15, 16, 17, 18, 19, 20, 21, 23, 24, 25, 26, 27, 29, 31, 32, 33, 34.

Eberhard Tittel of Berlin for numbers 5, 22, 28, 30.

Most of the illustrations were included in the Werkbund Exhibition prepared by Drs. Fischer and von Hartmann for the Neue Sammlung, Munich 1975, and appeared in the catalogue of the exhibition, entitled *Zwischen Kunst und Industrie: Der Deutsche Werkbund*. The interested reader is referred to this publication, which covers the full range of Werkbund activities from 1907 to 1973.

ABBREVIATIONS

BA	Bundesarchiv, Koblenz
BASK	Bayerische Akademie der Schönen Künste, Munich (Riezler papers)
Bauhaus	Bauhaus-Archiv, Berlin (Gropius papers)
BDA	Bund deutscher Architekten
BDC	Berlin Document Center, Reichskammer der bildenden Künste, personnel files
DWB	Deutscher Werkbund, as author
DWB-J	Deutscher Werkbund Jahrbuch
DWB-M	Deutscher Werkbund Mitteilungen
GerN	Germanisches Nationalmuseum, Nürnberg (Riemerschmid papers)
KEO	Karl-Ernst-Osthaus Archiv, Hagen
LC	Library of Congress, Washington, D.C. (Mies van der Rohe papers)
RdbK	Reichskammer der bildenden Künste
RIBA	Royal Institute of British Architects, London
WB	Werkbund-Archiv, Berlin
WD	Werkbund-Archiv, Düsseldorf

THE GERMAN WERKBUND

INTRODUCTION

THE GERMAN WERKBUND was formed in 1907, in response to a widespread feeling that the rapid industrialization and modernization of Germany posed a threat to the national culture. Unlike similar associations spawned by the Arts and Crafts reform movement, however, the Werkbund rejected the backward-looking handicraft romanticism of most English and Continental cultural critics, and refused to indulge in the cultural pessimism increasingly fashionable in intellectual circles.[1] Instead of yielding to "cultural despair," its founders set out to prove that an organization dedicated to raising the standard of German work in the applied arts through cooperation with progressive elements in industry could restore dignity to labor and at the same time produce a harmonious national style in tune with the spirit of the modern age. The Werkbund pioneers addressed themselves to the task of bridging the gulf between art and industry, and worked to realize their vision of a Germany in which the machine, directed by the nation's best artists, would revitalize the applied arts "from the sofa cushion to urban planning."[2]

The Werkbund, which at the beginning hoped to render itself redundant within ten years, never realized the aims of its founders. Its efforts neither banished the specter of alienation from the world of work nor converted a significant segment of industry to the ideal of quality and good

[1] On the response of the intellectuals, see Fritz Stern, *The Politics of Cultural Despair: A Study in the Rise of the Germanic Ideology* (Garden City, N.Y., 1965).

[2] This much-repeated phrase was probably coined by the architect Herman Muthesius. See his "Wo stehen wir?" *Jahrbuch des deutschen Werkbundes* (1912), p. 16 [hereafter *DWB-J*].

design. Nevertheless, the ability and determination of its members enabled the association to establish itself on a national scale by 1914, to survive the demise of the Second Reich, and to reach new heights of activity and influence under the Weimar Republic.

Between 1919 and 1930, the Werkbund—led by such pioneers of the modern movement as Walter Gropius and Ludwig Mies van der Rohe of the Bauhaus—became one of Germany's most significant cultural institutions. With a series of outstanding international exhibitions to its credit, most notably Cologne 1914 and Stuttgart-Weissenhof 1927, it exerted an influence that extended beyond Germany's borders. Its example inspired the creation of similar groups in other countries, and its contributions to the development of 20th century architecture and design won for it a permanent place in histories of the modern movement.[3] Yet during this same period, the Werkbund's links with the artistic avant-garde and with the liberal-democratic political tradition of Friedrich Naumann and Theodor Heuss (both prominent Werkbund members) brought the association under increasing attack from the National Socialists and their conservative allies, who denounced it as an agent of "cultural bolshevism." Weakened by the Depression, which intensified splits within its ranks, the Werkbund's fate was sealed by the collapse of the Republic in 1933. The efforts of its leaders to come to terms with Germany's new rulers after Hitler came to power proved vain. Absorbed into the corporate structure of the National Socialist state, the Werkbund in 1934 ceased to exist as a private association. Some Werkbund ideas—and men—succeeded in finding a place within the Third Reich, but it was only after the Second World War that the Werkbund, reconstituted, embarked on the most recent chapter of its history.[4]

[3] E.g., Leonardo Benevolo, *History of Modern Architecture* (2 vols., London, 1971); and Herwin Schaefer, *The Roots of Modern Design* (London, 1970).

[4] See Wend Fischer, *Zwischen Kunst und Industrie: Der Deutsche*

Although my purpose is to tell the story of the Werkbund from the foundation of the association to its destruction in 1934, I have placed special emphasis on the Weimar period. The Werkbund's development between 1918 and 1933 has been relatively neglected by earlier writers, mostly art historians, who have tended to concentrate on the association's seminal role before 1914, while during the Weimar years they have focused attention on the Bauhaus, that brilliant offspring of the Werkbund that even in the 1920's had eclipsed its progenitor in the public eye.[5] In my view, the impressive achievements of the early Werkbund and the deserved interest evoked by the Bauhaus are not sufficient reasons to neglect the contributions of the Weimar Werkbund to the cause of modern architecture and design. Moreover, because the Werkbund was one of the few national cultural institutions to survive from the Second Reich into the Third, examination of its ideals and programs can illuminate both the extraordinary flowering of the modern spirit commonly designated as "Weimar Culture" and the intellectual-cultural origins of National Socialism.

Although the Werkbund's significance has been recognized by historians of art and art education, few students of German society and culture in their broader aspect have given it more than passing mention.[6] Yet the ideas and ideals it represented constitute a fascinating chapter in German intellectual history. The Werkbund brought together university professors with craftsmen, fine artists with industrialists, designers with politicians, and so offers an unusual opportunity to examine the interaction between elements of the German elite that are often studied in

Werkbund (Munich, 1975), pp. 397-591 [hereafter *Deutsche Werkbund*], for a documented account of Werkbund activities since 1947.

[5] On the Bauhaus, see especially Hans Maria Wingler, *The Bauhaus: Weimar, Dessau, Berlin, Chicago* (Cambridge, Mass., 1969).

[6] Stern, *Cultural Despair*, refers to the Werkbund on pp. 221-22; it is mentioned in a paragraph on the visual arts in the Second Reich, by Hajo Holborn, *A History of Modern Germany, 1840-1945* (New York, 1969), p. 405.

isolation. By focusing on the efforts of the Werkbund and its leading members to come to terms with the modern age, one can learn much about the forces that have shaped 20th century Germany, as well as illuminate the more general relationship between intellectual, artistic, social, and political change. Finally, the Werkbund deserves attention because it raised fundamental questions about art and society. Over the years, it constituted a forum for the debate of issues that are still alive today: how to restore joy in work in the context of industrial society, to forge a link between high and popular culture in a democracy, and to redefine the role of the handicrafts in a machine age. Werkbund discussions on these and similar topics were generally inconclusive and often couched in terms that now seem dated, but they undoubtedly repay analysis and will therefore play as large a role in my presentation as the group's actual achievements.

The story of the Werkbund to its dissolution under the National Socialists has been briefly told several times.[7] Only one person, Theodor Heuss, contemplated writing a full-scale history of the organization along the lines attempted here. Heuss, who was to become the first president of the German Federal Republic, had been associated with the Werkbund from its early years and remained loyal to its ideals until his death in 1963. After World War II, he encouraged the revival of the association, and during his presidency he had a part in creating the *Rat für Formgebung*, a council for industrial design based on Werkbund principles.[8] During the Hitler years, Heuss wrote

[7] Most recently by G. B. von Hartmann and Wend Fischer, in Fischer, *Deutsche Werkbund*, pp. 15-21. See also Hans Eckstein, "Idee und Geschichte des Deutschen Werkbundes 1907-1957" [hereafter "Idee"] in Hans Eckstein, ed., *50 Jahre Deutscher Werkbund* (Frankfurt, 1958), pp. 7-18; and Julius Posener, "Der Deutsche Werkbund," *Werk und Zeit Texte*, supplement to *Werk und Zeit*, No. 5 (May 1970).

[8] See Heuss's address to the Werkbund in 1952, "Was ist Qualität?" in Theodor Heuss, *Die Grossen Reden: Der Humanist* (Tübingen, 1965), pp. 49-93. Heuss's connection with the Werkbund is briefly recounted in Hans-Heinrich Welchert, *Theodor Heuss: Ein Lebensbild* (Bonn, 1953), pp. 29-36.

biographies of three men who played important roles in the Werkbund: Friedrich Naumann, the politician; Robert Bosch, a prominent Württemberg industrialist; and the architect Hans Poelzig.[9] His intimacy with these and other leading Werkbund personalities, his long connection with the organization, and his belief in its fundamental goals would have made Heuss the ideal historian of the group. Unfortunately, he abandoned the project after the destruction of the Werkbund archives in an air raid in 1944 obliterated what he regarded as essential documentation.[10]

The destruction of the Werkbund files undoubtedly created a gap in the sources that no amount of diligent searching can fill. Nevertheless, much has been done since 1947 to make good the loss, particularly by the *Werkbund-Archiv*, founded in 1971 in Berlin, whose main purpose is to make Werkbund documents readily accessible to scholars and others interested in problems of design.[11] I myself have been able to locate a mass of Werkbund publications of the period 1907-1934, ranging from yearbooks and exhibition catalogues to membership lists and publicity brochures. Various archives and the papers of former members yielded minutes of internal meetings. I have also drawn on published and unpublished letters, diaries, and autobiographical accounts by Werkbund members and their contemporaries, as well as on newspapers and periodicals of the period. Finally, interviews and correspondence with a few survivors have provided vivid glimpses into the past. The available material thus constitutes a large body of documentary evidence, on which I have

[9] *Friedrich Naumann: Der Mann, Das Werk, Die Zeit* (2nd rev. ed., Stuttgart, 1949); *Robert Bosch: Leben und Leistung* (Stuttgart, 1946); *Hans Poelzig: Bauten und Entwürfe: Das Lebensbild eines deutschen Baumeisters* (3rd ed., Tübingen, 1955).

[10] See Theodor Heuss, *Erinnerungen, 1905-1933* (Tübingen, 1963), pp. 106-107; and Heuss, "Notizen und Exkurse zur Geschichte des Deutschen Werkbundes" in Eckstein, *50 Jahre Deutscher Werkbund*, pp. 19-26 [hereafter "Notizen"].

[11] Cf. the first yearbook of the Werkbund-Archiv (Berlin, 1972), with a foreword by Julius Posener and introduction by Diethart Kerbs, the director of the Archive.

based what is essentially a collective biography of the Werkbund. As an outside observer, it is probably impossible for me to convey the full flavor of the association, characterized as it was by the clash of outstanding personalities; but I hope that the perspective lent by distance has enabled me fairly to place the Werkbund in its historical context, and to do justice both to its ideals and its achievements.

CHAPTER I

The Founding of the Werkbund

THE FOUNDING meeting of the *Deutsche Werkbund*, held in Munich on October 5 and 6, 1907, brought together about one hundred prominent artists, industrialists, and art lovers. Convened in response to an appeal by twelve individual artists and twelve manufacturers, it represented a novel approach to one of the problems that engaged the attention of educated Germans at the time, namely how to reforge the links between designer and producer, between art and industry, that had been broken in the course of the nation's recent spectacular economic development. The fact that both artists and entrepreneurs attended the convention raised hopes that the Werkbund would succeed in its aim of injecting a much-needed artistic and ethical element into German economic life. When the meeting, chaired by a director of a ceramics factory, J. J. Scharvogel, chose a professor of architecture, Theodor Fischer, as the society's first president, it gave symbolic expression to the spirit that the new association planned to foster.[1]

The keynote speech was given by Fritz Schumacher, professor of architecture at the *Technische Hochschule* in Dresden. Schumacher stated the Werkbund's objective: to

[1] Eckstein, "Idee," p. 10; Heinrich Waentig, *Wirtschaft und Kunst: Eine Untersuchung über Geschichte und Theorie der modernen Kunstgewerbebewegung* (Jena, 1909), pp. 290-92; Peter Bruckmann, "Die Gründung des Deutschen Werkbundes 6 Oktober 1907," *Die Form*, VII, No. 10 (1932), 297-99; and an unsigned essay, "Zur Gründungsgeschichte des Deutschen Werkbundes," *Die Form*, VII, No. 11 (1932), 329-31.

reform the German arts and crafts through a genuine rapprochement between artists and producers. Although he deplored the destruction of the artistic culture associated with a preindustrial past, he stressed that the progress of industrialization and mechanization was irresistible, and that the Werkbund must strive to counter the excessive materialism and rationalism that were its by-products without sacrificing the positive benefits of modernity. If practically-minded artists and idealistic entrepreneurs could work in concert, the result would be the "reconquest of a harmonious culture" that would represent a new cultural synthesis in tune with the realities of contemporary life.[2]

The immediate task before the new association would be to improve the design and quality of German consumer goods. Schumacher made it quite clear, however, that the Werkbund was not created merely to appease the sensibilities of aesthetes offended by the sheer ugliness of current products. Nor was its purpose to increase the profits of participating firms. Instead, Schumacher sought to enlist the moral and patriotic sentiments of his auditors in support of the ideal of quality, arguing that quality work would both strengthen the nation's competitive position in the markets of the world and foster social peace at home.

While the aims of the Werkbund, as expounded by Schumacher, closely paralleled those of the German Arts and Crafts movement which had already spawned numerous lay and specialist societies, the men gathered at Munich believed that a new organization was needed to implement reforms more effectively. By drawing together an aristocracy of creativity and talent from all parts of Germany, the Werkbund hoped it would be in a unique position to encourage the healthy development of the most

[2] Fritz Schumacher, "Die Wiedereroberung harmonischer Kultur," *Kunstwart*, XXI (Jan. 1908), 135-38. Portions of the text were reprinted in *Die Form*, VII, No. 11 (1932), 331-32, and are reproduced by Fischer, *Deutsche Werkbund*, pp. 32-34.

advanced tendencies of the day. Yet it would be wrong to
note the progressive aspirations of the Werkbund's found-
ers without acknowledging that their purpose was essen-
tially a conservative one, namely to restore the lost moral
and aesthetic unity of German culture. This ambivalence
was reflected at the Munich convention, where romantic
nostalgia for a lost world combined with determination
to meet contemporary needs; and it remained a feature of
the Werkbund during the next twenty-six years of its in-
dependent existence.[3]

To understand the origins of the Werkbund, one must
look beyond the events of October 1907. This is in part
because the new society represented the culmination of a
movement for artistic and intellectual reform dating from
the 19th century,[4] but also because of the three individuals
who can most justly be described as its founding fathers—
Hermann Muthesius, Friedrich Naumann, and Henry van
de Velde—only Naumann actually attended the Munich
meeting. These three men, coming from very different
backgrounds, agreed in their fundamental purposes, but
each held distinctive views on matters of policy and or-
ganization. Their ideas and ideals deserve analysis be-
cause they helped to set the Werkbund on its course. At
the same time, examination of the motives that led each
of them to support the Werkbund sheds light on those
features of the contemporary situation which contributed
most to the association's creation and initial success.

[3] The romanticism of the Werkbund founders is illustrated by
reminiscences of Richard Riemerschmid and Fritz Schumacher in
"Zur Gründungsgeschichte des Deutschen Werkbundes," *Die Form*,
VII, No. 11 (1932), 331. Apparently, for example, it had originally
been suggested that the founding convention be held in the
Katherinenkirche in Nürnberg because of its association with
Wagner's *Meistersinger*, and so with the medieval crafts tradition.

[4] For the Werkbund as culmination of a decade of reform rather
than the harbinger of a new era, see Joseph August Lux, *Das neue
Kunstgewerbe in Deutschland* (Leipzig, 1908). A signatory of the
appeal that led to the Werkbund founding, Lux held a fundamen-
tally conservative view of its purpose. For a comprehensive survey
of the German Arts and Crafts reform movement before 1907,
Waentig, *Wirtschaft und Kunst*.

The man most frequently cited as *the* father of the Werkbund was Hermann Muthesius, who, in 1907, was a civil servant in the Prussian Ministry of Trade.[5] Born in Thuringia in 1861, the son of a mason, Muthesius learned his father's trade, went on to *Realgymnasium* in Leipzig, and completed his architectural training at the *Technische Hochschule* in Berlin. While still a student, he was sent to Japan by a private firm, but in 1893 he returned to Germany and began his career in the Prussian civil service as government architect in the design office of the Prussian Ministry of Public Works. The turning point in his career came in 1896 when he secured an appointment as architectural attaché at the German embassy in London, filling a position apparently created in response to the Kaiser's personal wishes.[6] Between 1896 and his return to Germany in 1903, Muthesius reported regularly on advances in English architecture, crafts, and industrial design, with a view toward adapting the best features of the English experience to German circumstances. He cultivated close contacts with the leaders of the English Arts and Crafts movement, and acquainted himself with contemporary British architecture and art education. The fruit of his diligence, in addition to his official reports, was an influential three-volume publication on the English home, which appeared after his return to Germany.[7]

[5] Reyner Banham, *Theory and Design in the First Machine Age* (London, 1960), p. 69 [hereafter *First Machine Age*]; Julius Posener, *Anfänge des Funktionalismus: Von Arts and Crafts zum Deutschen Werkbund* (Berlin, 1964), p. 111. Unlike Banham and Posener, Stern (*Cultural Despair*, p. 221) lists Muthesius as just one of several founders, along with Friedrich Naumann, Eugen Diederichs, Ferdinand Avenarius, and Alfred Lichtwark. In fact, neither Avenarius nor Lichtwark played a direct part, and Diederichs' role was also peripheral. Cf. Gerhard Kratzsch, *Kunstwart und Dürerbund: Ein Beitrag zur Geschichte der Gebildeten im Zeitalter des Imperialismus* (Göttingen, 1969), p. 217, n. 65.

[6] Posener, *Anfänge des Funktionalismus*, pp. 109-11; Karl Scheffler, *Die fetten und die mageren Jahre* (Munich, 1948), p. 42.

[7] Hermann Muthesius, *Das englische Haus* (3 vols., Berlin, 1904). On Muthesius as a transmitter of the English tradition to Germany, see Julius Posener, "Hermann Muthesius," *Architects' Yearbook*, No.

In 1904, Muthesius, now in the Prussian Ministry of Trade in Berlin, resumed his architectural practice, building villas in the "English style" for the wealthy bourgeois of the capital.[8] In his official capacity, he applied the lessons learned in England by promoting a reform of the arts and crafts schools. He also used his influence to secure the appointment of first-class designers to key positions: Peter Behrens at the Art Academy in Düsseldorf, Hans Poelzig at the Breslau Academy, and Bruno Paul at the Berlin School of Applied Arts.[9]

Muthesius' appointment to the first chair of the applied arts at the Berlin Commercial University (*Handelshochschule*) in the spring of 1907 gave him additional authority to further the cause of reform. However, his inaugural lecture, in which he set out the basic principles of his program for the arts and crafts, aroused a storm of protest from conservative elements in the German art industries, and produced an appeal to the Kaiser for his immediate dismissal. This step by the *Fachverband für die wirtschaftlichen Interessen des Kunstgewerbes* (Trade Association to Further the Economic Interests of the Art Industries) failed to overthrow Muthesius. Instead, it precipitated a confrontation between progressive and traditionalist factions within the *Fachverband* at its annual meeting in Düsseldorf in June 1907, led to secession of the pro-Muthesius firms, and culminated in the formation of the Werkbund.[10]

Muthesius' *Handelshochschule* speech introduced many

10 (1962), pp. 45-61; and "Muthesius in England" in Julius Posener, *From Schinkel to the Bauhaus* (London, 1972), pp. 17-23.

8 Julius Posener, "Muthesius als Architekt," *Werkbund-Archiv*, 1 (1972), 55-79.

9 Nikolaus Pevsner, *Academies of Art, Past and Present* (Cambridge, England, 1940), p. 267. Paul's appointment may not have been directly due to Muthesius, but it certainly corresponded to his wishes.

10 Waentig, *Wirtschaft und Kunst*, p. 285; Eckstein, "Idee," pp. 7-8; Nikolaus Pevsner, *Pioneers of Modern Design: From William Morris to Walter Gropius* (3rd ed., Harmondsworth, 1960), p. 35.

themes that were subsequently incorporated into the Werkbund program. Commenting on a recent applied arts exhibition at Dresden, Muthesius welcomed the increased respect shown for the innate character of materials, the emphasis on functional and constructional design criteria, and the decline in nostalgic sentimentality, artificiality, and excessive ornamentation. Nevertheless, he recognized that the reformers still faced tremendous obstacles. The consuming public, corrupted by social snobbery, sudden wealth, and the ready availability of "luxury" goods cheaply made by machine, would have to be won back to the old ideals of simplicity, purity, and quality. At the same time, producers would have to develop a new sense of cultural responsibility, based on the recognition that men are molded by the objects that surround them. Once manufacturers were made aware that by producing cheap imitations and fashionable novelties they were damaging the national character through pollution of the visual environment, Muthesius believed they would abjure their evil ways and address themselves to their proper task of creating a modern German home whose honest simplicity would beneficially influence the character of its inhabitants.

To Muthesius it seemed evident that the reform movement that had begun in the sphere of interior design would lead on to the development of new concepts in architecture and eventually would affect all the arts. Moreover, discounting the doubts of many manufacturers and dealers regarding the marketability of the new designs, he proclaimed his faith in their eventual victory, citing the commercial success already attained by the *Dresdner Werkstätten für Handwerkskunst* to prove his point. Here was evidence that an enterprise that enthusiastically adopted the quality ideal would gain a competitive advantage over its more conservative rivals. By ceasing to produce shoddy goods, Muthesius argued, industry would not only be acting morally but would reap great profits. At the same time, it would enable the Reich to redeem its

reputation on the world market. Instead of seeking des-
perately—and ineffectually—to adapt their designs to for-
eign tastes and predilections, German producers, building
on the achievements demonstrated at the German section
of the St. Louis exhibition of 1904, might one day dictate
good taste to the world, while enriching themselves. The
rewards of a change of heart seemed plain: profits, power,
and freedom from the stylistic tyranny of the French, then
still dominant in the realm of fashion and design.[11]

Thus in 1907 Muthesius set forth a number of ideas
that regularly reappeared in Werkbund propaganda. Typi-
cally Muthesian features included the stress on good taste
and quality as virtues in themselves, and the determina-
tion to mobilize economic, ethical, and patriotic senti-
ments in support of fundamentally aesthetic reforms. The
speech also revealed Muthesius' distrust of the artistic in-
dividualism that at Dresden had still obscured the emerg-
ing functionalist trend. For he felt certain that the style
of the future would not be the product of isolated genius
self-consciously striving to create new forms, but would
develop out of the efforts of many individuals working in
a new spirit to utilize available artistic, technical, and
economic ideas in the design and production of consumer
goods.[12]

Unlike many of his contemporaries, Muthesius firmly
believed that German culture could and would be saved.
This basic optimism enabled him to throw himself with-
out reserve into the fight for converts, while his faith in
the power of organization made him a wholehearted ad-
vocate of the Werkbund idea. By its very existence, the

[11] Muthesius' speech, "Die Bedeutung des Kunstgewerbes," is re-
produced in Posener, Anfänge des Funktionalismus, pp. 176-91. On
the St. Louis exhibition, which Muthesius attended as an official
observer for the German government, ibid., p. 111; and Waentig,
Wirtschaft und Kunst, p. 282.

[12] Both Hans Poelzig and Fritz Schumacher concurred in Muthe-
sius' judgment of the Dresden exhibition. See Das Deutsche Kunst-
gewerbe 1906. Exhibition Catalogue (Munich, 1906).

Werkbund would testify to the strength of the reform impulse and create the positive climate of opinion needed for success. Because Muthesius knew that controversy surrounding his person might jeopardize the new organization, he stayed away from the Munich meeting. But as soon as the Werkbund was established, he openly identified himself with it.[13] Elected vice-president, he devoted his energies to expanding the Werkbund's influence, provided it with useful government contacts, and to a great extent succeeded in imposing his views on the association in the period to 1914. His home in Berlin served as a meeting place for men connected with the reform movement in art and industry; and the social gatherings over which he presided there helped to strengthen the Werkbund by creating a sense of community among individuals who often had little in common beyond their desire to further its goals.[14]

Although Muthesius' presence in Berlin gave the Werkbund a valuable foothold in the nation's capital, that city could not claim to be the birthplace of the new society. Vienna, Munich, and particularly Dresden all have a better right to that distinction, in view of their outstanding contributions to the arts and crafts. Moreover, rather than Muthesius, the Prussian civil servant, it was the politician Friedrich Naumann who devised the organizational structure that for the first time gave national unity to the reform movement. On the eve of the Werkbund's birth, Naumann, a former Protestant pastor and supporter of Adolph Stöcker's Christian Socialism, had already won a national reputation as a liberal politician with strong social views. Founder of the short-lived National-Social party (1896-1903), Naumann had acquired disciples in all parts of the country, and in 1907 he successfully contested a

[13] Eckstein, "Idee," p. 10. Muthesius had originally been scheduled to address the meeting jointly with Schumacher.

[14] Heuss, *Erinnerungen*, p. 111. According to Heuss, Muthesius at home managed to relax his otherwise bureaucratic manner and to create an atmosphere conducive to good fellowship, a gift he consciously exploited to further his aims.

Reichstag seat for the left liberals in the South German city of Heilbronn.[15]

To understand what attracted Naumann to the Werkbund cause, one must first of all take into account his strong artistic leanings. He drew with enthusiasm and considerable skill, and contributed frequent exhibition reports and other essays on aesthetic topics to *Die Hilfe*.[16] An early advocate of the need to discover new forms suited to the modern age, he repeatedly gave forceful expression to his faith in the possibility of revivifying German culture in the age of the machine.[17] His belief in the social and political significance of aesthetic questions drew him into the Werkbund orbit, and in turn enabled him to bring into the organization people who would have committed themselves neither to a political party nor to any purely artistic movement.[18]

Naumann addressed the Munich convention and helped to write the Werkbund's constitution adopted at the first annual meeting in 1908. He also produced its initial propaganda pamphlet, *Deutsche Gewerbekunst*, which identified the Werkbund with a wide range of social and national goals.[19] According to this brochure, the Werkbund, by propagating the principle of quality, would raise the value of labor, improve the worker's status, increase his joy in work, and thus reverse the trend to proletariani-

[15] See Heuss, *Naumann*, pp. 87-245; Dieter Düding, *Der Nationalsoziale Verein 1896-1903* (Munich, 1972); and Werner Conze, "Friedrich Naumann, Grundlage und Ansatz seiner Politik in der nationalsozialen Zeit (1895-1903)," in Walther Hubatsch, ed., *Schicksalswege deutscher Vergangenheit* (Düsseldorf, 1950), pp. 355-87.

[16] Naumann had founded *Die Hilfe* in 1894, as the organ of the progressive wing of the Christian-Social movement. On his artistic capacities and interests, see Heuss, *Naumann*, pp. 217-22; and Heinz Ladendorf, "Nachwort," in Friedrich Naumann, *Werke*, VI, Aesthetische Schriften (Cologne, 1964), 603-18.

[17] E.g., "Die Kunst im Zeitalter der Maschine" (1904), in Naumann, *Werke*, VI, 186-201.

[18] Conze, "Friedrich Naumann," p. 377.

[19] "Deutsche Gewerbekunst" (1908), in Naumann, *Werke*, VI, 254-89.

zation hitherto associated with the advance of capitalism. Moreover, quality work would help to shape a culture based on respect for the creative power of the individual personality, while improving the competitive position of German exports. Comparing the Werkbund to the Navy League, of which he was an ardent supporter, Naumann argued that just as the League encouraged Germany to demand a larger role in world politics, so the Werkbund should work to extend Germany's economic power. Unlike the Navy League, however, the Werkbund was to remain independent of official guidance or subsidies, for Naumann was convinced that it would be most effective as a purely private association, acting on its own initiative to further the nation's cultural and economic growth.[20]

It was at the Dresden Arts and Crafts exhibition of 1906 that Naumann helped to lay the foundations for the Werkbund. The exhibition itself had been organized by one of Naumann's political disciples, Fritz Schumacher, who enthusiastically subscribed to his program of freeing the German worker from the trammels of Marxist dogma, winning him over to the national ideal, and reawakening his religious impulses.[21] While attending the exhibition, at which he delivered an address and which he later reviewed for *Die Hilfe*,[22] Naumann developed the organizational blueprint for the Werkbund in conversation with

[20] *Ibid.*, pp. 284-86. Although Naumann began as a Christian Socialist, by 1907 he had become an economic liberal, intent to keep the state out of industrial life. By 1917, he had once more revised his views, advocating "a peacetime economic system in which the cartels would become semipublic bodies charged with broad fiscal and regulatory functions under the general supervision of the State." Ralph H. Bowen, *German Theories of the Corporative State* (New York, 1947), p. 190; and Editor's introduction, Naumann, *Werke*, III, xi-xxxii.

[21] Fritz Schumacher, *Stufen des Lebens: Erinnerungen eines Baumeisters* (Stuttgart, 1935), pp. 212 and 256. Schumacher's allegiance did not extend to aesthetics; he rejected Naumann's dogmatic functionalism.

[22] See "Kunst und Industrie" and "Kunstgewerbe und Sozialpolitik," Naumann, *Werke*, VI, 433-51. Naumann's Dresden speech was published in the exhibition catalogue, *Das Deutsche Kunstgewerbe 1906*.

another of his adherents, Karl Schmidt-Hellerau of the *Dresdner Werkstätten*. Schmidt, son of an artisan family, had spent a year in England following his apprenticeship. The furniture workshop that he established on his return to Dresden in 1898 soon grew into a sizable enterprise employing many of Germany's leading designers and craftsmen and exploiting the most advanced machine technology to produce relatively inexpensive quality goods for mass consumption.[23] A carpenter by trade, Schmidt, under Naumann's influence, had abandoned some of the traditionalism often associated with his craft. In particular, he responded to Naumann's modification of the English Arts and Crafts philosophy, which stressed the need to restore the dignity of labor in alliance with—rather than in opposition to—the machine. Inspired by Naumann's social idealism, Schmidt initiated an ambitious apprentice training program within the *Werkstätten*; built a new community, the *Gartenstadt Hellerau*, to house its workers; and generally turned his firm into a model enterprise.[24] Thus the Werkbund was only one fruit of a continuing association between Naumann and Schmidt, who, despite very different educational and professional backgrounds, shared the desire to create a strong, stable, and harmonious social order.

In 1906, both Naumann and Schmidt felt that, to prevent dissipation of the gains made by the Dresden exhibition, it would be necessary to create a national organization capable of nurturing the progressive forces it had released. Developing an idea apparently originated by Muthesius and Theodor Fischer, they agreed that the first

[23] Friedrich Naumann, "Der Deutsche Gewerbestil," *Illustrierte Zeitung* (1914), Werkbund supplement, p. 23; Waentig, *Wirtschaft und Kunst*, pp. 286-89; Heuss, *Naumann*, p. 223; Heuss, *Erinnerungen*, pp. 111-12; Pevsner, *Pioneers of Modern Design*, pp. 34-35.

[24] Schumacher, *Stufen des Lebens*, p. 262; Heuss, *Naumann*, p. 225. The *Gartenstadt Hellerau* was one of a number of garden cities inspired by Ebenezer Howard's *Garden Cities of Tomorrow* (1898). Four Werkbund notables (Schumacher, Muthesius, Fischer, and Adolf Hildebrand) constituted the architectural committee, and most of the plans were the work of Richard Riemerschmid of Munich. Pevsner, *Pioneers of Modern Design*, p. 176.

prerequisite was to find a man who could devote himself solely to this task. Naumann thereupon proposed Wolf Dohrn, a young man of excellent education and recognized ability who at twenty-eight had not yet found his calling. Son of the famous zoologist Anton Dohrn and fellow student of Theodor Heuss in Lujo Brentano's economics seminar at Munich, Dohrn had become a supporter of Naumann during the electoral campaign of 1903.[25] He responded with enthusiasm to Naumann's suggestion that he organize a new arts and crafts society and, in order to prepare himself, decided to take up a craft. Under the guidance of Karl Schmidt, he trained as a carpenter and soon became Schmidt's collaborator in the *Werkstätten*, acting as spokesman for the firm at the Düsseldorf meeting of June 1907, when the *Dresdner Werkstätten* seceded from the Arts and Crafts Association in protest against its attack on Muthesius.[26] A few months later, Dohrn became the Werkbund's first executive director, a post he held until 1910 when he withdrew, against the wishes of his many friends within the association, to devote himself to Schmidt's Hellerau garden city development and to his own pet project—the Jacques-Dalcroze school of modern dance.[27] Thus, thanks to the mediating role of Friedrich Naumann, Dresden became the first headquarters of the new association, although much of its inspiration had come from Berlin, and the society was formally incorporated in Munich, the home of its president, Theodor Fischer.

In addition to his following in Dresden, Naumann had

[25] Theodor Heuss claimed that it was he who first suggested Dohrn as the right man for the job. See his *Erinnerungen*, pp. 109-11 and *Naumann*, p. 223.

[26] Waentig, *Wirtschaft und Kunst*, p. 290.

[27] Dohrn's enthusiasm for Dalcroze and eurythmics was resented by some of his Werkbund friends as a pointless diversion of his energies. Cf. Heuss, *Erinnerungen*, pp. 113-14; and Schumacher, *Stufen des Lebens*, p. 163. Dohrn died in 1913, in a mountaineering accident, without having fulfilled the great hopes placed in him by Naumann. Heuss, Obituary, *März*, VIII, No. 1 (1914), 279; Heuss, "Notizen," p. 21.

other disciples in the Werkbund, of whom Peter Bruck-mann, the silverware manufacturer from Heilbronn in Württemberg, was perhaps the most important. An en-thusiastic political supporter of Naumann, Bruckmann, who had led the progressive industrialists at the June 1907 Düsseldorf meeting, became one of the Werkbund's principal figures, acting as president or vice-president al-most continuously from 1909 until 1932.[28] Another friend and admirer of Naumann's among the Werkbund pioneers was Eugen Diederichs, an innovative typographer, printer, and publisher, whose firm was one of the Werkbund's original sponsors. From 1912 to 1914, Diederichs pub-lished the Werkbund yearbooks as part of a list that in-cluded the first German edition of Ruskin, Ebenezer Howard's book on the garden city, and numerous other literary, artistic, and philosophical works related to Werk-bund concerns.[29] A spokesman for the quasi-mystical re-form movement to which he gave the name "New Roman-ticism," Diederichs "set the revitalization of Germany through ideology in opposition to the principle of organi-zation."[30] In other words, like many intellectuals of the day, he rejected Naumann's belief in the possibility of re-form through political action even while subscribing to his basic cultural and social program.[31]

Naumann agreed with Muthesius on methods and ob-jectives, but seems to have been more successful than the latter in persuading others of the need for concerted effort

[28] Bruckmann's significance for the pre-1914 Werkbund was summed up on the occasion of his resignation from the presidency in 1919, in *Mitteilungen des Deutschen Werkbundes* 1919/4, p. 136 [hereafter *DWB-M*]. See also Ernst Jäckh, *Der Goldene Pflug: Lebens-ernte eines Weltbürgers* (Stuttgart, 1954), p. 90.

[29] *60 Jahre: Ein Almanach*, Eugen Diederichs Verlag (Düsseldorf, 1956), pp. 189-237; Eugen Diederichs, *Aus meinem Leben* (Leipzig, 1938), p. 54.

[30] George L. Mosse, *The Crisis of German Ideology* (London, 1970), pp. 52-63 and *passim*.

[31] Eugen Diederichs, *Selbstzeugnisse und Briefe von Zeitgenossen* (Düsseldorf, 1967), pp. 215 and 217. Diederichs represents an in-stance of Naumann's failure to politicize the *Bildungsbürgertum*, noted by Conze, "Friedrich Naumann," p. 377.

in the cause of cultural reform. In addition, it was he who elaborated the notion of "quality work" in economic and social terms, supplying the platform that held the Werkbund together before 1914. Naumann must therefore be regarded as one of the men most responsible both for the organization of the Werkbund and its early success.

Despite the crucial roles of Muthesius and Naumann, no account of the Werkbund's origins would be complete without mention of Henry van de Velde. A Belgian by birth, van de Velde had come to Germany in the 1890's and quickly moved into the first rank of the nation's designers. Like many leading Werkbund decorators and architects, he began life as a painter but soon, inspired by the work and social vision of John Ruskin and William Morris, applied his innovative talent to the decorative arts. One of the creators of the *Art Nouveau* or *Jugendstil*, which transformed the visual environment around the turn of the century, van de Velde influenced the German Arts and Crafts movement both through his work and his theoretical pronouncements on art, the machine, and society.[32] In his *Kunstgewerbliche Laienpredigten*, he insisted that art and architecture must be put in the service of society in order to create a nobler environment for contemporary man.[33] Van de Velde regarded himself as a socialist in the tradition of Morris, a radical reformer of the modern social order. Rejecting the l'art pour l'art philosophy of the late 19th century, he turned his back as well on the artistic conventions of the past, and set out to create a new ornament and style appropriate to the machine age.[34]

[32] His impact on Germany is treated in Karl-Heinz Hüter, *Henry van de Velde: Sein Werk bis zum Ende seiner Tätigkeit in Deutschland* (Berlin, 1967). See also van de Velde's selected essays, *Zum neuen Stil*, ed. J. Curjel (Munich, 1955).

[33] 2 vols. (Leipzig, 1902).

[34] The sources and nature of van de Velde's social views are discussed by Donald Drew Egbert, *Social Radicalism and the Arts* (New York, 1970), Ch. 12. Pevsner, *Pioneers of Modern Design*, pp. 27-29, and Walter Curt Behrendt, *Der Kampf um den Stil in*

Van de Velde also initiated important reforms in the field of art education. As early as 1894 he advocated that classes in the applied and decorative arts should be incorporated into the curriculum of the art academies, which hitherto had mostly confined themselves to turning out large numbers of easel painters and sculptors. When he was appointed to head the Weimar Art Academy in 1902, van de Velde introduced craft training and fostered co-operation between the students and local artisans and manufacturers. His aim—like that of the Werkbund later—was to end the social isolation of the artist and to raise the aesthetic quality of both craft and machine production.[35] Not surprisingly, it appeared to van de Velde, in retrospect, that the founders of the Werkbund merely acted as spokesmen for a program that he had originated. Claiming to be the "spiritual father" of the new association, he insisted in his autobiography that Peter Bruckmann, Theodor Fischer, and Richard Riemerschmid were the men who really started the Werkbund and that all three owed their creative and ethical ideals to him. He mentioned neither Muthesius nor Naumann and failed to acknowledge the possibility that others might have evolved "his" ideas independently.[36]

It is easy to show that van de Velde's claims were exaggerated. Many of his views on art and society, the role of the machine, the relationship between the pure and applied arts, were common property by 1907. Moreover, his "new style," far from reflecting fundamental modern

Kunstgewerbe und in der Architektur (Stuttgart, 1920), pp. 46-50, deal with van de Velde's stylistic utopianism.

[35] On van de Velde's educational work, see his *Geschichte meines Lebens* (Munich, 1962), pp. 210-11; Nikolaus Pevsner, "Post-War Tendencies in German Art Schools," *Journal of the Royal Society of Arts*, LXXXIV (1936), 250; and Edwin Redslob, *Von Weimar nach Europa* (Berlin, 1972), pp. 44-51.

[36] van de Velde, *Geschichte meines Lebens*, pp. 320-21. By contrast, Waentig, *Wirtschaft und Kunst*, does not mention van de Velde at all in connection with the Werkbund, and Eckstein, "Idee," also omits him from the list of Werkbund founders.

values, revealed an unrestrained individualism, seldom went beyond the level of ornament, and soon appeared dated. Finally, whereas van de Velde spoke and wrote of the need to serve a wide public through the machine production of quality goods, in practice his designs tended to involve costly handwork and therefore met the needs only of the wealthy few.[37]

What nevertheless made van de Velde a significant figure in the early Werkbund is simply the fact that an artist of his caliber publicly espoused the cause of the new association. The Werkbund only became possible because a number of leading artists shared the desire to reform German aesthetic culture and recognized that this entailed cooperation with progressive elements in the crafts and industry.[38] While it is misleading to speak of the Werkbund as originating with the artists, it is certainly true that without the support of men like van de Velde it could neither have come into existence nor continued to function.

Although it claimed to represent a new type of association, the Werkbund from the start realized that it was part of a larger movement for cultural reform that had already created a variety of superficially similar associations.[39] Of these probably the most significant was the the *Dürerbund* founded in 1902 by Ferdinand Avenarius. Editor of

[37] Schaefer, *Roots of Modern Design*, pp. 164-65. Schumacher, *Stufen des Lebens*, p. 192, perceptively characterized van de Velde as a socialist in theory but an individualist in practice. The rapid replacement of the *Jugendstil* by a functional neoclassicism is noted by Behrendt, *Kampf um den Stil*, pp. 74-87; Ludwig Grote, "Funktionalismus und Stil," in Grote, ed., *Historismus und bildende Kunst* (Munich, 1965), p. 62; and Benevolo, *History of Modern Architecture*, II, 385.

[38] Naumann, "Deutsche Gewerbekunst," pp. 265-69, and Behrendt, *Kampf um den Stil*, pp. 92-93, both noted the diversity of artistic views represented within the Werkbund, and the sense of common purpose that nevertheless enabled rival artists to cooperate.

[39] Both Schumacher, in his address to the founding convention, and Naumann, in "Deutsche Gewerbekunst," made an effort to analyze existing associations in order to establish the Werkbund's raison d'être.

a cultural weekly, the *Kunstwart,* Avenarius dedicated him-
self to the task of awakening a true appreciation for art
among educated Germans and thus did much to prepare
the ground for the Werkbund.[40] What chiefly distinguished
the new association from the *Dürerbund* was that the latter
was a *Bildungsverein,* an educational society open to all,
whereas the Werkbund restricted membership to those al-
ready converted to its ideals and professionally qualified
to contribute to the cause by word or deed.[41]

Another association whose goals overlapped with those
of the Werkbund was the *Bund Heimatschutz,* founded
in 1904. Although the *Bund* concerned itself primarily with
the preservation of traditional culture, some of its members
welcomed contemporary developments in the applied arts
and architecture and were prepared to cooperate in creat-
ing a new architecture for an industrialized Germany, pro-
vided that care was taken to blend the new structures
harmoniously into the inherited landscape.[42]

Finally, even a brief survey of the Werkbund's German
predecessors must include the Art Education Movement
founded by Alfred Lichtwark a decade earlier. When the
Werkbund turned to the question of the reform of art edu-
cation in 1908, it could draw on the ideas and personnel
of the earlier group with which it shared the belief that
reform of artistic education at all levels was a necessary

[40] The *Kunstwart* has been described as the chief organ of the
"Gebildeten-Reformbewegung," a reform movement by and for the
educated classes in Germany in the early 1900's. Cf. Kratzsch, *Kunst-
wart und Dürerbund,* pp. 31-40.

[41] Naumann, "Deutsche Gewerbekunst," pp. 262-65. Naumann
compared the Werkbund to a trade union, on the one hand, and to
an industrial association, on the other.

[42] The *Bund Heimatschutz* is discussed by Kratzsch, *Kunstwart
und Dürerbund,* as an integral part of the reform movement.
Kratzsch shows its relatively progressive character by contrasting
it with the *Werdandibund,* created in 1907 with the express purpose
of supporting *völkisch* and regional elements in the applied arts.
Both *Heimatschutz* and Werkbund stressed the need to overcome
narrow provincialism in the name of German national culture.
Ibid., p. 217.

preliminary to the recovery of a sound aesthetic and ethical culture.[43]

The Werkbund, a potential competitor to the existing reform groups, tended at first to cooperate with the others. Indeed, there was a considerable overlap of personnel. Thus, the architect Paul Schultze-Naumburg, a founding member of the Werkbund, contributed regularly to Avenarius' *Kunstwart* and played a leading role in the *Bund Heimatschutz*. Similarly, Friedrich Naumann and Fritz Schumacher both wrote for the *Kunstwart* and belonged to the *Dürerbund*. By 1912 nearly half of the Werkbund's executive committee belonged to the *Dürerbund* as well.[44] Moreover, all these groups shared an intellectual tradition, deriving from the cultural critics of the late 19th century, notably Julius Langbehn. Langbehn's call for a revival of artistic values in a materialistic age appealed strongly to educated Germans. His bestselling *Rembrandt als Erzieher*, first published anonymously in 1890, quickly became one of the most popular books among the artists, influenced the Art Education Movement, and deeply impressed reformers like Muthesius.[45] For although Langbehn has been categorized as a "cultural pessimist," his unsparing critique of German society and values spurred his more sanguine countrymen to mobilize the energies of the educated in order to combat the evils to which he had drawn attention.

[43] On the *Kunsterziehungsbewegung*, Stern, *Cultural Despair*, pp. 220-21; Marcel Franciscono, *Walter Gropius and the Creation of the Bauhaus in Weimar* (Urbana, Ill., 1971), pp. 182-83; Pevsner, *Academies of Art*, p. 265; Schumacher, *Stufen des Lebens*, pp. 194-95.

[44] However, only 15% of the *Dürerbund's* board of directors were Werkbund men. Cf. Kratzsch, *Kunstwart und Dürerbund*, Appendix I. Whereas the Werkbund consisted largely of professionals, the *Dürerbund* membership included a preponderance of primary school teachers, clerics, and students. *Ibid.*, Appendix II, 1905 Membership List of the *Dürerbund*. On Schultze-Naumburg, Sebastian Müller, *Kunst und Industrie* (Munich, 1974), pp. 74-76.

[45] On Langbehn, see Stern, *Cultural Despair*, pp. 131-227. Muthesius, for one, paid tribute to Langbehn's influence in "Wo stehen wir?" *DWB-J* (1912), pp. 14-16.

The Werkbund grew out of a distinctively German tradition, but it also had precursors outside Germany. In all the industrializing countries, similar problems had evoked a parallel response. Thus England, first to experience the industrial revolution, had also initiated the intellectual reaction against its adverse cultural effects. In the mid-19th century, the Arts and Crafts reformers, particularly John Ruskin and William Morris, had criticized contemporary society and preached a redeeming gospel of honest workmanship and good design.[46] Under their influence, in 1903 Josef Hoffmann of Vienna established the *Wiener Werkstätten*, the first workshops on the Continent to manufacture quality household goods in the English Arts and Crafts tradition.[47] At the same time van de Velde, Muthesius, Naumann, and others adapted the aesthetic and social ideals of the English reformers to continental conditions.

In so doing, however, they soon moved ahead of England, where the Arts and Crafts movement continued to glorify the handicrafts and only a few, notably the architect John Sedding, were prepared to accept the machine and "elaborate a craft machine aesthetic close to the theories" later espoused by the Werkbund.[48] In the United States, Frank Lloyd Wright, one of the pioneers of the modern movement in architecture, tried, in 1893, to found an association in Chicago in which artists and industrialists working together would employ the machine for the benefit of culture; but his effort to replace the existing Arts

[46] On the English Arts and Crafts movement, Pevsner, *Pioneers of Modern Design*, Ch. 6; Alf Bøe, *From Gothic Revival to Functional Form* (Oslo, 1957); Gillian Naylor, *The Arts and Crafts Movement* (London, 1971); Fiona MacCarthy, *All Things Bright and Beautiful* (London, 1972). Still indispensable is Waentig, *Wirtschaft und Kunst*, Part 1, on the "New Gospel" of Carlyle, Ruskin, and Morris.

[47] Waentig, *Wirtschaft und Kunst*, pp. 277-78; Giulia Veronesi, "Josef Hoffmann," in *Encyclopedia of Modern Architecture*, ed. Gerd Hatje (London, 1971), pp. 147-49.

[48] Naylor, *Arts and Crafts Movement*, pp. 164-65. Sedding expressed these views in 1893.

and Crafts society with something like the Werkbund proved unacceptable to men still dogmatically attached to the tradition of Ruskin and Morris.[49]

Sedding in England and Wright in the United States failed to find fertile ground for their progressive notions. Instead, it was in Germany, a relative latecomer among the industrialized nations, that the first serious step was taken to create a working alliance between art and industry. In 1907, the A.E.G., Germany's leading manufacturer of electrical products, appointed Peter Behrens as the company's official designer.[50] The fact that one of Germany's most progressive and rapidly expanding industrial groups should employ an artist at the highest level set an important precedent.[51] Van de Velde had already developed the notion of cultural reform through artist participation for the luxury crafts, and the *Werkstätten* movement had extended it to the bourgeois sphere; but the A.E.G.'s decision for the first time raised hopes that this "Werkbund" idea might affect the quality of life of the general public

[49] See the reference to Wright's "The Architect and the Machine" (1894) and "The Art and Craft of the Machine," in Olgivanna Lloyd Wright, *Frank Lloyd Wright* (New York, 1966), p. 206. See also H. de Fries, ed., *Frank Lloyd Wright: Aus dem Lebenswerke eines Architekten* (Berlin, 1926), pp. 13-16. I am indebted to Mr. Walter Segal of London for this reference.

[50] The Behrens appointment seems to have been the act of the A.E.G.'s managing director, Paul Jordan, rather than of its founder and head, Emil Rathenau. Cf. Theodor Heuss, "Peter Behrens," Obituary, in *Die Hilfe* (1940), p. 75. Rathenau is mentioned in the Werkbund context in a letter from H. H. Peach to Joseph Thorpe, Aug. 22, 1918 (*RIBA*, DIAP 61/3), as one of the first-rate men who took up the Werkbund idea, "turning loose Behrens and others on the job." (In the margin, Peach inked the comment: "I hear he was an autocrat, paid badly.") Peach also alluded to Rathenau in notes for a talk on the Werkbund, circa 1918 (*RIBA*, DIAP 1/1), ranking him with Muthesius, Naumann, and Bruckmann. However, I have been unable to find any direct evidence that either Emil or his famous son, Walther, who succeeded his father as head of the A.E.G. in 1915, was personally involved in Werkbund affairs.

[51] Banham, *First Machine Age*, p. 69. For descriptions of Behrens' work for the A.E.G., see A.E.G., *Peter Behrens: 50 Jahre Gestaltung in der Industrie* (Berlin, 1958); and F. H. Ehmcke, *Persönliches und Sachliches* (Berlin, 1928), pp. 5-8.

and thus transform the face of Germany. While the Werk-
bund could not take credit for this step, Behrens soon be-
came prominent within the new association. Indeed, his
position in the A.E.G. corresponded so closely to the Werk-
bund ideal that he may be regarded as its most representa-
tive figure in the prewar era.[52]

Despite the fact that the Werkbund program had strong
roots both in Germany and abroad, it would be wrong to
conclude that it was an inevitable product of the con-
temporary situation. From the start, the association had
enemies not only among the tradition-bound economic in-
terest groups threatened by modernity, but also among in-
tellectuals and artists. Prominent among the latter was the
Austrian architect Adolf Loos, himself an innovator of the
first rank and theorist of modern functionalism. To Loos,
the Werkbund was simply superfluous.[53] Convinced that
form follows function, that styles emerge spontaneously as
production adapts to new patterns of living, Loos insisted
that no organization could influence or hasten the process.
He also opposed the intervention of the artist in the design
process, and regarded the self-consciously "artistic" cul-
ture for which men like Josef Hoffmann and van de Velde
were striving as a sign of decadence rather than progress.
Condemning all ornament as a crime, Loos believed that
only the truly simple could be classed as modern, and that
the world would be a much better place if professors
stayed within their ivory towers and artists returned to
their studios—or went off to sweep the streets! To Loos, the
"applied artist" was a monstrosity and the search for nov-
elty and modernity the cause of much ugliness in the

[52] Posener, "Deutsche Werkbund," p. 1, calls Behrens the first
industrial designer and refers to him as "Mr. Werkbund." Cf. also
Naumann, "Deutsche Gewerbekunst," p. 261.

[53] Adolf Loos, "Die Überflüssigen" (1908), in Adolf Loos, Sämt-
liche Schriften, I (Vienna, 1962), 267-75. Loos's contribution to
modern functionalism is discussed briefly by Pevsner, Pioneers of
Modern Design, pp. 199-200, and Schaefer, Roots of Modern Design,
pp. 182-88. See also Ludwig Münz and Gustav Künstler, Adolf
Loos: Pioneer of Modern Architecture (New York, 1966).

world.[54] Nor did he approve of the Werkbund slogan of "quality." Ugly things, if poorly made, at least possess the virtue of rapid obsolescence. He conceded that objects of daily use can be beautiful, but argued that if they are aesthetically pleasing it is not because they are artist-designed but because they perfectly fulfill their function and embody the highest potential of modern technology.

Another eminent critic of the Werkbund was the economist Werner Sombart. Unlike Muthesius or Naumann, Sombart believed that the machine age would never evolve a high culture. On the contrary, modern technology as employed by the capitalist system played the villain in his account of the art industries.[55] In *Kunstgewerbe und Kultur*, published in 1908, Sombart maintained that the applied artist under capitalism could never be more than a prostitute at the beck and call of an all-powerful economic master.[56] Moreover, art was at the mercy not only of profit-seeking producers but of the mass market. As ninety-nine percent of consumers lacked either the taste or the money to purchase quality goods, Sombart saw little prospect for genuine cultural reform. No social policy he could imagine, and, by implication, no association like the Werkbund, could turn snobs or proletarians into discriminating patrons of the arts.

Sombart did not object to the machine as such, nor to large-scale production, but rather to the capitalist system that misused them. He recognized the futility of attempts to reverse the trend toward rationalization, regarding as utopian those who wished to return to the crafts or even to preserve a separate sphere in which the quality arts and crafts could survive. The modern age, celebrated by

[54] Loos, "Ornament und Verbrechen," *Sämtliche Schriften*, I, 276-87.

[55] Naumann, who had been greatly influenced by Sombart's *Modern Capitalism* (Leipzig, 1902-1908) and acknowledged him as an expert on the art industries, rejected that economist's pessimistic estimate of the German nation's artistic potential. Cf. Naumann, "Kunst und Volk" (1902), *Werke*, VI, 81-83.

[56] *Kunstgewerbe und Kultur* (Berlin, 1908). This book was actually written in 1906, that is, before the founding of the Werkbund.

the common man for its comforts and by the upper classes because they profited therefrom, could not be wished away. Only a minority could be found to mourn the fate of art in a utilitarian environment—a handful of intellectual outsiders and those artists and artisans broken on the wheel of fortune.[57] On the other hand, Sombart disliked the doctrinaire modernists who tried to develop an aesthetic based on functionalism and the machine. Recognizing the irreversibility of industrialization was one thing; welcoming its cultural by-products with enthusiasm was quite another.[58] Moreover, he argued, although useful articles need not be ugly, hot water bottles and umbrellas are simply not fit objects for the artist's attention. Some things are better left in undistinguished obscurity, and need to be formed with practicality rather than beauty in mind.[59] Indeed, excessive emphasis on the artistic component of life was corrosive of higher values, making men slaves of their visual environment. Rejecting the concept of a nation of artists and aesthetes, Sombart preferred the heroic ideal to either the commercial or the aesthetic.

Yet Sombart did not entirely disapprove of the educational efforts of the Werkbund or the *Kunstwart* circle. A member of the Werkbund from 1908 to 1910, he, too, favored attempts to improve the general level of taste and to combat the preference of producers for cheapness rather than quality. Although his economic determinism logically ruled out the possibility of success for such measures, he was enough a man of his time to be touched by that faith in the power of education to which the majority of his intellectual contemporaries subscribed. Loos, too, maintained close relations with many Werkbund members who in turn regarded him as a comrade in a common endeavor. It would seem that both Loos and Sombart found greater

[57] Sombart, *Kunstgewerbe und Kultur*, pp. 83-85.

[58] *Ibid.*, pp. 71-76.

[59] Sombart was evidently one of those of whom Loos wrote, in "Die Überflüssigen," p. 267: "Modern man regards Art as a high Goddess and considers it blasphemy to prostitute Her for articles of use." [Unless otherwise indicated, all translations are my own.]

understanding for their view among the reformers whom they criticized than among the reactionaries whose distrust of modernity inspired the most persistent resistance to the Werkbund program.

In the face of its critics, the Werkbund's main asset was the conviction that through organization, education, and creative work it would indeed be possible to bring about genuine improvements in German society and culture. Its members, not content merely to judge the present in the light of the past, sought to evolve new ideals pointing to a better future and to propagate these by word and deed.

CHAPTER II

The Evolution of the
Werkbund to 1914

BETWEEN 1908 and 1914 the Werkbund translated its vaguely defined principles into a program of action. It developed a national organization and exerted growing influence on standards of public taste and design. In 1914, it was ready to mount a large-scale exhibition that, from June until the outbreak of war in August, made the Rhineland city of Cologne the center of pilgrimage for domestic and foreign visitors wishing to view the finest products of German skill and industry. Yet all was not well within the Werkbund. At the July 1914 annual meeting, held at Cologne in conjunction with the exhibition, deep internal conflicts came to the surface and brought the association to the verge of collapse.

The tensions that nearly led to the secession of some of the Werkbund's most creative members in the summer of 1914 had been present from the beginning, but during the early years they were masked by the visible achievements of the association. Had it been a debating society primarily intent on establishing a consistent theoretical foundation for modern design, the Werkbund could not have survived more than a year or two, given the highly diverse interests and aesthetic predilections of its members. However, as its name implied, the *Werk*bund preferred practice to theory, creative deeds to words. At its first annual meeting in Munich in 1908, the president, Theodor Fischer, had even urged the association to avoid *any* discussion of art, arguing that aesthetic questions could be settled only by individuals, not resolved by organi-

zational fiat.[1] That Fischer's appeal was not heeded is evident from the fact that his plea had to be repeated at intervals by other Werkbund leaders. Nevertheless, the intention of its founders was clear: to ensure that each member did his best to produce quality work, whatever his sphere of activity or his artistic preferences. Efforts to raise the general level of the applied arts inevitably led to attempts to define quality, good taste, and style; but Werkbund aesthetics remained a by-product of Werkbund work, arising from the need to achieve some agreement on fundamentals as a basis for common action.[2]

The Werkbund grew rapidly throughout the prewar period, but especially after April 1912 when the head office was transferred to the Imperial capital of Berlin. From 971 in March 1912, the membership rose to 1,319 a year later, and reached 1,870 in 1914.[3] The move from Dresden coincided with the appointment of Ernst Jäckh as executive secretary, succeeding Alfons Paquet, who had assisted Dohrn in 1910 and 1911 and then briefly taken over from him. Paquet was well qualified in theory—his doctoral thesis for the University of Jena had dealt with the economics of exhibitions—but proved an ineffective leader. It was hoped that Jäckh would supply the energy and organizational skill required to get the Werkbund out of the doldrums.[4]

In 1912, Jäckh, a political journalist, was editor of a

[1] Inaugural Address, in DWB, *Die Veredelung der gewerblichen Arbeit im Zusammenwirken von Kunst, Industrie und Handwerk* (Leipzig, 1908), p. 4 [hereafter *Veredelung*].

[2] Müller, *Kunst und Industrie*, a detailed study of the Werkbund before 1914, deals with its contribution to the creation of a modern aesthetic based on rationalistic functionalism. Although Müller acknowledges that the development of a consistent theory was not the primary aim of the Werkbund, he focuses on the role of prominent Werkbund architects and designers in defining functionalism, and analyzes the theoretical implications of the Werkbund's call for an alliance between art and industry.

[3] Ernst Jäckh, "6. Jahresbericht des deutschen Werkbundes," *DWB-J* (1914), p. 87.

[4] Heuss, *Erinnerungen*, p. 114. Paquet later achieved considerable renown as a journalist, travel writer, and poet.

newspaper in Heilbronn, where he had been instrumental in getting Friedrich Naumann elected to the Reichstag. He was chosen for the Werkbund post by Peter Bruckmann, president of the association since 1909. Unlike Dohrn and Paquet, Jäckh had never displayed any interest in artistic matters, but he had demonstrated administrative ability and combined this with imagination, energy, and political ambition. Moreover, his journalistic activities and interest in the Near East had led him to acquire contacts in the German Foreign Office and other branches of the Reich bureaucracy that the Werkbund executive hoped to exploit for its own purposes.[5]

The appointment of Jäckh and the transfer to the capital were part of a conscious effort to extend the Werkbund's influence. This was accompanied by a rapid expansion of the network of local Werkbund groups. In the two years ending March 1914, twenty-six new branches were started, bringing the total to forty-five.[6] This directly increased the size of the board of directors (*Ausschuss*), as each local was headed by an appointed agent (*Vertrauensmann*) with an ex officio seat on the board.[7] By a constitutional amendment of June 1912, the executive committee (*Vorstand*) experienced a parallel expansion, from six to twelve, and received the right to co-opt additional members. At the same time, the executive secretary became a full and permanent voting member.[8]

As the Werkbund grew, the annual meetings changed. What had once been intimate gatherings of a self-selected elite gradually became large conventions enjoying public patronage and attracting attention from the national press. Thus the Leipzig meeting of 1913 took on the character of a public festival, complete with military displays, dance ensembles, musical and theatrical events, and an evening

[5] Letter from Hermann Muthesius to Jäckh, 1912, cited in Jäckh, *Goldene Pflug*, p. 196.

[6] Jäckh, "6. Jahresbericht," p. 89.

[7] See paragraph 13 of the constitution, appended to *DWB-J* (1913).

[8] *Ibid.*, paragraph 8.

boatride to the accompaniment of a string quartet.[9] Eugen Diederichs, who had helped to organize this occasion in order to prove that the Werkbund could achieve a deeper sense of community and a "heightened consciousness of life" through the use of visual and auditory effects, was disappointed by the outcome. Somehow the organization that had begun as a "band of conspirators" had been transmuted into an assembly of worthies, many lacking the youthful enthusiasm and conviction of the early days.[10]

While its more romantic members deplored the change, Jäckh stressed the beneficial effects of growth: "At first the Werkbund had been described as an areopagus of leaders and educators; it then expanded into a sort of parliament whose excellent speeches were widely quoted; only now has it become an active force."[11] Nevertheless, Jäckh's attempt to extend Werkbund influence by increasing membership did produce some dilution of quality. As the prominent art critic, Robert Breuer, noted in 1914, an association whose membership list covered many quarto sheets could not possibly consist only of outstanding personalities.[12] Moreover, the constitution of 1912 for the first time provided for corporate membership, with each association entitled to a voting representative; by 1914, approximately twenty-seven organizations, some semi-public in nature, had taken advantage of this clause.[13] The sudden expan-

[9] Lulu von Strauss und Torney-Diederichs, eds., *Eugen Diederichs: Leben und Werk* (Jena, 1936), pp. 216-17. The Leipzig congress was officially welcomed by representatives of the Reich Ministry of the Interior, the Austrian Ministry of Public Works, and the governments of Saxony, Württemberg, and Baden. Jäckh, "6. Jahresbericht," p. 90.

[10] F. H. Ehmcke, citing Diederichs in "Erinnerung an Eugen Diederichs," *Geordnetes und Gültiges* (Munich, 1955), p. 24.

[11] Jäckh, "6. Jahresbericht," pp. 88-89. Jäckh emphasized that membership continued to be by invitation only, with the executive committee basing the final verdict on applications submitted by the local Werkbund agents.

[12] Robert Breuer, "Die Kölner Werkbund-Ausstellung, Mai-Oktober 1914," *Deutsche Kunst und Dekoration*, xxxiv, No. 12 (1914), 418.

[13] This included ten chambers of commerce, fifteen crafts associations, two industrial associations, and sixteen miscellaneous

sion of the Werkbund also led to a centralization of deci-
sion-making powers in Berlin. Despite more frequent board
meetings, greater emphasis on the branches, and the crea-
tion of an elaborate committee structure, the participation
of ordinary members came to count for less.[14] Increasingly,
the association was controlled by a small inner circle at
headquarters, a circumstance that aroused resentment and
reinforced the feeling that, under Jäckh, the Werkbund
was falling into the hands of bureaucrats out of touch with
important sections of the membership.

Only one by-product of the Werkbund's growth met
with general approval, namely, its strengthened financial
position. The first Berlin year saw the budget increase
from 18,000 to 30,000 mark and this rose to 42,000 mark
in 1913-1914.[15] Receipts from dues, assessed on a sliding
scale from a minimum of 10 mark for an individual mem-
bership, rose steeply as the organization nearly doubled in
size between 1911 and 1914. The addition of business and
corporate members, who contributed at a higher rate,
worked in the same direction, as did the fact that public
bodies were increasingly prepared to support Werkbund
objectives. Thus when the Prussian Ministry of Trade and
Commerce purchased 700 copies of the association's first
yearbook for distribution as school prizes, it not only
propagated the cause, but also provided a useful subsidy.[16]

A further source of income may have been the sale of
Werkbund publications. The yearbooks, published annu-
ally from 1912, sold out every year despite sharply rising
editions: 10,000 in 1912, 12,000 in 1913, and 20,000 in

groups, among them the *Deutsche Handelstag*, the *Handwerks- und
Gewerbekammertag*, and the *Exportverband deutscher Qualitäts-
fabrikanten*. Jäckh, "6. Jahresbericht," p. 89.

[14] The branches were frequently formed in response to suggestions
from Berlin and were closely controlled by the central office, which
sought to codify their rights and duties. See Ernst Jäckh, "5. Jahres-
bericht des deutschen Werkbundes," *DWB-J* (1913), pp. 99-100, and
"6. Jahresbericht," p. 89.

[15] Jäckh, "6. Jahresbericht," p. 87.

[16] Jäckh, "5. Jahresbericht," p. 101; "6. Jahresbericht," p. 90.

1914.[17] In addition, the association produced a wide range of books and pamphlets. Much of the potential profit from these publications was cancelled out by the fact that members received the yearbook free, and other items at preferential rates. Yet the expanding public sale of its literature presumably contributed to the healthy financial state of the association, which in turn enabled it to support an ever more ambitious program of activities.[18]

During these years, the Werkbund divided its efforts among three main areas: general propaganda, consumer education, and the reform of product design. The first category included the publishing program and exhibition work, as well as the annual meetings. Attended by a growing number of nonmembers, congresses were held in turn in different German cities that vied with each other for the honor, and their educational impact was enhanced by extensive press coverage.[19]

The Werkbund also sought to use Germany's museums to influence public taste. By 1913, its board of directors included ten museum heads, of whom four were Werkbund agents in their regions. Moreover, in 1909 it had helped to create the *Deutsches Museum für Kunst in Handel und Gewerbe* in Hagen. The brainchild of Karl-Ernst Osthaus, a wealthy and eccentric patron of modern art, the *Deutsches Museum* became in effect the "Werkbund Museum," dependent on it for regular financial contributions and collaborating with it in a number of ventures.[20] The

[17] Jäckh, "6. Jahresbericht," p. 90.

[18] For details of Werkbund publications, see the Bibliography and also Fischer, *Deutsche Werkbund*, pp. 607-10. Unfortunately, it is not possible to form an accurate picture of Werkbund revenues and expenditures from available budget statements. Information on the readership of the yearbooks and other Werkbund publications also is not available.

[19] Of the 400 persons who attended the congress at Dresden in 1911, only 260 were Werkbund members. See DWB, 4. *Jahresbericht 1911/12*, p. 9.

[20] See DWB, *Verhandlungsbericht 1909*, pp. 23-25, for a report by Osthaus to the Werkbund on the organization of the *Deutsches Museum*. Also, DWB, *Die Durchgeistigung der deutschen Arbeit* (Jena, 1911), pp. 43-46 [hereafter *Durchgeistigung*]; and Sebastian

museum's specialty was the organization of traveling exhibitions of modern quality products from its own collections. By 1911, it had sent forty-eight of these to various parts of the country, and in 1912 it sponsored the most significant display of this kind, an exhibition of model factory designs organized by the young Walter Gropius.[21] Gropius, a pupil of Peter Behrens, had been introduced to the Werkbund by Osthaus in 1910; his work for the *Deutsches Museum* led him to develop a theme that he later pursued in the 1913 yearbook and at the Cologne exhibition.[22] Also worthy of note is an exhibition of 1912 sponsored by the *Deutsches Museum* and the Werkbund with the Museum Association of Newark, New Jersey. Comprising approximately 1,300 objets d'art, paintings, and architectural photographs, this touring display was designed both to publicize Werkbund aims abroad and to sell German goods.[23] Finally, the *Deutsches Museum*, after the dissolution of the Werkbund's own press and photographic bureau, served as an information center on Werkbund topics, even organizing a slide collection for use by the association's lecturers.[24]

Closely related to its general propaganda was the Werkbund's program of consumer education. Although its eventual aim was to reform German production, the association recognized that it would be self-defeating to ask manufac-

Müller, "Das Deutsche Museum für Kunst in Handel und Gewerbe," in Herta Hesse-Frielinghaus, ed., *Karl-Ernst Osthaus: Leben und Werk* (Recklinghausen, 1971), pp. 259-342.

[21] Müller, *Kunst und Industrie*, p. 46. DWB, *I. Jahresbericht 1908/09*, p. 16, indicates that this project of 1909 originated with the Werkbund and the *Heimatschutzverbände*, and antedated the creation of the *Deutsches Museum*.

[22] Walter Gropius, "Die Entwicklung moderner Industrie-Baukunst," *DWB-J* (1913), pp. 17-22.

[23] Schaefer, *Roots of Modern Design*, p. 196; Müller, *Kunst und Industrie*, p. 122; Jäckh, "5. Jahresbericht," p. 106.

[24] Organized in 1909 by a committee consisting of three well-known and influential journalists (Fritz Hellwag, Robert Breuer, and Max Osborn), the Werkbund press service was dissolved in the following year. See DWB, *Verhandlungsbericht 1909*, pp. 40-41; 2. *Jahresbericht 1909/10*, p. 13; and 3. *Jahresbericht 1910/11*, p. 6.

turers and craftsmen to adopt the ideal of quality, without first ensuring that a market for their work existed.[25] The German consumer had to be taught a new aesthetic awareness that would lead him to seek out quality goods of simple design even if this involved considerable trouble and expense.[26] As Muthesius put it, the German bourgeois had to be convinced that good taste is as important as cleanliness, a part of true morality.[27] It was also necessary to overcome the fanatical frugality prevalent among the intellectuals, who often disdained material possessions, contenting themselves with tasteless furnishings so long as they were cheap.[28] Other consumers, who purchased antiques or standard reproductions as investments, had to be shown that carefully selected modern designs would hold their value in the long run.[29] The fact that the wealthier consumer continued to demand custom-designed, hand-crafted furnishings also ran counter to the Werkbund's program. While such luxury products were sometimes purchased as status symbols, more than snobbery was involved: even in Werkbund circles there was resistance to the notion that machine-made goods produced in quantity could be aesthetically pleasing.[30]

Finally, the Werkbund gospel was obstructed by the public's addiction to novelty. Whereas many consumers had to be weaned away from visual indifference or aesthetic con-

[25] Waentig, *Wirtschaft und Kunst*, Ch. 2, on Art and Demand.

[26] The obstacles facing the Werkbund in its work with consumers were set out by Naumann, "Deutsche Gewerbekunst," pp. 278-83. At the Werkbund's third annual meeting, Karl Schaefer, director of the Leipzig Museum, drew attention to the shortage of well-designed modern goods, DWB, *Durchgeistigung*, p. 49.

[27] Muthesius, "Wo stehen wir?" *DWB-J* (1912), p. 19.

[28] Heuss referred to this "Sparsamkeitsfanatismus" of the intellectuals in "Gewerbekunst und Volkswirtschaft," *Preussische Jahrbücher*, CXLI (1910), 10-11.

[29] Naumann, "Deutsche Gewerbekunst," p. 283.

[30] Thus Theodor Fischer believed a certain lack of perfection was necessary for aesthetic pleasure, and thought machine products cold and monotonous because of their exactness and uniformity. See DWB, *Veredelung*, p. 14; and Müller, *Kunst und Industrie*, pp. 70-72.

servatism, others were only too susceptible to the appeal of passing fashion. To counter this, the Werkbund stressed the timeless quality of well-designed and well-made objects and inveighed against the worship of the new for its own sake. In doing so, however, it seemed to contradict its own belief in the need for a modern style to meet contemporary requirements. If good taste could be defined purely in terms of quality, what was to prevent traditionalists in or outside the association from arguing that a revival of past styles was fully compatible with the Werkbund ideal? Thus Paul Schultze-Naumburg, and on occasion Muthesius too, maintained that the dignity and simple honesty of preindustrial bourgeois taste could set a standard for the modern world.[31] By contrast, prophets of modernity like van de Velde found it difficult to convince others that their designs were anything more than the latest term in an infinite series of styles. Failure to reconcile these two points of view undoubtedly hampered the Werkbund in its efforts to persuade German consumers that modernity was as much a component of quality design as were sound material and honest workmanship.

The Werkbund's program of consumer education concentrated almost entirely on the well-to-do, particularly the wealthy bourgeoisie. Unlike Langbehn, who had despised the bourgeoisie as incurably philistine, and believed that salvation could come only from the aristocracy and the peasant *Volk*,[32] the Werkbund leaders pinned their hopes on the urban middle class that in their view constituted not just the backbone of the nation, but the apex of its political and cultural life. More specifically, they addressed themselves to the educated urban elite, the *Gebildete*, who, despite the efforts of earlier reformers, still failed lament-

[31] *Ibid.*, p. 75 on Schultze-Naumburg, and pp. 43-44 on Muthesius. Whereas the former took the "Biedermeier" style of the early 19th century as his model, Muthesius idealized the English country house tradition; but in both cases, the Werkbund idea of functional simplicity was linked with "bourgeois" styles of the past.

[32] Stern, *Cultural Despair*, pp. 169-75.

ably to appreciate the importance of quality and good design.

In order to win over the *Gebildete*, the Werkbund relied heavily on ethical and patriotic appeals, stressing that the educated elite had a duty to spread the gospel of good taste first to other sections of the bourgeoisie and then to groups lower in the social hierarchy. Although it believed that art must always be the work of a minority,[33] the Werkbund hoped that the urban workers would eventually participate in a revitalized German culture; but in the short run, even the socially-minded followers of Naumann had to recognize that the working class simply could not afford quality goods. To urge the workers to value quality seemed pointless until the price of well-made, durable goods could be brought down through competition, and until the shift to quality created a stratum of highly paid workers able to purchase the products of their skilled labor.[34]

Keenly aware of the magnitude of the task before it, the Werkbund used a wide variety of approaches in its campaign of consumer education. One of the more unusual was an attempt to enlist the nation's retailers as agents of reform. Because shopkeepers seemed to possess great power to affect consumer decisions, for good or ill, through their choice and presentation of available products, the association arranged courses for different branches of the retail trade.[35] Featuring illustrated lectures by Werkbund experts, these seem to have been well attended, and the results were sufficiently encouraging to ensure annual

[33] For examples of the argument that culture is not a *Volk* product but always comes from above, Hermann Muthesius, *Kultur und Kunst* (2nd ed., Jena, 1909), p. 27; Muthesius, "Wo stehen wir?" *DWB-J* (1912), pp. 25-26; Naumann, "Deutsche Gewerbestil," p. 23.

[34] Naumann, "Deutsche Gewerbekunst," pp. 278-81.

[35] Friedrich Naumann, "Werkbund und Handel," *DWB-J* (1913), pp. 5-16; Hermann Muthesius, *Wirtschaftsformen im Kunstgewerbe* (Berlin, 1908), pp. 17-19. Ideally, Muthesius believed that the middleman should be abolished, but he recognized this as utopian and so advocated education to turn the shopkeeper into an expert judge of quality and style.

repetition and extension of the courses.[36] Related to this was a protracted campaign to improve the standard of window display in retail establishments. Convinced that "the shop window is the most practical means of educating both the retailer and the public at large," the Werkbund organized window dressing competitions in Hagen, Berlin, and elsewhere.[37] Moreover, in 1910, it helped to establish a special school for display art in Berlin.[38] Despite initial opposition from professional decorators, and hesitancy on the part of Berlin's businessmen to adapt to new ways, it soon was able to claim that the German capital, on average, had the best decorated, most artistic shop windows in the world.[39]

Another unusual project, undertaken in 1913 jointly with the *Dürerbund*, was to prepare a directory of quality goods obtainable in approved shops. The resulting volume, the *Deutsches Warenbuch*, originally due to appear at the end of 1914, was delayed until the following year by the outbreak of war. But the idea dated back at least as far as 1908, when Naumann had called for compilation of a "Baedeker" of practical consumer advice, available to

[36] The outline for the first course of lectures appeared in DWB, *1. Jahresbericht*, Appendix II, 21-24. According to DWB, *2. Jahresbericht*, p. 14, about 5,000 salesmen and women from all parts of the country attended in 1909-10. See Müller, *Kunst und Industrie*, pp. 18-20.

[37] Eugen Kalkschmidt, "Die vierte Tagung des deutschen Werkbundes," *Dekorative Kunst*, XIX (1911), 524. Osthaus took credit for initiating this program, but according to Frau Else Oppler-Legband, Berlin—not Hagen—was the birthplace of the movement. See DWB, *Durchgeistigung*, pp. 45-46 and 51-55; and Karl-Ernst Osthaus, "Das Schaufenster," *DWB-J* (1913), pp. 59-69.

[38] A private undertaking to which the Werkbund gave significant financial assistance, this *Höhere Fachschule für Dekorationskunst* was also subsidized by the Prussian Ministry of Trade and the Berlin Chamber of Commerce. Müller, *Kunst und Industrie*, p. 126; DWB, *4. Jahresbericht 1911/12*, pp. 18-19. In 1911, the school was incorporated into the *Schule Reimann*.

[39] Jäckh, "5. Jahresbericht," pp. 107-108, noted the beneficial effect of improved window displays on the urban street scene as a whole.

Werkbund members on a nonprofit basis.[40] Although one function of the *Warenbuch* was to improve the distribution of quality goods, it was designed above all to educate consumer taste by showing a variety of items for the home, selected by a committee largely composed of Werkbund experts.

The Werkbund thus devoted a great deal of effort to remolding the German consumer through propaganda and example. It realized, however, that to implement its long-term goals, changes in the entire educational system were required.[41] Thus, although the top priority of the Werkbund's education committee, established in 1908, was to reform industrial training, a session was set aside at the first annual meeting for a general debate on art education in the schools.[42] The association from the start provided a forum for all who, echoing Langbehn, blamed the public's lack of aesthetic judgment on the exclusively intellectual bias of German education.[43]

The Werkbund's chief authority on educational matters was Georg Kerschensteiner, a Munich educator who became a member of the association's education committee and also served on its board of directors. A disciple of Alfred Lichtwark, Kerschensteiner had converted Karl Schmidt and Friedrich Naumann to his belief in the ethical value of manual training, and had inspired Muthesius' reform of the Prussian arts and crafts schools.[44] His involvement with the Werkbund seems to have diminished

[40] "Deutsche Gewerbekunst," p. 284. On the *Dürerbund-Werkbund Genossenschaft,* F. Avenarius, "Deutsches Warenbuch," *Kunstwart,* XXIX (Oct. 1915), 19-22; Jäckh, "6. Jahresbericht," pp. 100-101.

[41] DWB, *Leitsätze ausgearbeitet von dem Geschaftsführenden Ausschuss auf Grund der Gründungsversammlung des Bundes zu München* (n.p., 1907), p. 8 [hereafter *Leitsätze*].

[42] DWB, *1. Jahresbericht,* p. 17.

[43] DWB, *Veredelung,* pp. 175-76. The reference to Langbehn was in Theodor Fischer's inaugural speech, *ibid.,* p. 13. Cf. Stern, *Cultural Despair,* pp. 175-76.

[44] On German art education before 1914 and the Werkbund's role in its reform, Pevsner, *Academies of Art,* pp. 265-76. On Kerschensteiner, see Müller, *Kunst und Industrie,* pp. 128-33; and Franciscono, *Walter Gropius,* pp. 183-85.

after his election to the Reichstag in 1912, but his ideas continued to be influential. Other authorities on art education such as Ludwig Pallat, Hermann Obrist, and Franz Cizek also used the Werkbund to propagate their views. By emphasizing the need to stimulate the creativity of the child, preserve his innate imaginative powers, train his eye and hand as well as his brain, and inculcate respect for manual skill, they hoped not only to develop future artisans, designers, and artists, but to create an enlightened public capable of supporting a higher national culture.[45]

In pursuing its consumer education program, the Werkbund increasingly looked to the "Great Powers of German Production."[46] Foremost among these were, of course, the German governments. The Werkbund drew on government support for its exhibition work and sought to influence state policy with regard to museums and schools. Its propaganda also stressed the responsibility of governments to act as model consumers. Although it recognized that in an age of private enterprise the state could no longer exert much direct influence on production, it argued that modern governments, through enlightened building programs and purchasing policies, could affect significantly the general level of taste.[47] As a result the Werkbund strove to convert to its cause officials responsible for decisions on matters of design.[48]

[45] See, e.g., the account of an illustrated lecture by Franz Cizek on the creative powers of children, held at the fourth annual meeting of the Werkbund in Dresden, 1911. DWB, 4. *Jahresbericht*, p. 9. Cizek apparently derived his ideas from Langbehn and influenced Itten and the Bauhaus. Stern, *Cultural Despair*, pp. 168-69; and Franciscono, *Walter Gropius*, pp. 188-91. Muthesius, in "Die neuere Entwicklung und der heutige Stand des kunstgewerblichen Schulwesens in Preussen," *Das Deutsche Kunstgewerbe 1906*, p. 51, stressed that the arts and crafts schools, in addition to training specialists, had a duty to serve as centers of public enlightenment.

[46] Peter Jessen, "Der Werkbund und die Grossmächte der Deutschen Arbeit," *DWB-J* (1912), pp. 2-10 [hereafter "Grossmächte"].

[47] DWB, *Leitsätze*, p. 7.

[48] Entirely in the Werkbund spirit was the *Gemeinnützige Vertriebsstelle deutscher Qualitätsarbeit*, established by the *Dürerbund* to advise army, navy, and civil service purchasing officers. See H. Wolff, "Die volkswirtschaftlichen Aufgaben des Deutschen Werk-

It also tried to persuade the Reich government that it had a responsibility to propagate Werkbund ideals overseas. By 1914, the German Foreign Office had accepted the idea that consulates and embassies should serve as showcases for quality work in the new style, and requested the Werkbund to organize a series of lectures for the benefit of consular and diplomatic officials, in conjunction with the Cologne exhibition.[49]

In addition to impressing on governments the need to improve their performance as patrons of excellence, the Werkbund did what it could to influence private concerns, particularly the big enterprises, who were urged to adopt Werkbund principles in their capacity as corporate consumers. This approach met with some success. For example, two major shipping companies, the *Norddeutsche Lloyd* and the *Hamburg-Amerika Line*, publicly proclaimed their allegiance to the quality ideal by joining the association as corporate members, and employed Werkbund artists like Hermann Muthesius, Bruno Paul, and Paul Troost to design interiors for their Atlantic liners.[50] The Werkbund also influenced the design of hotels, department stores, and warehouses, both by publicizing good examples in its yearbooks and by encouraging its members to address themselves to these matters.[51]

The Werkbund especially stressed the social and aesthetic responsibility of private industry to set a high standard for office and factory construction. In the area

bundes," *DWB-J* (1912), p. 90; and Avenarius, "Deutsches Warenbuch," p. 19.

[49] *DWB-M* 1915/1 (June 1915), p. 5. The idea had been suggested by Gustav Gericke at the Munich annual meeting of 1908. DWB, *Veredelung*, p. 24. Gericke, director of the *Linoleumfabrik 'Ankermarke'* in Delmenhorst, joined the Werkbund executive in 1908 and remained active until the war. He, Peter Bruckmann, and Karl Schmidt (who joined the executive committee in 1912), represented the manufacturers within the association's councils.

[50] Jessen, "Grossmächte," p. 5; Bruno Paul, "Passagierdampfer und ihre Einrichtungen," *DWB-J* (1914), pp. 55-58.

[51] See especially the Werkbund yearbook for 1913, devoted to art in industry and commerce.

of industrial architecture, its role was indeed seminal. Thanks to the patronage of a variety of enlightened firms, Peter Behrens, Hans Poelzig, Walter Gropius, and other Werkbund architects were given an opportunity to experiment.[52] The Werkbund yearbooks, the display of modern factory designs by the *Deutsches Museum*, and the Cologne exhibition buildings of Gropius all helped to publicize their efforts, and won acceptance for the new methods and style in industrial building.

Finally, the Werkbund drew the attention of big business to the importance of providing well-designed and inexpensive housing for the industrial labor force. Although it was usual for manufacturers to provide accommodation for their workers before 1914, the associated social, aesthetic, and economic problems had not yet been satisfactorily solved, and the Werkbund therefore found much to do in this area. Karl Schmidt, working with leading Werkbund architects, set an example in the housing he provided for workers of the *Deutsche Werkstätten* within the framework of the garden city at Hellerau.[53] In addition, the Werkbund investigated the possibility of standardizing and mass producing building components.[54] Although such innovations never got much beyond the level of theory in the prewar period, the Werkbund undoubtedly helped create the climate of opinion that made it possible to implement some of them in the 1920's.

Despite the importance given to consumer education before 1914, the Werkbund aspired to be more than just

[52] Müller, *Kunst und Industrie*, pp. 46-62; Banham, *First Machine Age*, pp. 79-87.

[53] This was the first garden city to include workers' housing. The others tended to be middle-class preserves. Müller, *Kunst und Industrie*, pp. 44-45.

[54] *Ibid.*, p. 45; Pevsner, *Pioneers of Modern Design*, pp. 38 and 224, n. 97, referring to an unpublished prewar memorandum on standardization by Gropius. See also DWB, *Hermann Muthesius: Die Werkbund-Arbeit der Zukunft und Aussprache darüber . . . 7. Jahresversammlung des Deutschen Werkbundes vom 2. bis 6. Juli 1914 in Köln* (Jena, 1914), pp. 64-65 [hereafter *Werkbund-arbeit*], comment by Karl-Ernst Osthaus favoring standardization for low-cost housing.

another agency dedicated to the reform of public taste. Its chief objective became the transformation of German production through an active alliance of art and industry, and in this area it made its most distinctive contribution.

One of the obstacles to success was the fact that most German industrialists, as those elsewhere, were men of limited education and petit-bourgeois tastes, whose cultural horizon seldom broadened beyond the everyday. Of course, not all German entrepreneurs were visually unaware and some were significant patrons of modern art. But in general, the synthesis of *Bildung* and *Besitz*, of culture and wealth, was an ideal rather than a reality.[55] In view of the prevailing philistinism of the manufacturers, the Werkbund had to develop ways of persuading them to adopt its program that did not demand comprehension of esoteric aesthetic principles. To this end, Werkbund propagandists argued that the preeminent social position of the producers obliged them to lead in matters of taste. Convinced that private industry had primary responsibility for the achievement of Werkbund goals, the association tried to awaken and reinforce a sense of moral obligation on the part of the capitalists.[56] By accepting into membership applicants from industry with only a basic commitment to its aims, it hoped to convert the lords of the business world to the ideal of service to the cultural community.[57] In the Werkbund context, this meant essentially persuading them to accept artistic control of product design, and to subordinate their quest for profits to the requirements of the reform movement.

[55] Hans Jaeger, *Unternehmer in der deutschen Politik, 1890-1918* (Bonn, 1967), pp. 285-87.

[56] Müller, *Kunst und Industrie*, p. 97, notes the private enterprise character of the Werkbund, and describes it as a self-help association of progressive artists and producers, created to challenge the monopoly of the state.

[57] Theodor Fischer, inaugural address, DWB, *Veredelung*, p. 17. At the same meeting, Gustav Gericke, speaking for industry, argued that all firms employing artists should be urged to join the Werkbund, in the hope that they would subsequently learn to conform to Werkbund ideals of quality. *Ibid.*, pp. 22-23 and 29.

The Werkbund also appealed to the patriotism of the producers. According to Muthesius, as good Germans they had an interest in ending the dominance of foreign styles at home and restoring the nation's reputation for quality and taste abroad.[58] Similarly, Peter Jessen argued that Germany must cease to be the Japan of Europe, known for its cheap and shoddy goods. Only by developing the technological and aesthetic excellence of her exports could she fulfill her cultural mission and reconcile the other nations to her status as a world power.[59] The notion that Germany could turn enemies into admirers through quality exports, and thus contribute to world peace, appeared repeatedly in the Werkbund literature and was evidently regarded as a powerful argument for the reform of production.[60]

On the other hand, the Werkbund leaders did not hesitate to appeal to self-interest. The producers were assured that the switch to quality work would in fact result in increased sales. They were also promised lower costs as productivity rose because of improved labor-management relations. Naumann, in particular, insisted that the worker in a firm making quality goods would take greater pride in his work, and so become more productive. Able to command a higher wage, the German worker would be reconciled to the capitalist system, abjure false Marxist doctrine, and become a satisfied member of the national community. In their capacity as employers, Werkbund industrialists could thus help to replace class warfare with social harmony, to their own benefit and to that of the country as a whole.[61]

[58] DWB, *Werkbundarbeit*, p. 39.

[59] Jessen, "Grossmächte," p. 2.

[60] See, e.g., Gustav Gericke in 1908, DWB, *Veredelung*, p. 31; Wolf Dohrn and Karl-Ernst Osthaus in 1910, DWB, *Durchgeistigung*, pp. 3 and 43-46. Cf. Waentig, *Wirtschaft und Kunst*, p. 415.

[61] Friedrich Naumann, "Kunst und Volkswirtschaft" (1912), in Naumann, *Werke*, VI, 312-14 and 316; Naumann, "Deutsche Gewerbekunst," p. 281; Heuss, "Gewerbekunst und Volkswirtschaft," p. 14. Dr. Adolf Vetter, an Austrian government official and Werkbund member, addressing the annual meeting in 1910 went so far as to

Werkbund annual meetings and gatherings at the local level were among the most effective means of influencing the association's producer members. As industrialists mixed with artists, craftsmen, and academics on a basis of equality, an atmosphere was created in which mutual problems could be discussed in a frank and friendly fashion. Industrialists were represented on Werkbund committees, and were served by publications such as the *Gewerbliche Materialkunde*, a series addressed to the analysis of the uses and potentialities of materials.[62] The Werkbund also used exhibitions to present issues to its producer members, for example the cement and concrete exhibit shown in conjunction with the third annual meeting in 1910. Organized by Peter Behrens, it focused discussion on the relationship between material and style, and stimulated interchange of views among industrialists, engineers, and architects. Moreover, as an example of successful cooperation between artists and industry, the exhibition helped persuade manufacturers that such collaboration was feasible and beneficial to their interests.[63]

Initially, the Werkbund, in its producer education work, addressed itself largely to the art industries or *Kunstgewerbe*, where the alliance of artist and producer seemed most likely to bear immediate fruit.[64] The Werkbund's founders complained that, despite the efforts of the Arts and Crafts reformers, most manufacturers of home fur-

assert that quality production was the cure for *all* the social and moral ills of the day! See his "Die staatsbürgerliche Bedeutung der Qualitätsarbeit," DWB, *Durchgeistigung*, pp. 17-18. Müller, *Kunst und Industrie*, pp. 88-89 criticizes Naumann's ideal of joy in work on the grounds that it served the class interests of employers rather than employees. Naumann saw no reason that it could not serve both simultaneously.

[62] Only two volumes appeared, one on woods in 1910 and another on gemstones in 1912.

[63] DWB, *Durchgeistigung*, p. 4 and *passim*. Among those who participated in the discussion were Theodor Fischer and Karl-Ernst Osthaus, both of whom entered pleas for the artistic and practical exploitation of synthetic materials.

[64] DWB, *Leitsätze*, p. 2.

nishings and objets d'art were still turning out derivative goods based on historic styles, or, perhaps even more reprehensible, on corrupted versions of *Jugendstil* designs. While most Werkbund leaders agreed that the *Jugendstil* innovators had started with good ideas, they felt that the style had since been debased by commercial interests, whose feeble imitations threatened to bring the entire modern movement into disrepute.[65]

To prevent repetition of this development, the Werkbund advocated cooperation between artist and producer at every stage of the production process. Most of the association's theorists had abandoned the hope of the early Arts and Crafts reform movement that it would be possible once more to reunite design and executive functions in a single person; but if they no longer believed in the artist-craftsman, they remained intensely aware of the disadvantages of excessive specialization, and were determined somehow to overcome them in the interests of German culture.[66] What they were groping toward was the concept of the modern industrial designer, fulfilling a distinct role but operating within the framework of a larger production team. This notion came into focus only gradually, however; in the years before World War I, no solution to the problem of how best to introduce the artist into the design process emerged. The Werkbund therefore avoided the issue as best it could, and instead concentrated on convincing the *Kunstgewerbe* producers to employ artists in any capacity they chose.[67]

Even this proved difficult. For many craftsmen resented the implication that they needed artists to tell them what

[65] E.g., Muthesius, *Kultur und Kunst*, pp. 8-13.

[66] DWB, *Leitsätze*, pp. 3-5; Muthesius, *Wirtschaftsformen im Kunstgewerbe*, p. 29. According to Posener, *From Schinkel to the Bauhaus*, p. 44, it was just this acceptance of the division of labor that showed the Werkbund to be more realistic and modern than the Arts and Crafts movement.

[67] To this end, Muthesius in 1908 tried to effect a rapprochement with the *Verband deutscher Kunstgewerbevereine*, from which the Werkbund founders had seceded the previous year. DWB, *Veredelung*, p. 44.

to do and preferred to regard themselves as art-workers, capable of producing their own designs, or, at least, adequate transcriptions of traditional models. By introducing artists into the workshop, the Werkbund called in question the workmen's competence and threatened to reduce their status to that of mere laborers. As late as 1914, the *Association for the Economic Interests of the Art Industries* opposed the employment of Werkbund designers, on the grounds that they were unnecessary and unwanted intermediaries between employer and executant.[68]

The Werkbund continued to welcome craftsmen-designers to membership and conceded them an important role in the manufacture of consumer goods, but the handicraft interests were right when they complained that the association's allegiance was shifting away from the arts and crafts. As Peter Jessen proclaimed in 1912, not the medieval-style craftsman but the modern entrepreneur would shape the future; it was therefore logical for the Werkbund to concentrate its efforts on the newer mass production industries manufacturing standardized goods for the world market.

In fact, major producers like the A.E.G. proved more amenable to Werkbund principles than the small workshops or independent craftsmen that dominated the traditional *Kunstgewerbe*. The large firms could afford to experiment with new designs and impose their taste on the public, whereas most small arts and crafts concerns were too dependent on consumer demand to pioneer in the development of styles.[69] The growing importance assigned

[68] Müller, *Kunst und Industrie*, p. 107, cites a publication of the Fachverband für die wirtschaftlichen Interessen des Kunstgewerbes e.V, entitled *Der 'Deutsche Werkbund' und seine Ausstellung Köln 1914. Eine Sammlung von Reden und Kritiken vor und nach der 'Tat'* (Berlin, 1915).

[69] This point was made at the Frankfurt annual meeting of 1909 by Dr. Schneider, spokesman for the German Association of Manufacturers. Cf. DWB, *Verhandlungsbericht der* II. *Jahresversammlung zu Frankfurt* . . . (n.p., n.d.), pp. 10-14. Muthesius had already noted that growing prosperity, which had brought about a marked rise in quality in other areas of German industry, failed to achieve

to exports by the Werkbund also encouraged it to neglect its original constituency; even the most progressive *Kunst-gewerbe* producers, employing modern machinery and rational management techniques, found it difficult to meet the home demand for quality goods, let alone produce on a scale that would allow them to conquer world markets. Finally, the Werkbund formula of cooperation between art and industry proved most fruitful where no adequate traditional forms existed, for example in the design of electrical appliances rather than chairs, or of factories rather than homes.

In general, while the level of material quality and work-manship may have risen in the art industries as a result of Werkbund efforts, greater advances in the development of a modern style were made in other areas. When Peter Bruckmann summed up the contribution of the Werkbund in January 1914, he had little to say about consumer goods production but much about the role of Werkbund members in designing railway stations (for Leipzig, Darmstadt, and Stuttgart), model factories (according to plans by Behrens, Riemerschmid, Gropius, Poelzig, and Muthesius), and in the sphere of city planning (Dresden, Leipzig, Breslau, Cologne, Hamburg, Munich).[70] Although regarded as an offshoot of the Arts and Crafts movement, the Werkbund by 1914 had moved a long way from its origins and had discovered new fields in which to experiment with forms adapted to the needs of modern life.

In its efforts to raise the standard of German production, the Werkbund had to remold the attitudes not only of con-sumers, craftsmen, and industrialists, but also of the nation's artists. For one of the most formidable obstacles to effective cooperation between art and industry stemmed from the tendency of the artists to regard all businessmen with suspicion. Whether based on socialist principles or on

this in the realm of *Kunstgewerbe*. Muthesius, *Wirtschaftsformen im Kunstgewerbe*, p. 28. See also DWB, *Leitsätze*, p. 3.

[70] Peter Bruckmann, *Deutscher Werkbund und Industrie* (Stutt-gart, 1914), pp. 10-11.

instinctive aversion to the profit-seeking materialism of modern industry, the anticapitalist ethos of many artists made it difficult for them to enter into a working relationship with members of the business community. One need only read van de Velde's speech on art and industry delivered at the Frankfurt Werkbund congress in 1909 to realize how much remained to be done to persuade even those artists committed to the association's program to abandon beliefs that stood in the way of its realization.[71]

With its artists as with the businessmen, the Werkbund hoped that personal regard and mutual respect between individuals within the association would facilitate productive collaboration. Its propagandists also sought to overcome the anticapitalism of the artists by appealing to their love of country. Thus Muthesius explained that Germany—encircled, poor in colonies and resources—had no option but to exploit the spiritual and intellectual gifts of her people commercially; and he pointed out that if in the short run it was the exporters who stood to gain, in the longer view concentration on quality exports would raise the national income, and so benefit Germans of all classes.[72]

The Werkbund also had to persuade the artists that the machine was an irreversible feature of modern life, with which anyone wishing to exert influence on contemporary realities would have to come to terms.[73] Repeatedly, it urged them to take a positive view of the opportunities offered by modern productive methods, and assured them

[71] Van de Velde's speech is reproduced in Eckstein, 50 *Jahre Deutscher Werkbund*, pp. 27-29. On van de Velde's anticapitalist, anti-industrial bias, Egbert, *Social Radicalism and the Arts*, pp. 609-16; Franciscono, *Walter Gropius*, p. 80; and Müller, *Kunst und Industrie*, p. 65.

[72] DWB, *Veredelung*, pp. 48-49; DWB, *Werkbundarbeit*, p. 39. Similarly, Friedrich Naumann appealed to patriotism in his address to the seventh annual meeting in 1914. See Naumann, "Werkbund und Weltwirtschaft," *Werke*, VI, 331-50, especially pp. 333-40 and 348-49.

[73] Theodor Heuss, "Gewerbekunst und Volkswirtschaft," p. 10; Naumann, "Kunst und Volkswirtschaft," pp. 308-11.

that the stylistic disorder and poor quality of which they legitimately complained were temporary phenomena, not necessary concomitants of the new technology or of emerging forms of economic organization.[74]

If artists were to collaborate effectively with modern industry, they needed to familiarize themselves with the potentialities of machine technology and of new materials. From the debates at the Werkbund meetings of 1910 and 1911, it is clear that the preference for traditional methods and materials died hard not only among craftsmen and manufacturers but also among architects and designers. Many Werkbund artists were more interested in raising standards of quality and craftsmanship than in stylistic innovation, and so had little incentive to form an alliance with modern industry.[75]

The greatest obstacle to this alliance, however, lay not in the anticapitalism or lingering antimodernism of the artists, but in their pronounced individualism. Naumann, Heuss, Muthesius, and Jessen all tried hard to overcome these anarchic tendencies by appealing to the artists' social idealism and cultural concern.[76] In addition, the Werkbund offered its artist members certain practical benefits. Through its propaganda, it increased opportunities for employment in industry and improved the conditions of such employment. More generally, its exhibitions and publications brought the work of its creative members to the notice of the public, thus generating a climate of opinion

[74] E.g., Adolf Vetter at the 1910 Werkbund congress, DWB, *Durchgeistigung*, p. 16.

[75] Speaking on behalf of the cement and concrete industry at the 1910 annual meeting, Hans Urbach called for better appreciation on the part of Werkbund artists of the difficulties involved in perfecting the new synthetics and discovering suitable applications. See his "Material und Stil," DWB, *Durchgeistigung*, pp. 37-39. Also, Bruckmann, *Deutscher Werkbund und Industrie*, p. 7.

[76] Naumann, in 1914, stressed the need for the individual to sacrifice a degree of personal freedom in order to achieve results in the real world. See his "Werkbund und Weltwirtschaft," pp. 347-49. Cf. Naumann, "Kunst und Volkswirtschaft," pp. 304-306 and 316; and Pevsner, *Pioneers of Modern Design*, pp. 110-12.

that enabled artists of the first rank to utilize their talents within the modern economy.[77] The artists also had an interest in Werkbund efforts to improve the quality of materials, for example the development of standardized colors and permanent dyes through cooperation with the highly progressive German chemical industry.[78] Finally, they approved the association's advocacy of educational reform. Personally involved with the restructuring of the art schools and the professionalization of architectural training, they also welcomed steps to improve craft skills. Above all, they recognized that the education of a discriminating public was a prerequisite for the further expansion of artistic influence on society.[79]

All its efforts notwithstanding, the Werkbund by 1914 found itself threatened by centrifugal forces militating against its continued effectiveness. For the first time, the desire to create and propagate quality work proved too weak to prevent the coalescence of a determined opposition in which Werkbund artists played a leading part. Aware of mounting discontent, the Werkbund executive designed the program for the forthcoming annual meeting in Cologne specifically with the artists in mind. Muthesius' keynote speech and Naumann's lecture ostensibly dealt with exports, but both expanded on the role of the artist in industry in a major effort to combat the attitudes that prevented many German artists from subscribing wholeheartedly to the Werkbund cause.

[77] Sigfried Giedion, *Space, Time and Architecture* (5th rev. ed., Cambridge, Mass., 1967), p. 480.

[78] The concern with color dates back to the first annual meeting at Munich, DWB, *Veredelung*, p. 16.

[79] It is striking that, in Werkbund discussions on education, it was the artists and educators rather than representatives of industry who participated most eagerly. Commented on by Wolf Dohrn in 1908, DWB, *Veredelung*, p. 172, this continued to characterize Werkbund debates.

CHAPTER III

Cologne 1914

IN JULY 1914, against the background of an ambitious exhibition intended to demonstrate its achievements, the Werkbund met to discuss basic principles and develop a program for future action. Instead of constituting a public display of strength and unity, however, this seventh annual meeting degenerated into a bitter debate. Triggered by Muthesius' keynote address, a duel developed between Muthesius and van de Velde on the issue of standardization (*Typisierung*) versus individualism. The violent emotions that colored the proceedings showed that more was at stake than a difference of views on this one subject. Rather, the debate revealed a profound division in Werkbund ranks between those who demanded unlimited freedom for the artist to create and experiment, and men like Muthesius and Jäckh, who stressed the need to raise the general level of quality and expected all Werkbund members, artists included, to subordinate their personal inclinations to this common goal.[1] To assess the Werkbund's position in 1914, it is therefore necessary not only to appraise the Cologne exhibition, but also to analyze the internal tensions that surfaced at the annual meeting.

[1] Scheffler, *Die fetten Jahre*, p. 40; Robert Breuer, "Typus und Individualität, zur Tagung des deutschen Werkbundes, Köln 2.-4. Juli 1914," *Deutsche Kunst und Dekoration*, XXXIV, No. 11 (Aug. 1914), 378. As Breuer saw it, "Sooner or later it was inevitable that the Individualists who recognized only their inner demon and nothing else in the world, would come into conflict with the Diplomatists of the typical, the organizers of an elevated general standard."

Some eight days before the opening of the Werkbund congress, Muthesius had distributed ten theses to serve as guidelines for the association's future work.[2] These urged German designers to concentrate on the development of standard or typical forms that could be manufactured in large quantities to meet the needs of the export trade. Muthesius used the term *Typisierung* to denote the concentration of design effort on a limited number of generally useful forms. Claiming that this was occurring in any case, he welcomed the trend toward standardization, because it alone could ensure the victory of good taste and provide the base from which the German industrial arts could conquer world markets.[3] The main task, according to Muthesius, was not to invent ever new forms but to refine those already in existence, although he acknowledged the need to guard against reverting to mere imitation of past styles.

In his speech to the Werkbund, Muthesius elaborated on his theses and modified them considerably. By then, he was on the defensive, for he knew that a group of artists led by van de Velde had met the previous evening to draw up a set of ten countertheses protesting any attempt to impose restraints on artistic freedom. Worked out in a night of feverish activity, these were hastily printed for distribution on the day of Muthesius' address and were read out, immediately after Muthesius concluded, by van de Velde himself.[4]

Aware that his policies were about to be challenged, Muthesius opened his address with an appeal for unity that referred to the traditional harmony of Werkbund as-

[2] Muthesius' "Leitsätze" were reprinted in DWB, *Werkbundarbeit*, p. 32, and can also be found in Posener, *Anfänge des Funktionalismus*, p. 205.

[3] Muthesius had spoken out in favor of standardization as early as 1904, in *Kultur und Kunst*, but his remarks at that time applied primarily to architectural form.

[4] For the text of the countertheses, DWB, *Werkbundarbeit*, pp. 49-51; and Posener, *Anfänge des Funktionalismus*, pp. 206-207. See also van de Velde, *Geschichte meines Lebens*, pp. 361-62, for an account of the dramatic night meeting at which they were conceived.

semblies and reminded his listeners that allegiance to a common ideal had always proved strong enough in the past to hold together this "company of intimate enemies."[5] He went on to state that his talk would not deal with high art—a subject more than adequately covered at previous meetings—but instead would focus on economic issues. Expanding on the theme of *Typisierung*, he now treated standardization not as a normative concept meant to influence design decisions, but simply as the inevitable outcome of current trends.[6] Muthesius also stressed that he had no intention of limiting artistic freedom. On the contrary, for the first time, he openly ranged himself on the side of the avant-garde against the reactionaries of the *Heimatschutz* movement, advocated experimentation, and even defended the right of art to err.[7]

Despite such conciliatory remarks and an evident effort to mute the polemical tone of his original theses, Muthesius failed to appease his opponents. Artists like Walter Gropius and Bruno Taut, young men who had their most creative years ahead of them, could hardly be expected to support someone who asserted that the modern style already existed in embryo and merely needed to be developed and applied on a broader scale.[8] Muthesius' rigidity on this point practically forced these youthful innovators

[5] DWB, *Werkbundarbeit*, p. 35. The description of the Werkbund as a "Vereinigung der intimsten Feinde" seems to have originated with Dohrn, who, as executive secretary during the association's first years, had had to struggle to hold the group together. Cf. Walter Curt Behrendt, "Die Deutsche Werkbund-Ausstellung in Köln," *Kunst und Künstler*, XII (1914), 626.

[6] The discrepancies between Muthesius' theses and his subsequent Werkbund speech have been noted by Posener, *Anfänge des Funktionalismus*, p. 204; and Franciscono, *Walter Gropius*, p. 76, n. 6.

[7] DWB, *Werkbundarbeit*, pp. 45-46. In 1911 Muthesius had still defended the *Bund Heimatschutz*, praising its pioneering efforts to awaken the German public from apathy with respect to architectural matters. See "Wo stehen wir?" *DWB-J* (1912), pp. 21-22. His appeasement of the conservatives at that time was criticized by Eugen Kalkschmidt, "Die vierte Tagung des deutschen Werkbundes," p. 523.

[8] DWB, *Werkbundarbeit*, pp. 38 and 47. In Muthesius' phrase: "Die Grundlinien sind festgelegt" (the base lines are established).

into the camp of the older *Jugendstil* individualists—van de Velde, August Endell, and Hermann Obrist—whose eccentricity Muthesius deplored and whose methods and style he had long ago condemned. To them, as to van de Velde, the standardization that Muthesius advocated seemed a way of giving "organized impotence" power over the "will to potency."[9] Although Muthesius paid repeated tribute to the younger artists, stating that it was up to the coming generation to rethink and reinvigorate the nation's spiritual estate, he failed to convince them that the Werkbund under his leadership had their interests at heart.[10]

Most of Muthesius' opponents among the artists shared his desire to see the emergence of a unified style, at once modern and distinctively German. But whereas Muthesius argued that the new style could be helped to victory by conscious, organized effort, his critics believed that the longed-for norm would emerge as the end product of an evolutionary development, spontaneously generated by the design decisions of innumerable creative geniuses. In their view, Muthesius' approach seemed likely to produce at best a mediocre eclecticism.[11]

Some in van de Velde's camp went even further, rejecting the goal of stylistic unity itself. Thus Osthaus and Endell admitted that types or norms were bound to develop, but did not share the general enthusiasm for the resulting harmonious culture. Far from being a positive value, a unified style would signal the death of creativity. A truly vigorous artistic culture would always be characterized by

[9] van de Velde, *Geschichte meines Lebens*, p. 361.

[10] Muthesius himself conceded that the old guard still dominated the Werkbund, forcing the rising generation to wait in the wings. DWB, *Werkbundarbeit*, p. 34. In 1914, Muthesius was 53 years old and van de Velde 51. Gropius and Bruno Taut were 31 and 34 respectively.

[11] Scheffler, *Die fetten Jahre*, p. 40, pointed out that, at Cologne, the advocates of the "norm" only managed to produce an historicist eclecticism, whereas the allegedly individualist devotees of "form" believed that a valid stylistic norm was in fact emerging. See also van de Velde, *Geschichte meines Lebens*, pp. 310-11, where he deplores the tendency of Germans to apply hothouse methods to hasten the development of a national style.

diversity rather than uniformity.[12] Similarly, the sculptor Rudolf Bosselt, director of the Arts and Crafts School in Magdeburg, advocated something like a "permanent revolution" in art. While the contemporary demands of mass production might call for *Typenbildner*—creators of types— Bosselt looked forward to a time when *Typenbrecher*— destroyers of types—would once more emerge to challenge accepted standards and create original forms.[13]

Muthesius further antagonized the Werkbund individualists by reminding them that a few outstanding artists, creating forms for limited production in quality workshops, could never produce enough to raise the general level of quality and taste. If the Werkbund was to attain its goals, it seemed evident that a host of ordinary designers would be required, men willing to work in close collaboration with industry, and less concerned to express their individual genius than to create easily reproducible forms of a high standard. Muthesius looked forward to the emergence of a new type of industrial designer who, guided by enlightened entrepreneurs and salesmen, would interpret and refine German products with the demands of the export market in mind.[14] But to his opponents his proposals seemed calculated only to bring back the bad old days of the pattern draftsman or *Musterzeichner*. In their view, Muthesius had abandoned the Werkbund ideal of cooperation between artist and industrialist on the basis of equality, giving the upper hand once more to the manufacturer, who would simply exploit the artist's skill and reputation for his own profit.[15]

[12] August Endell, DWB, *Werkbundarbeit*, p. 59; Osthaus, *ibid.*, p. 65.

[13] DWB, *Werkbundarbeit*, pp. 85-86.

[14] *Ibid.*, p. 41.

[15] August Endell, in Franciscono, *Walter Gropius*, Appendix C, pp. 272-74; Endell, "Nachwort zur Werkbundtagung," *Bauhaus-Archiv*, Berlin [hereafter *Bauhaus*], GS 2/1, "Werkbundkrise," p. 6. In this unpublished memorandum, Endell predicted that the employment of Werkbund designers by industrial firms would merely serve as a form of high-class advertising for the businesses concerned, unless the Werkbund insisted on equality of status for the artist.

By stressing exports, Muthesius, of necessity, neglected the interests of the architects and others tied to the home market by the nature of their work. These men would have preferred the Werkbund to concentrate on converting potential patrons of domestic building projects to its ideals, so as to secure additional contracts for progressive architects and to stimulate construction-related industries. Thus Karl-Ernst Osthaus conceded that it was nice to have the ministries of commerce well represented at Werkbund meetings, but deplored the absence of officials from the ministries of works who were responsible for the construction of public buildings.[16]

For other reasons, too, many artists sympathized with van de Velde's view that the need to export was not a blessing but a curse.[17] Export on a large scale seemed likely to encourage the production of inferior goods cheap enough to satisfy the debased tastes of the foreigner. The Werkbund therefore could have an interest only in the export of high quality goods able to surmount tariff barriers because of their perfect beauty; but, as Endell pointed out, in this sphere organized effort and *Typisierung* were neither necessary nor desirable.[18] According to van de Velde, nothing superb had ever been created purely for the benefit of the export trade. The highest quality, in his opinion, had always been the product of a select group of patrons and connoisseurs, working in close cooperation with favored artists. The taste of this elite would eventually filter down to the nation at large; only then would foreign countries begin to take notice.[19] In support of this view, van de Velde might well have cited American reaction to the 1912 Newark exhibition of the *Deutsches Museum*, when local critics singled out for praise the expressionistic

[16] DWB, *Werkbundarbeit*, p. 68.
[17] This was the essence of van de Velde's eighth counterthesis. Cf. ibid., p. 51.
[18] *Ibid.*, pp. 58-59.
[19] *Ibid.*, p. 51, the ninth counterthesis.

individualism of the exhibits, contrasting this favorably with the predominant functionalism of U.S. designs.[20]

From the tone of the debate on Muthesius' address, held the following day, it is plain that van de Velde and his supporters were less interested in getting Muthesius to clarify his often confused, even contradictory assertions, than they were in undermining his position within the Werkbund. Thus van de Velde's charge that Muthesius' advocacy of *Typisierung* hid a desire to dictate a restrictive canon to the artists was grossly unfair. Whatever Muthesius may have meant by his ill-defined term, it was not that.[21] Moreover, van de Velde himself had advocated design for machine production and recognized both the need for evolving typical forms and the danger of excessive emphasis on the personal contributions of name designers.[22] Had he always felt so strongly about *Typisierung*, it is hard to understand why he failed to challenge Muthesius when the issue was first raised at the Werkbund congress of 1911.[23]

On the other hand, van de Velde was sincere in his belief that under Muthesius' guidance the Werkbund had ceased to serve the cause of art and instead had become the agent of extraneous political and economic interests. To him the very notion of *Kulturpolitik* was anathema, entailing the subordination of culture to politics.[24] Moreover, many Werkbund artists felt that the balance within the association had shifted too much in favor of industry, and there is evidence that some had been on the verge of seceding for this reason even before Muthesius published his theses. For example, two weeks before the annual

[20] Müller, "Deutsches Museum," pp. 296-300.

[21] Posener, *Anfänge des Funktionalismus*, p. 204.

[22] van de Velde, *Geschichte meines Lebens*, p. 321; Hüter, *Henry van de Velde*, pp. 243-44.

[23] Muthesius, "Wo stehen wir?" *DWB-J* (1912), p. 24.

[24] A. M. Hammacher, *Le Monde de Henry van de Velde* (Anvers, 1967), pp. 194-96; van de Velde, *Geschichte meines Lebens*, pp. 310-11.

meeting, Hans Poelzig, director of the Breslau Academy of Art and a noted industrial architect, referred to the Werkbund (of which he had been a respected member since 1908) as a "monster," and indicated to Gropius that he had nearly made up his mind to pull out of the association.[25] In any case, Muthesius correctly sensed that his specific proposals were the occasion rather than the cause of the eruption at Cologne, and that the latter was the work of men determined to contest his leadership, whatever he might say.[26]

In order to forestall the secession of the van de Velde group, Muthesius eventually withdrew his theses instead of putting them to the vote as he had intended.[27] Meanwhile, however, the exaggerated arguments produced by some of the dissidents in the course of debate had awakened considerable sympathy for him.[28] For example, when Bruno Taut called for reorganization of the Werkbund to give control to the artists and demanded that van de Velde or Poelzig be made artistic "dictator," the response was overwhelmingly negative. Similarly, Robert Breuer gave offense by claiming that those who backed Muthesius thereby indicated willingness to see the artist assassinated by the schoolmaster.[29] Such lack of tact on the part of the opposition made it easy for Muthesius to pose as the protagonist of sound progressive views unaccountably set upon by a clique of individualists wrongly claiming to speak for all the artists. That many artists supported

[25] Hans Poelzig to Walter Gropius, June 30, 1914, in Franciscono, *Walter Gropius*, p. 263. Also Gropius to the Werkbund leadership, July 14, 1914, *ibid.*, p. 268

[26] DWB, *Werkbundarbeit*, p. 101.

[27] However, the manner in which he did so gave additional offense. According to Osthaus, Muthesius had agreed to back down before the debate on his address, but tried to make it look as if he had yielded to the sentiment of the meeting. Cf. Osthaus to Peter Behrens(?), July 13, 1914, in Franciscono, *Walter Gropius*, pp. 266-67

[28] *Ibid.*, p. 267. Van de Velde himself complained about the damage done the cause by extremists among his backers, in *Geschichte meines Lebens*, p. 268.

[29] DWB, *Werkbundarbeit*, pp. 75-76 and 89.

Muthesius is evident from the fact that the *Münchner Bund*, the Munich branch of the Werkbund, entered a group protest against van de Velde's stand. In a letter telegram signed by Richard Riemerschmid, it urged the executive to proceed with its work by formulating a detailed program using Muthesius' theses as guidelines.[30]

When the debate was over, both factions initially felt they had achieved their primary aims. The rebels believed Muthesius had been taught a lesson and would henceforth put the interests of the artists first; and van de Velde himself appeared satisfied that he had emerged the acknowledged head of the German reform movement.[31] Meanwhile, the membership at large, content that a final rupture had been averted, attributed this to Muthesius' statesmanlike willingness to compromise. There was a general feeling that the confrontation had cleared the air, and that the violent discharge of pent-up emotion and resentment would in the long run prove beneficial to the association.[32] The harmony apparently restored at Cologne was soon shattered, however. Within days of the debate, a small group led by Karl-Ernst Osthaus and Walter Gropius accused Muthesius of systematically undermining the Cologne compromise, and resumed efforts to force him to resign.[33] For his part, Muthesius denied having made any conces-

[30] Bayerische Akademie der Schönen Künste, Walter Riezler papers [hereafter *BASK*], DWB II, undated *Brieftelegramm*. Founded before the Werkbund, the *Münchner Bund* by 1914 had in effect become the Munich Werkbund group.

[31] But according to Hammacher, *Le Monde de Henry van de Velde*, pp. 171-72, the 1914 Werkbund crisis revealed van de Velde's essential isolation, making it easy for German patriots to destroy the remnants of his authority after the war broke out. Nikolaus Pevsner, too, judged that it was the standardizers who were the real victors at Cologne. See Pevsner, "Patient Progress Three: The DIA," in his *Studies in Art, Architecture and Design*, II, (London, 1968), p. 231.

[32] Breuer, "Typus und Individualität," p. 378.

[33] Letter from Gropius to the Werkbund leadership, July 14, 1914, in Franciscono, *Walter Gropius*, p. 268. On Gropius and the Werkbund crisis of July 1914, see also Peter Stressig, "Hohenhagen: Experimentierfeld modernen Bauens" in Hesse-Frielinghaus, *Karl-Ernst Osthaus*, pp. 465-67.

sions. Confident that he had the Werkbund majority behind him, he felt justified in pursuing his original course, and dismissed the latest attacks as the product of Osthaus's ambition to become president of the Werkbund.[34]

This second attempt to unseat Muthesius was as unsuccessful as the first, primarily because his opponents feared that further attacks would destroy the Werkbund. In the final analysis, Muthesius' enemies were unwilling to use the ultimate weapon urged upon them by Gropius, namely, the threat of secession. Van de Velde himself had no wish to break up the association, but rather hoped to win it over to his views.[35] Peter Behrens, Richard Riemerschmid, and others dedicated to the cause of collaboration between art and industry wanted to preserve the Werkbund at all costs and therefore helped to restrain the insurgents.[36] Even Osthaus eventually joined with Behrens to advise against using secession to enforce the artists' demand for Muthesius' resignation.[37] By the end of July, Gropius stood alone, and so had to abandon his campaign against Muthesius, who managed to remain prominent in Werkbund councils for several more years.

That the theoretical issues raised in the course of the Cologne debate remained unresolved was relatively unimportant. For at the heart of the conflict was not disagreement on points of doctrine but a difference about Werkbund policy.[38] Whereas the leadership sought in the first instance to raise standards of quality in cooperation with industry and governments, the opposition wanted to further the cause of the artists as pioneers of a new style

[34] Letter from Muthesius to Walter Riezler, July 31, 1914, *BASK*, DWB II. Muthesius accused his assailants of delusions of grandeur, and derided their claim to have achieved a victory at Cologne.

[35] van de Velde, *Geschichte meines Lebens*, p. 368.

[36] See the contributions to the Werkbund debate by Peter Behrens, Karl Gross, and Richard Riemerschmid, DWB, *Werkbundarbeit*, pp. 56-57, 61-62, and 69-70.

[37] Letter from Osthaus to Behrens, and Behrens' reply of July 13, 1914, in Franciscono, *Walter Gropius*, pp. 266-67.

[38] Letter from Osthaus to Ernst Jäckh, July 13, 1914, in Franciscono, *Walter Gropius*, pp. 267-68.

and a higher culture. Refusing to regard these two func-
tions as mutually exclusive, the membership at large
apparently believed that the Werkbund should promulgate
good taste *and* encourage artistic innovation. On the other
hand, it had to admit that the quality ideal could more
readily be pursued by organizational means. Moreover, it
seemed foolish to curtail the Werkbund's educational
activities just when these were raising the association to
new heights of influence.

Nor was it at all clear what more the Werkbund could
do to help its artists. Essentially, supporters of van de
Velde such as Behrens and Breuer agreed with followers
of Muthesius such as Riezler that the organization could
best serve its creative members by leaving them strictly
alone.[39] While they recognized that the Werkbund needed
its artists, most members thought it more practical to
concentrate on educating the public to appreciate talent,
in order to ensure its full utilization in the national
interest. This meant finding scope not only for the genius
of the few but also for the skills of the less gifted who
nevertheless could help to satisfy the new mass demand
for applied art.[40] Thus leadership and opposition alike
refused to make a choice between art and industry or
between creativity and standardized production. Instead
both factions hoped that the Werkbund might reconcile
these opposites and combine them into a higher synthesis.[41]

Indeed, according to the German idealist philosopher
Karl Joël, the Werkbund's greatest achievement was pre-
cisely to bring the standardizing and individualizing
tendencies into balance. Commenting on the Cologne

[39] See the comments by Behrens, Breuer, and Riezler, DWB,
Werkbundarbeit, pp. 56-57, 88-90, and 79-80.

[40] Rudolf Bosselt, in DWB, *Werkbundarbeit,* pp. 84-86.

[41] Fritz Hellwag, "Der deutsche Werkbund und seine Künstler,"
Kunstgewerbeblatt, N.F., xxvii (1915-16), 62. Hüter, *Henry van de
Velde,* p. 245, insists that the Werkbund at Cologne was faced with
an absolute choice between art and industry, experimentation and
mass production. But this either-or approach, characteristic of
Hüter's Marxist analysis, was alien to the Werkbund.

debate, Joël noted the membership's determination to reject both dogmatism and anarchy, both stylistic conventionalism and lack of style. In his view, the Werkbund's artistic goal was to produce an "organic"—as distinct from a "mechanistic"—art, creating a unified style through the evolutionary fusion of artistic genius, material requirements, and specific functional needs.[42] Some such "organic" philosophy may well have influenced Werkbund members in July 1914 when they decided that their association, the product of a marriage of convenience between incompatible interests, was still worth preserving.[43]

Although the Werkbund's internal dissension was widely commented on in the German press, the main focus of interest at Cologne in July 1914 was the exhibition itself. While Werkbund members engaged in self-criticism and mutual recrimination, the exhibition attracted throngs of visitors prepared to be impressed by this comprehensive display of German work and talent. This exhibition, the most ambitious undertaking of the association in the prewar period, was the first for which it took primary responsibility. Already in its manifesto of 1907, the Werkbund had stressed the importance of exhibitions in educating the domestic consumer and improving the reputation of German goods abroad.[44] A year later, at the Munich annual meeting, it agreed to help organize the German section at the Brussels World Fair of 1910.[45] Thereafter, it influenced several national and international

[42] Karl Joël, *Neue Weltkultur* (Leipzig, 1915), pp. 82-86. Best known for his book *Nietzsche und die Romantik* (1905, 1913), Joël predicted the imminent victory of German "Kultur" over the mechanistic civilization of the West. This victory would prepare the way for creation of a "Werkbund der Völker" (Werkbund of the nations), a unity in diversity, in which mechanistic materialism would yield to a higher idealism. His remarks on the Werkbund were quoted approvingly in *DWB-M* 1915/1, p. 4.

[43] Breuer, DWB, *Werkbundarbeit*, p. 88.

[44] DWB, *Leitsätze*, pp. 9-10.

[45] It acted in response to a request for assistance from a representative of the Reich Ministry of the Interior, *Regierungsrat* Albert, whose speech to the newly formed Werkbund exhibition committee was reprinted in DWB, *Veredelung*, pp. 174-77.

exhibitions, notably at Liège (1911), Munich and Mann-
heim (1912), and Leipzig (1913). Finally, in 1911 or
1912, the decision was taken to mount a large-scale
Werkbund exhibition that would both take stock of the
association's achievements and stimulate further reforms.
Interrupted by the outbreak of war in August 1914, the
Cologne exhibition was robbed of its full affect. Neverthe-
less, the Werkbund could take credit for having harnessed
private enterprise and public agencies to create a national
exhibition of international significance, recognized at
home and abroad as a superb example of German organ-
izational skill.[46]

Even the most enthusiastic supporters of the exhibition
in its planning stages had reservations about the final
outcome, however. After it had opened, there was general
agreement that it had been allowed to get too big, with
quality sacrificed to quantity. Many blamed this on the
original decision to cooperate with the city of Cologne.
Municipal officials, by encouraging participation of indi-
viduals and groups unable to meet the Werkbund's stand-
ards, were serving the best interests of their city but not
necessarily of the Werkbund.[47] The need to attract
financial support from other cities and regions had also
led to compromises. The original plan had called for the
organization of arts and crafts displays (except for the

[46] Eckstein, "Idee," p. 12; DWB, 4. *Jahresbericht*, p. 13. On the
aims and impact of the exhibition, see Jäckh, "6. Jahresbericht,"
p. 101; Peter Jessen, "Die Deutsche Werkbund-Ausstellung Köln
1914," *DWB-J* (1915), pp. 1-7; and the special Werkbund issue of
the *Illustrierte Zeitung* (Leipzig), CXLII, No. 3699 (1914), pub-
lished in conjunction with the Cologne exhibition authorities. Origi-
nally planned to run from May to October, the exhibition was not
ready until June and had to close when war broke out.

[47] According to Robert Breuer, "Kölner Werkbund-Ausstellung,"
p. 426, the inhibitions of Muthesius and others against enlarging
the exhibition had been overcome by Cologne's mayor Carl Rehorst.
See also Walter Curt Behrendt, "Die Deutsche Werkbund-Ausstel-
lung in Köln," *Kunst und Künstler*, XII (1914), 616, complaining
that the exhibition had become the object of the tourist association
politics of an ambitious commercial center with metropolitan pre-
tentions!

Austrian) by product type rather than geographic origin;
but in the end, several localities insisted on separate sec-
tions as the price for their participation.[48]

Above all, it was the need to subordinate aesthetic to
commercial considerations that forced the Werkbund to
modify its basic exhibition principles. Spelled out in the
manifesto of 1907, these had stressed the importance of
selectivity and artistic control, and had insisted that long-
range national goals must take precedence over profits
for the participating individuals or firms. But at Cologne
the Werkbund, hampered by financial constraints, had to
compromise at every turn and so found itself the sponsor
of an exhibition that failed to do justice to its own highest
ideals.[49]

The shortcomings of the Cologne exhibition cannot be
blamed entirely on extraneous forces, as some apologists
were inclined to do.[50] After all, the association's leadership
had actively promoted the idea of a large-scale exhibition
and welcomed the city of Cologne to partnership. Ernst
Jäckh, always inclined to think big, was not alone in be-
lieving that an imposing display of energy and power
would best serve to convert both the industrialists and the
prosperous consumers of the Rhine-Ruhr district to the
Werkbund cause.[51] However, even if the pressure to enlarge
and dilute had been resisted, the verdict on Cologne would

[48] The original plan is described by Carl Rehorst, "Die Deutsche
Werkbund-Ausstellung Köln 1914," DWB-J (1913), p. 89. The part
played by cultural particularism at Cologne was deplored by Jessen,
"Die Deutsche Werkbund-Ausstellung Köln 1914," DWB-J (1915),
p. 5; G. J. Wolf, "Der Deutsche Werkbund und die Werkbund-Aus-
stellung in Köln," Dekorative Kunst, XXII (1913-14), 544; and
Breuer, "Kölner Werkbund-Ausstellung," p. 436.

[49] The effect of financial constraints is noted by Ernst Jäckh,
"Deutsche Werkbundausstellung in Köln, II," Kunstwart, XXVII, No.
20 (1914), 138-39. See also Jäckh's annual report for 1914-15, in
DWB-M 1915/1.

[50] E.g., G. J. Wolf, "Der Deutsche Werkbund und die Werkbund-
Ausstellung in Köln," p. 529.

[51] Jäckh, "5. Jahresbericht," p. 105; Bruckmann, Deutscher Werk-
bund und Industrie, pp. 12-13.

have been mixed. Admittedly, a rigid exclusion of products of doubtful quality would have allowed superior work to show to greater advantage, but it might also have thrown into relief the intrinsic flaws of the exhibition, stemming from uncertainty about stylistic criteria and goals within the Werkbund and, indeed, in the Arts and Crafts reform movement as a whole.

The Werkbund had always included aesthetic criteria in its definition of quality, but it gradually became apparent that the desire of the reformers for a new "German" style might come into conflict with the pursuit of quality in the narrower sense. The potential dualism between quality and style became explicit in 1911 when Muthesius, addressing the Werkbund congress, asserted that the demands of form must take precedence over the requirements of function, material, or technique.[52] Yet in the same yearbook that carried Muthesius' statement, Peter Jessen played down the importance of form and reasserted the primacy of quality and good taste.[53]

On balance, it was Jessen's priorities that dominated the Werkbund before 1914. Just as Muthesius' views on standardization became influential only after the war, so his suggestion of 1911 that it might be possible to evolve a modern aesthetic independent of material quality proved fruitful only after 1918.[54] Nevertheless, the concern with form continued to grow during the prewar period and the Werkbund at Cologne undoubtedly intended to show

[52] Muthesius, "Wo stehen wir?" *DWB-J* (1912), p. 19. Muthesius defined the Werkbund's purpose as the revival of appreciation for form and of architectonic sensibility. Banham, *First Machine Age*, pp. 71-79, gives a detailed analysis of this speech in which he somewhat overemphasizes the novelty of Muthesius' recommendations. In 1911, Muthesius, far from urging that the Werkbund break with its past, wanted it to revive the demand for a new style that had been foremost in the early years of the Arts and Crafts reform movement.

[53] Jessen, "Grossmächte," p. 49.

[54] That Muthesius himself was ambivalent on this point is shown by Müller, *Kunst und Industrie*, pp. 37-43.

progress towards the creation of a distinctively German style adapted to the needs of the modern age and expressing its spirit.[55]

From the point of view of quality, the Cologne exhibition demonstrated that the standard of technical skill and materials had risen substantially. Both craftsmen and mechanized producers were represented with items of high caliber. Nevertheless, quality remained uneven, in good part because there were simply not enough first-class products to fill the extensive exhibition halls. As regards the stylistic component of the Werkbund program, the verdict was less favorable still. The lack of agreement on aesthetics, evident in Werkbund debates, showed clearly in the diversity of forms and styles represented. Only the Austrian pavilion produced an effect of harmony, but as the Austrians had concentrated unashamedly on the production of expensive artist-designed items, their style could hardly provide the form for the mass society of the industrial age.[56] In one other small section Karl-Ernst Osthaus of the *Deutsches Museum* managed to achieve a degree of coherence by rigid application of selection criteria allegedly based on Werkbund standards. However, as the Werkbund had never reached agreement on what constituted good or bad design, the products displayed could not claim to represent the "Werkbund style."[57]

[55] Jäckh, "Deutsche Werkbundausstellung in Köln, I," *Kunstwart*, XXVII, No. 18 (1914), 412-13. In part, this was stimulated by the desire to develop designs that would attract foreign buyers.

[56] Behrendt, "Die Deutsche Werkbund-Ausstellung in Köln," pp. 620-21, described the Austrian contribution as luxury art for the upper 10,000 of the modern metropolis, attractive but nonfunctional, even decadent. Obrist, in DWB, *Werkbundarbeit*, pp. 63-64, agreed with this assessment but expressed delight that the assemblage of marvelous things in the Austrian pavilion owed nothing to the Werkbund!

[57] Wolf, "Der Deutsche Werkbund . . . ," p. 548, dismissed this display as snobbish and pretentious, whereas Breuer, "Kölner Werkbund-Ausstellung," p. 435, praised it as a model for future Werkbund exhibitions. On the failure to achieve a recognizable Werkbund style by 1914, cf. Walther Scheidig, *Weimar Crafts of the Bauhaus, 1919-1924* (London, 1967), p. 10.

In interior decoration, although some observers claimed to see a functional *Behrensstil* replacing the *Jugendstil* popular a few years before, the quirks of individual designers tended to prevail. Inspired by the ideal of a harmonious interior, each artist-decorator at Cologne sought to express his personality and to impose his view of the world on potential clients.[58] The result was the stylistic cacophony that greeted visitors to the exhibition. Some observers also complained of an excessive use of color that contributed to a feeling of restlessness and lack of harmony, while creating an oppressive, almost barbaric, effect.[59] Even Muthesius had to admit that, on the whole, the designs shown at Cologne were still too ponderous, idiosyncratic, and lacking in urbanity to appeal readily to foreign tastes.[60] Finally, even if the Cologne exhibits had projected a unified and pleasing style, they could not have had much influence on the general standard, for hardly any were priced within reach of the mass consumer. According to Theodor Heuss, no one below the rank of schoolmaster or judicial clerk could aspire to own the items shown.[61]

The Cologne exhibition, now generally recognized as a milestone in the development of modern architecture, was

[58] Muthesius had deplored this as early as 1904, in his *Kultur und Kunst*, p. 1. Like Loos, he preferred the English approach to interior decoration that allowed home furnishings to reflect the personality of the owner rather than of the professional decorator. See Franciscono, *Walter Gropius*, p. 94. The decorator's power over the client was enhanced in Germany by the belief that everything had to match. Thus an English observer complained around this time that "an artistic German . . . will choose a cat to go with his hearth-rug." A. Clutton Brock, *A Modern Creed of Work* (London, 1916), p. 15.

[59] E.g., C. H. Whitaker, "Work-Pleasure, The Remarkable Exhibition at Cologne," *American Institute of Architects Journal* (Wash. D.C.), II (1914), 423; Wolf, "Der Deutsche Werkbund . . . ," p. 550.

[60] DWB, *Werkbundarbeit*, p. 46.

[61] Theodor Heuss, "Der Werkbund in Köln," *März*, VIII, No. 2 (1914), 910-11; see also Eugen Fischer, "Die Ausstellung des Werkbundes in Köln," *Die Tat*, VI (1914-15), 530-33, who deplored the Werkbund's failure to include "das Volkszimmer und die Volkswohnung."

originally intended primarily as a showcase for the products of the German art industries. Most of the nearly one hundred exhibition buildings were designed to house displays or to serve other specific functions, rather than as examples of architectural style. There were exceptions: the factory and administration buildings by Gropius, van de Velde's theater, an apartment block by Alfred Fischer, and two small model housing groups, one illustrating the style recommended for use in the colonies and the other an industrial workers' settlement in the rustic mode, the so-called *Niederrheinische Dorf*.[62] On the whole, however, architecture at Cologne took second place to *Kunstgewerbe*.

The relative neglect of architecture provoked considerable internal criticism. Younger men like Walter Gropius and Bruno Taut, educated to regard architecture as queen of the arts, especially questioned the minor role assigned to building in the exhibition. The organizers, however, seem consciously to have decided not to feature architecture at Cologne. Intent above all to propagate the principle of collaboration between art and industry and to expand German exports, they resisted pressure from the avantgarde architects to make the exhibition a showcase for their work.[63]

The design of necessary structures was for the most part entrusted to those Werkbund artists who agreed to subordinate themselves to the exhibition as a whole. Relative conservatives like Theodor Fischer and Peter Behrens were deliberately given preference, despite the fact that prior commitments prevented them from attaining their

[62] See Wolf, "Der Deutsche Werkbund . . . ," p. 547. The architect of the latter was Georg Metzendorf of Essen, designer of workers' housing for the firm of Krupp.

[63] On the Werkbund's decision, Jessen, "Die Deutsche Werkbund-Ausstellung Köln 1914," *DWB-J* (1915), p. 6. Already at Dresden in 1906, the future Werkbund leaders had stressed the architectonic element in design and called for subordination of the decorative arts to architecture. It is worth noting that, whereas the first Werkbund generation had consisted largely of painters turned architect, the new architects were formally trained for their chosen profession.

own best standards.[64] Van de Velde's commission for the Werkbund theater was delayed to the last minute, partly because some opposed the idea of employing a Belgian in the context of a German national exhibition, but even more because his pronounced individualism threatened to destroy the unified effect which the planners hoped to achieve. It required the intervention of Konrad Adenauer, then *Oberbürgermeister* of Cologne, to tip the balance in his favor.[65] Gropius was assigned the factory building only after Hans Poelzig had withdrawn from the project, with the result that the design was based on an earlier one intended for Leipzig the year before.[66] Finally, the most original structure at Cologne, Bruno Taut's glass house, was not commissioned by the exhibition organizers but by the glass industry, to house its display.

Even as exhibition architecture, most of the buildings at Cologne left something to be desired, falling well below the standard set at Munich in 1908 or Dresden in 1911. Theodor Heuss, apparently in sympathy with the artistic individualists within the Werkbund, deplored the fact that originality had been sacrificed to an unattainable ideal of harmony. With few exceptions, the resulting architecture, ranging in character from representational monumentality to triviality, could not be taken seriously.[67] Other, less tactful, critics described the exhibition buildings as "impoverished and imitative" or condemned them as "the product of an honorary assembly of senile academics" working in a spirit of distaste and indifference.[68] Only Jäckh claimed to have detected the emergence of a stylistic norm characterized by functionalism, rejection of orna-

[64] Behrendt, "Die Deutsche Werkbund-Ausstellung in Köln," p. 626.

[65] van de Velde, *Geschichte meines Lebens*, pp. 354-55; Hammacher, *Le Monde de Henry van de Velde*, pp. 183 and 193-94.

[66] Stressig, "Hohenhagen," p. 465, on the prehistory of Gropius's Machine Hall.

[67] Heuss, "Der Werkbund in Köln," p. 908.

[68] Obrist, DWB, *Werkbundarbeit*, p. 82; Behrendt, "Die Deutsche Werkbund-Ausstellung in Köln," p. 617.

ment, and a preference for straight lines.[69] More knowledg-
able and artistically sophisticated commentators felt rather
that they were witnessing a return to architectural eclec-
ticism of the very kind against which the Werkbund
pioneers had rebelled not so long before. "What," exclaimed
Hermann Obrist, "shall we . . . say, when we look at these
pseudo-Romanesque, pseudo-Baroque, pseudo-Classical,
pseudo-Biedermeier buildings or this village in artificial
volk style?"[70] The presence of a handful of genuinely
forward-looking structures merely intensified the general
effect of stylistic uncertainty. Despite Werkbund longings
for a unified style, Cologne, in both architecture and the
decorative arts, emerged as an artistic "tower of Babel."[71]

It is unfair to judge the prewar Werkbund solely on the
basis of Cologne: a much more impressive picture emerges
from a study of the yearbooks. Yet the 1914 exhibition did
bring all the association's problems into the open, particu-
larly as they bore on the essential concept of the "new style."
Werkbund members could not agree either on the charac-
teristics of this style nor on what steps could or should
be taken to encourage its development. If, as some believed,
style depends on social and economic conditions, there
seemed to be little point in trying to further its definition
through organization. On the whole, however, Werkbund
members tended to be activists, combining belief in the
inevitability of stylistic progress with a voluntarist faith
that their own efforts could speed the process. The more
radical among them, regarding themselves as fighters in a
cause whose victory was assured, even hoped that artistic
renewal might serve in turn as a stimulus to social change:
by creating forms and symbols in the new spirit, art and
architecture would determine how people in future times

[69] Jäckh, "Deutsche Werkbundausstellung in Köln, II," p. 138.
[70] DWB, *Werkbundarbeit*, p. 63. According to Banham, *First Ma-
chine Age*, p. 85, even Gropius's group of buildings shared this
failing: "Stylistically, the various elements . . . are a fairly com-
plete florilegium of the modern eclectic sources from which an up-
to-date Werkbund designer could draw at the time."
[71] Wolf, "Der Deutsche Werkbund . . . ," p. 530.

would think, feel, and act. In this way aesthetic reform might serve as a prelude to the birth of a totally new social order.[72]

Finally, the definition of the new style was complicated by the fact that it could not be dealt with apart from the question of national character. Swept up in the strong current of cultural nationalism that accompanied the rise of German economic and military power on the eve of the war, the Werkbund adopted the ideal of a "German style." Yet as its leading propagandists had to recognize, a style that mirrored the realities of contemporary industrial society was bound in some sense to be "international."[73] To reconcile the two perspectives they appropriated the popular notion of a German cultural mission: Germany should aspire to lead the world both in terms of technology and quality, and through creation of a valid modern style. Should she succeed, she would not only benefit herself but serve the cause of international peace, while repaying her debt to all the nations from whom she had drawn inspiration in the past.[74] The Werkbund was determined to help Germany overcome her stylistic dependence on England and to shatter the artistic primacy of France. Cologne was chosen for the exhibition partly in order to impress the neighboring French, and its organizers were gleeful when the Parisian press, referring to it as an "artistic Sedan," speculated that the Werkbund was secretly an agent of the German government.[75] Yet the call for a German style in the prewar Werkbund had little in common with the extreme chauvinism or aggressive nationalism of the Pan-Germans, just as it had only minimal links with the racially oriented *völkisch* stream. The competition of styles it desired was

[72] Older men like Muthesius or Schultze-Naumburg sought to use their architecture to restore threatened bourgeois values; but they shared with the radicals a faith in the social power of art.

[73] E.g., Muthesius, DWB, *Werkbundarbeit*, p. 46.

[74] Osthaus, in DWB, *Durchgeistigung*, p. 43; Naumann, "Werkbund und Weltwirtschaft," *Werke*, VI, 349-50.

[75] Breuer, "Kölner Werkbund-Ausstellung," p. 423; Jäckh, Deutsche Werkbundausstellung in Köln, I," p. 413.

meant to be peaceful, and it was only after the outbreak of war that the quest for stylistic leadership became widely identified with the ideal of political domination.

Although there was a tendency before 1914 for traditionalists and modernists, nationalists and internationalists to drift apart, Werkbund opinion had not yet polarized on either issue. The greatest threat to the cohesion and effectiveness of the association was rather the growing alienation of the artistic avant-garde. Expressionism, born just before the war, came close to reviving the l'art pour l'art philosophy of the turn of the century. Ambitious young artists, increasingly hostile to the prevailing nationalism, utilitarianism, and materialism of their age, once more neglected practical design problems, instead using the emotional and symbolic powers of art to express their own deepest feelings about man and society. The Werkbund program of cooperation between art and industry seemed to them merely a disguise for the commercialization of art.[76]

A number of architects with affinities to the Expressionist movement continued to hope that the Werkbund might help them to realize their artistic goals. Thus Walter Gropius, modifying his predominantly intellectual-rational approach to building in order to stress the symbolic role of architectural form, tried hard to convert the association to his new ideals.[77] Bruno Taut, even more closely linked with the Expressionist painters and writers than was Gropius, rejected completely the idea of functional art and

[76] Eric Mendelsohn, *Letters of an Architect* (London, 1967), p. 37; also, a letter from Diederichs to Muthesius, July 11, 1914, in Strauss und Torney-Diederichs, *Eugen Diederichs*, p. 236. Diederichs attributed the outbreak of artistic temperament at Cologne to resurgence of an outdated scorn for the applied arts per se.

[77] The symbolic element in the prewar architecture of both Gropius and Bruno Taut is discussed by Göran Lindahl, "Von der Zukunftskathedrale bis zur Wohnmaschine: Deutsche Architektur und Architekturdebatte nach dem ersten Weltkriege," *Idea and Form, Figura*, Uppsala Studies in the History of Art, N.S., 1 (1959), 226-32, [hereafter "Zukunftskathedrale"]. Gropius's change of emphasis is evident in his "Der stilbildende Wert industrieller Bauformen," *DWB-J* (1914), p. 32.

dedicated his imaginative glass house at Cologne to Paul Scheerbart, the poet of glass; yet he too preferred to remain within the Werkbund.[78]

Some of the older Werkbund men also sought to make contact with the new artistic and intellectual movement. Osthaus furthered the cause of Expressionist art through his patronage, while Diederichs hoped to win the creative elite of the younger generation to the Werkbund cause by appealing to its idealism and desire for international amity. Deeply involved with the international youth movement, Diederichs tried to get the Werkbund to take notice of avant-garde developments in France and Italy, particularly of Marinetti and the Futurists. His efforts to invite a large French deputation to Cologne for a week as guests of the exhibition came to nothing, however, apparently because Konrad Adenauer feared that his city would suffer from a sudden influx of unripe Cubists and Futurists.[79]

One can only speculate whether the advocates of the new art could have carved out a place for themselves within the Werkbund had war not intervened. The Werkbund leadership certainly realized the importance of accommodating the younger generation of artists and it is possible that the association might gradually have entered an "Expressionist" phase. However reluctantly, the Werkbund at Cologne did allow Gropius and Taut to show what they could do; and together with van de Velde's theater, their buidings turned the otherwise architectually undistinguished exhibition into "the real public birthplace of dynamic architecture."[80] On the other hand, there is little

[78] On Taut, Gropius, and the avant-garde, Franciscono, *Walter Gropius*, pp. 88-126. Taut was one of the few architects who belonged to the Expressionist *Sturm* circle. Gropius appeared only on its fringes. In general, architects played a limited role in what was essentially a literary-fine arts movement. *Ibid.*, p. 91; and Dennis Sharp, *Modern Architecture and Expressionism* (London, 1966), p. 21.

[79] On Osthaus, cf. Stressig, "Hohenhagen," p. 354; on Diederichs, Strauss und Torney-Diederichs, *Eugen Diederichs*, pp. 230-32 and 236.

[80] Sharp, *Modern Architecture and Expressionism*, pp. 27-28. Ac-

doubt that the generation coming to maturity in the years before the war regarded the Werkbund as part of the political and social establishment that they rejected.[81] Without a major reformation, it is therefore unlikely that the association could have captured their allegiance.

At the same time, even its most ardent supporters, surveying what had been achieved to date, must have had doubts about the efficacy of Werkbund methods. In 1914, the German style remained to be found and the general level of quality and taste fell far short of Werkbund standards. While the number of well-designed furnishings had risen, limited mechanization kept quantities down and prices high, so that the best work still was done by craftsmen serving the luxury trade. The much-vaunted alliance of art and industry had yet to prove its value. Even in areas such as transport, where Werkbund artists were creating forms for the new age, adoption of their designs was slow. Finally, despite the spurt in influence and popularity due to the Cologne exhibition, the Werkbund had clearly failed to convert Germany's prosperous bourgeoisie to its ideals.[82]

Yet it was precisely the lack of overwhelming success that preserved the Werkbund in 1914. Only the knowledge that the enemy was still strong made men like van de Velde, Osthaus, Poelzig, Gropius, and Taut willing to co-

cording to Giedion, *Space, Time and Architecture*, p. 480, the Werkbund "worked steadily to create opportunities for youthful talents and found responsible roles for them at just the right moments. Both the rising generation and the generation that was at its height were represented at Cologne."

[81] According to Müller, *Kunst und Industrie*, p. 124, the Werkbund at Cologne appeared a mere caricature of its former self, "conservative in art, economically and socially bourgeois, and dangerously nationalistic," its original idealism "subordinated to a search for ways of expanding its organizational influence. . . ." Müller's judgment echoes the views of the Werkbund's youthful critics before the war.

[82] Scheffler, *Die fetten Jahre*, p. 40. But Muthesius felt that at least the *Gebildete* already sympathized with Werkbund aims. Cf. the letter from Muthesius to Riemerschmid, Dec. 15, 1913, *Germanisches Nationalmuseum*, Riemerschmid papers [hereafter GerN].

operate with persons whom they disliked and distrusted. Far from precipitating its disintegration, the failure of the Werkbund to achieve its goals led its members to reform their ranks and determine anew to do battle against the common foe.

CHAPTER IV

The Werkbund in a Nation at War

THE OUTBREAK of war in August 1914 abruptly cut short the Cologne Werkbund exhibition. The transition from peace to war was so unexpected that there was not even time to photograph everything worth preserving. The three Werkbund officials charged with preparing a publication to commemorate the exhibition went straight from the site into military service. Within days, the halls that had housed the finest products of Germany's industry and crafts were converted to receive wounded soldiers from the front.[1]

The remarkable spirit of unity and community evoked by the war had an immediate effect on the Werkbund, pushing the serious rifts revealed at the Cologne congress into the background. In its early phases, at least, the war strengthened the hand of those within the association who believed in the absolute value of concerted effort and quasi-military discipline. As Peter Jessen put it, war—that great builder of character—would purify and transform the Werkbund, compelling its artists to subordinate themselves to the general will.[2] Meanwhile, Henry van de Velde, the chief opponent of this "Prussian" philosophy of organization, fell victim to the tide of national feeling that swept Germany in August 1914. Forced by rising antiforeign sentiment to

[1] Jessen, "Die Deutsche Werkbund-Ausstellung Köln 1914," *DWB-J* (1915), p. 1. This yearbook was a curtailed version of the publication originally planned to commemorate the exhibition, and was illustrated largely by photographs put at the Werkbund's disposal by casual visitors.

[2] *Ibid.*, p. 42.

resign his Weimar post even before the outbreak of war, van de Velde spent the first years of the conflict in Germany under close surveillance, and then escaped to Switzerland, where he lived in unproductive seclusion, purposefully cutting himself off from cooperation with the belligerents–particularly his former German friends.[3] His withdrawal left the leadership of the anti-Muthesius faction in the hands of Osthaus, who continued to insist that only the inspired leadership of artistic geniuses could secure the Werkbund's success, and to reject Muthesius' arguments for the promulgation of "Types."[4] However, Osthaus and his friends were fighting a losing battle. For the war not only created an emotional climate unfavorable to extreme individualism; it also undermined the position of the artist-idealists by altering the economic conditions for creative work.

The demands of war strengthened the trend toward standardization and mechanized production that Muthesius had welcomed, leading in 1917 to creation of an Institute of Standards, the *Normenausschuss der deutschen Industrie*, modeled on American precedents. The Werkbund cooperated fully with the *Normenausschuss*, and was represented on its important building codes subcommittee by Peter Behrens and Hermann Muthesius.[5] Introduced to Germany as a measure of war economy, after 1918 the new codes became an integral part of architectural practice and of rationalized industrial production.[6]

[3] van de Velde, *Geschichte meines Lebens*, pp. 373-75 and 503 n. Jäckh had intervened with the Foreign Office to ease the conditions of van de Velde's wartime life in Weimar. Cf. Jäckh, *Goldene Pflug*, pp. 342-43.
[4] See KEO A 1846, Osthaus to Bruno Rauecker, Oct. 19, 1915: "The war has not converted me to Typization, but just the contrary. . . . Today I see more clearly than ever that the joy and salvation of our people rest with the carefully nurtured capability of individuals whom the masses will follow spontaneously. . . . Beethoven and Types! For me, this would entail the final renunciation of any higher aim in architecture and city planning."
[5] Walter Curt Behrendt, "Normen im Bauwesen," *DWB-M* 1918/3, pp. 4-9.
[6] Banham, *First Machine Age*, p. 78.

Wartime shortages of raw materials, combined with greatly inflated demand, also worked in favor of those who thought it more important to campaign for quality than to press for aestheic excellence. Single-minded devotion to the cause of high art seemed out of place in a time of national tribulation, whereas the fight for quality could be justified on economic as well as ethical and aesthetic grounds. The Werkbund therefore redoubled its efforts to encourage the production and consumption of simple goods in durable materials, and to stem the flow of shoddy products manufactured to meet the demand from consumers disappointingly unaffected by nearly a decade of Werkbund propaganda.[7] The need to conserve scarce raw materials added a welcome weapon to the arsenal of Werkbund arguments, one that became increasingly relevant as conditions worsened.

An important effort in the sphere of wartime consumer education was the publication, in late 1915, of the *Deutsches Warenbuch*. This product of the prewar *Dürerbund-Werkbund Cooperative Association* contained 248 pages of household articles of good design currently produced in Germany and stocked by 150 cooperating shops throughout the country.[8] War conditions made it necessary to scale down the first edition from a projected 100,000 to a mere 10,000. Nevertheless, the *Warenbuch* represented a positive contribution to the cause of quality, as well as a testimonial to the persistence and dedication of all involved. The inclusion of a price list, giving names of suppliers, transformed what might have been just another attractive catalogue into a useful shopper's guide. One indication of the *Warenbuch*'s influence is that it attracted vigorous opposition. Social Democrats denounced it as a capitalist venture serving the interests of participating manufacturers, while producers who had been excluded regarded it as discriminatory. Indeed, some Bavarian handicraftsmen felt sufficiently threatened to instigate a campaign

[7] Walter Riezler, *Die Kulturarbeit des Deutschen Werkbundes* (Munich, 1916), p. 37.
[8] *Ibid.*, p. 18.

against it in the Munich press.[9] Generally, however, the
Warenbuch enjoyed favorable publicity from groups and
individuals ranging across the political spectrum, and by
the summer of 1916, the first edition was entirely sold
out.[10] Although robbed of its full effect by the war, it
constituted an experiment in tune with the requirements
of the time, and one that was to be remembered later.

While the transition to a war economy failed to bring
the Werkbund's activities to a complete halt, it did force
the association to alter its course. The blockade, which
effectively cut off Germany from foreign markets, made
further efforts to influence the production of goods for
export pointless. Moreover, by drastically curtailing domes-
tic building construction, the war restricted opportunities
for innovative architecture. Apart from the *Warenbuch*,
little of the prewar program remained relevant. The Werk-
bund's leaders had to find new ways to further its goals.

One of the first was a campaign to ensure that Werk-
bund men and ideas would play a role in the reconstruction
of war-damaged areas. At the request of the East Prussian
authorities, the association drew up lists of architect-
members willing to design dwellings or prepared to act as
government servants in the work of reconstruction.[11] By
1916, a Werkbund man, Paul Fischer, headed the East
Prussian building commission, which was largely staffed
by sympathizing district architects; and another prominent
Werkbund personality, Carl Rehorst (formerly mayor of
Cologne), acted as advisor on reconstruction to the German
occupation forces in Belgium.[12] On the other hand, a
scheme initiated by Karl Schmidt of the *Deutsche Werk-
stätten* for supplying furniture and appliances to the re-

[9] See a review of the *Warenbuch* in *Kunstgewerbeblatt*, xxvii
(1915-16), 159; Ferdinand Avenarius, "Deutsches Warenbuch,"
Kunstwart, xxix, No. 10 (Feb. 1916), 121-25; DWB-M 1916/4, pp.
6-7; DWB-M 1916/5, pp. 4 and 14.

[10] Avenarius, "Deutsches Warenbuch," pp. 124-25, mentions that
the Association of Nationalist Retail Assistants (*Deutschnationale
Handlungsgehilfenverband*) was urging its members to purchase
the *Warenbuch* and follow its advice.

[11] DWB-M 1915/1, pp. 5-6. [12] DWB-M 1916/5, p. 16.

constructed areas had to be abandoned when it ran into opposition from the *Handwerkskammer* (Chamber of the Crafts) in Königsberg; the East Prussian craftsmen evidently feared the competition of the more highly organized and progressive workshops of Dresden and Munich.[13]

Wartime patriotism also inspired the Werkbund to participate in the movement to establish a German fashion industry independent of French or other foreign influence, although it was aware that in doing so it was venturing into a sphere where it would be unable to enforce the adoption of its own high standards. Rather than allow the market to be swamped with poorly designed clothes, the Werkbund felt obligated to intervene on the side of good taste, and decided to sponsor a fashion show in Berlin. This gala event, under the patronage of the Imperial Crown Princess, took place on March 27, 1915, in the Prussian House of Deputies, and attracted favorable comment in the general and specialist press. Nevertheless, it proved impossible to make it a regular event or to produce similar showings in other German cities.[14] Whereas the Crown Princess remained convinced that she could win society over to the support of German fashions, the Werkbund itself soon cooled to the entire enterprise, though not before it had sponsored two pamphlets that captured the spirit of the movement at its most extreme: *Deutsche Form* by Fritz Stahl and *Die Weltpolitik der Weltmode* by Norbert Stern.[15] The Werkbund campaign meanwhile had come under attack from one of the association's founder-members, Eugen Diederichs, who devoted two articles to the subject in his monthly, *Die Tat*.[16] According to

[13] *DWB-M* 1915/1, p. 6. A revised proposal that the government subsidize the purchase of quality furnishings executed to Werkbund specifications by local craftsmen, also came to nothing.

[14] *Ibid.*, pp. 6-7.

[15] Stahl was the pseudonym of Siegfried Lilienthal, the influential art critic of the *Berliner Tageblatt*. His book appeared as a Werkbund pamphlet, whereas Stern's formed part of a series, *Der Deutsche Krieg*, edited by Ernst Jäckh.

[16] Issues of Oct. 1915 and June 1916, reproduced in Eugen Diederichs, *Politik des Geistes* (Jena, 1920), pp. 147-50.

Diederichs, the main characteristic of the 'new style' shown at Berlin—the wide skirt—merely mimicked the latest Parisian trend. Moreover, in a time of textile shortages and economic stringency, it was basically unpatriotic. Diederichs also poked fun at Norbert Stern's recommendation that German women wear shades of gray to suit the mood of the times, and dress along Turkish lines, adopting even the Turkish shawl.[17] Stern's attempt to create a fashion equivalent of German imperialism represented the high point of Werkbund involvement with this reform movement. The association's leaders came to share Diederich's fear that the only beneficiaries would be the big clothing manufacturers of Frankfurt and Berlin, who proved disappointingly resistant to quality principles. For a time, the Werkbund tried to achieve reforms by encouraging collaboration between its artists and the smaller boutiques, but by 1916 it had abandoned hope that an artistically reputable German fashion industry, capable of rivaling Paris, could be established overnight.[18]

Although inept and unproductive, the Werkbund's wartime intervention in the realm of feminine fashions was consistent with its general philosophy. In its concern for the renewal of German culture, the Werkbund had always sought to influence every facet of national life. The outbreak of war merely extended its ambitions somewhat, and stimulated a desire for quick results. As Peter Jessen declared in 1915, the association would continue to touch on all aspects of German creative endeavor, "from granite and concrete structures to female clothing, from city planning and housing to office design, from the theater to the cemetery."[19] Tragically, it was the last area which came to the fore as the war went on; the Werkbund yearbook for 1916-1917 was devoted in its entirety to the

[17] *Ibid.*, p. 149. Diederichs quoted Stern: "Eine türkische Mode ist ein deutsches Nationalgebot."

[18] Peter Bruckmann, presidential address to the Bamberg Werkbund congress July 1916, *DWB-M* 1916/5, p. 3.

[19] Jessen, "Die Deutsche Werkbund-Ausstellung Köln 1914," *DWB-J* (1915), p. 2.

topic of war graves and memorials.[20] Undertaken in collaboration with the army authorities and subsidized by the ministries of culture of several German states, the yearbook contained two hundred designs selected by a committee that included five representatives of the Werkbund.[21] In addition to setting a standard of quality, the Werkbund hoped thereby to stimulate concern for considerations of art in church and army, and among the general public.[22] Looking back on this campaign at war's end, Theodor Heuss expressed his skepticism regarding its artistic and social significance; even the most cultivated and intellectual soldier would find it small comfort to know that his gravestone had been designed by Hoffmann or Bonatz![23] But during the war, the Werkbund had no misgivings about its importance, and used exhibitions and lectures to supplement the effect of the yearbook.

Although its wartime program took shape largely in response to national requirements, the Werkbund also sought to meet the needs of its members. Called to the forces, many of the artists felt frustrated by inability to pursue their vocation and became embittered against those who remained behind.[24] By July 1916, 250 Werkbund members were at the front and the war had already claimed more than 20 Werkbund lives.[25] On the other hand those who remained at home faced unemployment and penury as society concluded that art was redundant in time of war. The Werkbund tried to secure military exemptions for particularly valuable artists—Ernst Jäckh claimed to have engineered the release of about three

20 DWB, *Kriegergräber im Felde und daheim* (Munich, 1917).

21 The Art Gallery in Mannheim and the *Bund Heimatschutz* also collaborated on this project. The Werkbund representatives were German Bestelmeyer, Theodor Fischer, Adelbert Niemeyer, Bruno Paul, and Louis Tuaillon. *DWB-M* 1916/5, p. 18.

22 Peter Jessen, "Vorwort," *DWB-J* (1916-17), pp. 7-8.

23 Heuss, "Probleme der Werkbundarbeit," *Der Friede*, I (1918-19), 618.

24 This is well expressed in a letter from Gropius, at the front, to Osthaus, May 5, 1916, *KEO*, Kü 344.

25 *DWB-M* 1915/1, p. 13; and *DWB-M* 1916/5, p. 1.

dozen political, artistic, and scientific notables.[26] At the same time, it sought to devise employment opportunities for those who remained in civilian life. The Werkbund projects described above, involving the reconstruction of the devastated areas, fashion design, and the creation of appropriate war memorials and tombstones, all were calculated both to benefit the national cause and to provide work for artists.

The dual nature of many Werkbund programs is perhaps best illustrated by the exhibition, "Die Kunst im Kriege" (Art in Wartime) organized by the Werkbund in cooperation with the *Deutsches Museum* in Hagen. The stated aim of the exhibition was to prevent a further decline in the appearance of German cities while preserving the nation's reservoir of artistic talent and skill. By alerting the country to the significant role that art could play in time of war, it sought to stimulate a flow of funds and commissions that would keep struggling artists afloat.[27] To the same end, the Werkbund sponsored and publicized artistic competitions for everything from gravestones to perfume packaging, and encouraged its members to compete for prizes, which, though generally small, provided valuable supplements to their dwindling incomes.[28]

Although the war seriously threatened the livelihood of many of its members, the Werkbund itself adapted with remarkable success to the new conditions. A whole series of additional projects was made possible by large subsidies from Robert Bosch, the maverick Stuttgart industrialist, who in this way sought to mitigate his guilt feelings over profiting from the war.[29] The subsidies from Bosch, covering approximately half of the Werkbund's annual

[26] Jäckh, *Goldene Pflug*, pp. 342-43.

[27] Annual report of the *Deutsches Museum*, in DWB-M 1916/5. The exhibition also showed items produced by wounded war veterans.

[28] DWB-M 1916/5, p. 12. Notifying members of these competitions was one of the prime functions of the Werkbund newsletter begun in 1915. Details of the perfume competition appeared in DWB-M 1916/4, p. 5.

[29] Heuss, "Notizen," p. 23; Heuss, *Erinnerungen*, p. 216.

budget during the war years, enabled the association to extend its activities at a time when most private groups were struggling for survival.[30] Indeed, the pressure of work became so heavy that Ernst Jäckh found it necessary to add three men to his staff: Fritz Hellwag, former editor of the *Kunstgewerbeblatt*; Otto Baur, trained as an architect; and Naumann's young protegé, the economic journalist Theodor Heuss.

Freed from much of the day-to-day work of the association by his new assistants, Jäckh himself could now expand his favorite role: that of an entrepreneur in the realm of ideas. Increasingly, he involved the Werkbund in politically motivated projects that bore only a tangential relation to its original program. While purists like Poelzig and Gropius resented this subordination of art to extraneous ends, in Jäckh's mind, culture and politics were simply two sides of the same coin.[31] To justify his position, Jäckh appealed to history, citing the example of Richard Wagner who had linked culture and politics in the mid-19th century.[32] But it took the war to change the outlook of many Werkbund members. A notable example was Moeller van den Bruck, author of *Der Preussische Stil*, one of the men for whom Jäckh secured an exemption from military service. Before 1914, Moeller had been an aesthete, proclaiming the supremacy of art and the artist; now he became a convert to German nationalism, and prophet of the Prussian tradition, happy to put his talents at the service of the army's press and propaganda division.[33] Moved by the

30 Bosch contributed 60,000 marks annually. In 1917-1918, membership dues brought in only 41,461 marks. See the financial report for 1917-1918 in *Bauhaus* GS 2/2.

31 See the letter from Poelzig to Gropius, Aug. 30, 1916, in *Hans Poelzig: Gesammelte Schriften und Werke*, ed. Julius Posener (Berlin, 1970); and Berlin, Werkbund-Archiv [hereafter WB] Poelzig papers, letter from Gropius to Poelzig, Sept. 23, 1916. Both Poelzig and Gropius were convinced that Jäckh's political adventurism would harm the Werkbund cause.

32 Ernst Jäckh, *Das Grössere Mitteleuropa* (Weimar, 1916), p. 5.

33 In the words of Fritz Stern, *Cultural Despair*, pp. 259-60: "Gone were the days of the literary café with Expressionist writers;

desire to serve the national cause and raise Germany's international status, many artists and intellectuals, even when they did not share Jäckh's specific enthusiasms, were prepared to support his policy of linking the Werkbund directly with the war effort.

In the first weeks of war, the Berlin Werkbund office initiated a concerted propaganda campaign on behalf of the German government. Using its contacts abroad, it transmitted as many as two thousand words daily by telegraph to foreign nationals in England, Holland, and elsewhere, in an attempt to influence opinion in Germany's favor.[34] Once the Reich government had established its own *Zentralstelle für Auslandsdienst*, the Werkbund withdrew from this activity, but it did not cease its work abroad. The defense of Germany against the charge of barbarism led to close collaboration with the Foreign Office, which subsidized Werkbund arts and crafts exhibitions in Bern, Winterthur, and Basel in 1917 and Copenhagen in 1918.[35] The Werkbund agreed only reluctantly to become involved in exhibition work under adverse wartime conditions, but seems to have been gratified by the results. The exhibitions gave German artists an opportunity to escape their enforced isolation and to prove to the world and the nation that Germany still had something to offer in the cultural sphere.[36]

The greatest boost to Werkbund morale came in 1915 with the founding of the English Design and Industries Association (DIA) in London. The British had been im-

now he took weekly walks with Ernst Jäckh, with whom he worked in the Werkbund as well."

[34] *DWB-M* 1915/1, pp. 11-12; Jäckh, *Goldene Pflug*, p. 201 n.

[35] Jäckh, *Goldene Pflug*, pp. 197 and 200-201; Albert Bauer, "Die Basler Werkbund-Ausstellung," *Innen-Dekoration*, XXIX (June 1918), 165-71; Theodor Heuss, "Werkbund-Ausstellung in Kopenhagen," *Deutsche Kunst und Dekoration*, XLIII (1918), 255-56.

[36] Hermann Muthesius developed this theme in his *Der Deutsche nach dem Kriege* (Munich, 1915). See also Fritz Hellwag, "Die deutsche Werkbund-Ausstellung in Bern," *Innen-Dekoration*, XXIX (1918), 155-62; and Peter Behrens, "Vorwort im Katalog der Ausstellung in Bern," reprinted in *Die Form*, VII, No. 10 (1932), 301.

pressed even before 1914 by the Werkbund's effort to improve the standard of design in German industry and crafts, and the Cologne exhibition, visited by several future DIA leaders, strengthened their determination to secure for England some of the advantages that sound organization could provide. With the outbreak of war, the English reformers managed to persuade their government of the need to emulate the German example for competitive reasons. The result was an exhibition of Werkbundtype quality goods sponsored by the Board of Trade in 1915, which led directly to establishment of the DIA.[37]

Delighted by these developments, the Werkbund translated a booklet of British writings related to the founding of the DIA, while Theodor Heuss and Fritz Hellwag employed their journalistic contacts to spread the good news, and to point out its significance for Anglo-German relations.[38] The design efforts of the German "barbarians," as one of the English reformers observed, were beginning to make a mark on the markets of the world, and the British could no longer afford their prejudices about German bad taste.[39] Impressed by the German and Austrian goods displayed at the Goldsmiths' Hall in London in March 1915, the founders of the DIA credited the superior organizing ability of the Germans for this great leap forward, and proceeded to copy the Werkbund constitution almost verbatim. To the Werkbund, it was particularly gratifying that the English were the first to take this step: as archrealists, their approbation was regarded as the best confirmation of the practical value of Werkbund idealism.[40]

[37] Great Britain, Board of Trade, *Exhibition of German and Austrian Articles Typifying Successful Design* (London, 1915). Also Pevsner, "Patient Progress Three: The DIA," pp. 226-41; and MacCarthy, *All Things Bright and Beautiful*, p. 77.

[38] DWB, *Englands Kunstindustrie und der Deutsche Werkbund* (Munich, 1916). By June 1916, 8,000 copies of this pamphlet, edited by Theodor Heuss, had been sold. DWB-M 1916/5. Cf. Heuss, "Ein englischer Werkbund," *Die Hilfe*, XXII (1916), 395; and Hellwag, "Die deutsche Werkbund-Ausstellung in Bern," p. 155.

[39] A. Clutton Brock, "Die Kunstindustrie in Deutschland," in DWB, *Englands Kunstindustrie*, p. 13.

[40] Riezler, *Kulturarbeit*, p. 7; DWB-M 1915/1, p. 4.

The Werkbund's satisfaction at finding imitators abroad was natural, but the use it made of the DIA founding was tainted by the Anglophobia of the times. In the past, the Werkbund had freely acknowledged the English Arts and Crafts movement as its progenitor. Now, however, it claimed priority for Germany by stressing the seminal role of the German architect Gottfried Semper, who had lived in England for some years around 1850. Semper, according to this version, had inspired the reform of art education in England, which led, after the Crystal Palace exhibition of 1851, to the founding of the Royal College of Art and the Victoria and Albert Museum. While it is true that Semper was in close contact with the Arts and Crafts reformers of his day, to conclude that they would have done nothing without him is obviously an exaggeration.[41]

The Werkbund further insisted that the English could never reproduce the success of the German design reform movement, based as it was on the superior diligence, persistence, and ability of the German people. Because the Werkbund was the fruit of an indigenous organic development, Germany need not be disturbed by foreign attempts to imitate the Werkbund's organizational forms.[42]

While propaganda directed to improving the image of Germany abroad and strengthening domestic morale absorbed much of the association's energy in the early war years, Ernst Jäckh constantly sought new ways to serve the national cause. One of the most extraordinary consisted in linking the Werkbund with Friedrich Naumann's campaign for Central European federation. Naumann, after August 1914, abandoned direct involvement in Werkbund affairs in order to devote himself to politics and

[41] DWB, *Englands Kunstindustrie*, p. 27, editor's note. On Semper in England, Nikolaus, Pevsner, *The Sources of Modern Architecture and Design* (London, 1968), p. 10.

[42] Jäckh, *Grössere Mitteleuropa*, p. 21; Jäckh, *Goldene Pflug*, pp. 200-201. The latter describes the establishment in July 1916 of a French "Werkbund," the Central Office for the Applied Arts. Unlike the Werkbund or the DIA, this was a government committee, decreed into existence by the Undersecretary for the Fine Arts, Albert Dalimier.

journalism. But his book *Mitteleuropa*, published in 1915, did contain references to the Werkbund. He cited it as evidence for his contention that both North and South, both Berlin and Vienna, had valuable contributions to make to Central Europe. In the new federation, as at the Cologne Werkbund exhibition, Prussian work discipline (*Arbeitsmilitarismus*) and Austrian good taste would collaborate to create goods that were both useful and decorative.[43]

Jäckh, who was a member of Naumann's *Arbeitsausschuss für Mitteleuropa* founded in 1916, expanded the concept of a federation of Central Europe eastwards to include the Balkans and Turkey, thus joining the original Austro-German community with his own dream of an intimate German-Turkish connection.[44] It was this *Grössere Mitteleuropa* that Jäckh introduced to the Werkbund at the Bamberg congress of June 1916.[45] In his keynote speech, Jäckh accumulated all the clichés of German wartime cultural propaganda, pitting German culture against Western civilization, the German sense for the organic against the rationalistic materialism of the West, the German idea of freedom against the profit-oriented subjection of the non-Germanic peoples, and the benevolent German hegemony, under which associated peoples could develop freely, against the destructive imperialism of the

[43] Friedrich Naumann, *Mitteleuropa*, in Naumann, *Werke*, IV, 627-28. On Naumann, the Werkbund, and the war, Heuss, *Naumann*, p. 225.

[44] Editor's introduction, "Schriften zum Mitteleuropa Problem," Naumann, *Werke*, IV, 391; Henry Cord Meyer, *Mitteleuropa in German Thought and Action 1815-1945* (The Hague, 1955), pp. 99-102.

[45] Entitled "Werkbund und Mitteleuropa," Jäckh's talk was distributed to Werkbund members with the *Mitteilungen* and published subsequently in an edition of 10,000 copies. Although Naumann continued to regard the German and Habsburg monarchies as the heart of *Mitteleuropa*, by the summer of 1916 he, too, urged the inclusion of Bulgaria to ensure the safety of the Baghdad railway link with Turkey and thus the land route to the Orient. See his "Bulgarien und Mitteleuropa," Naumann, *Werke*, IV, 767-836. Written after Bulgaria's entry into the war on the side of Germany, this essay was incorporated in the popular edition of *Mitteleuropa* published Oct. 1916.

Western powers. From this he moved on to assert that a single organic or biological principle revealed itself both in the Werkbund and in *Mitteleuropa*, the former constituting its artistic expression, the latter its realization in political terms. Together they could be considered microcosm and macrocosm of the same German ideal, necessary products of the German psyche, and unique to Germany.[46] The Werkbund not only had a special role to play in *Mitteleuropa*; after German victory it would help to establish a new international order and a world culture. Jäckh's vision was of a Werkbund league of nations in which East and West would meet and fertilize each other.[47]

It is impossible to judge the Werkbund's response to Jäckh's oratorical extravagances, but the association did agree to implement his plan for a "House of Friendship" to be erected in Constantinople as an expression of the spirit of Greater *Mitteleuropa*.[48] As conceived by Jäckh, this was to be an ambitious group of structures housing everything from a library to a concert hall.[49] The Turks donated a site, and the undertaking enjoyed the support of the Sultan as well as the German Kaiser. Funds came from the German-Turkish Union, a private association of which Jäckh was the leading spirit and that owed much to the Werkbund's patron Robert Bosch, whom Naumann had won over to *Mitteleuropa* and Jäckh to the cause of German-Turkish friendship.[50]

The Werkbund's role in the House of Friendship was confined to selecting the architect. Of twelve leading Ger-

[46] Jäckh, *Grössere Mitteleuropa*, pp. 5-6.

[47] *Ibid.*, p. 27; Jäckh, *Goldene Pflug*, p. 202, claimed that in his Werkbund address, he had been the first to proclaim the idea of a League of Nations—a whole month before Lord Grey announced his version!

[48] *DWB-M* 1916/5, pp. 4 and 16.

[49] Jäckh, *Grössere Mitteleuropa*, p. 21; for documents relating to the House of Friendship project, Jäckh, *Goldene Pflug*, pp. 322-33.

[50] Meyer, *Mitteleuropa*, p. 221; Heuss, *Bosch*, p. 312. Jäckh claimed that the initiative for the project had come from the Turkish government, but according to Hans Poelzig it was foisted by Jäckh on both the Turks and the Werkbund. Cf. letter from Poelzig to Gropius, Aug. 30, 1916, in Posener, *Hans Poelzig*, pp. 83-84.

mans invited to submit designs, eleven accepted, and the twelfth, Walter Gropius, would have done so had he been able to obtain leave from the army.[51] The participants not only handed in projects but acted as the selection committee. After two days of discussion, they managed to agree on an uninspired design by German Bestelmeyer, passing over Poelzig's imaginative proposal that Theodor Heuss, for one, regarded as by far the most original submission.[52] The result could be explained easily enough: each juror had cast the first of his two votes for his own plan, and the second for the scheme that seemed to him least offensive rather than best.[53]

The cornerstone-laying for the House of Friendship took place on April 27, 1917, in the presence of prominent Turkish and German dignitaries. Ernst Jäckh, addressing the assembled notables, somewhat prematurely spoke of the project as a symbol of the victorious German-Turkish wartime alliance. He stressed its roots in geopolitical necessity and noted that it corresponded to the dearest wishes of German rulers reaching back, by way of Bismarck and Moltke, to Frederick the Great.[54] The Kaiser eventually gave substance to this claim by repairing directly to the site of the project on his first and only visit to Constantinople in October 1917.[55] By then, the site had been fully cleared, and construction began in the following year,

[51] Jäckh, *Grössere Mitteleuropa*, p. 22; *DWB-M* 1918/4, p. 31. Gropius, despite his distrust of Jäckh, would have liked to take part. See *WB*, Poelzig papers, Gropius to Poelzig, Sept. 23, 1916.

[52] Heuss, *Erinnerungen*, p. 222.

[53] See Fritz Schumacher, *Selbstgespräche* (Stuttgart, 1935), p. 126. Schumacher based his comments on the account of his friend Paul Bonatz, one of the participating architects.

[54] Heuss, "Das 'Haus der Freundschaft' in Konstantinopel," in *DWB*, *Das Haus der Freundschaft in Konstantinopel: Ein Wettbewerb deutscher Architekten* (Munich, 1918), pp. 46-48. Germany was represented by its ambassador, von Kühlmann, and the German-Turkish Union by its vice-president, Hjalmar Schacht, and by Robert Bosch who had accompanied Jäckh to Constantinople for this ceremony. William II did *not* attend, as Meyer asserts in his *Mitteleuropa*, p. 221.

[55] Heuss, "Das 'Haus der Freundschaft' in Konstantinopel," p. 48.

only to be brought to a halt by Germany's defeat. Thus ended a scheme through which the Werkbund had hoped to show that it was not an apolitical band of artists far removed from reality, but an organization capable of playing a constructive role in a world created by the fortunes of war.[56]

While Jäckh's activities publicly identified the Werkbund with Naumann's vision of *Mitteleuropa*, it became apparent, as Werkbund members were drawn into the national debate on war aims, that there was no single position acceptable to all. Most agreed that Germany would be victorious and welcomed the prospect, but they differed in their judgments on the nature of the postwar world and the place that their country—and the Werkbund—should seek to fill in the international arena.

Even among the advocates of *Mitteleuropa*, views ranged widely. On the one hand, Jäckh and his philosopher friend Karl Joël emphasized the liberal and international implications of the concept. Both regarded the Werkbund and *Mitteleuropa* as nuclei of a future supranational community dedicated to the cause of universal harmony. The Cologne Werkbund congress, which had been attended by Austrians, Swiss, Dutch, Danes, Hungarians, and Norwegians, seemed to them the forerunner of a new Europe inspired by German ideals but not dominated by German power.[57] But it was possible to interpret *Mitteleuropa* in more conventionally nationalistic terms. For example, the architectural critic Fritz Hoeber viewed both the Werkbund and *Mitteleuropa* as essentially Germanic and believed they would have to be imposed on the world by physical might. Just as the victorious knights of the crusades had spread Gothic architecture throughout the world, so the victories of Germany and her Central European allies would assure the new art forms originated within the

[56] Peter Bruckmann, presidential address at Bamberg, June 1916, DWB-M 1916/5, p. 4.
[57] DWB-M 1915/1, p. 4. Jäckh dedicated his *Grössere Mitteleuropa* to Joël.

Werkbund their rightful place.[58] Hoeber thus confirmed
the suspicions of certain foreign observers at the 1914
Werkbund congress who had contended that the Werk-
bund movement was too closely tied to the German cause,
as well as the fears of those in and outside Germany who
thought Naumann's *Mitteleuropa* simply a disguise for
German domination.[59]

Although the *Mitteleuropa* idea took hold within the
Werkbund, we know that at least two prominent Werk-
bund leaders rejected it outright. One was Peter Behrens,
by then Germany's most successful industrial designer
and factory architect. Behrens does not seem to have ex-
pressed his views on war aims publicly, but it is possible
to deduce his position from that of the *Bund deutscher
Gelehrter und Künstler*, which he helped to found. This
organization of about 1,000 politically unaffiliated intellec-
tuals and artists identified itself completely with the Ger-
man cause and engaged in psychological warfare on its
behalf. But for the most part it regarded the war as a de-
fensive struggle against English imperialism, a battle for
national survival rather than for territorial annexations or
cultural conquests.[60]

The other Werkbund leader whose wartime views are
worth examining is Hermann Muthesius. Before 1914,

[58] Fritz Hoeber, "Architekturfragen," *Die neue Rundschau*, XXIX,
No. 2 (1918), 1103-8. Hoeber, a great admirer of Peter Behrens,
cited French and Russian protests against the allegedly Teutonic
façade of Behrens' German Embassy in St. Petersburg (designed in
1911-12) to prove that the Entente powers even before the war had
recognized that the Werkbund threatened their status as dictators
of taste.

[59] E.g., the statements of the Hungarian and Norwegian repre-
sentatives at Cologne, DWB, *Werkbundarbeit*, pp. 13 and 31. Meyer,
Mitteleuropa, pp. 251-52 discusses attacks on Naumann's concept
by those who regarded it as a cover for Prussian militarism and
Pan-German aims.

[60] Joachim Schwierskott, *Arthur Moeller van den Bruck und der
revolutionäre Nationalismus in der Weimarer Republik* (Göttingen,
1962), pp. 44-45. Schwierskott's judgment that the *Bund* was closer
to the advocates of a negotiated "peace without annexations" than
to the extremists of the Fatherland Party, is confirmed by its pam-
phlet series, *Um Deutschlands Zukunft*, Nos. 1-10, Berlin, 1917-21.

Muthesius, although certainly an ardent patriot, had opposed the artistic ultranationalism characteristic of the *Heimatschutz* and *völkisch* strands of the cultural reform movement. Within the Werkbund, it had been his critics who had been most determined to stress the need to develop the new style from German roots, whereas Muthesius had urged the adoption of a contemporary style adapted to the foreign taste for lightness and elegance.[61] However, in two essays published in 1915, Muthesius revealed himself as an extreme cultural nationalist. The war, he proclaimed, was a blessing because Germany, cut off from the outside world, would be forced at long last to abandon her excessive admiration for things foreign, her dependence on the approval of outsiders, and the undignified incorporation of alien elements into German language and art. Now she might learn the value of a truly German form and take pride in the leading position she had achieved in the realm of the applied arts and architecture. After the war, it would be her mission to impress the German style on the world. For, Muthesius felt certain, the postwar world would not only be ruled, financed, educated, and supplied by Germany; it would also bear a German face. Only the nation that imposed its style on the world could truly claim to be its leader, and Germany was destined to be that nation.[62]

Muthesius had expressed similar sentiments at Cologne and had always regarded the Werkbund as an adjunct of state policy, serving national goals. But after the outbreak of war, his tone became aggressively nationalistic and exclusive in spirit, while the identification of culture and politics became complete. Equating the Werkbund, the Prussian army, and the German welfare state, Muthesius in 1915 declared all three to be the product of Germany's special gift for organization and warned that they would inevitably defeat England's Manchester Liberalism,

[61] See DWB, *Werkbundarbeit*, p. 46 and *passim*.
[62] Hermann Muthesius, *Die Zukunft der deutschen Form* (Stuttgart, 1915), pp. 5-6, 16, and 36.

despite all efforts of the British to imitate their outward forms. It was the task of the German army to ensure recognition for German achievements. Military victory would enable the nation to create a power mystique (*Macht-Legende*) commensurate with the facts, and so destroy forever the myths of England's superiority in economics and politics, and of French pre-eminence in the arts.[63]

Muthesius' essays, calling for Germany's political and cultural hegemony, showed that the Werkbund idea could be linked just as well with Pan-Germanism as with *Mitteleuropa*.[64] Yet, despite their differences, Jäckh, Hoeber, Muthesius, and perhaps even Behrens shared a belief in the intimate connection between Werkbund principles and German foreign policy. A notable exception to this tendency was Walter Riezler, whose essay, *Die Kulturabeit des Deutschen Werkbundes*, appeared in 1916. Riezler, director of the municipal gallery in Stettin and a founder-member of the Werkbund, regarded himself as an artist rather than a civil servant. Trained as a musicologist, his sympathies generally lay with the creative element in the Werkbund rather than with its "politicians." At Cologne, Riezler had nonetheless declared his support for Muthesius against van de Velde, but he never shared Muthesius' willingness to subordinate the Werkbund to national political purposes nor the belief that Germany had a cultural mission to the world. Instead, he maintained that the chief task facing the Werkbund after the war would be to raise the domestic level of taste and design. Exports he regarded as at best a by-product of a reform movement whose main justification lay in giving greater dignity and intensity to German life.[65] Moreover, Riezler was prepared to acknowledge the contribution of others, notably the Austrians, to the modern movement and to the cause of Arts and Crafts reform. Like Naumann, who had suggested that the Ger-

[63] Hermann Muthesius, *Der Deutsche nach dem Kriege* (Stuttgart, 1915), pp. 17, 50-53, and 62-63.
[64] On the conflict between the Pan-Germans and the advocates of Mitteleuropa, cf. Meyer, *Mitteleuropa*, pp. 233-36.
[65] Riezler, *Kulturarbeit*, p. 39.

mans "ought to learn more of Austrian melody, the Aus-
trians more of German horsepower,"[66] Riezler believed that
the Austrians had much to teach the more theoretically
inclined and intellectualistic Reich Germans, and that the
"German form" would be a joint product of the two coun-
tries.[67] Thus Riezler somehow managed to avoid the chau-
vinistic rhetoric typical of so much wartime writing as
well as the exaggerated nationalism which led many of
his compatriots dangerously to overestimate the expansive
power of German cultural and political forms.

During 1915 and 1916, when Germany's armies seemed
invincible, the Werkbund for a time became an adjunct
of German cultural imperialism. However, as the prospects
for an early and glorious conclusion to the war be-
gan to dim, the association abandoned this position. The
change was particularly marked after the summer of
1916, when Muthesius resigned from the vice-presidency;
and by the last year of the war it was Riezler's modest
view of the association's function and future that domi-
nated Werkbund thinking. In particular, the Werkbund
Mitteilungen, edited by Fritz Hellwag, from January 1,
1918 in collaboration with Theodor Heuss, reported the
more prosaic aspects of the association's wartime activi-
ties in language remarkably free from chauvinistic excess.
Designed with care, each issue by a different typographic
artist, these newsletters were more notable for their form
than for their content. Avoiding grave national and social
issues, they concentrated on preserving a measure of
formal beauty in a period of intensifying privation and
social disorder.[68]

As late as October 1918, the *Mitteilungen* carried stories
on Werkbund topics as if unaware of the impending end

[66] Meyer, *Mitteleuropa*, p. 209.
[67] Riezler, *Kulturarbeit*, pp. 23 and 40. The fact that Riezler's
pamphlet was published by Jäckh in conjunction with the *Institut
für Kulturforschung* in Vienna may also account, in part, for the
pro-Austrian tone of his remarks.
[68] Heuss, "Notizen," p. 23. For a critique of this approach, see
Adolf Behne, "Kritik des Werkbundes," *Die Tat*, IX, no. 1 (1917), 34.

or the catastrophic consequences for Germany it would entail. If misgivings were felt about eventual victory, they did not make their way into print. Whether this was due to ignorance or unquestioning loyalty, to wishful thinking or patriotic self-restraint, or even to the existence of censorship, we may never know. Probably a combination of all these accounted for the absence of alarmist speculations, or indeed of any comment on the progress of the war, even when many must have known that German victory was out of the question and bitter defeat a real possibility.[69] The *Mitteilungen* did reflect a growing concern with the problems of transition to a peacetime economy, and with the role the Werkbund could expect to play in the postwar world. Thus, in the course of criticizing a government bill for the taxation of luxury goods, the Werkbund stressed that it would be more necessary than ever, when peace came, to have quality goods available for export, in order to earn essential foreign currency. Foreseeing difficult times, the association predicted that only products meeting the highest standards of quality and design would prove acceptable henceforth to foreign buyers.[70] Similarly, the *Mitteilungen* reported a meeting of the Werkbund executive and board in early October 1918, at which a major topic of debate was how best to ensure fair distribution of raw materials to industry after the cessation of hostilities.[71]

The *Mitteilungen* also addressed themselves to a variety of specific problems facing the association's members. Although economic concerns tended to predominate, art edu-

[69] Heuss, *Erinnerungen*, p. 223, describes how the German ambassador to Denmark, Brockdorff-Rantzau, admitted to him in July 1918 that the war was lost. The conversation took place when Heuss was in Copenhagen to attend the Werkbund exhibition there.
[70] Heuss, "Luxusbesteuerung," *DWB-M* 1918/2, pp. 1-4. The Werkbund's efforts against the luxury tax met with limited success; on a motion of the Progressive Party, the Reichstag modified the legislation along the lines of a Werkbund submission, dropping a clause discriminating particularly against goods made of precious materials.
[71] *DWB-M* 1918/3, pp. 30-31.

cation remained a favorite subject; there were articles on furniture and poster design; and the very last wartime issue included a review of a book on diamonds! Meanwhile, there were reports of organizational changes, notably the establishment of two independent Werkbund groups, one for artworkers and the other for color art. Unlike the standing committees of the Werkbund, these *Freie Gruppen* were only loosely affiliated with the parent association, addressed themselves to matters affecting specific sections of the membership, and welcomed participation from interested outsiders.[72] Finally, the *Mitteilungen* detailed plans for future Werkbund yearbooks, to deal in turn with the arts and crafts, monumental and decorative arts, landscape gardening, and standardization.

When one reads the last Werkbund newsletters before the collapse of the Second Reich, one gets the feeling that people were holding their breath, sensing great events to come but as yet unable to imagine their shape. While some tried to escape their fears by concentrating on concrete everyday problems, others indulged in abstract speculations about art or outlined utopias for an unknown and unknowable future. Behind the appearance of sustained activity lay a lack of direction that presaged the end of an era. Within weeks, the war came to a halt, but not before the totally unimaginable had occurred: the abrupt collapse of the German military machine and the toppling of the Imperial regime. Against all expectations, the postwar world was not to be simply a modified version of the one before 1914, but a revolutionary one presenting Germany—and the Werkbund—with unprecedented trials and challenges.

[72] *DWB-M* 1918/2, pp. 21 and 29.

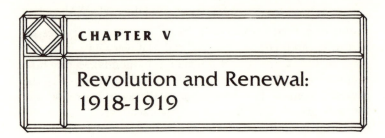

CHAPTER V

Revolution and Renewal:
1918-1919

THE ARMISTICE of November 1918 did not bring peace to Germany. Instead, it inaugurated a period of political and social turmoil and growing economic distress. Faced with defeat and revolutionary unrest, Germans responded in very different ways. Some felt that the destruction of the old order, long overdue, created a welcome opportunity to build a new and better society; others despairingly prophesied complete social and cultural disintegration. Against this background of chaos and conflict, the Werkbund struggled to survive and to evolve a program appropriate to the needs of the day.

The altered relations between nations in the aftermath of the war forced the Werkbund to modify, if not abandon, its self-image as an agent of Germany's cultural mission abroad. Neither the Pan-Germanism of Muthesius nor the more modest ideal of a German-led *Mitteleuropa* could be sustained in defeat. Fundamental adjustments also had to be made to the Werkbund's economic ambitions. Originally created to combat the cultural evils of overly rapid economic growth, the Werkbund now found itself faced with an entirely different set of problems born of material deprivation and drastically reduced opportunities. The war had virtually brought civilian construction to a halt and severely damaged the luxury crafts and quality industries. Moreover, it had accelerated the process of technological change that many Werkbund artists and artisans had already perceived as a threat before 1914. As Fritz Schu-

macher wrote, the war had organized the masses into a human machine and had stimulated an irreversible trend to mechanization and rationalization diametrically opposed to the personal, individual character of art. If German culture was to be preserved, it was more than ever necessary to find ways for man to master the machine and to redefine the role of the artist in the new society.[1]

The Werkbund also had to adapt to a changed intellectual climate. Whereas before 1914 most German intellectuals had either accepted the existing political order or attacked it as isolated critics, the war had awakened more general concern among them for matters of national organization, power, and purpose. Now, for the first time, significant numbers of educated Germans were prepared to enter the public arena and assume positions of leadership.[2] Those writers and artists who committed themselves to the cause of political revolution were only a minority; but many others strove for social change by calling upon the creative power of ideas and art. Dadaists, Expressionists, Neo-Conservatives—all set forth utopian schemes for social renewal, while organized groups of artists dedicated themselves to defining a new relationship between the artistic avant-garde and the masses. Aspiring to the leadership of the new age, the intellectuals hoped to produce a world in which war would cease and true art flourish.[3]

[1] Fritz Schumacher, "Mechanisierung und Architektur" (Jan. 1918) in Schumacher, *Kulturpolitik* (Jena, 1920), pp. 145f.

[2] See Alfred Weber, "Die Bedeutung der geistigen Führer in Deutschland," *Die neue Rundschau*, XXIX, No. 10 (1918), 1249-68. Weber, a prominent Heidelberg economist, brother of the sociologist Max Weber, was an ardent Werkbund member who believed that the Werkbund progressives, already before the war, had made a promising start at providing the ideals and leadership urgently required by a nation in process of democratization and modernization.

[3] The mood of the time is captured in Allan Carl Greenberg, "Artists and the Weimar Republic: Dada and the Bauhaus, 1917-1925," Ph.D. dissertation, University of Illinois, 1967. The manifestoes of the various artist groups are collected in Diether Schmidt, ed., *Manifeste 1905-1933* (Dresden, n.d.). See also Ulrich Conrads and Hans G. Sperlich, *Fantastic Architecture* (London, 1963), and Fritz Herzog, *Die Kunstzeitschriften der Nachkriegszeit* (Berlin,

Although profoundly affected by this intellectual fer-ment, the Werkbund managed to postpone a general stock-taking on the ideological front until September 1919, when it held its first postwar membership meeting in Stuttgart. In the interim, the old executive committee continued to act for the association as a whole. Concentrating on practical issues, it took decisions that perhaps did as much or more to shape the postrevolutionary Werkbund as did the radical thought of the day.[4] But before examining these activities, something must be said about the initial reaction of the Werkbund to the revolutionary events of 1918.

As far as the leadership itself was concerned, it is ap-parent that the Werkbund largely escaped the prevailing mood of exaltation mixed with despair. Unlike the Dadaist or Expressionist manifestoes, the *Mitteilungen* reflected a determined optimism, without any trace of the then-fashionable Spenglerian gloom.[5] Refusing to think in terms of the "Decline of the West," Heuss and Hellwag, in the first postrevolutionary issue of the newsletter, maintained that contemporary problems, while serious enough, were not symptoms of decay but stimuli capable of evoking a creative response.[6]

The tone was set by Theodor Heuss, who insisted that

1940), Ch. III, which deals with the "isms" of the period as revealed in the art journals.

[4] Theodor Heuss, "Vom deutschen Werkbund," *Die Hilfe*, xxv (1919), 520.

[5] Wingler, *The Bauhaus*, p. 3; Lindahl, "Zukunftskathedrale," pp. 242-43 and 250-51; Stressig, "Hohenhagen," p. 471. The most important radical artists' group to arise from the revolution was the *Arbeitsrat für Kunst* in Berlin. According to Franciscono, *Walter Gropius*, p. 121, it contained few "who did not at least for the present stand with such popular philosophers as Spengler in seeing the West in decline." By contrast, Heuss in "Werkbundfragen nach dem Kriege," *Vivos Voco*, I (1919-20), 410, insisted that the artist, to remain productive, *must* reject Spengler's pessimisim.

[6] Theodor Heuss, "Zeitwende I," *DWB-M* 1918/4, p. 8. The follow-ing analysis is based on this article by Heuss, and Fritz Hellwag's "Zeitwende II," *DWB-M* 1918/4, pp. 9-14. Heuss's reaction to the events of 1918-1919 is discussed in Jürgen C. Hess, *Theodor Heuss vor 1933* (Stuttgart, 1973), pp. 40-42, 59-69, and *passim*.

the essential task was to maintain faith in the nation's future. Blaming both the war and the defeat on the Imperial regime rather than on the German people, he argued that the capacity of Germans to work and create would eventually restore fundamental values at home and secure renewed respect for the nation abroad. Heuss welcomed the establishment of a democratic people's state (*Volksstaat*) on political grounds.[7] He also agreed with Hellwag that the new Republic was probably an improvement from the point of view of culture. In any case, it could hardly do more harm to the cause of art than had the old regime. Hellwag hailed the revolution as dissipator of the poisonous clouds of romanticism that had fouled the prewar atmosphere. Heuss, more cautiously, refused to predict how art would fare under the new regime but maintained that there was no prima facie reason why the fall of the dynasties should impoverish cultural life. The patronage of the princes had begun to decline before the war, while the massive intervention of the Kaiser in artistic matters had been a disaster. Backed by resources greater than those at the disposal of Lorenzo de Medici, William II, according to Heuss, had acted as the "all too vocal exponent of the spirit of those newly enriched Germans who, unsure of themselves and rooted in material considerations, had to resort to loud gestures in order to prove their worth."[8] If, in the Wilhelminian era, more modern elements had been able to survive, this proved that a powerful trend towards the democratization of culture had been underway before 1914. The war and the fall of the dynasty, Heuss believed, had eliminated the final barriers to both political democracy and the flowering of modern art.

Neither Heuss nor Hellwag seem seriously to have

[7] Heuss, like Alfred Weber, welcomed the intensification of German national consciousness produced by the war, believing that it had finally set Germany on the road to true nationhood. Cf. Hess, *Heuss vor 1933*, p. 144.

[8] Heuss, "Zeitwende I," p. 4.

entertained the idea that the *Volk*, in the end, might come to reject both democracy and modern art. Thus, when the poet Paul Ernst warned, in the Werkbund newsletter, that the proletariat was the class most wedded to materialism and therefore least capable of appreciating the higher human values, the editors appended a rejoinder praising the cultural work of the prewar Social Democratic Party (SPD), and citing as evidence a scheme of the trade unions to bring 100,000 workers to the Cologne Werkbund exhibition.[9] On the other hand, Heuss did reject the simple equation of art and democracy widely held by the radical artists, and he expressed concern that the democratic state might harm the arts by excessive interference. Because art was essentially a personal matter, he believed the best cultural policy for the new Republic would be one of benign neglect. In theory, democracy might be expected to liberate creative forces heretofore dormant in the *Volk*, but Heuss foresaw that, in practice, the mechanism of the parliamentary system might bring to power groups and individuals inimical to art. Now that freedom from courtly and bureaucratic control had been won, he urged the Republic —prophetically—to beware lest at any time it give power over cultural matters to a popular demagogue.

Although both Heuss and Hellwag recognized that it would be necessary to come to terms with the socialist as well as the democratic side of the revolution, their response to socialism diverged fundamentally. Hellwag, the more radical of the two, welcomed the imminent disappearance of the evils associated with modern competitive capitalism and mass production, and the emergence of an economic system in which the artist, no longer alienated, would enter into fruitful collaboration with industry. He also rejected Heuss's negative view of state power, favoring government intervention in the economy. However, even Hellwag felt it necessary to remind Germany's new rulers of the responsibilities of power. As guardian and propaga-

[9] Paul Ernst, "Materialismus und Maschinenarbeit," *DWB-M* 1918/4, pp. 21-24.

tor of German *Kultur*, the revolutionary state would have to take positive steps to bring about a cultural renaissance, set a good example in its choice of artistic advisors, and embark on serious reform of art education at all levels.

Heuss, on the other hand, warned that there was no automatic link between socialism and art. True, Ruskin, Morris, and Walter Crane had rejected the capitalism of their day, repelled by the profit-seeking spirit of the new captains of industry and by the mechanization of work that appeared to be inextricably associated with the capitalist system. But subsequent developments had shown not only that the return to nonmechanized crafts production was utopian in an age of competitive world markets and proliferating populations, but also that advanced capitalism could be reconciled with quality. Finally, Heuss argued that neither the artisans nor the industrialists who produced quality consumer goods would be adversely affected in the near future by socialist legislation, as socialization would probably be confined to the realm of raw material extraction and the processing of semi-finished products.

It is unlikely that Heuss's economic reasoning did much either to dampen the radicals' enthusiasm for socialism or to reassure his more conservative readers. The fear of socialism was too strong in certain circles to yield to rational argument; and Heuss himself recognized that the progressive intellectuals tended to respond less to socialism's economic program than to its ethical appeal. Heuss did not underrate the dynamism of the quasi-religious vision that led many artists, in particular, to welcome the proletariat as the embodiment of the spirit of the age, and he even admitted that it might one day bear artistic fruit; but he cautioned that socialism in Germany, essentially petit-bourgeois and anti-intellectual in spirit, might be incapable of adapting its doctrine to the changing realities of the contemporary world. Devoloping a theme he was to take up repeatedly in years to come, Heuss sought to persuade the readers of the Werkbund newsletter

that Marxism was simply out-of-date. In his view, the central problem of modern capitalism was no longer how to distribute profits more equitably but how to reestablish a satisfactory relationship between the worker and his product. Because Marxist class analysis seemed to contribute nothing on this point, Heuss declared it irrelevant to the Werkbund's concerns.

To judge by the *Mitteilungen*, then, the Werkbund welcomed the November Revolution and recognized the Republic as the legitimate heir to German state power. Neither democracy nor socialism seemed a serious threat to future artistic and cultural development, and no insuperable obstacles were seen to the solution of outstanding problems. From the start, its leaders encouraged the membership to cooperate with the new authorities in pursuit of traditional Werkbund goals. To what extent the membership at large shared the sentiments of Heuss and Hellwag cannot be determined. The character of the group, with its range of interests, occupations, and outlook, ruled out a unified "Werkbund" response to the confused events of late 1918. What little evidence we have about the thoughts of individual Werkbund members indicates that their reactions covered the whole gamut from enthusiasm to dismay. However, because many shared in the mania for organizing new political and artistic action groups, something of the climate of opinion in Werkbund circles can be learned by looking at their public activities.

A number of members immersed themselves in party politics. Prominent Werkbund personalities helped to found the German Democratic Party (DDP) on November 20, 1918. Friedrich Naumann became the DDP's first chairman in 1919, shortly before his death, and the new party secured the active support of the Werkbund's president, Peter Bruckmann, of its chief patron, Robert Bosch, and of its leading publicist, Theodor Heuss.[10] On the other

[10] Bruckmann became chairman of the DDP in Württemberg in 1921. See Klaus Simon, *Die württembergischen Demokraten* (Stuttgart, 1969), p. 219. Heuss represented the party in the Reichstag

hand, Ernst Jäckh, although involved with the DDP, preferred nonpartisan outlets for his political energies. At the end of the war, he concentrated on creating the German League of Nations Association (*Deutsche Liga für den Völkerbund*). Formally inaugurated on December 17, 1918 with Jäckh as executive director, this organization fell heir to the funds originally accumulated for the House of Friendship project.[11] Jäckh also helped to found the *Deutsche Hochschule für Politik*, a nonparty institute conceived by Friedrich Naumann to promote the study of political science, hitherto neglected in Germany.[12] At the same time, he continued to cultivate close relations with leading members of the government and civil service, in order to advance his various causes, including the Werkbund.[13]

The artist-members of the Werkbund generally refrained from direct involvement in politics. An exception was architect Paul Bonatz of Stuttgart, designer of that city's exemplary railway station, who became a member of the municipal workers' council (*Arbeiterrat*) during the revolution and joined the Social Democratic Party. But within a year Bonatz had withdrawn from the SPD and turned his back once more on party politics.[14] On the whole, even the temperamentally most activist Werkbund artists found the parties uncongenial and preferred to form or join

from 1924 to 1928, and its successor, the *Staatspartei*, from 1930 to Sept. 1932, and again from March to July 1933. Hess, *Heuss vor 1933*, p. 18.

[11] Jäckh, *Goldene Pflug*, pp. 333 and 348-55.

[12] Ernst Jäckh, *Weltsaat: Erlebtes und Erstrebtes* (Stuttgart, 1960), pp. 79f; Theodor Heuss Archiv, *Theodor Heuss: Der Mann, Das Werk, Die Zeit. Eine Ausstellung* (Tübingen, 1967), pp. 128-30. See also Walter Struve, *Elites against Democracy* (Princeton, 1973), pp. 112-13.

[13] Jäckh, *Goldene Pflug*, p. 192, relates, for example, how he intervened with the Prussian Minister of Culture, Konrad Haenisch (an old school friend), to get Poelzig appointed to the staff of the Technical University in Berlin in 1920, after the latter's election to the presidency of the Werkbund made a move from Dresden to the Reich capital seem desirable.

[14] Paul Bonatz, *Leben und Bauen* (Stuttgart, 1950), pp. 88-95.

groups they could dominate and in which they could hope to maintain the purity of their ideals. Thus Richard Riemerschmid became vice-president of a Council of Creative Artists founded in Munich on November 20, 1918. This group sought to further the interests of its artist-members and to devise new ways of bringing art to the people.[15] Similarly, the architect Martin Elsässer helped to establish a Chamber of Architects in Württemberg, to represent the professional interests of all connected with the building trades, and to uphold principles of quality and design in a period of economic stringency.[16]

The purely economic interests of artisans and artists also found organizational expression. Werkbund members were encouraged to join the *Wirtschaftsbund deutscher Kunsthandwerker* and the *Wirtschaftlicher Verband bildender Künstler*; and Werkbund architects played a leading role in reorganizing the *Bund deutscher Architekten* (BDA), the chief professional association of the independent architects.[17]

In Berlin, meanwhile, Werkbund members participated in the creation of a number of revolutionary artist associations, notably the *Arbeitsrat für Kunst* and the *Novembergruppe*.[18] Bruno Taut became the *Arbeitsrat's* first president, and when he resigned in February 1919, Walter Gropius took his place. In addition to Gropius, the four-man *Arbeitsrat* executive committee included two other Werkbund members: the painter César Klein (who was also a founding member of the *Novembergruppe*) and the

[15] "Rat der bildenden Künstler in München," *DWB-M* 1918/4, pp. 19-21.

[16] Martin Elsässer, "Die Baukunstkammer für Württemberg," *DWB-M* 1919/2, pp 51-53.

[17] See *DWB-M* 1919/1, p. 24; *DWB-M* 1919/3, pp. 91-92; Bernhard Gaber, *Die Entwicklung des Berufstandes der freischaffenden Architekten* (Essen, 1966), pp. 83-88 [hereafter *Entwicklung*].

[18] On the *Arbeitsrat*, Franciscono, *Walter Gropius*, Chs. 3 and 4, and Appendix D. On the *Novembergruppe*, Will Grohmann, "Zehn Jahre Novembergruppe," *Kunst der Zeit*, III, Nos. 1-3 (1928), 1-9; and Helga Kliemann, *Die Novembergruppe* (Berlin, 1969).

architect Otto Bartning.[19] For a short time, at least, these
men, although they maintained their Werkbund connec-
tion, preferred to experiment with an organization of a
new type, restricted to artists, affirming a radical artistic
creed, and seeking by primarily nonpolitical means to
further the cause of cultural, if not social, revolution.

A considerable number of Werkbund members thus took
advantage of the revolution to pursue schemes for artistic
and social change outside the framework of the Werkbund
and without waiting for the older association to provide
direction or leadership. As rival organizations absorbed
much of the creative energy and idealism of its most able
members, the Werkbund's effectiveness was increasingly
challenged. However, it is important to realize that the
activists probably represented only a conspicuous minority.
There were many more Werkbund members who, with
Fritz Ehmcke of Munich, hoped for an early dissipation
of the chaotic postwar atmosphere that tempted artists to
dabble in politics and politicians in art.[20]

It must also be stressed that not all Werkbund artists
who were politically active in 1918 were left-wing radicals.
The opposite pole was represented on the association's
executive by Peter Behrens; and the *Bund deutscher
Gelehrter und Künstler*, one of the sources of the "con-
servative revolution," continued to be a corporate member
of the Werkbund throughout this period.[21] The association

19 The fourth member of the inner group was Adolf Behne, at
that time highly critical of the Werkbund. Cf. Conrads and Sperlich,
Fantastic Architecture, p. 137.

20 See Fritz Ehmcke, "Das politische Plakat" (May 1919), in
Ehmcke, *Persönliches und Sachliches*, pp. 54-55. A noted typogra-
pher, Ehmcke had designed publications and emblems for the Werk-
bund before the war. He continued as an active member during the
Weimar years, but became critical of the association's progressive
leadership in the late 1920's.

21 Jeno Kurucz, *Struktur und Funktion der Intelligenz während
der Weimarer Republik* (Cologne, 1967), p. 79, names the *Bund*
and the more exclusive *Deutsche Gesellschaft* as precursors of the
Juni Klub that embodied the conservative revolutionary spirit. More
generally on the "conservative revolution," cf. Stern, *Cultural*

thus faced the problem of how to appease the progressives without permanently alienating what was probably the silent majority. It solved this in the initial postwar period by opening the *Mitteilungen* to the views of both radicals and conservatives, by avoiding all references to party politics, and by temporizing on aesthetic questions.[22] This won for the Werkbund a breathing space in which to establish contact with the new authorities and to use its still considerable influence to further its aims.

As the Werkbund embarked on the task of finding solutions for the problems of the new era, it recognized that government support would be more necessary than ever to supplement the efforts of private individuals. The first priority therefore was to discover ways to work with Germany's new rulers. In Prussia, the socialists who dominated the government proved gratifyingly willing to cooperate. Political uncertainty following the disintegration of the Second Reich forced the Werkbund to cancel the arts and crafts exhibition planned for Stockholm in late 1918, but within months the association was once again involved in exhibition work, this time in conjunction with the Prussian Ministry of Culture. The result was a show of simple home furnishings that opened on April 17, 1919, in Berlin's Arts and Crafts Museum under the artistic direction of the head of the Museum school, Bruno Paul. Its purpose was to display selected objects of good design in current production and suited for use in the homes of

Despair, pp. 5-22 and *passim*; and Klemens von Klemperer, *Germany's New Conservatism* (Princeton, 1957).

[22] Thus, to please the avant-garde, the Werkbund published the first manifesto of the *Arbeitsrat für Kunst* and Bruno Taut's radical "Architektur-Programm," in *DWB-M* 1918/4, pp. 14-19. At Gropius's request, it also distributed the first Bauhaus manifesto free to members in April 1919, with *DWB-M* 1919/1. To balance this, it published a review by Walter Riezler, highly critical of the *Arbeitsrat's* first exhibition, "Ausstellung unbekannter Künstler." Cf. Riezler, "Revolution und Baukunst," *DWB-M* 1919/1, pp. 18-20. The editors of the newsletter expressly dissociated themselves from both extremes. Cf. editors' note, *DWB-M* 1919/1, p. 18.

ordinary workers.[23] The Werkbund's participation demonstrated its desire to work within the framework of the new democracy, while the opening speech by the Prussian Minister of Culture, the Social Democrat Konrad Haenisch, illustrated the positive attitude of the postrevolutionary government to the Werkbund cause. Referring to the excellent work done by the Werkbund before and during the war, Haenisch welcomed the exhibition as a symbol of the unity of culture and labor, of head and hand, that he regarded as the enduring element in the Werkbund program.[24]

Notwithstanding such evidence of good will, the Werkbund realized that most of the politicians and civil servants whom the revolution had brought to power would first have to be taught the significance of quality and good design. To this end, it published Ehmcke's *Amtliche Graphik*, a critique of government graphics, conceived under the Imperial regime but more relevant than ever after 1918. In general, the Werkbund intervened to ensure that outstanding artists were entrusted with the design of the Republic's symbols, and it gave full support to the *Baukunsträte*, self-governing bodies of artists and others in the construction industry established to make certain that independent architects of proven ability received public building contracts.[25] It also reopened the vexed question

[23] Theodor Heuss, "Die Berliner Ausstellung 'Einfacher Hausrat,'" *DWB-M* 1919/2, pp. 68-69. Also DWB, *Deutscher Hausrat: Eine Sammlung von zweckmässigen Entwürfen für die Einrichtung von Kleinwohnungen* (Dresden, 1919). This showed working drawings of tested standard designs, for both hand and machine reproduction. To lower costs, the volume advocated the use of inexpensive native woods, painted in bright colors for decorative effect.

[24] *DWB-M* 1919/1, pp. 26-27. Haenisch's plan for a new "Ministry for the Fine and Applied Arts" had to be scrapped because of the economic situation.

[25] For example, twelve of the twenty jurors chosen to select the new stamp designs were Werkbund members; and in September 1919, the Werkbund went on record in favor of establishing regional building councils with districts drawn to correspond with those of the *BDA*. Cf. *DWB-M* 1919/1, p. 26; 1919/4, pp. 133 and 139.

of artistic and architectural competitions to which it had already addressed itself before the war. Fearing that artistic excellence would be sacrificed if aesthetic decisions were subject to majority vote or the decision of unenlightened and anonymous civil servants, the Werkbund solicited suggestions for revising the procedures by which public authorities selected building plans.[26]

The Werkbund's greatest success was the establishment of a new Reich office with responsibility for the entire realm of federal art policy. Recognizing the need to create an institutional link between the artists and the national government, it suggested the appointment of a single official, the *Reichskunstwart*, to fulfill this function. A Werkbund-inspired motion urging creation of this post was unanimously adopted by the National Assembly on October 30, 1919, during the third reading of the Ministry of the Interior's budget.[27] Thanks largely to the machinations of Ernst Jäckh, a Werkbund man—Edwin Redslob—was chosen as the nation's first *Reichskunstwart*.[28] Redslob, for years the Werkbund's regional representative for Thuringia, had recently left his post as director of the Erfurt museum for a similar position in Stuttgart. A close friend of van de Velde's, he was brought into contact with contemporary artists of all persuasions through his museum work, and apparently enjoyed the confidence of young and old alike.[29] How close was the identification between the Werkbund and the *Reichskunstwart* can be seen from the

26 The most interesting scheme was one put forward by the *Arbeitsrat für Kunst*, DWB-M 1919-20/5, pp. 164-65.

27 DWB-M 1919/4, pp. 137-38. This was preceded by conversations between Hans Poelzig for the Werkbund, and government officials, including the Deputy Chancellor and the Minister of the Interior.

28 DWB-M 1919-20/6, pp. 188-89; Theodor Heuss, introduction to *Edwin Redslob zum 70. Geburtstag: Eine Festgabe*, ed. Georg Rohde (Berlin, 1955), p. 10.

29 The fact that Redslob was a close friend of van de Velde's, whom he had supported against Muthesius at Cologne, endeared him to the radicals. Cf. Franciscono, *Walter Gropius*, Appendix C, p. 265. Edwin Redslob, *Von Weimar nach Europa* (Berlin, 1972) and *Redslob Festgabe*, pp. 381f. give details of Redslob's career.

fact that Otto Baur, then the association's business manager, deputized for Redslob in the capital until the latter could arrange his transfer from Stuttgart to Berlin.[30] At last, it seemed that Werkbund principles would be implemented at the highest level, by an individual prepared to encourage artistic excellence, and in a setting that would permit him to do so without petty political or bureaucratic interference.[31]

Although the Werkbund was delighted at this development, no one believed that the appointment of a *Reichskunstwart* would revolutionize official cultural policy overnight. For one thing, it had been hoped that the Republic would create a full-fledged Ministry of Culture to coordinate cultural activities at home and abroad.[32] Instead, the cabinet decided to subordinate the *Reichskunstwart* to the Minister of the Interior, leaving the Foreign Office responsible for the implementation of cultural policy abroad, and the Ministry of Finance in control of building administration.[33] Despite these limitations, Redslob's authority was wide-ranging. He was empowered to coordinate, at Reich level, all legislative and administrative measures that involved art, and was expected to mediate between the authorities, the independent artists, and private cultural associations like the Werkbund. Thus his jurisdiction extended well beyond the task of designing

[30] *DWB-M* 1919-20/5, p. 168. Redslob took up his post on July 1, 1920.

[31] Paul Westheim, "Reichskunstwart," *Frankfurter Zeitung*, Jan. 14, 1920. Westheim expressed the hope that Redslob would act as a benevolent artistic dictator, avoiding any diminution of his authority by committees or councils of "experts."

[32] See C. H. Becker, *Kulturpolitische Aufgaben des Reiches* (Leipzig, 1919), pp. 37-42. At a minimum, Becker (who played an important part in formulating Reich and Prussian cultural policies until 1930) had hoped for a Reich Cultural Bureau within the Ministry of the Interior.

[33] However, it appears that Redslob had been promised a say in all architectural questions. Cf. Westheim, "Reichskunstwart," reporting for the *Frankfurter Zeitung*, Jan. 14, 1920, on Redslob's first press conference.

federal publications or the control of government museums and exhibitions.[34]

Redslob's was a position with unlimited scope for initiative, and it is possible that a tougher man with greater political skill might have done more to exploit its potential.[35] However, the most serious brake on the *Reichskunstwart's* effectiveness did not stem from the definition of the office or the personal limitations of its only incumbent, but from the fact that, under the constitution, the Reich government played a minimal role in cultural affairs. The institutions concerned with the dissemination of culture were largely controlled by the states or municipalities, and it was at the regional and local levels that most important design decisions were taken.[36] Because no Reich official sitting in Berlin could ensure the success of the Werkbund program even in Prussia, much less in Stuttgart or Dresden or Munich, the Werkbund after 1918 encouraged the formation or rejuvenation of branches in major cities throughout the country, to exert pressure on city and state authorities, initiate exhibitions and other activities, and support individual members in their efforts to further the association's goals.[37]

The primary sphere in which the Werkbund sought to

[34] Lane, *Architecture and Politics*, p. 43, gives this narrow definition of the *Reichskunstwart's* functions. Cf. Manfred Abelein, *Die Kulturpolitik des Deutschen Reiches und der Bundesrepublik Deutschland* (Cologne, 1968), p. 60.

[35] Heuss, *Erinnerungen*, p. 379. Heuss assessed Redslob as knowledgeable but rather weak, definitely not a fighter.

[36] Hellmut Lehmann-Haupt, *Art under a Dictatorship* (New York, 1954), p. 29, stressed the essentially urban character of the culture of Weimar, noting that it was the city governments which made possible the development of a democratic art during the 1920's. Education remained a state responsibility, although the Reich government did seek to impose a minimum uniformity. Cf. Andreas Flittner, "Wissenschaft und Volksbildung," in Flittner, ed., *Deutsches Geistesleben und Nationalsozialismus* (Tübingen, 1965), pp. 226f.

[37] See Hermann Koenig/Hamburg, "Werkbund-Kleinarbeit," *DWB-M* 1919/3, pp. 87-90; and "Arbeitsgemeinschaft Hannover des Deutschen Werkbundes," *DWB-M* 1919-20/5, p. 166.

influence government policy after November 1918 was education. With the dawn of the democratic age, the general public, through its elected representatives, was cast in the role of patron of the arts, formerly reserved to the princely courts and the ruling classes. Furthermore, because of the postwar decline of the export trade, the domestic consumer now replaced the foreign buyer as the chief potential purchaser of quality goods. The common man, as taxpayer, voter, and consumer, was thus the critical factor determining the level of German national culture.[38] In order to establish sound foundations for the democratic culture of the future, the Werkbund urged the state governments to expand curriculum time allotted to arts and crafts training and the study of color and materials.[39] It also stressed the importance of adult education, in order to create an enlightened public prepared to support the arts on a more generous scale.

Yet while the nation's cultural elite urged the appropriation of large sums for artistic purposes, the German people showed little desire to inaugurate ambitious cultural and educational experiments. In the wake of revolution, while intellectuals like Richard Benz and Eugen Diederichs dreamt of a fusion between artist and *Volk*, the gap between the cultured few and the mass of the people, hard-pressed by economic and political circumstance, may actually have widened.[40] Meanwhile, inflation undermined the stability of existing institutions of popular education and culture, making it extremely difficult to maintain even

[38] Paul F. Schmidt, "Ein demokratisches Kulturprogramm," *DWB-M* 1919/1, pp. 1-4.

[39] Hellwag, "Zeitwende II," *DWB-M* 1918/4, p. 14.

[40] Richard Edmund Benz, *Ein Kulturprogramm* (Jena, 1920), published by Eugen Diederichs who appended a postscript deploring the public's exclusive concern with mundane political and economic matters, and its failure to implement Benz's ideas. The exaggerated hopes of the radical artists and intellectuals are also revealed in the manifesto of the *Arbeitsrat für Kunst*, *DWB-M* 1918/4, pp. 14-19; and Schmidt, "Ein demokratisches Kulturprogramm," *DWB-M* 1919/1, pp. 2-3.

the prewar level of service in schools, museums, and galleries.[41]

The Werkbund, too, had to curtail its programs. Increasing costs of printing and distribution raised the price of its publications, and despite rising dues soon made it impossible to supply members with the customary number of publications.[42] Plans to convert the cinema, that popular medium par excellence, into an instrument of Werkbund propaganda also had to be postponed.[43] Only after a degree of political and economic stability was restored in the mid-1920's could the Werkbund resume its campaign of public enlightenment.

Meanwhile, it turned its attention instead to the more limited sphere of art education. Already during the war, the *Münchner Bund* had published important contributions on this theme by Theodor Fischer and Richard Riemerschmid. After 1918, the *Mitteilungen* devoted a great deal of space to reports on art education reform.[44] A committee, chaired by Otto Bartning, made suggestions for improving

[41] Konrad Haenisch, *Die Not der geistigen Arbeiter* (Leipzig, 1920) and "Die Kunst im Volksstaate" in Haenisch, *Neue Bahnen der Kulturpolitik* (Berlin, 1921), pp. 150f. Defending his performance as Prussian Minister of Culture, Haenisch maintained that inflation and public indifference had combined to thwart all his efforts to carry out a positive art policy.

[42] Although the Werkbund's difficulties were primarily economic, political developments affected it on occasion. Thus the *Mitteilungen* of April 1919, designed by Fritz Ehmcke of Munich, appeared late because of the revolution in Bavaria!

[43] Dr. Ing. Wiener, "Propaganda," *DWB-M* 1919/1, pp. 10-14, discussed the importance of employing slides and motion pictures to reach those closed to the influence of the printed word. Fritz Hellwag raised the question of producing educational films at a meeting of the Werkbund executive in June 1919, but it was decided that it was more important to influence commercial films, whereupon a committee was set up to discuss ways and means with *Ufa*, the main commercial distributor in Germany. DWB, "Bericht über die Vorstandssitzung des DWB am 30. Juni 1919 . . . ," pp. 2-3 [hereafter "Vorstand, June 30, 1919"].

[44] See e.g., Otto Bartning, "Vorschläge zu einem Lehrplan für Handwerker, Architekten und bildende Künstler," *DWB-M* 1919/2, pp. 42-46. This report was originally prepared for a committee of the *Arbeitsrat für Kunst* of which Gropius was also a member. See Franciscono, *Walter Gropius*, p. 128 n.

the education of architects, and the training of craftsmen and tradesmen also was carefully reexamined.[45] The Werkbund tried to influence government policy directly, for example by sending Bartning as its representative to an education conference held by the Prussian Ministry of Culture in July 1919.[46] It also agitated against federal legislation that would have extended compulsory formal education for crafts apprentices, protested the closing of the Arts and Crafts School in Düsseldorf, and supported Gropius's experimental Bauhaus in a brief to the government of Saxe-Weimar.[47] Thus the Werkbund applied political pressure where it could to support educational reforms.

The Werkbund probably made its greatest contribution to art education by providing the reform movement with its leaders. Two Werkbund members of long standing, Bruno Paul, and Walter Gropius, headed schools in Berlin and Weimar respectively that have been termed "the most important experiments in art education . . . ventured upon in our country."[48] Gropius himself acknowledged that the Bauhaus owed much to prewar Werkbund ideas, and he remained in close touch with other Werkbund educational reformers after 1918.[49] The basic Bauhaus idea that artists

[45] Otto Bartning, "Praktischer Vorschlag zur Lehre des Architekten," *DWB-M* 1919-20/5, pp. 148-56. On crafts training, A. Hamburger, "Von der Erziehung zum Handwerker," *DWB-M* 1919/2, pp. 47-50; Karl Gross, "Handwerkliche und künstlerische Schulerziehung," *DWB-M* 1919/3, p. 86; and Julius Schramm, "Die Lehrlingsausbildung im Handwerk," *DWB-M* 1919-20/5, pp. 157-60.

[46] *DWB-M* 1919/2, p. 42.

[47] *DWB-M* 1919-20/5, p. 160; 1919/1, pp. 9-10; 1919-20/5, p. 169.

[48] Pevsner, *Academies of Art*, pp. 276-87. Bruno Paul, in 1923, succeeded in amalgamating the Berlin Arts and Crafts school that he had headed since 1907 with the Academy of Arts, to create the United State Schools for Fine and Applied Arts. Paul's basic approach at the time was similar to Gropius's, but Pevsner notes that the older man avoided the radical rhetoric of the Bauhaus reformers and was probably more representative of the Werkbund mainstream.

[49] Defending the Bauhaus before the Thuringian legislature in July 1920, Gropius claimed the Werkbund's Riemerschmid, Fischer, and Bartning as direct precursors of his school. Cf. Wingler, *The Bauhaus*, p. 424. Franciscono, *Walter Gropius*, p. 130, suggests that this was simply a ploy to make the Bauhaus look respectable, but Gropius was probably sincere in his acknowledgment of Werkbund

and craftsmen should be trained together in a school directed by an architect was generally accepted in Werkbund circles, and the association for a time fell under the influence of the same crafts romanticism that dominated the first, "Expressionist," Bauhaus phase.[50]

The establishment of the post of *Reichskunstwart* and the creation of the Weimar Bauhaus were probably the most important achievements of the Werkbund immediately after the war. Generally speaking, its efforts to influence the new Germany through direct action were thwarted by lack of resources. Reduced to carrying on its work largely through the power of individual example, the association encouraged its members to use what personal influence they could command to impose their own high standards of work on their fellows. In response, men like Gropius in Weimar, Fritz Schumacher in Hamburg, Paul Bonatz in Stuttgart, and Richard Riemerschmid in Munich pursued their various goals in the name of the Werkbund, thereby contributing much to the creation of the new "Weimar" culture.[51]

influence. Moreover, he continued to maintain a close professional and personal relationship with the Werkbund's chief postwar educational expert, Otto Bartning.

[50] According to Franciscono, *Walter Gropius*, pp. 150-52, Gropius, under *Arbeitsrat* influence, abandoned or at least modified his prewar Werkbund ideas on design for industry, instead adopting an Expressionist-Crafts ideal with *völkisch* overtones. But it must be noted that the Werkbund at this time was moving in the same direction. Cf. Lothar Lang, *Das Bauhaus 1919-1933* (2nd ed., Berlin, 1965), p. 34. Lang goes so far as to attribute Gropius's insistence on the unity of art and craft to Werkbund influence! Franciscono also underestimates the extent to which the membership of the *Arbeitsrat* and Bauhaus overlapped with that of the Werkbund, and prefers to contrast Werkbund and *Arbeitsrat* influences on the Bauhaus.

[51] At this time, Gropius advocated exemplary action as the most potent tool of artistic reform. Cf. "Vorstand, June 30, 1919," p. 8. Similarly, Bruno Taut, in "Bericht über die Vorstandssitzung des Deutschen Werkbundes am 30. Juli 1919 . . . ," p. 15 [hereafter "Vorstand, July 30, 1919"]. Schumacher, too, was sustained by the belief that the applied artist could contribute to social and cultural reform. By creating a better environment for the people, the designer

As the Werkbund sought to cope with the aftereffects of defeat and revolution, it found itself under attack on a number of fronts. "Without the Werkbund!" was the cry of its most extreme critics, who wished to abolish it completely, and form artists' associations of an entirely new kind.[52] A spokesman of this group was Adolf Behne, one of the founders and leading spirits of the *Arbeitsrat für Kunst*. Sympathetic to the prewar critics of the Werkbund who had denounced its elitism and pedantry and deplored its close association with the bourgeois establishment, Behne rejected the very notion of an alliance between art and industry. Like Loos and other theorists of the period before 1914, he argued that the form of articles of use must be allowed to develop naturally from their function, while the sole purpose of art should be to create joy and beauty, shedding its light from above on lesser forms of creative endeavor.[53]

Behne's theoretical opposition to the Werkbund program fed on the widespread anticapitalism that the war and postwar crisis had converted into a significant feature of the intellectual climate. Many artists regarded the war as a product of economic rivalries and held the Werkbund partly responsible for the conflict because it had encouraged German competitive exports.[54] Those who believed in the coming proletarian revolution condemned the Werkbund as an instrument of industrial and commercial interests, a servant of the class enemy.[55] Finally, a non-Marxist

would encourage them unconsciously to change their lifestyle and to become not only visually more aware, but also morally "better." Cf. Schumacher, *Kulturpolitik*, p. 51.

[52] Max Taut, in Schmidt, ed., *Manifeste*, p. 228.

[53] Behne, "Kritik des Werkbundes," pp. 430-31. The relationship between Behne and Loos is discussed by Franciscono, *Walter Gropius*, pp. 89-90.

[54] Thus Georg Kutzke, *Veraussetzungen zur künstlerischen Weltmission der Deutschen* (Eisleben, 1919), pp. 13f. See also Hellwag's review of Kutzke, *DWB-M* 1918-19/5-6, pp. 5-13; and Kutzke's rejoinder, "Anmerkungen zur Stilentwicklung," *DWB-M* 1919/2, pp. 63-67.

[55] Peter Bruckmann, in 1919, conceded that many Werkbund

variant gained strength, which blamed the capitalist
system for the rapid rationalization and mechanization so
destructive of inherited cultural values. As the impact of
war made the damaging effects of these processes increas-
ingly evident, the Werkbund found itself under pressure to
modify its stance. How serious was the challenge to the
prewar formula of collaboration with progressive industry
can be seen from the fact that Walter Gropius, who in
1914 had described industrial building forms as *the* style-
creating force of the contemporary world, after the war
expatiated with equal vigor on the immorality of an in-
dustrial system based on modern technology.[56]

The radical anticapitalism of the immediate postwar
years involved an ethical revulsion against the spirit of
modern economic life. Typical was Bruno Taut's indignant
assertion at a meeting of the Werkbund executive com-
mittee that "to earn money is always a dirty business.
Things originate in themselves, and what happens to them
afterwards should be left to others."[57] Against this, the
Werkbund could only reply that money had to be made by
someone if the arts were to prosper, and that one therefore
had a duty to ensure that it was made decently.[58] But
neither rational argument nor the old appeal to patriotism
served any longer to justify the alliance of art and industry
in the minds of the Werkbund's radical critics, whose
opposition was reinforced by an upsurge of antimilitarism
and doctrinaire internationalism generated by the war
experience. The Werkbund stood condemned because it
had cooperated with the war effort and had maintained
close contacts to the last with the Imperial authorities.
Propaganda activities abroad and involvement with Jäckh's

artists had been converted to extreme political as well as aesthetic
views. Cf. "Vorstand, June 30, 1919," p. 5. The programs of the
revolutionary artists were reviewed by Hellwag in *DWB-M* 1919/2,
pp. 31-41.

[56] E.g., his "Baugeist und Krämertum," cited in Franciscono,
Walter Gropius, p. 22.

[57] "Vorstand, July 30, 1919," p. 16.

[58] Theodor Heuss, "Vorstand, July 30, 1919," p. 16.

Turkish schemes laid the Werkbund open to the charge of constituting the intellectual-artistic equivalent of Pan-Germanism.[59] In reaction against the idea of a German cultural mission that had been upheld by Muthesius and others, many artists and intellectuals now proclaimed the internationalism of art and opposed any attempt to subordinate it to purely national purposes. For them, further collaboration with the Werkbund would only be possible if it purged itself of those who had directed it in wartime and still regarded it as an instrument of national policy.

While the extreme individualism of the radical artists continued to plague the Werkbund, their aversion to discipline and distrust of organization proved equally damaging to its revolutionary rivals. Despite their rhetorical praise of the superiority of cooperation over competition, the artists of the *Arbeitsrat* and the *Novembergruppe* found it difficult to accept any group control. Rent by internal strife, the *Arbeitsrat* lasted only to 1921, while the *Novembergruppe* after 1922 bore little resemblance to the association of revolutionary idealists created just a few years before.[60] Both groups soon discovered that they would have to compromise with the existing order to be socially effective. As early as March 1919, the *Arbeitsrat* appealed for funds to the industrialist Robert Bosch, and in July of that year Bruno Taut suggested a joint *Arbeitsrat*-Werkbund project to reconstruct northern France in cooperation with the German authorities.[61] Such intiatives made it difficult

59 Kutzke, *Voraussetzungen*, p. 16; Taut, "Vorstand, July 30, 1919," pp. 3-4. But as Jäckh pointed out (p. 5), Taut, who cited the Turkish involvement as evidence of the Werkbund's wartime imperialism, had been pleased enough at the time to participate in the House of Friendship competition!

60 On the *Arbeitsrat*'s decision to disband, *Bauhaus*, GN 10/124, letter from Gropius to Bartning, June 2, 1921; and Conrad and Sperlich, *Fantastic Architecture*, pp. 23-24. On the *Novembergruppe*, Greenberg, "Artists and the Weimar Republic," p. 192.

61 See the letter from Bosch to the *Arbeitsrat*, March 20, 1919, in *Bauhaus*, GN 10/224, turning down this request. Cf. "Vorstand July 30, 1919," p. 13; and minutes of a meeting of the *Arbeitsrat* Nov. 18, 1919 in *Bauhaus*, GN 10/44. At this meeting, Behne outlined reconstruction plans and Taut stated he would welcome Werk-

for the radicals to maintain principled rejection of the Werkbund, and laid the *Arbeitsrat* open to the charge that it, too, had gone over to the bourgeois enemy.[62]

Another feature of the period that created problems for the Werkbund was the extent to which intellectuals subscribed to belief in the spontaneous creativity of the *Volk*. That art would spring naturally from the bosom of the people became an article of faith that led many to condemn as "stylistic imperialism" the Werkbund's prewar efforts to influence popular taste.[63] But if the *Volk* itself determined the art of the future, it was not clear what role the artist could play. Some spoke of a mystical symbiosis between artist and *Volk*, which they claimed had characterized the great age of the Gothic. But only a handful, among them Adolf Behne and Bruno Taut, recognized that an artist who believed in an organic popular art must be prepared to suppress his individuality and become an anonymous contributor to the *Volk* creation. The majority continued to insist on recognition of their personal contributions as designers or architects.[64] The most they would concede was that the applied artist, rather than impose his own standards, should take the taste of the users into account; but this proposition, though an advance over prewar practice, was hardly radical and indeed proved entirely acceptable to the old guard within the Werkbund.[65]

bund funds for their realization. Ironically, it was Jäckh and Heuss who urged caution, warning that the French might resent such intervention as an attempt to establish something like a permanent Werkbund exhibition on French soil!

[62] E.g., the radical artist Otto Freundlich, who condemned the *Arbeitsrat*, *Novembergruppe* and Werkbund in the same breath. Greenberg, "Artists and the Weimar Republic," p. 63.

[63] Gropius, in "Vorstand, June 30, 1919," p. 6, used the word "Geschmacksimperialismus."

[64] Franciscono, *Walter Gropius*, p. 93, n. 14.

[65] Peter Behrens, for example, described the role of the architect in the new veterans settlements as that of a coordinator, implementing the wishes of builders and users. He expressly rejected any intention of imposing taste from above, and concurred with Gropius that the architect was responsible only for the general plan, all

The quasi-religious belief in the unity of art and *Volk* was symptomatic of a new irrationalism that popularized faith, spontaneity, diversity, and creativity, while turning reason, organization, standardization and mechanization into terms of abuse. The radical artists, identifying the Werkbund with the latter set of values, were bound to condemn it as a reactionary force. But this attitude was not by any means confined to the Left. Paradoxically, one of the most outspoken critics of the Werkbund was Karl Scheffler, editor of the influential *Kunst und Künstler*, an opponent of both Expressionist art and revolutionary socialism, whom the radicals regarded as hopelessly out-of-date.[66]

Whereas the left-wing artists were primarily concerned with the social and artistic regeneration of the nation, Scheffler wanted above all to overcome the national humiliation inflicted on Germany by the Treaty of Versailles. Convinced that the victors intended indefinitely to exploit a defeated Germany, he advocated withdrawal into national self-sufficiency and urged the Werkbund to sponsor an ethical revolution that would persuade every citizen to cut down the nation's dependence on imported raw materials by restricting consumption to the barest essentials. Such patriotic self-restraint, Scheffler argued, would indirectly serve all classes and parties. The resulting failure of the mass production industries would end the laborer's alienation from his work; while the middle classes would benefit from the return to a purer, more dignified lifestyle,

details to be worked out cooperatively between the craftsmen and the inhabitants. Cf. "Vorstand, June 20, 1919," pp. 4 and 6.

[66] For the radicals' judgment on Scheffler, see Gropius in "Vorstand, June 30, 1919," p. 12, and Bruno Taut in "Vorstand, July 30, 1919," p. 8. Taut claimed that Scheffler, like Paul Westheim (editor of *Der Cicerone*), took notice only of artists who had already made their reputation. Taut's dislike may have stemmed in part from Scheffler's condemnation of his glass house at the Cologne Werkbund exhibition. Cf. Scheffler to Adolf Behne, letter of July 25, 1914, cited in Conrad and Sperlich, *Fantastic Architecture*, p. 151.

with the officer's lady once more setting the fashion, rather than the prostitute! Rejecting both the bourgeois philistinism and the joyless puritanism of the Imperial era, Scheffler called for an "aristocratization" of society, a conservative revolution to recover essential values.[67]

Although his objective differed from theirs, Scheffler agreed with the Werkbund's left-wing critics that the association, corrupted by success and tainted by the prevailing materialism of the prewar world, had been transformed into an instrument of the establishment. Like them, he also deplored the growing imbalance between the association's constituent groups, but whereas the progressive artists felt victimized by the business interests, Scheffler argued that it was the skilled craftsmen who had been most discriminated against. In his judgment, overrepresentation of the artists and literati had led the Werkbund to concentrate on questions of style to the detriment of quality and craftsmanship.[68] He was therefore almost as eager to get the artists out of the Werkbund as Behne and the brothers Taut were to have them withdraw. Scheffler, too, deplored the excessive role of commercial, particularly export, interests within the Werkbund, its support of expansionist imperialism, and its addiction to power politics.[69] Above all, he struck a popular note when he called for a return to the handicrafts—or rather, to the ethos of manual labor. Only *Handwerk*, in his view, could

[67] Karl Scheffler, "Ein Arbeitsprogramm für den Deutschen Werkbund," *Kunst und Künstler*, XVII (1920), 43-52; *Sittliche Diktatur: ein Aufruf an alle Deutschen* (Stuttgart and Berlin, 1920); and *Die Zukunft der deutschen Form* (Berlin, 1919). The argument of all three publications was essentially the same.

[68] Scheffler, "Arbeitsprogramm," pp. 48-49. Similarly, Gropius warned that quality and art had nothing in common and urged the Werkbund to pursue only the former. Cf. "Vorstand, June 30, 1919," p. 8; and letter from Gropius to Poelzig, Jan. 16, 1919, WB, Poelzig papers, calling for an end to chatter about art ("Kunstgeschwätz").

[69] Scheffler even attacked the Werkbund's wartime exhibitions because they involved it in excessive contact with governmental authorities, although he conceded that these ventures into the political sphere had been inspired by patriotism. Scheffler, "Arbeitsprogramm," pp. 48-49.

save Germany from excessive urbanization, industrial slavery, and the unhealthy influence of the machine on thought and feeling.[70]

Unlike the radicals who at first were inclined to turn their backs on the Werkbund, Scheffler hoped that it might be converted into an instrument of national renewal capable of winning support from radicals and conservatives alike. To this end, he recommended that it cease to be half artists' club, half industrial pressure group, and instead become once more what it had been at the start, a "guild" of idealists dedicated to the production of quality work. His detailed blueprint for structural reorganization called for splitting the Werkbund into two quasi-independent associations, a small one representing artists, craftsmen, and industrialists, and a much larger body composed entirely of laymen. The latter would propagate the ideal of simplicity and quality by incorporating societies with similar aims, establishing cells across the country, and undertaking an extensive publishing program centered on a Werkbund newspaper.[71]

Scheffler's project deserves a place in the history of the Werkbund not only because his manifesto reflected significant facets of the contemporary mood, but because his wish to present it to the annual meeting in 1919 precipitated an internal debate that nearly destroyed the association. The question of whether or not Scheffler should be allowed to present his views at Stuttgart brought into the

[70] *Ibid.*; and Scheffler, *Die Zukunft der deutschen Form*, p. 36. Franciscono, *Walter Gropius*, p. 123, notes the anti-industrial bias of the avant-garde artists and points out that Behne, for example, agreed with the neoconservative architect Heinrich Tessenow in rejecting both the metropolis and the machine. Indeed, the social utopias of the radical Right and the radical Left were difficult to distinguish. See Greenberg, "Artists and the Weimar Republic," p. 114 n.; Lindahl, "Zukunftskathedrale," p. 233. Tessenow developed the antimetropolitan argument in his *Handwerk und Kleinstadt* (Berlin, 1919).

[71] Scheffler, "Arbeitsprogramm," pp. 49-50. Scheffler believed that a Werkbund newspaper might become the national organ Germany so badly needed!

open the conflict between the Werkbund leadership and its radical opponents, and stimulated the progressive artists to call in turn for revision of the association's organization and program.[72]

The leader of the anti-Scheffler forces on the Werkbund executive was Walter Gropius. Only a few months earlier Gropius had despaired of the Werkbund, arguing that it could never be awakened from its deathlike sleep.[73] By June 1919, however, he appears to have realized that the Werkbund possessed greater authority and financial resources than the *Arbeitsrat* could hope to command. As a result, he was prepared to return to the older organization if he could do so on his own terms. In his view, to salvage the Werkbund would involve transforming it from a menace to culture (*Kulturgefahr*) into a union of all creative elements in German contemporary art, and transferring leadership from the "politicians" and architectural "operators" into the hands of true artists with whom the young could identify.[74] Seconded by Bruno Taut, Gropius resumed his offensive against the Werkbund leaders, with the Scheffler proposal serving to focus the opposition much as Muthesius' theses had done at Cologne.

This proved to be good strategy. Whereas the general criticisms of the radicals largely fell on deaf ears, no one, apart from Peter Behrens, was prepared to back Scheffler wholeheartedly, and even Behrens was willing to compromise if by so doing he could win Gropius and Taut back to the Werkbund. For however much they might dislike the arguments of the radicals, Behrens, Bruckmann, Heuss, and Jäckh agreed on the necessity of accommodating these awkward, misguided, but talented rebels, as can be seen from the fact that they even gave serious consideration to the idea of amalgamating the *Arbeitsrat* with the

[72] "Vorstand, June 30, 1919," pp. 11-12; and "Vorstand, July 30, 1919," pp. 1-10.

[73] Stressig, "Hohenhagen," pp. 471-72, quoting a letter from Gropius to Osthaus dated Dec. 23, 1918 and another of Feb. 2, 1919.

[74] *Ibid.*, pp. 472-73. Gropius characterized his opponents, particularly Behrens, Paul, and Muthesius, as "Architekten-Hochstapler."

Werkbund and of creating an artists' advisory board that the radicals would dominate.[75]

If nothing came of this idea, the cause was in good measure the decision of Gropius and Taut to enforce their will by resorting to confrontation tactics. As in the weeks after Cologne 1914, so in the summer of 1919 Gropius made himself thoroughly unpopular by threatening to resign from the executive unless his wishes were met. When the Werkbund, yielding to his ultimatum, decided not to let Scheffler speak at Stuttgart, one member of the executive walked out in protest, and the radicals made no further gains.[76] Instead, to their disgust, the Werkbund proceeded to mollify Scheffler by helping him to publish a version of his manifesto. Shorn of all references to the Werkbund, Scheffler's *Sittliche Diktatur* (Moral Dictatorship) appeared in 1920, and led to the creation of an "Association for the Renewal of Economic Morality and Responsibility" headed by Count Siegfried von Roedern whom Jäckh had introduced to Scheffler as a suitable president for the new *Bund*.[77] Although the two groups remained formally independent, the Werkbund was represented on the executive of the *Bund der Erneuerung* by Jäckh and Behrens, and helped it to locate office premises in the same building as its own headquarters. The *Bund* at first attracted a number of prominent outsiders, among them the historian Friedrich Meinecke and Walther Rathenau, but it quickly ran out of funds and had to dissolve after pub-

[75] "Vorstand, July 30, 1919," pp. 7-8.
[76] The ultimatum was actually delivered by Bruno Taut, in Gropius's absence. See "Vorstand, July 30, 1919," pp. 9-10, and Appendix I, letter from Gropius to the Werkbund, July 24, 1919. The man who walked out was Dr. Soetbeer, Secretary-General of the *Deutsche Handelstag*.
[77] *DWB-M* July 1920. Werkbund members were urged to support the new association, and Scheffler's pamphlet was supplied to them at a reduced price. Von Roedern, a former Minister of Finance, had held a series of major posts in the Reich and Prussian administrations. Cf. Scheffler, *Die fetten Jahre*, pp. 312-13; and Peter Behrens, "Bund der Erneuerung," *Die neue Rundschau*, XXXI, No. 2 (1920), 1051-54.

lishing the first of a projected series of hortatory pamphlets.[78]

Even before this, Scheffler, who had assumed the vice-presidency, came to feel that the organization was disturbingly elitist: almost everyone on the board either had a title or held government office. His disillusionment was compounded when the association abandoned its original ideal of moral reform in favor of political efforts to impose its leaders' standards on the public, for example by legislating high taxes on the consumption of alcohol and tobacco. When the group collapsed, he felt little regret, and happily reverted to his former, more congenial, apolitical role.[79]

Meanwhile, the Werkbund radicals failed to consolidate their gains. Bruno Taut, after first agreeing to replace Scheffler as keynote speaker at the forthcoming annual meeting, withdrew in favor of Hans Poelzig, whom Osthaus and Gropius had persuaded to take on the Werkbund vice-presidency in 1916.[80] At that time, the radical opposition had hoped that Poelzig would exert his influence to bring about real changes, but in fact the Werkbund after Muthesius' resignation, had carried on much as before, and it is therefore hard to understand why, in 1919, the same individuals were prepared to follow Poelzig's lead. Fifty years old in 1919, Poelzig could hardly be regarded as a member of the younger generation; and his relationship with the *Arbeitsrat* was strangely ambivalent. While he sympathized with its belief that the arts must unite on

[78] Entitled *Was soll ich tun?* (Stuttgart and Berlin, 1921), this pamphlet expanded on Scheffler's theme of the need to restrict consumption so as to avoid dependence on imports, save scarce foreign currency, and restore sound ethical values. Perhaps with an eye to the Werkbund, however, it specifically exempted artistic and cultural activities from its strictures against conspicuous consumption!

[79] Scheffler, *Die fetten Jahre*, pp. 313-15.

[80] Letter from Bruno Taut to the Werkbund, July 31, 1919, "Vorstand, July 30, 1919," Appendix II. On the 1916 leadership changeover, Stressig, "Hohenhagen," p. 449. But Heuss, *Poelzig*, p. 85, claimed Poelzig had agreed to join the Werkbund executive in response to pressure from Karl Schmidt-Hellerau, not Osthaus.

the ground of architecture, Poelzig was highly critical of the *Arbeitsrat*'s public statements, and soon resigned his membership.[81] Significantly, when it was suggested in July 1919 that the Werkbund executive be reconstituted to include radicals and conservatives in equal numbers, Poelzig was listed among the latter together with Behrens, Riemerschmid, and Bruno Paul, rather than with the *Arbeitsrat* contingent.[82] One must conclude that when Poelzig agreed to give the programmatic address at the 1919 Werkbund congress, he did so not as spokesman for the radicals, but as a compromise candidate who was expected to rally support from all factions.

When the Werkbund assembled at Stuttgart in September 1919, there was no consensus on what the association's future program should be. Despite the "victory" of the radical artists within the executive committee during the summer, it seemed at first as if the old leaders and their prewar ideology would prevail. This impression was confirmed by the first session, which opened with a speech by the Werkbund's president, Peter Bruckmann, who paid tribute to the association's war dead, and to Friedrich Naumann, whose death had been announced just a few days before. Emphasizing the Werkbund's role as an organ of cultural nationalism, Bruckmann stressed that its first task must be to maintain faith in German ability and creative potential, countering the pressure of foreign art and influence especially in areas occupied by the enemy. At the same time, the association had the duty to protect all, whether young or old, who were prepared to dedicate their intellect and will to the solution of outstanding artistic problems.[83]

The theme of artists' responsibility was developed in

[81] According to Conrads and Sperlich, *Fantastic Architecture*, p. 24, Poelzig never joined the *Arbeitsrat*. But from *WB*, Poelzig papers, it appears that Poelzig accepted Behne's invitation of June 16, 1919 to become a member. *Bauhaus*, GN 10, contains an account of a confrontation between Poelzig and Taut in the *Arbeitsrat* that led to Poelzig's withdrawal; the date on this document is illegible.

[82] "Vorstand, July 30, 1919," p. 11.

[83] *DWB-M* 1919/4, pp. 105-108.

greater detail by the next speaker, Richard Riemerschmid of Munich, who gave a brief survey of the current state of German art. With determined optimism, Riemerschmid claimed that the lost war provided the Werkbund with an opportunity to free itself from the unfortunate alliance with aggressive nationalism and profit-seeking interests that had dominated its recent policy. Likewise, Germany's unaccustomed poverty—by putting a premium on simple and durable work—might rid German art of the excesses born of affluence and accentuated by the immature, flamboyant elements in the Expressionist movement. For his part, Riemerschmid looked forward to the birth of a truly new art dedicated to the inward happiness of the individual and the welfare of all mankind.[84]

In contrast to the vague idealism of Riemerschmid, Theodor Heuss rounded out the first day's proceedings with a talk on "Business, the State and the Arts." After outlining the implications of changed economic conditions for all three, Heuss reminded his listeners that only capitalism and mechanization made it possible for Germany to support its rapidly growing population and to raise the nation's standard of living. Further, he insisted that, as resources would continue to be scarce, Germany would have to rationalize production even more and utilize to the full all the nation's store of skills and wisdom. Repeating his contention that the form of the state was less relevant to the condition of the arts than the morale of the population, Heuss, like Bruckmann, gave highest priority to the restoration of Germany's pride, dignity, and sense of purpose.[85]

On the whole, the first day's speeches gave no indica-

[84] *Ibid.* Riemerschmid's talk, "Von der deutschen Kunst," later appeared in *Die Hilfe*, xxv (1919), No. 47.

[85] "Wirtschaft, Staat, Kunst," *DWB-M* 1919/4, pp. 105-108. Heuss's talk was reprinted in the *Westdeutsche Wochenschrift*, Cologne, 1919, Nos. 27 and 28. See also "Deutscher Werkbund," *Frankfurter Zeitung*, July 9, 1919, a special report from Stuttgart dated July 6 that summarized the talks by Bruckmann, Riemerschmid, and Heuss.

tion that the Werkbund's leaders planned to set the organization on a new course. It was only on the following day, when Poelzig rose to speak, that a more radical note was introduced and a stimulus provided for the reorientation of Werkbund thinking. As an artist claiming to speak for his fellows, Poelzig demanded that the Werkbund return to the purity and idealism of its early years and become, once more, the conscience of the nation. To reawaken the enthusiasm of its members and win the allegiance of youth, it would be necessary to purge the association of all the politicians, compromisers, and self-interested individuals who had come to dominate its councils. In the latter category, Poelzig placed the representatives of the art industries, whose presence within the Werkbund he deplored. Taking the relationship between "Art, Industry, and the Crafts (*Handwerk*)" as his theme, Poelzig urged that a clear line be drawn between the world of industry on the one hand, and that of art and craft on the other. Industry he equated with profit-seeking materialism, with the soulless, money-grubbing spirit that, too long, had exploited talented artists in order to produce goods of ephemeral value for a fickle market.

By contrast, Poelzig continued, the "Crafts" shared with "Art" a belief in the value of work for its own sake and therefore were capable of creating forms of enduring merit. If the Werkbund hoped to win the indispensable support of the rising generation of progressive artists, it would have to identify with the crafts, and put art rather than quality or good taste at the heart of its program. Instead of maximizing exports, it should strive to produce lasting works of art and encourage a return to the joy and pride in work characteristic of the medieval craftsman. It would be the Werkbund's task to teach the artist to think of himself once more as a craftsman, and the craftsman as a creative artist. By replacing academic pedantry with practical training and, above all, by helping to bring about a spiritual revolution in Germany, the Werkbund could lay the foundations for a new architecture that would in

turn inspire creative workers in all fields to greater achievements.[86]

Despite or, perhaps, because of its ambiguities, Poelzig's talk made a deep impression on the meeting, which promptly proclaimed it the foundation for future Werkbund policy; but the ensuing debate showed that there were many who remained unconvinced by Poelzig's rhetoric and critical of fundamental points in his argument. Only Osthaus and Günther von Pechmann, head of the applied arts division of the Bavarian National Museum, fully supported Poelzig's blanket attack on capitalism and the spirit of modern industry.[87] Without directly contradicting the speaker, most of the other commentators reminded the audience that some industrial concerns, at least, were inspired by high idealism. Karl Schmidt and Peter Bruckmann pointed to the positive contributions their own firms had made to the national culture, and argued that many other large-scale producers had likewise grown out of small workshops and retained the noncommercial spirit of their origins. Schmidt went on to cite Robert Bosch as an outstanding example of the Werkbund spirit, asserting with some justice that this manufacturer of excellently designed automotive products had done more over the last twenty years for the Werkbund and German culture than all Stuttgart's artists combined.[88] Bosch himself was incensed by Poelzig's dismissal of automobiles as ephemeral art, and of industrial design as inferior to pure art and architecture. But he neither spoke up for his views nor reduced his subsidies to the Werkbund.[89]

[86] Poelzig's speech, entitled "Werkbundaufgaben," was reproduced in full in DWB-M 1919/4, pp. 109-24. A brief excerpt is given in Eckstein, 50 Jahre Deutscher Werkbund, p. 35. The only English version seems to be a partial text (translated from the Dutch!) in Sharp, Modern Architecture and Expressionism, Appendix I.

[87] DWB-M 1919/4, pp. 126-27. The full text of Osthaus's comments appeared as "Deutscher Werkbund" in Das hohe Ufer, I, No. 10 (Oct. 1919). This short-lived periodical was edited by the art journalist Hans Kaiser, business manager of the Arbeitsgemeinschaft Hannover des deutschen Werkbundes.

[88] DWB-M 1919/4, pp. 128-29.

[89] Heuss, Bosch, p. 610. Heuss, who admired both Bosch and

At the end of the debate on his address, Poelzig acknowledged that no firm line could be drawn between art and industry, and that the Werkbund could not hope to remain effective unless it enjoyed the support of industrialists.[90] Moreover, he admitted that so long as industry continued to employ artists, the Werkbund would have to concern itself with industrial design. He thus arrived at a position not unlike Walter Riezler's, who pointed out that the artists, rather than curse the utilitarianism of the age, would do better once more to hallow the everyday with their skill and dedication.[91]

Although the antibusiness tone of Poelzig's speech had aroused the most indignation, other aspects of his thought also came under attack. For example, Dr. Erich Wienbeck, who represented the National Association of German Crafts on the Werkbund executive and might have been expected to welcome Poelzig's espousal of the artisans' cause, objected to his statements on the training of craftsmen. Wienbeck correctly pointed out that while Poelzig opposed state intervention in the education of architects, he advocated government control of craft training. For his part, Wienbeck urged the Werkbund to strengthen the traditional apprenticeship system by fighting government proposals that would extend to apprentices the right to strike and to bargain about wages. Rather than theorize about art as Poelzig had done, the Werkbund should strive to prevent the adoption of measures that would spell the end of quality work in Germany.[92]

Despite its unanimous decision to make Poelzig's speech the basis of future policy, the Werkbund remained divid-

Poelzig, regarded these two as representing opposite poles in his own life and thought. Poelzig stood for the irrational creative intuition that knew how to discipline itself in the face of the concrete task. Bosch represented the rationally established and mastered principle that yet, through imagination, could reach beyond the useful to the generally valid. Cf. Heuss, in *Die Technische Hochschule Stuttgart 1954* (Stuttgart, 1954), pp. 13-14.

[90] *DWB-M* 1919/4, p. 131. [91] *Ibid.*, pp. 130-31.
[92] *Ibid.*, pp. 126-27.

ed. As far as the avant-garde artists were concerned, the beneficial effect of Poelzig's appeal was counterbalanced by other aspects of the Stuttgart congress. In particular, there was a great deal of annoyance at the fact that the Werkbund allowed itself to be used for the propagation of Wilhelm Ostwald's color theories by sponsoring a "Day of Color" in conjunction with the annual meeting. Ostwald, a prominent theoretical chemist and Nobel prize winner, had become convinced years before that all problems of color could be reduced to basic scientific principles. Claiming to have discovered the relevant laws, Ostwald wanted them taught in the schools and applied in both art and industry. Since 1912, he had sought to spread his ideas in and through the Werkbund, and the "Day of Color" simply marked the high point of a continuing campaign to publicize his doctrine.[93] Instead of setting the final seal of approval on Ostwald's views, however, this event aroused a storm of indignation. Those present at Stuttgart rejected Ostwald's contentions that color should be quantified, and science permitted to prescribe laws for art. Paul F. Schmidt, writing in *Der Cicerone*, which spoke for the radical Expressionists, put the choice clearly: either Ostwald or Werkbund.[94] Impressed by Poelzig's speech, Schmidt had been prepared to believe that the Stuttgart meeting might inaugurate a genuine reformation in Werkbund attitudes; but Werkbund support for what he regarded as Ostwald's pretentious pseudoscience was more than he could swallow. Similarly, Theodor Heuss derided as absurd Ostwald's naive faith in his own theories, and warned that while it might do the artist good to know about such things, he should on no account allow himself to come under their influence. For, Heuss maintained, art was not simply the product of method, but the offspring

[93] See Wilhelm Ostwald, *Lebenslinien: Eine Selbstbiographie*, Vol. III (Berlin, 1927), 353-406; and DWB, *Erster deutscher Farbentag* (Berlin, [1920]).

[94] "Werkbund-Krisis," *Der Cicerone* (Leipzig), VII, No. 21, 704-705.

of human impulses that lay deeper in the soul than reason or knowledge.[95]

In the end, the Werkbund, bowing to pressure, repudiated Ostwald just as it had disowned Karl Scheffler, that other relic of the pre-Expressionist past.[96] Hans Hildebrandt, a Stuttgart mural painter, replaced Ostwald as head of the Werkbund's Free Group for Color Art; the *Mitteilungen* ceased to propagate his views; Edwin Redslob, as *Reichskunstwart*, used his influence to prevent the spread of his system; and the Werkbund acted behind the scenes to mobilize opinion against the teaching of Ostwald's ideas in the schools.[97] Yet the radical trend within the Werkbund was not clearly confirmed until the first meeting of the new executive committee in Berlin on October 18, when Hans Poelzig was officially chosen to replace Bruckmann as Werkbund president. When Richard Riemerschmid was passed over in favor of Poelzig by a vote of 13 to 3, a decision seemed finally to have been taken between the forces of the past and those of the future.[98] Paul Schmidt, still skeptical of Werkbund intentions at Stuttgart, declared himself satisfied at last; and even Adolf Behne expressed willingness to give the reconstituted association a second chance.[99] So hopeful were the

[95] Theodor Heuss, "Vom deutschen Werkbund," *Die Hilfe*, xxv (1919), 521.

[96] Ostwald had already discredited himself in the eyes of many Werkbund members by his support of Muthesius at Cologne and his advocacy of Pan-German claims during the war. Cf. Daniel Gasman, *The Scientific Origins of National Socialism* (London, 1971), p. 140. President of the Monist League and editor of its journal, Ostwald in 1911 had helped found a Munich group called "Die Brücke" (not to be confused with the artists' group of that name). Aiming to be an "organization of organizers," this association had attracted such Werkbund notables as Kerschensteiner, Karl Schmidt, Jäckh, Behrens, and Muthesius. Ostwald joined the Werkbund in 1912. See Ostwald, *Lebenslinien*, III, 299.

[97] *DWB-M* 1919/4, p. 131; Ostwald, *Lebenslinien*, III, 394 and 437-39.

[98] "Vorstand, Oct. 18, 1919"; *DWB-M* 1919/4, pp. 137-39.

[99] Postscript to Schmidt, "Werkbund-Krisis," p. 705; Adolf Behne, "Werkbund," *Sozialistische Monatshefte*, xxvi, No. 1 (1920), 68-69.

radicals at this time that Fritz Hellwag even thought Poelzig might be able to persuade George Grosz, that bitter young satirist of German society, to join the Werkbund.[100] The new executive committee, which included Bartning, Gropius, César Klein, Osthaus, Pankok, and Bruno Taut, seemed capable of holding the Werkbund to the program Poelzig had outlined at Stuttgart, the more so as Peter Behrens and Bruno Paul had withdrawn to take on a purely advisory status.[101] A crisis had been forestalled, and the Werkbund looked to the future as an organ for the realization of avant-garde ideas and ideals.

[100] Letter from Hellwag to Poelzig, Jan. 22, 1920, WB, Poelzig papers. There is no evidence that anything came of this suggestion.
[101] Editor's note, Das hohe Ufer, 1, No. 10 (1919), reporting on the Werkbund executive meeting of Oct. 18.

CHAPTER VI

Years of Trial: 1920-1923

THE PERIOD 1920-1923 was one of grave trials. Economic distress and political discord threatened to undermine not only the new republican institutions but the basic structure of German society. As inflation accelerated, prophets of doom among the intellectuals found their worst fears confirmed, while the radicals, abandoning dreams of imminent social and cultural revolution, yielded to the general malaise affecting the nation. As the élan generated at the Stuttgart congress dissipated, the Werkbund found itself unable to make good its claim to leadership of the creative avant-garde. Only after inflation was brought under control in late 1923 could it resume the attempt to guide the progressive artists and architects onto paths of cultural reform.

The great inflation did not reach its peak in Germany until 1923, but its impact was felt much earlier. Already in 1920, the Werkbund had to curtail its activities because of rising costs. Economic pressures eroded the capacity of its supporters, both private and public, to contribute to its finances at the very time when the value of existing reserves plummeted. At first, the Werkbund hoped that due economy, combined with appeals to corporate members for extra contributions, would allow the Berlin headquarters to maintain itself at its wartime strength. But although additional funds were forthcoming, these did not suffice to cover the salaries of Fritz Hellwag and Theodor Heuss, both of whom left the payroll at the end of 1921.[1] Ernst

[1] The decision to dismiss Hellwag and Heuss was announced at

Jäckh followed suit, officially handing over his post as executive secretary to his deputy, Otto Baur, at the Werkbund annual meeting in June 1922.[2] Although he henceforth devoted most of his energies to the *Hochschule für Politik*, Jäckh continued to give the Werkbund the benefit of his advice and played a major part in ensuring its financial survival. Heuss, too, served the cause after he left the paid staff, both by participating in Werkbund decision-making at the board and executive committee levels, and by writing and speaking on Werkbund topics. Nevertheless, the departure of these men substantially weakened the Berlin office, impairing its ability to initiate programs and to exercise a strong centralizing function.[3]

A number of external factors reinforced a tendency to decentralization during these years. Sharply rising transport costs made it difficult to hold frequent board meetings and discouraged members from attending the annual congresses. No annual meeting was held in 1920, and those convened at Munich and Augsburg in 1921 and 1922 respectively were sustained primarily by the Werkbund's connection with the *Deutsche Gewerbeschau 1922*. Internal cohesion also suffered from the fact that the exorbitant cost of printing forced the Werkbund to abandon its regular newsletter in 1921. Published as *Das Werk* from April 1920 to March 1921, the *Mitteilungen* appeared only intermittently for the remainder of that year. In 1922, the Werkbund began to publish an illustrated monthly, *Die Form*, which incorporated the *Mitteilungen* as a regular

the Werkbund annual meeting in May 1921. See G. J. Wolf's report, *Dekorative Kunst*, XXIX, No. 9 (1921), Supplement. Poelzig had already argued two years before in favor of halving the Berlin staff, on the grounds that it was too large, now that the Werkbund's "political" days were over. Cf. "Vorstand, June 30, 1919," p. 6.

[2] *DWB-M*, in *Die Form*, I, No. 4 (1922), 55.

[3] Heuss, *Erinnerungen*, p. 259, states that he remained at the Werkbund head office until 1924. However, according to the evidence available, he must have carried on after 1921 without pay. In any case, he was no longer involved in the day to day running of the association.

feature; but this modest forerunner of the *Form* published by the Werkbund from 1925 to 1935 had to be abandoned after only five issues, for financial reasons. Moreover, high publishing costs led to the demise of the successful Werkbund yearbooks. The last of the series appeared in 1920. In 1923, the association managed to publish a comparable volume on industrial building, but only by drawing on the *Bund Heimatschutz* and two engineering societies to help finance the project.[4] Financial stringency even forced the Werkbund, in 1922, to cancel its contract with a clipping service; and thereafter Berlin headquarters had to rely completely on the branches to keep it informed of events outside the capital.[5]

Less directly, inflation weakened the Werkbund by undermining the solvency of its members. The social strata from which it had traditionally drawn its membership were among those hardest hit by postwar developments. Small workshops and independent craftsmen dedicated to quality had particular difficulty in securing essential materials, and faced a shrinking market for their output. Intellectuals, artists, and other professionals, their savings eroded, were often forced to abandon their precious independence and accept proletarian status.[6] Jäckh, who represented the Werkbund on the new Reich Economic Council, tried to assist these groups by securing creation of a commission to study their plight, and of a fund, at the disposal of the Minister of the Interior, to assist needy individuals.[7] In

[4] Werner Lindner and Georg Steinmetz, eds., *Die Ingenieurbauten in ihrer guten Gestaltung* (Berlin, 1923). This was originally intended as the Werkbund yearbook for 1922.

[5] *DWB-M*, in *Die Form*, I, No. 5 (1922), 54.

[6] Cf. Bruno Rauecker, "Die Proletarisierung der geistigen Arbeiter," *Die Hilfe*, April 29, 1920, pp. 268-71. Rauecker, a welfare economist, disciple of Naumann, and author of many books on social policy, had joined the Werkbund in 1912.

[7] *DWB-M* May 1920, p. 12; July 1920, p. 11; Oct. 1920, p. 18. Jäckh, appointed by the Werkbund, was one of three members on the *Reichswirtschaftsrat* representing the "artists." The other two were chosen by the *Wirtschaftliche Verbände bildender Künstler*, a pressure group whose main purpose, unlike that of the Werkbund, was to serve the economic interests of its members.

1921, Jäckh also held talks with the Minister of Recon-
struction, Walther Rathenau, to explore the possibility of
utilizing quality goods in the work of reconstruction, an
initiative which led to Werkbund representation within
the Ministry.[8] Finally, the Werkbund, and particularly
Theodor Heuss acting on its behalf, made energetic efforts
to have the luxury tax repealed. First introduced during
the war, this tax was supported after 1918 by the socialists,
understandably concerned to curtail conspicuous consump-
tion in a time of mass distress. However, as the Werkbund
pointed out, far from contributing to social justice, the
tax had failed to halt luxury spending and merely imposed
an additional burden on producers who served the quality
market, particularly artists and craftsmen. The Werkbund
regarded the luxury tax as an expression of puritan philis-
tinism, and sought to convince the public that its overall
effect would be to deprive Germany of a valuable asset in
international trade while hampering her cultural develop-
ment.[9] As a short-term palliative, the Werkbund helped
set up an advisory bureau to assist those most directly
affected.[10] Such efforts did little to alleviate the hardships
under which many Werkbund men were suffering, but they
did provide the association with a practical function at a
time when it was impossible to initiate positive programs
of any magnitude, and so helped to retain the loyalty and
support of its membership.

While economic strains threatened the Werkbund's
existence during the inflation years, its capacity to survive
was also weakened by the resumption of internal conflict.

[8] "Vorstand, July 19, 1921," p. I^v.

[9] Heuss, who had first taken up this theme in 1918, continued to
pursue it after his election to the Reichstag in 1924. See Heuss,
"Luxusbesteuerung," *DWB-M* 1918/2, pp. 1-4; and "Zur 'Luxus-
steuer,'" *DWB-M* 1925/6 (Sept. 1925), pp. 1-5. (The latter consisted
of excerpts from a speech against the tax delivered in the Reichstag
a few days before.) See also Hugo Hillig/Hamburg, "Zur Soziologie
des Künstlers," *DWB-M* Feb.-March 1921, pp. 5-9. Heuss, Osthaus,
and Scheffler all used arguments similar to Hillig's in their attacks
on the luxury tax.

[10] *DWB-M* July 1920, p. 10.

At Stuttgart, the radicals seemed to have carried the day, and the subsequent election of Hans Poelzig as Werkbund president had raised hopes that the association would at last use its influence and resources to back the cause of progressive art without equivocation. Werkbund and *Arbeitsrat* agreed to work hand in hand, and although formal union was never achieved, for a brief moment the Werkbund appeared as a worthy ally in the struggle of the avant-garde for leadership in the new Republic.[11] But the radicals' hopes were to be disappointed, and it is interesting to trace the process of their disillusionment.

For one thing, it soon became clear that many had misinterpreted the significance of the events of September and October 1919. Poelzig, the idol of the avant-garde and generally recognized as Germany's leading architect, had no intention of adopting a position of all-out support for the young insurgents. On the contrary, Poelzig had accepted the presidency only after friends had convinced him that he alone could hold the generations together. As a compromise figure, he consciously refrained from imposing his artistic ideals and judgments on the association as a whole.[12] Furthermore, Poelzig from the first regarded his commitment to the Werkbund as a limited and temporary one.[13] For a time, he was willing to suppress his aversion to "politics," bureaucracy, and compromise, but as an artist dedicated first and foremost to his work, Poelzig realized that he could not sustain a high level of participation in Werkbund affairs without damage to his

[11] Gropius's efforts to secure amalgamation of *Arbeitsrat* and Werkbund are recorded in the minutes of an *Arbeitsrat* meeting of Nov. 18, 1919, *Bauhaus*, GN 10/44. In the course of the discussion it became evident that others failed to share his confidence in the new Werkbund executive headed by Poelzig, although most were prepared to accept financial help from the Werkbund and to cooperate with it on specific projects.

[12] Heuss, *Poelzig*, p. 84.

[13] "Vorstand, Oct. 18, 1921," pp. 1-6. Poelzig, before the vote, stated that he was only prepared to take on the job for a year in the first instance, and warned that he would be unable to give it his full attention.

vocation. As a result, he inevitably disappointed the exaggerated hopes that his words at Stuttgart had inspired.

Poelzig's ambivalence was not the only reason for the renewed alienation of his radical admirers from the Werkbund, however. Just as in the Republic as a whole, so within the Werkbund, what revolutionary sentiment had existed after the fall of the Second Reich proved short-lived. By the beginning of 1920, it became fashionable once more to stress the continuity of the postwar Werkbund with that of the founding years, and to deride the Expressionist movement as an aberration from accepted principles of sound art and design.[14] Although conclusive evidence on this point is lacking, it would appear that the majority of Werkbund members in the early 1920's found Scheffler's *Bund der Erneuerung* or even the *Heimatschutz* movement more congenial than the revolutionary *Arbeitsrat für Kunst*.

That the Stuttgart compromise had in fact broken down was publicly acknowledged in May 1921, when Hans Poelzig yielded the Werkbund presidency to Richard Riemerschmid.[15] Although the official reason was the need to concentrate forces in Munich because of Werkbund participation in the *Deutsche Gewerbeschau* exhibition planned for the following year, the change of leadership undoubtedly represented a change of mood within the association. This is confirmed by the fact that several important artists withdrew from active participation at about the same time. Gropius did so in protest against the growing reaction within the Werkbund.[16] Bruno Taut,

14 One who had suspected all along that the Werkbund's "conversion" of Sept. 1919 had merely represented a temporary concession to the spirit of the times was W. C. Behrendt. Cf. his "Zur Tagung des deutschen Werkbundes in Stuttgart," *Kunst und Künstler*, XVII (1919-20), 90-91; and "Handwerk als Gesinnungsfrage," *Deutsche Allgemeine Zeitung* (Berlin), Sept. 13, 1919.

15 "Bericht über die Jahresversammlung in München," *DWB-M* June 1921, p. 1.

16 *GerN*, letters from Gropius to Riemerschmid, May 23, 1921, and Riemerschmid to Gropius, June 2, 1921. Also illuminating is the

although he did not formally resign from the executive until 1923, ceased to play any significant role in Werkbund affairs after Gropius's withdrawal.[17] Heinrich Tessenow, who had refused a seat on the executive in October 1919 but was apparently won over thereafter by Poelzig, saw no point in continuing his affiliation with the Werkbund leadership once Poelzig had decided to withdraw, and resigned in April 1921.[18]

As the "new men" pulled out, their places on the executive were taken by Werkbund notables who in 1919 had temporarily yielded ground to the radicals. Paul, Behrens, Riemerschmid, Bruckmann, and Riezler once more came to the fore. Combined with the withdrawal of the admired Poelzig, this resurgence of the "old guard" persuaded the younger radicals that the Werkbund had deliberately turned its back on the new art, and that they had no option but to pursue their aims independently. Yet it would be wrong to place the entire responsibility for the failure of the Stuttgart compromise on the machinations of the reactionaries, as many of the radicals tended to do. Gropius himself admitted it was unrealistic for the Werkbund or any other organization to identify itself with the progressive artists before they had substantial achievements to their credit.[19] Moreover there was some substance to the charge of Riemerschmid and others that the radicals had not done everything possible to press their views construc-

correspondence between Gropius and Bartning, *Bauhaus*, GN 10/ 122-24.

[17] *DWB-M*, in *Die Form*, I, No. 4 (1922), 55, shows that whereas Bartning accepted reelection to the executive in 1922, Taut merely agreed to serve out his term. Bartning's reminiscences of the Weimar meeting of 1923 are available in Heinz Thiersch, ed., *Wir fingen einfach an. Arbeiten und Aufsätze von Freunden und Schülern um Richard Riemerschmid zu dessen 85. Geburtstag* (Munich, 1953), p. 12 [hereafter *Richard Riemerschmid*].

[18] "Vorstand, Oct. 18, 1919"; "Protokoll der Geschäftsführersitzung am 12. April 1921," p. 1, notes Tessenow's withdrawal, without explanation.

[19] *GerN*, Gropius to Riemerschmid, May 23, 1921, p. 2.

tively within the Werkbund. By failing openly to voice their objections to current policy, particularly at the Munich annual meeting in May 1921, the radicals in effect yielded without a fight. The resignations that followed only served to formalize a prior admission of defeat.[20]

Finally, it is difficult to see what more the Werkbund could have done to help the avant-garde artists. The usual diversity of views among its members, magnified by the chaotic state of the arts during the early years of the Republic, ruled out any real consensus on aesthetic questions. No matter how much it wished to reach an accommodation with the radicals, the Werkbund could hardly allow itself to be run by, or in the sole interest of, artists who failed to agree among themselves on what they really wanted in the realm of art. For the "Age of Expressionism" was not, in fact, dominated by a single style. Not only did it witness the growth of a counter-movement, the so-called *Neue Sachlichkeit* or Neo-objectivity;[21] there were also persistent attempts to revive folk art in the name of an aroused national consciousness. Given this bewildering array of options, it would have been folly for the Werkbund to commit itself to any particular group or style, even if it had been able to agree on a criterion for judging the respective merits of the contenders.

In fact, no such standard existed. Gropius, Taut, Bartning, and others, who demanded support for "die Jüngeren" or "die Werdenden," when challenged could supply no precise instructions for identifying the young, coming men.[22] Age was clearly an unsatisfactory yardstick, for Riemerschmid, whom the progressives rejected unanimously, was only a year older than Poelzig, and Gropius

[20] *GerN*, Riemerschmid to Gropius, June 2, 1921; *Bauhaus*, GN 10/124, Gropius to Bartning, June 2, 1921.

[21] See Lindahl, "Zukunftskathedrale"; Sharp, *Modern Architecture and Expressionism*; and John Willett, *Expressionism* (London, 1970). Also, Ch. VII, below.

[22] "Vorstands- und Ausschuss-Sitzung des D.W.B. am 25. Oktober 1920 in Berlin" [hereafter "V-A, Oct. 25, 1920"], pp. 2-4.

himself was already a ripe thirty-eight. Moreover, it was difficult to assess which of the new men represented the future when most still lacked significant commissions and therefore had given little concrete evidence of their ability. Gropius tended to base his judgments on whether the artist in question professed radical opinions, but at a time when progressives and reactionaries often used the same language, this was a doubtful procedure. The glorification of *Handwerk*, and appeals for a mystical union of artist and worker, artist and *Volk*, were concepts that made the artistic Left the potential ally of the ideological Right. In a way, Riemerschmid and Behrens, men willing to adapt to the realities of a world in which mass production and the machine posed a challenge to the designer, could more justly claim to be progressive than artists like Gropius who currently espoused a pseudomedieval cult of the crafts.[23] Nor could the difficulty be solved by appealing to an abstract *Zeitstil*, or spirit of the age. As Walter Riezler pointed out, in one sense all who create at any one time, no matter how they differ from one another, are bound to reflect the contemporary mood. If, in the early 1920's, it proved impossible to establish stylistic unity or coherence, one could argue that the cause was the manifest disharmony of the age, and that efforts to impose uniformity in chaotic times, even if successful, would do more harm than good.[24]

Under the circumstances, all that the radical minority could legitimately demand of the Werkbund was that it create opportunities for experimentation and uphold the freedom of all sincerely engaged in developing a genuine modern art. This the Werkbund tried to do, not least by giving its support to the work of the Bauhaus. Even during these years of "reaction," the link between Werkbund and Bauhaus remained intact. Gropius's efforts to secure the

23 Cf. Behrens, in "Vorstand, July 30, 1919," pp. 4-5.
24 Walter Riezler, "Qualität und Form, Betrachtungen zur Deutschen Gewerbeschau München 1922," *Die Form*, I, No. 1 (1922), 29-31.

benefits of the Werkbund's prestige for his new school culminated in the Weimar Werkbund congress of 1923, held in conjunction with the first major Bauhaus exhibition.[25] The Werkbund's participation in the "Bauhaus Week" served as public affirmation of its faith in the significance of Gropius's experiment.[26]

On the other hand, the radicals were correct in thinking that there were still many within the Werkbund who would gladly have stifled the more extreme manifestations of the artistic revolution in the name of a traditional aesthetic; and they were also right to fear that revival of the old Werkbund slogan of "quality" would work against acceptance of the new, which by its very nature lacks the perfection born of experience. Forced to balance between avant-gardism and reaction, the Werkbund leadership soon realized that it could not hope to satisfy adherents of either, and therefore once more turned away from questions of doctrine to practical matters.

If the Werkbund wished to be more than an aesthetic debating society, it had to find ways once again to exert a positive influence on German life and culture. The most obvious course in the early 1920's seemed to be to resume its exhibition work, but it was only after considerable internal controversy that the association took this step.

First broached in the summer of 1919, the idea of cooperating with the *Deutsche Gewerbeschau*, planned for Munich in 1922, appealed particularly to members of the *Münchner Bund*. Karl Bertsch of the *Deutsche Werkstätten* in Munich argued the case for participation at the Werkbund executive meeting of July 30, 1919, and met with a positive response from the majority, who believed firmly in the value of exhibitions as a means of promoting quality production and stimulating closer cooperation between art,

[25] Gropius had tried as early as 1921 to get the Werkbund to Weimar. See *BA*, Rep. 301/110, memorandum from Jäckh to the executive committee, April 24, 1922.

[26] Theodor Heuss, "Der Deutsche Werkbund in Weimar," *Frankfurter Zeitung*, Sept. 22, 1923; Wingler, *The Bauhaus*, p. 6.

industry, and the crafts.[27] Because the association at the time lacked sufficient resources to pursue an independent exhibition program, the invitation from Munich provided a welcome opportunity to revive its activities in this area with others footing the bill. Admittedly, the exhibition committee rather than the Werkbund as such would be the recipient of any subsidies forthcoming from the Reich and from the state governments, but it was realistic to expect that the Werkbund's prestige would give it a decisive voice in organizing the exhibition. In fact, it was the desire of the Bavarian sponsors to give the fair a truly national character that led them to seek Werkbund help. For its part, the Reich government made its contribution dependent on the fulfillment of conditions of quality and design that it believed only strong Werkbund involvement could ensure.[28] Thus, although the *Gewerbeschau* did not result from a Werkbund initiative, the association could hope to dominate the fair, at least in its artistic aspects.

The Werkbund accordingly decided in February 1920 to take part in the *Gewerbeschau*, despite opposition from the young radicals whose sentiments still carried considerable weight.[29] Indeed, under radical pressure, the association had just withdrawn support from the Leipzig fair, Germany's largest and most important trade exhibition, on the grounds that its organizers lacked sympathy with the Werkbund program and merely sought to exploit Werkbund prestige for commercial ends.[30] On the other hand,

[27] "Vorstand, July 30, 1919," pp. 14-15.
[28] Edwin Redslob reported the demands of the *Reichwirtschafts-ministerium* in "V-A, Oct. 25, 1920," pp. 1-2. See also the correspondence among Redslob, the Reich authorities, and the Werkbund, in *BA*, Rep 301/18, "Deutsche Gewerbeschau München 1922."
[29] Bartning to Poelzig, Sept. 24, 1920, copy, in *BA*, Rep 301/18.
[30] Const. J. David, "Der deutsche Werkbund und die Gewerbeschau München 1922," *Die Kornscheuer*, II, No. 5 (1921), 77-83; *DWB-M* Oct. 1920, pp. 17-18. The Werkbund originally decided to cooperate with the Leipzig fair in the spring of 1919, and Behrens, with other Werkbund artists, joined the fair's selection committee. *DWB-M* 1919/1, pp. 24-25 and 1919/2, p. 67. When the Werkbund pulled out a year later, many members continued to participate as

the Werkbund repeatedly reaffirmed its willingness to enter into alliance with manufacturing and commercial interests when it could do so without too greatly compromising its ideals. Thus in 1920 it not only agreed to collaborate with the *Gewerbeschau*, but also worked out an arrangement with the new Frankfurt fair, approving construction of a *Haus Werkbund* to display selected products exemplifying the Werkbund concept of quality.[31]

Completed in the autumn of 1921, the *Haus Werkbund* showed work by nonmembers and did not claim to encompass all that was good at the fair. More modestly, it tried to prevent good designs from being drowned in a sea of shoddy, as tended to happen at Leipzig, and to give practical help to those few manufacturers who still took seriously their role as educators of consumer taste.[32] Before long, however, it became apparent that the Frankfurt arrangement could not do all that its supporters had hoped. The *Haus Werkbund* tended to display luxury goods rather than items priced within reach of the impoverished German consumer. Furthermore, whereas the Leipzig fair aimed at the domestic buyer, Frankfurt from the start catered to the export market.[33] Werkbund participation at Frankfurt therefore did relatively little for the cause of good everyday design in Germany, while its chief economic beneficiaries were the exporters and foreign buyers rather than the German quality producers, artists, and craftsmen.

The only other exhibition in which the Werkbund played an important part in these years suffered from similar defects. In 1921, the association, carrying on the work of

individuals, including Edwin Redslob, who delivered a major speech at the fair in 1920. Cf. Redslob, *Die Werbekraft der Qualität* (Berlin, 1920).

[31] "V-A, Oct. 25, 1920," pp. 5-6.

[32] Theodor Heuss, "Haus Werkbund," *Frankfurter Messe-Zeitung*, May 14, 1921; and "Wertarbeit und Messe," *Die Hilfe*, Oct. 15, 1921, pp. 461-62. Unsigned reports in *Dekorative Kunst*, xxiv, No. 8 (May 1921) and No. 12 (Sept. 1921) welcomed Werkbund participation and forecast that the *Haus Werkbund* would become the heart of the Frankfurt fair.

[33] Unsigned report, *Frankfurter Zeitung*, Sept. 24, 1923.

the *Deutsches Museum*, which had fallen victim to inflation, sent a display of German arts and crafts to the United States. Selected by Otto Baur with the help of Richard L. F. Schulz and Lilly Reich, who had just joined the Werkbund executive as its first and only woman member, this exhibition took the Werkbund message to Newark and a number of other cities; but while it resulted in welcome sales, it did nothing to further the association's major aims.[34]

The Werkbund's participation in the *Deutsche Gewerbeschau* must thus be seen in the context of its general program of exhibitions. If the Munich scheme proved particularly controversial, the reason was primarily that its potential domestic impact was much greater than that of the ordinary annual fair or traveling display. While this increased its significance in the eyes of supporters, it also magnified the misgivings of the skeptics. In addition, the latter had doubts regarding certain specific features of the *Gewerbeschau* proposal, questioning its timing and objecting to the nationalist motivation of the exhibition organizers who regarded the *Gewerbeschau* as a way of proving German superiority in the applied arts.[35] Predicting

[34] Newark, New Jersey Museum Association, *The Applied Arts* (Newark, 1922). The Werkbund designated John Cotton Dana, the American responsible for this exhibition, as its area representative in the United States. "Bericht über die Vorstands-Sitzung des Deutschen Werkbundes in Heilbronn am 6. November 1922," p. 1 [hereafter "Vorstand, Nov. 6, 1922"]. See also *DWB-M* Oct. 1920. Lilly Reich, who had organized the Werkbund's fashion show in Berlin in 1915, was, like Schulz, involved with the Frankfurt *Haus Werkbund*, and actually moved from Berlin to Frankfurt in 1923 or 1924 for its sake. See Otto W. Sutter, "Das Haus Werkbund," *Werkbund-Gedanken*, No. 1, supplement to *Stuttgarter Neues Tagblatt*, Jan. 17, 1924 [hereafter *Werkbund-Gedanken*]. On the demise of the *Deutsches Museum*, hastened by the death of Osthaus in 1921, Dr. Hugo Kaltenpath, "Der Weg der Folkwang-Sammlung von Hagen nach Essen," in Hesse-Frielinghaus, *Karl-Ernst Osthaus*, pp. 526-38.

[35] W. C. Behrendt, "Die Schicksalsstunde des Deutschen Werkbundes," *Die Kornscheuer*, II, No. 5 (1921), 83-91. The manifesto of the exhibition directorate expressed the hope that the exhibition would help revive German consciousness of nationhood, without regard for the political boundaries "invented" at Versailles and St. Germain. *DWB-M* Sept. 1920, pp. 11-13.

a fiasco, opponents of participation warned that the exhibition might backfire, and actually prove damaging to Germany's image abroad.[36]

Finally, there were many in and outside the Werkbund who felt that Munich was a poor site for a national exhibition. By 1920, the Bavarian capital, after having submitted briefly to a Soviet-style revolutionary regime, had become a citadel of political reaction. In addition, the strength of Bavarian particularism made Munich seem a less than ideal place to hold an exhibition dedicated to demonstrating the cohesiveness of German national culture.[37]

A product of compromise at many levels, the *Deutsche Gewerbeschau* in the end neither satisfied the hopes of its supporters nor fulfilled the dire prophecies of its opponents. On the whole, its organizers had reason to feel satisfied that it constituted a practical contribution to Germany's economic and cultural recovery and national morale. Despite all its flaws, it represented an impressive achievement for a country recently defeated in a major war and still suffering its aftereffects. Disappointingly, some of Germany's leading manufacturers had not considered it worth their while to participate. Economic circumstances thus combined with local egoism and Bavarian provincialism to make the *Gewerbeschau* less "national" than its organizers had hoped. Nevertheless, the Werkbund did succeed in converting an essentially Bavarian effort into something approaching a national event.[38]

[36] David, "Der deutsche Werkbund und die Gewerbeschau München 1922," p. 79.

[37] Thus Alexander Koch, editor of *Innen-Dekoration* and *Deutsche Kunst und Dekoration* (Darmstadt), warned against the choice of Munich. Koch, who claimed to have originated the *Gewerbeschau* idea in 1919, recommended Frankfurt as the ideal location. *Deutsche Kunst und Dekoration*, XLIV (April-Sept. 1919), 223-24, and XLVII (Oct. 1920-March 1921), 170-71. Also, Alexander Koch, *Das neue Kunsthandwerk in Deutschland und Oesterreich* (Darmstadt, 1923), pp. 1-3.

[38] Josef Popp, "Ein Nachwort zur Deutschen Gewerbeschau," *Dekorative Kunst*, XXXI (1922-23), 65; Hermann Esswein, "Die

Werkbund participation also served to ensure a reason-
ably high standard of material quality at the exhibition.
But aesthetically the *Gewerbeschau* proved less satisfac-
tory. Conservatives deplored its experimental and "Expres-
sionist" aspects, which in their view marked a regression
from standards of clarity and simplicity achieved before
the war.[39] On the other hand, the radicals judged the
overall effect to be disturbingly conventional. As the latter
had feared, the exhibition failed to reveal the emergence
of a new and exciting *Zeitstil*.[40] Thus Theodor Heuss noted
that, apart from some student work and fresh designing
in the ceramics section, the applied arts displays included
little of artistic distinction. Only Peter Behrens' *Dombau-
hütte*, an exhibition structure designed to house an inter-
denominational display of religious art, won Heuss's
approval as an interesting example of current tendencies
in art and architecture.[41]

The paucity of outstanding work may have been due in
part to the decision of the radicals to abstain as a group
after Poelzig's resignation.[42] But a more probable explana-
tion was the fact that the modern movement had as yet

Deutsche Gewerbeschau München 1922," *Deutsche Kunst und
Dekoration*, L (April-Sept. 1922), 277-78; and Esswein, in Koch,
Das neue Kunsthandwerk in Deutschland und Oesterreich, pp. 7-12.

[39] The anti-Expressionist position was maintained by Popp and
Esswein, cf. previous note; while the exhibition's "Expressionist"
features were welcomed by G. J. Wolf, in *Dekorative Kunst*, xxx
(July 10, 1922), 225-47.

[40] W. C. Behrendt voiced the disappointment of the radicals in
his "Deutsche Gewerbeschau München 1922," *Kunst und Künstler*,
xxi (1922-23), 58. He claimed to find hardly a trace of Expression-
ism in the *Gewerbeschau*.

[41] Theodor Heuss, "Deutsche Gewerbeschau," Parts i and ii, in
Der Bund, i (1922), 57-58 and 87-88. On the *Dombauhütte*, Lindahl,
"Zukunftskathedrale," p. 268.

[42] Behrendt, "Deutsche Gewerbeschau München 1922," p. 58.
But it should be noted that Poelzig, after resigning the Werkbund
presidency, remained on the presidium of the exhibition and con-
tributed a fountain. *GerN*, Poelzig to Riemerschmid, June 10, 1921.
Likewise Bartning participated in an artistic capacity after he had
resigned as Werkbund representative to the exhibition in favor of
Riemerschmid of the *Münchner Bund*.

produced little of real significance. The *Zeitstil* was still in the making, and it is unlikely that even an exhibition organized on doctrinaire progressive lines would have significantly hastened the process. In the event, both old and new, traditional and Expressionist forms were exhibited side by side, reflecting the philosophy of the artists' committee chaired by Riemerschmid, who had declared that the real distinction was not between the old and the new but between the good and the bad.[43]

Only one incident occurred to justify the fears of those who had warned that the Werkbund would be unable to withstand the pernicious atmosphere of Munich. This centered on a modern crucifix by Ludwig Gies of Lübeck. Housed in Behrens' *Dombauhütte*, the crucifix became the object of violent controversy that led to mass demonstrations by both conservative Catholic and National Socialist groups. Rather than resist this attempt to infringe on artistic freedom, the exhibition organizers quickly agreed to remove the offending crucifix and to close the *Dombauhütte* itself.[44] The alacrity with which they did so served to justify Riemerschmid's suspicion that the majority of the directors secretly sympathized with the antimodernists and welcomed this enforced censorship.[45] Moreover, influential figures within the Werkbund either shared this sentiment, or at least were more inclined to

[43] Letter from Bartning to Poelzig, Sept. 24, 1920, criticizing Riemerschmid for being lukewarm about the new art; and copy of Riemerschmid's comment on the above, Oct. 16, 1920, both in *BA*, Rep 301/18. Also, Riemerschmid and others, "V-A, Oct. 25, 1920," pp. 2-4.

[44] Riemerschmid gave an account of the incident in "Vorstand, Nov. 6, 1922," p. 1.

[45] *GerN*, letter from Riemerschmid to Heuss, Sept. 6, 1922. J. J. Scharvogel of the Technical University in Munich was president of the exhibition directorate, and Behrens acted as secretary, while Riemerschmid chaired the artists' committee (Künstlerausschuss). The honorary directorate, headed by Konrad Adenauer of Cologne, included such notables as Cuno, Gessler, Groener, Luther, Marx, Noske, and Stegerwald. The honorary presidium consisted of Reich President Ebert, Chancellor Wirth, the president of the Reichstag Loebe, the president of the *Reichswirtschaftsrat* Edler von Braun, and several Bavarian worthies. *Die Form*, 1, Nos. 4 and 5 (1922).

compromise than to fight when faced with a threat to cultural autonomy. Thus Peter Behrens, by giving written consent to the closing of his *Dombauhütte*, in a sense condoned what amounted to political interference in artistic matters; and Riemerschmid himself, although indignant as an artist, as a good nationalist argued that a Werkbund protest would merely exacerbate existing tensions between Bavaria and the rest of the Reich, and thus damage the cause of national unity.[46] Whatever its reasons, the Werkbund yielded on the crucifix issue with scarcely a murmur, thus confirming what many had long suspected: that under Riemerschmid's leadership the association had ceased to be a reliable supporter of progressive art.

The Werkbund's effort to reconcile the interests of art and industry through participation in the *Deutsche Gewerbeschau* was paralleled by an equally energetic attempt to cement the relationship between artists and craftsmen. As we have seen, after the war it was the artists who first tried to give *Handwerk* a more prominent role within the Werkbund. Almost without exception, the avant-garde at this time believed that modern art could emerge only on the basis of a close working alliance between art and the crafts. Many artists went even further, advocating a merger of function between designer and executant. Their aim was to create a new breed of artist-craftsmen and craftsman-artists, able both to conceive works of aesthetic merit and produce them with their own hands.[47]

True, the revolutionary era had also spawned a diametrically opposed philosophy. At this very time Futurists and Constructivists systematically rejected glorification of the crafts as symptomatic of an outdated romanticism, and instead elevated prewar acceptance of the machine into

[46] "Vorstand, Nov. 6, 1922," p. 2. Although the executive decided to send a deputation to protest to the Munich authorities on the Werkbund's behalf, Riemerschmid's inclusion virtually ensured that no vigorous action would be taken.

[47] Fritz Hellwag, "Zeitgeist und Werkbundarbeit," *Kunstwanderer*, IV (March 1922), 318-20.

something like a religion of technical form.[48] But these movements, perhaps closer to the original Werkbund formula, made little impression on Germany in the immediate postwar period. Whereas revolutionary artists in Italy, Holland, or the Soviet Union looked ahead to a new machine art, in Germany the prevailing attitude was that expressed by Poelzig at Stuttgart, when he insisted on the fundamental distinction between artistic and technical form. The Werkbund, eager to maintain contact with Germany's progressive artists, had little choice but to adopt their preference for the crafts.

While the current artistic philosophy pushed the Werkbund towards an alliance with the crafts, a corresponding tendency within the *Handwerk* movement produced a desire on the part of the artisan organizations to work with and through the Werkbund. Economically hardpressed and fearful of the rising force of socialism, Germany's independent craftsmen and skilled workers recognized their need for allies if they were to maintain their status.[49] At the same time, the fact that some branches of the crafts had actually emerged from the war strengthened numerically and organizationally, made it possible for them to face adversity in a relatively positive and optimistic spirit. Sympathetic observers noted a new willingness to adapt to modern conditions, to improve production techniques and distribution methods, and generally to compete vigorously with the large-scale capitalist producers.[50] A more progressive outlook and a new appreciation for the importance of quality and good

[48] Banham, *First Machine Age*, Ch. 14.

[49] Heinrich August Winkler, *Mittelstand, Demokratie und Nationalsozialismus* (Cologne, 1972). Although Winkler asserts (p. 35) that the craftsmen on the whole suffered less from inflation than did the industrial workers, he nevertheless indicates (p. 28, n. 46) that between 50% and 60% of the independent craftsmen in the building trades had been forced out of business by Jan. 1924. Evidently, things were bad enough to justify an acute feeling of panic.

[50] E. Meissner, "Qualitätswille im Handwerk," *DWB-M* Aug. 1920, pp. 11-12; Franciscono, *Walter Gropius*, p. 21.

design brought *Handwerk* closer to the Werkbund in spirit, and provided the basis for practical cooperation.

If the artists were moved in the first instance by aesthetic considerations and the artisans by economic motives, a number of men who favored closer contact between Werkbund and *Handwerk* did so because such an alliance promised to produce desired social and ethical consequences. Osthaus, Scheffler, Heuss, and others, felt that helping the independent craftsmen was one way to arrest the decline of the *Mittelstand*, that intermediate stratum whose preservation they regarded as essential for the health of the German social order. In their view, cooperation between artists and craftsmen, between workers of brain and hand, would save both groups from sinking into the proletariat and protect society as a whole from the evils of class conflict. They also believed that a revitalized *Handwerk* could serve as an instrument of cultural and social regeneration, by spreading joy in creation and pride in work.[51]

The theme of joy in work, *Freude der Arbeit*, which had played a role in Werkbund thinking from the start, assumed a particularly prominent place just after the war, when the apparent failure of capitalism created an environment conducive to its elaboration. The Arts and Crafts concern with man as primarily a producer rather than a consumer, finding his chief pleasure in creative labor, seemed especially appropriate now that there was little to consume and the material rewards of labor were few. Whereas the socialists responded to economic distress by pressing for higher wages and shorter hours, *Mittelstand* ideologists regarded the collapse of Germany's prewar prosperity as an opportunity to reject materialism in all its forms and to rejuvenate the national culture on the basis of a healthy ethic of work. Thus Paul Renner

[51] Scheffler, *Die Zukunft der deutschen Kunst*; Karl-Ernst Osthaus, "Die Kunst im Aufbau der neuen Lebensform," *DWB-M* 1919/5-6, pp. 2-5; Heuss, "Deutsche Werkgesinnung" in his *Zwischen Gestern und Morgen* (Stuttgart, 1919), pp. 62-68.

argued, as Heuss had done, that Marxism was out of date, and urged the artist to persuade the worker to fight for a meaningful work experience rather than for material well-being or greater leisure.[52] Similarly, Osthaus argued that to enjoy one's work was much more important than to possess worldly goods, and was even prepared to welcome economic misfortune if it promoted the kind of labor most conducive to joy in work: the production of high-quality goods through the application of imagination, taste, and talent.[53]

Neither Osthaus nor most of the others who shared his crafts romanticism and antipathy to standardized machine production thought to ask either who was to consume the quality goods so joyfully produced, or how the cultural level of the nation as a whole could be raised if production of well-designed objects remained restricted to limited quantities of costly hand-crafted items. Because of his economic and political training, Theodor Heuss found it impossible to overlook these and other implications of the crafts enthusiasm. It was clear to him that the domestic and foreign markets could never be satisfied by handicraft production alone, and that Germany would need to utilize modern technology to the full if she was to provide her growing population with the necessities of life.[54] Unwilling to abandon the notion of joy in work, Heuss had therefore to prove its relevance in the sphere of modern industry. Rejecting Osthaus's dictum that the machine had irremediably damaged the dignity of work, Heuss sought ways to restore it within the framework of industrial

[52] "Kunstler und Gewerbe," *DWB-M* Feb.-March 1921, pp. 12-17. The opposite point of view was adopted by Adolf Behne, "Kunst, Handwerk, Technik," *Die neue Rundschau*, xxxiii, No. 10 (1922), 1021-37. Behne insisted that the workers rightly demanded not pleasure in work but more material goods and greater leisure.

[53] Osthaus, "Die Kunst im Aufbau der neuen Lebensform," *DWB-M* 1919/5-6, pp. 4-5.

[54] Hess, *Heuss vor 1933*, pp. 138-39, shows how Heuss sought to keep Germans from contemplating emigration as a solution to economic distress, by providing employment in the export industries. Goods, not people, were to be shipped abroad.

society.[55] Just how a laborer in a rationalized plant, tied to the rhythm of the machine, was to recover pleasure in work was a problem that the Werkbund failed to solve at the time, and one that remains a challenge to this day. Heuss tended to rest his hopes on the emergence of a new work ethic through the reform of education, whereas Bruno Rauecker thought the answer lay in the concept of industrial democracy, and favored extensive legislation on industrial relations and worker participation in management. By devising new social policies and management techniques, Rauecker hoped to overcome the alienation of the worker from the product of his labor and thus lay the basis for cultural renewal along Werkbund lines.[56]

When the Werkbund executive first decided to make "Joy in Work" the theme of the annual meeting in 1922, it acted under the influence of the handicraft mystique. The scheduled keynote speech, by the dramatist Gerhart Hauptmann, was to deal with "The Holy Hand" (*Die heilige Hand*).[57] But when Hauptmann canceled his appearance at the last minute, Peter Bruckmann, stepping into the breach, gave a rather different direction to the proceedings. Instead of emphasizing the psychological and ethical aspects of the topic as Hauptmann would undoubtedly have done, Bruckmann stressed the socio-political determinants and implications of joy in work. Drawing on the theoretical contributions of Friedrich Naumann and Walther Rathenau, as well as on his own experience as an industrialist, Bruckmann discussed the entire problem of the integration of the worker into the modern economy and dealt in turn with the division of labor, the organization of production, and the effect of machine

[55] Heuss, "Deutsche Werkgesinnung," pp. 62-68.

[56] "Qualitätsarbeit und Sozialpolitik," *DWB-M* 1919/2, pp. 58-63. Both Heuss and Rauecker were influenced by Naumann, who had given a great deal of thought to the problem of industrial democracy before 1914.

[57] *GerN*, letter from Riemerschmid to Hauptmann, May 16, 1922 and Hauptmann's acceptance of June 15, in which he changed the title to "Die denkende Hand" (The Thinking Hand)!

technology.[58] However, the handicraft bias reasserted itself once more in the debate following Bruckmann's talk, with Wienbeck and others expressing skepticism about the possibility of engineering *Freude der Arbeit* in an industrial setting.[59] On the whole "joy in work" continued to be associated primarily with skilled work and the traditional crafts, and so served as a link between the Werkbund and the *Mittelstand* ideologists of the crafts associations. Werkbund and *Handwerk*, claiming immunity from the prevailing materialism and class egoism of German society, posed as idealistic champions of national solidarity, bulwarks of the corporate spirit in a chaotic world. By adopting the notion of joy in work, they sought to further the cause of social harmony threatened both by the liberals, with their emphasis on laissez-faire individualism, and by the socialists with their talk of class war.[60]

The pro-*Handwerk* sentiment within the Werkbund also expressed itself in the creation of several subsidiary organizations. Of these, the first and longest-lived was the *Werkstattgruppe*, a direct offspring of the *Freie Gruppe für Kunsthandwerk* founded in 1918 by Karl Gross of Dresden.[61] Dedicated to preserving the idealism and cre-

[58] *DWB-M*, in *Die Form*, I, No. 4 (1922), 56; Theodor Heuss, "Die Werkbundtagung in Augsburg," *Frankfurter Zeitung*, July 5, 1922; unsigned report, "Der Werkbundtag, Augsburg," in *Hamburgischer Correspondent*, July 7, 1922. Rathenau's books outlining schemes for a non-Marxist transformation of society were popular after the war, particularly in *Mittelstand* and DDP circles. His slogan of "Gemeinwirtschaft" appealed as an alternative to socialism. Cf. Winkler, *Mittelstand*, p. 85.

[59] Heuss, "Die Werkbundtagung in Augsburg." The attempt of one speaker, a Munich physician named Fürst, to link psychotechnical testing in industry with the theme of the conference seems to have met with little response. Cf. "Der Werkbundtag, Augsburg," *Hamburgischer Correspondent*, July 7, 1922.

[60] On *Mittelstand* ideology, Winkler, *Mittelstand*, pp. 84-86 and 112; and Hermann Lebovics, *Social Conservatism and the Middle Classes in Germany, 1914-1933* (Princeton, 1969). The chief ideologist of the organized *Handwerk* movement was Hans Meusch, who later in the decade briefly played a role within the Werkbund. See Ch. VII, below.

[61] *DWB-M* 1918/2, pp. 21-23.

ativity of the German handicrafts, this select group of art workers was largely responsible for the Werkbund yearbook of 1920, devoted to the arts and crafts.[62] Although the *Werkstattgruppe* by 1922 could boast only sixty members in all of Germany, it exerted considerable influence within the Werkbund. Thus, it secured the creation of a *Meister-ring*, a group of master craftsmen who, modeling themselves on their medieval predecessors, set out to pass their ripened skills on to the next generation by training apprentices. The *Meisterring*'s slogan, "Aufbau der Meister-lehre, Abbau der Schule" (promotion of apprenticeship, demotion of the schools) summed up its conviction that the survival of the quality crafts depended on restoring the patriarchal master-apprentice relationship.[63] Its philosophy echoed the view then current among progressive artists and educators that the only antidote to the soul-destroying pedantry of the schools was renewed immersion of the artist in practical work.[64]

Yet while most Werkbund educators wished to give practical training in the crafts an enlarged place in the curriculum at all levels, they could hardly be expected to welcome the radical destruction of their institutional bases, the arts and crafts schools. As a result, they came to oppose the doctrinaire antiacademicism of the *Meisterring*.[65] The advocates of the apprenticeship philosophy lost further

[62] DWB, *Handwerkliche Kunst in alter und neuer Zeit* (Berlin, 1920).

[63] *DWB-M* Nov.-Dec. 1920, pp. 9-11; *DWB-M*, in *Die Form*, I, No. 5 (1922), 53.

[64] Otto Bartning, "Handfertigkeits-Unterricht für Knaben," *DWB-M* June 1920, pp. 4-8, went so far as to urge that machines be rigidly excluded from manual training in order to preserve its full value as a counterweight to the intellectualistic bias of the schools. Similarly Gropius, writing to Poelzig on Jan. 16, 1919, had called for an end to theorizing and argued that the arts, including architecture, should simply be treated and taught as specialized crafts. *WB*, Poelzig papers.

[65] The resistance to formal schooling on the part of the artisans had already been deplored by Hermann Muthesius in 1906. Cf. his *Kunstgewerbliches Schulwesen in Preussen* (Berlin, 1906), pp. 46-48.

ground as it became evident that their approach could never meet Germany's need for ever larger numbers of skilled and semiskilled workers. By 1928, the *Meisterring*'s two dozen-odd members constituted little more than a token reminder of the utopian *Handwerk* phase in the Werkbund's recent past.[66]

Another group spawned by the *Werkstattgruppe*, the *Bund der Freunde wertvoller Handwerkstechniken*, had an even shorter life. Founded in 1921 on the initiative of the *Reichskunstwart*, in order to preserve threatened crafts techniques, it fell victim to inflation soon after organizing a small but impressive display of handicrafts at the *Deutsche Gewerbeschau*.[67] In addition, the economic interests of German artworkers were served by the *Wirtschaftsbund deutscher Kunsthandwerker*, which the Werkbund and its *Werkstattgruppe* helped to establish for the purpose of securing representation for the German quality crafts at major fairs.[68]

The various groups clustered around Karl Gross's *Werkstattgruppe* were not the only foci of *Handwerk* representation within the Werkbund. Another was Dr. Erich Wienbeck, syndic of the *Handwerkskammer Hannover*, and from 1920 deputy in the *Reichstag* for the *Deutschnationale Volkspartei* (DNVP). Wienbeck, who had joined the Werkbund executive early in 1919, became ex officio representative of the *Reichsverband des deutschen Handwerks* (National Association of German Artisans) formed

[66] The Werkbund membership list for 1928 used special symbols to indicate who belonged to the *Meisterring* or the *Werkstattgruppe*. There was a certain overlap between the two; and it was also possible to belong to the *Meisterring* without joining the Werkbund.

[67] "Sitzungsbericht, Vorstandssitzung des D.W.B. am 29. Oktober 1921 in München," pp. 4-5; "Mitteilungen des Reichskunstwarts," *Die Form*, I, No. 1 (1922), 57; E. Meissner, "Die Werkstattgruppe des deutschen Werkbundes," *Die Form*, I (1925-26), 29-30.

[68] Karl Gross, "Das Handwerk im Organismus des Deutschen Werkbundes," DWB-M, in *Die Form*, I, No. 1 (1922), 57. The initial manifesto of the *Wirtschaftsbund* appears in *ibid.*, p. 59. Its newsletter was published as a supplement to *Die Form*, I, Nos. 1-3, but did not appear in the last two issues of the 1922 publication.

later that year.[69] Concerned primarily with the economic and social aspects of the crafts predicament, Wienbeck urged Werkbund opposition to the luxury tax and generally tried to mold the association into a pressure group serving the interests of organized *Handwerk*. By contrast, Julius Schramm, a master craftsman and member of the *Meisterring*, concentrated on artistic and educational matters, acting as a link between the creative art workers, the craft guilds (*Innungen*) that represented general artisan interests, and the Werkbund.[70] Attempts to involve craftsmen directly in the work of the Werkbund executive came to nothing, however.[71] One must conclude that even the select minority of German artisans with pretentions to artistic excellence had reservations about the Werkbund and preferred to work through smaller groups made up exclusively of their fellows.

Of all the associations created in the era of Werkbund cooperation with *Handwerk*, the one that initially gave most promise of success was the *Arbeitsgemeinschaft für Handwerkskultur*. Founded on the initiative of the *Reichskunstwart* in January 1922, its executive committee included representatives of the *Reichskunstwart*, the *Reichsverband des Deutschen Handwerks*, the *Verband deutscher Kunstgewerbevereine*, the *Deutscher Bund Heimatschutz*, and the Werkbund.[72] The Werkbund played an active role at the first major convention of the *Arbeitsgemeinschaft* held at Hannover on June 12, 1922, and for some time thereafter gave energetic support to the

[69] Winkler, *Mittelstand*, p. 84.

[70] Gross, "Das Handwerk im Organismus des Deutschen Werkbundes," p. 56.

[71] Poelzig, in July 1919, had urged that more art workers be co-opted into the executive, and Wienbeck was charged with bringing back a list of suitable names after consultation with Karl Gross. Cf. "Vorstand, July 30, 1919," pp. 5 and 10. There is no evidence that this attempt to shift the balance away from the artists and architects to the craftsmen met with any success.

[72] "Mitteilungen des Reichskunstwarts," *Die Form*, I, No. 1 (1922), 58.

new association.[73] In this, it had the enthusiastic backing of the *Werkstattgruppe*, which regarded the *Arbeitsgemeinschaft* as the centralizing organ for all interested in the preservation of a vigorous crafts tradition.[74]

By giving the crafts a more important place in its councils and by supporting the *Arbeitsgemeinschaft für Handwerkskultur*, the Werkbund in the early 1920's amply demonstrated that it shared the widespread belief in the economic and cultural significance of *Handwerk*. Yet its close identification with the organized crafts proved short-lived, and it is instructive to examine the reasons for the subsequent estrangement. In part this resulted from a conflict of personalities between the Werkbund president, Richard Riemerschmid, and Edwin Redslob, who played a leading role in the new association. But at the root of the quarrel that led to the Werkbund's withdrawal from the *Arbeitsgemeinschaft* was a difference of outlook on issues that was merely brought to a head by personal antipathy between the leaders of the two organizations.[75]

In the first place, the dispute seems to have hinged on the definition of "quality." The Werkbund leadership could not accept the view of Redslob and the *Arbeitsgemeinschaft* that a sense of tradition, local pride, and "rootedness" sufficed to produce quality in the arts and crafts.[76] To Riemerschmid and others in the Werkbund, true quality

[73] "Mitteilungen des Reichskunstwarts," *Die Form*, I, No. 4 (1922), 59.

[74] Report on a meeting of the *Werkstattgruppe* in Munich, July 1, 1922, in DWB-M, *Die Form*, I, No. 5 (1922), 53.

[75] Riemerschmid detailed his charges against Redslob in a letter of March 12, 1923, BA, Rep 301/110, and another of April 14, 1923, BA, Rep 301/111. See also his comments to the Werkbund executive, "Protokoll der Vorstandssitzung des Deutschen Werkbundes in Berlin am 23. Juli 1923 . . ." [hereafter "Vorstand, July 23, 1923"], p. 2. The annual report of the Werkbund for 1923 explained its decision to withdraw from the *Arbeitsgemeinschaft*. See DWB-M No. 5, Aug. 27, 1924, p. 1.

[76] See Redslob, *Die Werbekraft der Qualität*; and Karl Gross, "Das Handwerk im Organismus des Deutschen Werkbundes," p. 56. The latter cited "Bodenständigkeit" (rootedness) as one of the qualities that the *Meisterring* particularly hoped to encourage in the work of its apprentices.

had to include elements of artistic originality. When it became evident that very few craftsmen were genuinely interested in the cause of modern design, the hope waned that the gulf between designer and executant would ever be bridged from the side of the artisans. The Werkbund therefore began once more to stress the essential role of the professional artist in the design process, for example encouraging the *Arbeitsgemeinschaft* to publish a set of patterns or *Musterblätter* for craftsmen to copy.[77] But the *Arbeitsgemeinschaft* was relatively uninterested in propagating Werkbund models. It preferred to encourage the revival of the regional folk arts and did little to combat the essentially conservative predilections of the majority of artisans.

Meanwhile, the Werkbund also drifted apart from other groups concerned with the quality crafts, such as the *Bund Heimatschutz* and the *Werdandibund*. The former, although it contained progressive elements, tended after 1919 to favor preservation of the crafts and of traditional forms for their own sake. The *Werdandibund* went even further, becoming a bitter foe of all things modern and an enthusiastic spokesman for *völkisch* art. The Werkbund could not accept the idea that style should be based either on the imagined requirements of some ideal "German" type or on the fossilized survivals of outdated local handicraft designs.[78] Convinced that contemporary forms must be based on the actual needs of living Germans, it found it impossible to work in close collaboration with the *Arbeitsgemeinschaft* once that association had unmistakably revealed its conservative bias. From regarding the *Arbeitsgemeinschaft* as a useful ally in the fight for quality, good design, and the creation of a modern national style, the Werkbund came to perceive it first as a rival and finally as an enemy.

[77] "Vorstand, Nov. 6, 1922," p. 6.
[78] Lehmann-Haupt, *Art under a Dictatorship*, p. 66; Theodor Heuss, "Zeitstil und Volksstil," *Deutsche Kunst und Dekoration*, L (April 1922), 5₄. Heuss here referred contemptuously to the *Werdandibünde* as "half-living offspring of Dilettantism and Conceit."

The break with the *Arbeitsgemeinschaft für Handwerks-kultur* was produced above all by growing doubts about the future role of *Handwerk* in the national culture. In 1919, with the apparent breakdown of the system of industrial capitalism, it was possible for some intellectuals to assert that the future economy of Germany would be based on handicraft production; but by 1923 no amount of admiration for the creative craftsman or sympathy for the plight of the handworkers as a group could obscure the fact that progressive mechanization was inescapable. Despite the chaos induced by monetary inflation, the process of modernization and rationalization accelerated during the early 1920's, stimulated by the availability of cheap credit. As a result, Riemerschmid, Heuss, and other Werkbund notables were confirmed in their view that the association would have to come to terms with modern technology if it wished to impress its ideals on the developing mass society.

In 1921, when Riemerschmid had insisted that the Werkbund's aesthetic preference for the handicrafts must not lead to neglect of the design problems in industry, he was relatively isolated. By 1923, many Werkbund people, even among the artists, had come around to his point of view. Not surprisingly, Peter Behrens led the way, pointing out that acceptance of modern industrial technology was the only alternative to economic ruin.[79] But even zealous advocates of the crafts began around 1922 to modify their ideas to take greater account of economic realities. Thus Karl Gross found it expedient to stress the contribution of *Handwerk* to machine design and the training of skilled workers for industrial production.[80] Similarly, Walter Gropius now insisted that the crafts taught in the Weimar Bauhaus were to be regarded not as ends in themselves but as preparation for the experimental development of industrial prototypes. His Werkbund speech of the summer

[79] Peter Behrens, "Stil?" *Die Form*, I, No. 1 (1922), 5-7.
[80] Gross, "Das Handwerk im Organismus des Deutschen Werkbundes," pp. 56-57.

of 1923, in which he publicly proclaimed the new unity of art and technology, marked him as a renegade to the *Handwerk* cause.[81] Although Gropius failed to persuade all his listeners, his new slogan undoubtedly strengthened the position of those within the Werkbund who, for whatever reason, thought it time to abandon the handicrafts to their fate and concentrate once more on matters affecting broader strata of German society.

Even after the Werkbund decided to leave the *Arbeitsgemeinschaft für Handwerkskultur* in November 1923, it continued to encourage the art workers of the *Werkstattgruppe* and to interest itself in the stylistic aspects of handicraft production. Nor did the Werkbund cease to cooperate with the *Reichskunstwart* whenever it could do so without compromising its progressive principles or condoning the artistically second-rate. However, the Werkbund never again enjoyed the full confidence of the *Handwerk* interests, nor was it able to revive the special relationship with Redslob that it had initially enjoyed.[82] During the next few years, as attention increasingly focused on questions of architecture and industrial design, the problems of the crafts were relegated to the periphery of Werkbund concerns. When the debate on handicrafts versus machine design was resumed later in the decade, it took place in an entirely new context. By then, the majority within the Werkbund had come to recognize

[81] Franciscono, *Walter Gropius*, p. 68; Lindahl, "Zukunftskathedrale," p. 265. But Franciscono shows that Gropius had never turned his back completely on industry. Cf. *Walter Gropius*, pp. 25-26 and Appendix A.

[82] In 1920, Redslob had set up a division of his office, headed by Otto Baur, to deal specifically with Werkbund matters. "V-A Oct. 25, 1920," p. 6. However, by 1923 he and Baur were scarcely speaking to each other, and Redslob and Riemerschmid hoped at best to arrange monthly meetings between them. Letter from Redslob to Riemerschmid, March 29, 1923, *BA*, Rep 301/110. In November 1923, Redslob in effect withdrew from the German Werkbund, while remaining close to its *Werkstattgruppe*. He preferred the less doctrinaire Austrian Werkbund, which invited him to become an honorary member. Cf. letter from Redslob to Riemerschmid, Nov. 8, 1923, *BA*, Rep 301/111; and interview with Redslob, Dec. 8, 1972.

what G. J. Wolf had already perceived in 1920, namely, that the identification of the Werkbund with *Handwerk* constituted a temporary aberration from the fundamental Werkbund ideal.[83]

Forced to maneuver between the radical Left and the *völkisch* Right, the Werkbund by 1923 had become somewhat colorless in its neutrality, a "shapeless pudding" incapable of inspiring genuine enthusiasm among the young.[84] Under Riemerschmid's leadership, it tended to favor a featureless eclecticism in the name of quality, and to reemphasize the eternal character of good design in its effort to avoid both modish radicalism and romantic reaction. Yet one can argue that this policy may have been the price of survival, and that the executive, whatever its shortcomings, had laid the foundations for future progress. Like the Weimar Republic itself, the Werkbund had maintained its organizational viability at the cost of sacrificing some of its early idealism, but its supporters saw no reason to doubt that it would be able to attain its fundamental goals, once the economic crisis had been overcome.

[83] Wolf, "Handwerkliche Kunst," *Deutsche Kunst und Dekoration*, xxiv, No. 2 (1920), Supplement.

[84] *GerN*, Gropius to Riemerschmid, May 23, 1921, denounced Riezler's programmatic speech at the Munich annual meeting as "ein Hymnus auf die breite Mitte, auf eine Geschmackskultur," its contents "farblos und neutral." The description of the Werkbund as a "formloser Brei" appeared in a letter from Gropius to Bartning, June 2, 1921, *Bauhaus*, GN 10/124.

1. Friedrich Naumann (1860-1919)

2. Hermann Muthesius (1861-1927)

3. Henry van de Velde (1863-1957)

4. Theodor Fischer (1862-1938)

5. Peter Bruckmann (1865-1937)

6. Hans Poelzig (1869-1936)

7. Richard Riemerschmid (1868-1957)

8. Ernst Jäckh (1875-1959)

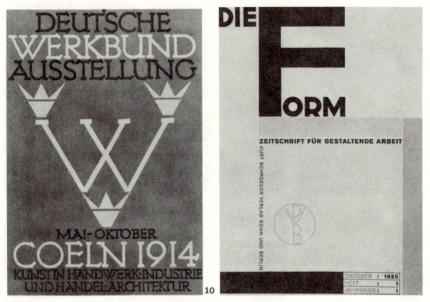

9 10

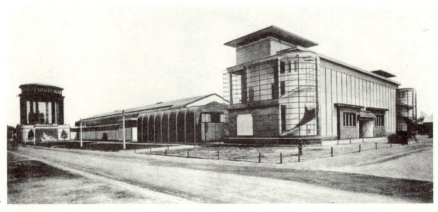

11

9. Poster by F. H. Ehmcke

10. Title page, first number of *Die Form*

11. Walter Gropius, Administration Building
and Model Factory, 1914

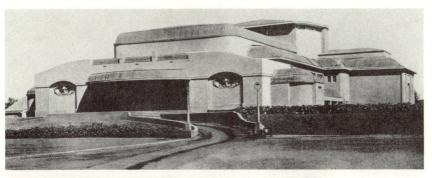

12

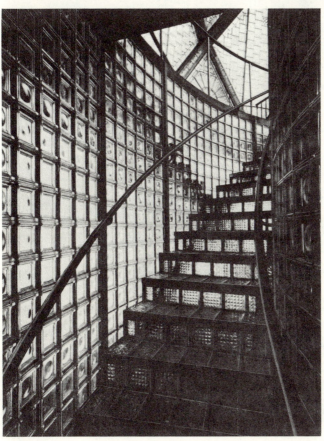

13

12. Henry van de Velde, Theater, 1914

13. Bruno Taut, Glass Pavilion staircase, 1914

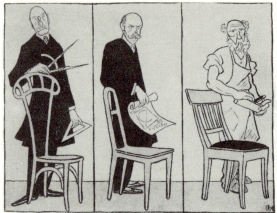

14

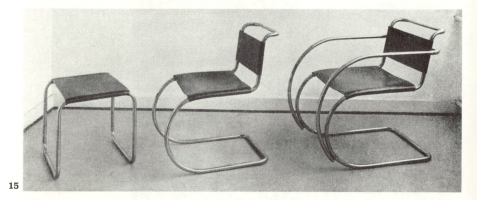

15

HOUSEWARES

16

17

14. Karl Arnold, cartoon from *Simplicissimus*, 1914. "Van de Velde designed the individu- alistic chair—Muthesius, the typical chair —and carpenter Heese, the chair for sitting on."

15. Ludwig Mies van der Rohe, tubular steel chair, Stuttgart Exhibition, 1927

16. Cooking pots, *Deutsches Warenbuch*, 1916

17. Hermann Esch, office clock, 1929

18

19

20 21 22

23 24

. Stemware, *Deutsches Warenbuch*, 1916

. Fireproof dishes, *Deutsches Warenbuch* 1916

. Gerhard Marcks, coffee maker, 1928

21. Ferdinand Kramer, desk, 1924

22. Wilhelm Wagenfeld, cubic dishes, 1938

23. Hermann Gretsch, dinner service, 1931

24. Georg Mendelsohn, metal containers, 1924

25

26

25. Bruno Paul, dining room, Dresden Exhibition, 1906

26. Ferdinand Kramer, dining room in the house designed by Oud, Stuttgart-Weissenhof, 1927

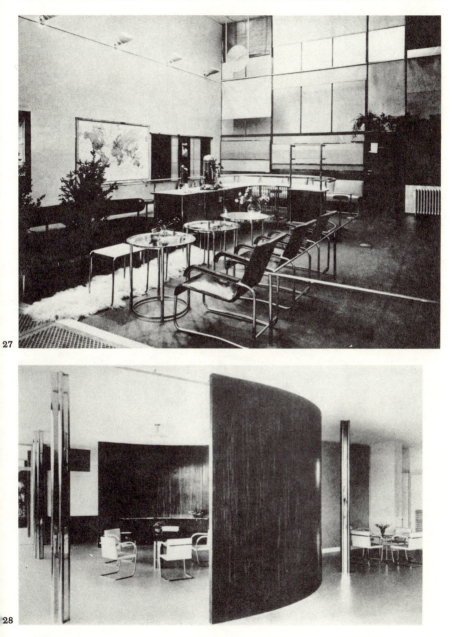

27. Walter Gropius, lounge, Paris Exhibition, 1930

28. Ludwig Mies van der Rohe, living room, Haus Tugendhat, 1930

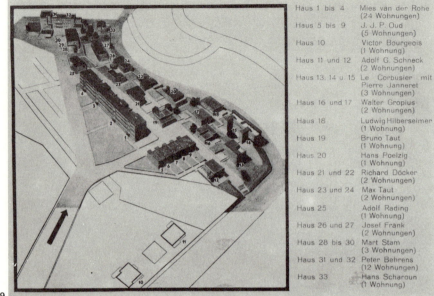

Haus 1 bis 4	Mies van der Rohe (24 Wohnungen)
Haus 5 bis 9	J. J. P. Oud (5 Wohnungen)
Haus 10	Victor Bourgeois (1 Wohnung)
Haus 11 und 12	Adolf G. Schneck (2 Wohnungen)
Haus 13, 14 u. 15	Le Corbusier mit Pierre Janneret (3 Wohnungen)
Haus 16 und 17	Walter Gropius (2 Wohnungen)
Haus 18	Ludwig Hilberseimer (1 Wohnung)
Haus 19	Bruno Taut (1 Wohnung)
Haus 20	Hans Poelzig (1 Wohnung)
Haus 21 und 22	Richard Döcker (2 Wohnungen)
Haus 23 und 24	Max Taut (2 Wohnungen)
Haus 25	Adolf Rading (1 Wohnung)
Haus 26 und 27	Josef Frank (2 Wohnungen)
Haus 28 bis 30	Mart Stam (3 Wohnungen)
Haus 31 und 32	Peter Behrens (12 Wohnungen)
Haus 33	Hans Scharoun (1 Wohnung)

29

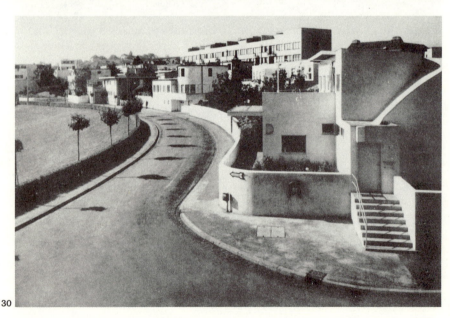

30

29. Site plan, Stuttgart-Weissenhof, 1927

30. Street scene, Stuttgart-Weissenhof, 1927

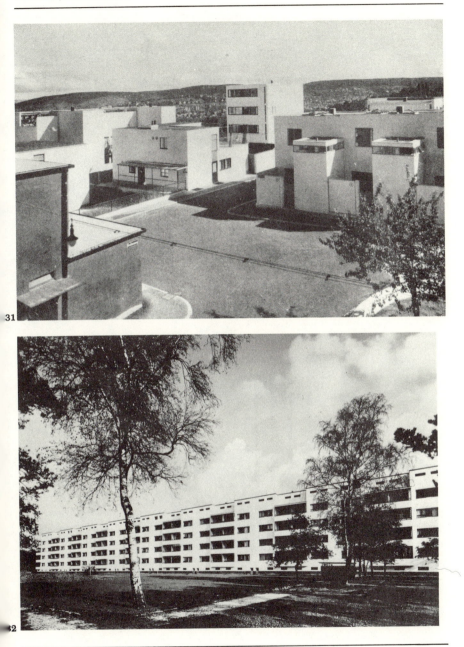

31. View of the houses by Gropius, Le Corbusier, and Oud, Stuttgart-Weissenhof, 1927

32. Walter Gropius, apartment houses, Siemensstadt, Berlin, 1929-1930

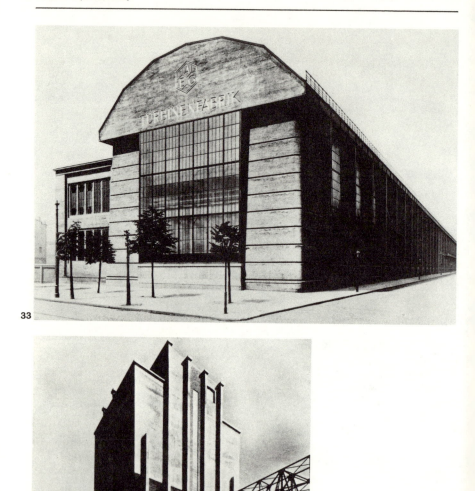

33. Peter Behrens, A.E.G. Turbine Factory, Berlin, 1909-1910

34. Alfred Fischer, Coal Tower, Zeche Sachsen, Hamm i. W., 1926

CHAPTER VII

Alliance with the Future: 1924-1929

WHEN stabilization of the currency at the end of 1923 brought inflation to a halt, the affairs of the Weimar Republic took a turn for the better. The restoration of relative equilibrium in the economic and political spheres raised hopes for a period of progress, and the Werkbund responded by resuming its prewar role as focus of the nation's forward-looking cultural elements. From 1924 it once more secured the cooperation of a portion of the artistic avant-garde; and it enjoyed the confidence and patronage of governments to an extent never achieved under the Imperial regime. Without minimizing the importance of the pioneer work performed before 1914, one can fairly assert that the Werkbund reached the peak of its influence between 1924 and 1929, serving as the "megaphone" of Germany's productive elite.[1]

The most striking feature of the Werkbund during this period was its unprecedented entry into conscious alliance with a specific artistic movement. Outsiders had long claimed to recognize a "Werkbund" style, some equating this with the *Jugendstil* and others with the eclectic neoclassical "functionalism" of Peter Behrens. But the association had always insisted that its primary aim was to propagate quality rather than to enforce a particular set

[1] S. Giedion, in Leonard Reinisch, ed., *Die Zeit ohne Eigenschaften: eine Bilanz der zwanziger Jahre* (Stuttgart, 1961), p. 12. On the Weimar Werkbund's significance, see also Paul Ortwin Rave, *Kunstdiktatur im Dritten Reich* (Hamburg, 1949), p. 16; and Schaefer, *Roots of Modern Design*, p. 168.

of formal or design principles. In the mid-1920's, it continued to maintain this position in theory, but by 1926 its leaders, at least, identified themselves with the movement known as the *Neue Sachlichkeit*.

Variously translated as "Neo-functionalism" or "Neo-objectivity," the *Neue Sachlichkeit* dominated the modern movement in architecture (in German, *Neues Bauen*) at a time when architecture had become the Werkbund's prime concern. More generally, the Werkbund during these years acted as propagandist for the modern age or *Neue Zeit*, using every technique at its disposal to define the form and spirit of the new era. It sponsored major exhibitions that gave progressive architects and designers the opportunity to experiment with new forms and materials; and in 1925 it resumed publication of *Die Form*, which quickly became one of the most influential organs of the modern movement. Edited first by Walter Curt Behrendt and from 1927 by Walter Riezler, this periodical constituted the nucleus of a broad Werkbund publishing program committed to the cause of contemporary design. The annual meetings, too, served the cause, focusing attention on major issues and exploring their implications for German society. To describe the Werkbund's activities during these vital and productive years in detail would require a book in itself. Here it will be possible only to outline its main contributions and to analyze the reciprocal relationship between the Werkbund and the chief artistic, intellectual, and social developments of the time. For the Werkbund both reflected and helped to shape current trends, and so to determine the character of "Weimar culture."

Expressionism and the associated *Handwerk* mystique, which preceded the vogue of the *Neue Sachlichkeit*, had already begun to evaporate in Germany by the early 1920's. In June 1921, Theodor Heuss could speak of the revolutionary postwar atmosphere in valedictory phrases and note an emerging ethos compounded of disillusion-

ment and sensible realism.[2] A year later, the tendency to elevate Expressionism to the status of the *Zeitstil*, against which Riezler had warned at the 1921 Werkbund congress, had yielded to a mood of tolerant eclecticism. In the first issue of *Die Form* of 1922, the architect Wilhelm Kreis welcomed the practical reconciliation between artists who only a short time earlier had unreservedly condemned one another.[3] His views were echoed by a younger colleague, Otto Bartning, who insisted that neither the Expressionists nor their chief adversaries, the purists of the Dutch *De Stijl* movement, could legitimately claim to represent the style of the future, and urged the practicing architect to take what suited his purposes from either camp.[4] Hans Poelzig, too, warned against artistic dogmatism, and argued that the ideal designer combined practicality with artistic fervor, dedicating himself solely to the requirements of function, material, and form.[5]

While some undoubtedly regretted the passing of the revolutionary epoch with its mood of utopian experimentalism, the general sentiment within the Werkbund was one of relief. The chaos of styles produced by the revolution no longer seemed a phenomenon to celebrate but a disorder to overcome. By 1922, most recognized that the unified style they all desired could not be imposed by fiat of the artist, but would at best emerge, after a time of transition, as the end product of myriad individual modifications of designs inherited from a very different past.[6]

[2] "Werkbund und Wiederaufbau," *Stuttgarter Neues Tagblatt*, June 2, 1921.

[3] "Die neue Einigung," *Die Form*, I, No. 1 (1922), 12-13. Kreis had been a signatory of the first Werkbund appeal of 1907.

[4] "Die Baukunst als Deuterin der Zeit," *ibid.*, p. 14.

[5] "Vom Bauen unserer Zeit," *ibid.*, p. 16; and "Architekturfragen" in Paul Westheim, ed., *Künstlerbekenntnisse: Briefe, Tagebuchblätter, Betrachtungen heutiger Künstler* (Berlin, [1923]), pp. 228-31.

[6] Theodor Heuss, "Stil und Gegenwart," *Die Form*, I, No. 1 (1922), 14-15; Walter Riezler, "Zum Geleit," *ibid.*, pp. 1-4; also, W. C. Behrendt, "Geleitwort," *Die Form*, I, No. 1 (1925-26), 2.

A number of reasons have been adduced to explain this change in atmosphere. Recognition of the failure of Germany's political and social revolution played an important part. The bloody suppression of the Spartacist rising by agents of the Social Democratic government in January 1919 destroyed the faith of many intellectuals and artists in the cause to which they had rallied in November 1918.[7] Moreover, it soon became apparent that the socialist-dominated governments could or would do little for art, and this produced, among the artists, a corresponding loss of enthusiasm for socialism.[8] Above all, as inflation increasingly hampered construction, the utopian architects, left without immediate prospect of realizing their more imaginative designs, tended to adopt a more practical approach. Yet the loss of revolutionary ardor antedated the climax of the inflation that came in November 1923, so that inflation alone can not be made to account for the end of the Expressionist era.[9]

Moreover, the *Neue Sachlichkeit* was more than a reaction against the exaggerated individualism and utopianism of the Expressionist years. At first, the term denoted only a return to practical realism and a renewal of concern with the functional determinants of style; but before long it developed theoretical pretensions of its own. As applied to the decorative arts and architecture, it represented a new canon of style that combined functionalism with purely aesthetic elements derived from Cubist painting. In fact, the phrase *"Neue Sachlichkeit"* was coined by a painter, Otto Dix, to describe "the new realism bearing a

[7] Stressig, "Hohenhagen," pp. 473-74.

[8] On the failure of the socialists in power to fulfill the expectations of the artist-intellectuals, e.g., Otto Grautoff, *Die neue Kunst* (Berlin, 1921), p. 132. Grautoff did not mention the Werkbund explicitly, but cited its leading personalities as representative of the tendencies he thought the new Reich should encourage.

[9] Lindahl, "Zukunftskathedrale," p. 248, stresses the importance of inflation; but cf. Charles Jencks, *Modern Movements in Architecture* (Harmondsworth, 1973), pp. 112-13. It has been argued that the very inability to build encouraged contemporaries to indulge in utopianism and fantasy.

socialist flavor" and making a creed of the machine.[10] Only in the mid-1920's was it used, by Gustav Hartlaub, director of the Art Gallery at Mannheim, to characterize the new movement in the applied arts and architecture.[11]

A noteworthy characteristic of the *Neue Sachlichkeit* is that it appealed by and large to the same artists who had espoused the Expressionist-handicraft position just a short time before. Thus when Walter Gropius, in 1923, adopted "Art and Technology: a New Unity" as the slogan of the Bauhaus, he was simply exchanging one credo for another.[12] In doing so, he seems to have voiced a widespread longing for a new faith, for about the same time Adolf Behne, Bruno Taut, Walter Curt Behrendt, and others abandoned their former ideals to become propagandists for the *Neue Sachlichkeit*.[13] What is more, they propagated their new convictions with the same fervor as they had the old, acting in a spirit far removed from the cold rationalism implied by the word *Sachlichkeit* itself.[14]

[10] Egbert, *Social Radicalism and the Arts*, p. 640.

[11] Wolfgang Sauer, "Weimar Culture: Experiments in Modernism," *Social Research*, XXXIX, No. 2 (Summer 1972), 271-72. Sauer's essay deals with Expressionism and *Neue Sachlichkeit* as the two main intellectual movements of the 1920's. In Sauer's view, neither has received from intellectual historians the attention it deserves. On the origins and meaning of *Neue Sachlichkeit*, see also Lane, *Architecture and Politics*, pp. 130-33 and p. 251, notes 24, 25, 30, and 31.

[12] On the change of attitude within the Bauhaus, Lindahl, "Zukunftskathedrale," pp. 260-67; and Jencks, *Modern Movements in Architecture*, pp. 112-18. Jencks accuses Gropius of moving towards rationalism solely "because the Zeitgeist was headed in this direction and it was convenient for Gropius to follow it."

[13] Behrendt, who may be regarded as typical, between 1919 and 1924 edited *Die Volkswohnung*, organ of the romantic antiurbanists around Tessenow and Taut. Converted to the *Neue Sachlichkeit* in 1924, he started a journal, *Der Neubau*, that stressed the need for standardization and technological innovation and, in the formulation of housing policy, gave precedence to economic necessity over socio-cultural idealism. Lindahl, "Zukunftskathedrale," pp. 280-82.

[14] *Ibid.*, p. 282; Sauer, "Weimar Culture," p. 271. Banham, *First Machine Age*, p. 269, remarks that the waning of Expressionism did not lead to a rupture of relations among the architects, for men

Although superficially antagonistic, Expressionism and *Neue Sachlichkeit* represented a continuous development. As Behne stated in 1922, the latter was essentially a postwar phenomenon, unthinkable without the intervening Expressionist phase despite its obvious links with the functionalism of Muthesius and the prewar Werkbund.[15] Gropius, too, conceived his ideas of 1923 less as a reconversion to prewar functionalist ideals than as a conversion to a new faith, in which the *Wohnmaschine*, the machine for living, replaced the *Zukunftskathedrale* or "cathedral of the future" as the symbol of creative aspiration.[16] The Bauhaus artist Oskar Schlemmer summed up the transformation in a diary entry for June 1922:

> "Rejection of Utopia. We can and may only desire reality, and strive to realize our ideas. Instead of cathedrals, the machine for living. Rejection therefore of all things medieval including the medieval concept of the handicrafts, the latter to be regarded purely as a training device and a design technique. Instead of ornamentation—the inevitable product of nonfunctional or aesthetic handicrafts informed by medieval notions—functional objects that serve their purpose."[17]

The Werkbund's first postinflation exhibition, mounted by the association's Württemberg branch in 1924, reflected the new mood. Devoted to *Form ohne Ornament*—un-

"changed their attitudes but not their friends." He fails to point out that many of these "friends" changed their views simultaneously!

[15] "Kunst, Handwerk, Technik," p. 1037. Behne, formerly secretary of the *Arbeitsrat für Kunst*, became the high priest of the *Neue Sachlichkeit*. See his *Der moderne Zweckbau* (1926; republished Berlin, 1964).

[16] Franciscono, *Walter Gropius*, p. 68. Banham, *First Machine Age*, pp. 192-93, accuses Gropius of adopting an outdated aesthetic fatally linked with prewar ideas, but this is no more accurate than the contemporary critique by Theodor Heuss, who charged Gropius in 1923 with betraying art in favor of a cold intellectualism. Heuss, "Bilanz von Weimar," *Werkbund-Gedanken*, Oct. 10, 1923.

[17] Oskar Schlemmer, *Briefe und Tagebücher* (Munich, 1958), p. 132.

ornamented form—this exhibition, originating in Stuttgart, demonstrated that the Werkbund had firmly turned its back on revolutionary Expressionism. Its positive message was considerably more ambiguous, however, for the notion of unornamented form proved to be a complex one, derived from several distinct or even contradictory sources. In one sense, it involved a return to the extreme functionalism of Adolf Loos, who years before had declared "ornament" irrelevant to modern life. Although Loos himself refused to recognize the derivation and denounced the Werkbund publication on the 1924 exhibition as "perfidious," the association believed it was moving in Loos's direction and hoped to win his approval.[18]

A second source for the *Form ohne Ornament* exhibition was the contemporary need to evolve standardized forms or types suitable for mass production. The trend to formal simplicity, rationality of design, and machine technology that had been welcomed by Muthesius and others in the prewar Werkbund, accelerated as hard times forced consumers to put a premium on utility and to regard ornamentation as extravagance. A third group of designers opposed excessive ornamentation primarily out of romantic nostalgia for the simplicities of the preindustrial age. This "neo-Biedermeier" spirit, which emphasized formal simplicity in the name of bourgeois good taste, inspired numerous contributors to the *Form ohne Ornament* exhibition.[19] Finally, the exhibition included the

[18] Loos, *Sämtliche Schriften*, pp. 213-14. Loos was referring to *Form ohne Ornament*, ed. W. Pfleiderer (Stuttgart, 1924). In an essay of the same year entitled "Ornament und Erziehung" (*Sämtliche Schriften*, pp. 391-98), Loos explained that he had never favored the total abolition of ornament demanded by the purists, but simply believed that ornament should not be restored where the principle of utility had led to its disappearance. The Werkbund reprinted portions of an article by Loos in *DWB-M* No. 7, Oct. 28, 1924. Cf. also Kubinsky, *Adolf Loos*, pp. 8-10.

[19] Pfleiderer introduction. DWB, *Form ohne Ornament*, pp. 3-22. The nostalgia for bourgeois standards is reflected in Hans Franke, "Werkbund und Provinz," *Werkbund-Gedanken*, No. 1, Jan. 1924. Franke welcomed the puritanism enforced by economic stringency

work of men who favored unornamented form for aes-
thetic reasons, either as abstract art or as symbol of the
machine age. Rejecting functionalism as the chief de-
terminant of style, they used form as a substitute for orna-
ment, a kind of ornament in itself.[20]

Although the *Form ohne Ornament* exhibition lacked a
consistent theoretical basis, and contained nonmodern ele-
ments, it played a significant role in the development of
the modern movement. By displaying a careful selection
of objects centered on a single theme, the Werkbund at
Stuttgart demonstrated the aesthetic potential of formal
simplicity and unornamented design. To the extent that it
emphasized a simple functionalism ideally suited to mass
production by machine, the exhibition encouraged the evo-
lution of a contemporary style in tune with both the tech-
nological requirements and the progressive spirit of the
age. The juxtaposition of handcrafted and machine-made
objects strengthened the general effect, as did the inclu-
sion of work emanating from the experimentally-inclined
Bauhaus next to the more traditional products of groups
like the *Deutsche Werkstätten*. While many in and outside
the Werkbund were shocked by some of the exhibits, the
fact that avant-garde designs were shown in the context
of current quality production rendered them somewhat
more palatable than they might have appeared in isola-
tion, and exonerated the Werkbund of the charge of doc-
trinaire modernism.[21] At the same time, by rejecting both
the ornate period styles and the agitated Expressionism of

as a way of raising the level of visual culture and, more important,
of renewing a true sense of community.

[20] Wilhelm Lotz, "Kunstgewerbe und Kunst," *Dekorative Kunst*,
XXXII, No. 9 (June 1924), 218-23; and "Das Ornament," *Dekora-
tive Kunst*, XXXII, No. 11 (Aug. 1924), 264-72. Also Schaefer, *Roots
of Modern Design*, p. 168; and Jencks, *Modern Movements in
Architecture*, pp. 115-16. The evolution of form as ornament was
taken up in a theoretical work published by the Werkbund in 1926,
Ernst Kropp, *Wandlung der Form*, Bücher der Form, v (Berlin,
1926).

[21] See Oskar Wolfer, "Die Werkbundausstellung 'Die Form' in
Stuttgart," *Dekorative Kunst*, XXXIII, No. 1 (1925), 20.

the immediate postwar period, the exhibition strengthened the trend to *Neue Sachlichkeit*, and publicly identified the Werkbund with this emerging tendency.[22]

Although the exhibition's thematic organization lent it an air of novelty, it remained essentially an arts and crafts display of the traditional kind. But as the spirit of *Neue Sachlichkeit* grew stronger, its protagonists within the Werkbund became convinced that the art industries and handicrafts could not provide the needed impetus for creation of a truly functional modern form. Despite a trend to greater formal simplicity, the spirit of radical functionalism never made substantial inroads in the sphere of German *Kunstgewerbe*.[23] The *Form ohne Ornament* exhibition had further demonstrated that one could not create modern forms simply by stripping objects of excessive ornamentation. Treated as a slogan, *"Form ohne Ornament"* seemed capable only of producing a new formalism, one that threatened almost instantly to degenerate into just another transitory and exploitable fashion.[24]

The Werkbund did not suddenly cease to regard itself as an organ of the arts and crafts movement, but by the mid-1920's its leaders had definitely abandoned faith in the crafts as a source of stylistic inspiration. Instead, following the pattern established by Muthesius, Poelzig,

[22] This was even more true of the version of the exhibition sent on a tour of several German cities. Cf. the catalogue of the exhibition in the Kunsthalle Mannheim, introduced by Gustav Hartlaub (Mannheim, 1925).

[23] The high point of modernity in the German art industries was probably reached around 1928 with the publication of *Schlichte Deutsche Wohnmöbel*, ed. Theda Behme (Munich, 1928). Although this volume took the style of 1780-1830 as its model, a few examples of the "Bauhaus style" were included for comparison. Also instructive are the yearbooks of the *Deutsche Werkstätten*, Hellerau, 1928 and 1929, which featured the work of many Werkbund members. All these publications represented the conservative wing of the Weimar Werkbund and should be contrasted with the Werkbund's *Die Form* for the same years.

[24] W. C. Behrendt, "Die Situation des Kunstgewerbes," *Die Form*, I, No. 3 (1925-26), 37-41; S. Kracauer, "Das Suchen nach Form," *Innen-Dekoration*, XXXVI (1925), 105.

Schumacher, and others before the war, they argued that a reformation in the other arts depended on the prior development of a truly contemporary architecture.[25] This shift from the arts and crafts to architecture was stimulated after 1918 by the need to provide low-cost housing for Germany's swelling urban population. As early as 1919, Heuss had proclaimed housing one of the Werkbund's highest priorities, and a number of Werkbund members, notably Bruno Taut and Heinrich Tessenow, had addressed themselves to the design problems involved.[26] But it was only after the end of inflation that it became possible to mount a large-scale attack on the housing problem.[27]

Even the Bauhaus, which gave building the dominant place in its philosophy, turned seriously to the urgent problems of domestic architecture and city planning only after its move from Weimar to Dessau in 1925. Throughout its first phase, as its critics were quick to note, it tended to devote itself to such socially irrelevant matters as the design of modern drinking glasses, tea services, and chess sets.[28] In part this was due to adverse circumstances, as was pointed out by Karl Scheffler in an early issue of *Die Form*. Deprived of a chance to build, the early advocates of a "new style" were virtually forced into the realm of *Kunstgewerbe*, their social idealism thwarted and their energies dissipated on superfluities. It was the economic transformation initiated by the war and completed by inflation that finally created an environment in which socially significant architecture could flourish.[29]

[25] Lindahl, "Zukunftskathedrale," p. 233.

[26] Heuss, "Probleme der Werkbundarbeit," *Der Friede*, 1 (1918-19), 617-19. On the prewar roots of Taut's and Tessenow's housing ideas, Lindahl, "Zukunftskathedrale," pp. 243-48; and Lane, *Architecture and Politics*, pp. 17-18.

[27] Behrendt, "Die Situation des Kunstgewerbes," p. 41.

[28] H. de Fries, quoted in Lindahl, "Zukunftskathedrale," p. 269. De Fries's comment originally appeared in *Die Baugilde*, Jan. 1925, p. 78, on the occasion of the Bauhaus's decision to leave Weimar.

[29] "Vergangenes und Zukünftiges," *Die Form*, 1, No. 9 (1925-26), 181-86.

When building activity resumed in the middle of the decade, a new generation stood ready to translate into real terms the ideal of a modern style centered on and unified by architecture. After the annual meeting of 1923 in Weimar, the Werkbund had made systematic efforts to attract the youthful avant-garde artists, by associating itself with a conference group organized by Bruno Taut's friend, the radical sculptor P. Henning, in Berlin. However, it consistently rejected the idea of establishing a separate youth group, and its attempt to involve Henning and his followers in regular Werkbund activities came to nothing.[30] Instead, when the unsatisfactory arrangement with Henning was terminated in 1924, the Werkbund decided to give several young architects a place on its executive committee. Mies van der Rohe and Hans Scharoun were only 35 and 31 respectively when they joined the Werkbund leadership, replacing Otto Bartning (41) and Bruno Taut (44). At the Werkbund annual meeting of 1926 the transformation was completed when Riemerschmid resigned and Mies became first vice-president. On Mies's insistence, Peter Bruckmann, one of the association's elder statesmen, took on the presidency to preserve continuity, but the intention was clearly to give the young Mies actual control in Berlin, while Bruckmann kept a benevolent eye on proceedings from the safe distance of Heilbronn.[31] The Werkbund thus simultaneously proclaimed its faith in the new architecture and delivered itself into the hands of the young radicals whom it had until then managed to keep at bay.

When Mies was chosen to lead the Werkbund in 1926, he had only begun to prove himself as an architect. His reputation at the time rested less on his professional achievements than on the views he had publicly espoused. Well-known in radical circles because of his role in organizing exhibitions for the *Novembergruppe*, Mies had

[30] *DWB-M* No. 1, April 26, 1924; No. 4, July 1925.
[31] "Protokoll der Vorstands-und Ausschuss-Sitzung . . . in Essen am 23. Juni 1926," pp. 2-3 [hereafter "V-A, June 23, 1926"].

been connected since 1923 with the "G" group that advocated novel principles of design diametrically opposed to those of the Expressionists.[32] Then, in 1925, he helped found the *Ring*, an association of Berlin architects that became extremely influential in the next few years.[33] Mies, unlike Gropius, had not taken an active part in Werkbund affairs before 1914, but his association with the Werkbund movement dated back to the prewar years when he had worked, in turn, in the architectural offices of Bruno Paul and Peter Behrens. By selecting him as vicepresident and once more giving Gropius a place on the executive, the Werkbund could stress its support for the younger, more progressive talents in German architecture without making an absolute break with its past.

The election to the executive of Hugo Häring and Adolf Rading in 1926 and Ludwig Hilberseimer in 1927 completed the process of rejuvenation.[34] It also confirmed the dominance within the Werkbund of the *Ring* architects. The connection with the *Ring* did not in itself commit the Werkbund to a particular architectural aesthetic, for the group's "radicals"—including Häring, Mies, Gropius, Scharoun, and Rading—differed among themselves on aesthetic questions, while such prewar notables as Peter Behrens and Heinrich Tessenow were also members. But as far as the general public was concerned, the *Ring* represented the new architecture at its most extreme; and the Werkbund, by giving some of its younger members a

[32] Peter Blake, *Mies van der Rohe* (Harmondsworth, 1966), p. 33; Banham, *First Machine Age*, pp. 185 and 192-93. "G" stood for "Gestaltung" (design).

[33] On the *Ring*, Lane, *Architecture and Politics*, p. 127; Sharp, *Modern Architecture and Expressionism*, p. 82. A list of members as of 1926 appears in Peter Pfankuch, ed., *Adolf Rading* (Berlin, 1970), p. 8.

[34] To appreciate the magnitude of the change in 1926, one must note that Riemerschmid had been running the Werkbund since 1924 with the help of an "inner council" consisting of Bruckmann, Poelzig, and Paul, seldom calling meetings of the full executive or consulting with the association's younger members. *DWB-M* No. 5, Aug. 27, 1924, p. 1.

prominent place in its councils, acquired a reputation for radicalism that it only partly deserved.

The reorientation of Werkbund policy in 1926 led to several further developments. One was creation of the association's first architectural committee by the Essen congress, which had declared architecture the foundation of the Werkbund's program.[35] Originally consisting of only seven members, this committee was empowered to co-opt an additional fourteen architects. The final group of twenty-one spanned the generations and represented a variety of views, showing that the Werkbund could command an impressive array of architectural talent.[36] Indeed, so many of Germany's leading architects became actively involved with the Werkbund after 1926, that it began to take on the attributes of an architects' association, a potential rival to professional groups like the *Bund deutscher Architekten* (BDA). In practice, relations between the Werkbund and the BDA remained close and amicable. Wilhelm Kreis of Düsseldorf, recently elected president of the BDA, joined the Werkbund executive in 1926, while Walter Gropius, at the suggestion of Hans Poelzig, became a member of the BDA's governing committee the following year.[37] By 1929, all but two of the BDA's enlarged executive were Werkbund members.[38] Kreis himself was certainly no radical, and sought a balance between the factions, but by the late 1920's, the BDA had come under the influence of the same young progressives who dominated the Werkbund.

Also in 1926 the Werkbund decided to turn its Berlin headquarters into a clearing house for everyone interested in the new architecture, and to this end solicited plans,

[35] "V-A, June 23, 1926," pp. 4-5.

[36] The original seven were Abel/Cologne, Bonatz/Stuttgart, Fischer/Essen, Rading/Breslau, Riemerschmid/Cologne, Poelzig and Mies van der Rohe/Berlin. For the final list of twenty-one, *DWB-M* March 1927.

[37] Gaber, *Entwicklung*, pp. 105-107.

[38] *Ibid.*, pp. 109-10.

photographs, and models from its members.[39] Its sympathy for the *Neue Bauen* found further expression in its journal, *Die Form*, which covered all aspects of creative design but gave increasing space to architecture and urban planning. Despite a limited circulation of around 5,000 copies, *Die Form* acquired a considerable reputation in Germany and abroad as the mouthpiece of the progressive architects, rivaled only by Ernst May's *Das neue Frankfurt*.[40] After October 1928, it changed over from monthly to biweekly publication, and its status as an architectural journal was enhanced in 1929 by inclusion of a regular section devoted to the economics of building.[41] The Werkbund sponsored a number of other publications that helped to propagate the modern movement in architecture, for example Ludwig Hilberseimer's *Internationale Neue Baukunst*.[42] Fi-

[39] *DWB-M* Oct. 1926. The Werkbund arranged architectural tours of Berlin for visitors to the city, and encouraged its branches to do likewise in the provinces.

[40] The circulation figure for *Die Form* comes from *Sperlings Zeitschriften- und Zeitungs-Adressbuch* for 1931, which gives a circulation of 7,500 for *Die Baugilde* (organ of the BDA) and only 1,000 for *Bauhaus*, edited by Ludwig Hilberseimer. Lane, *Architecture and Politics*, pp. 125-26 and 130, incorrectly states that *Die Form* "followed the example" of May's *Das neue Frankfurt* (1926-33) and Wagner's *Das neue Berlin* (1929). In fact, it was the earliest and longest-lived of the three. All, as Lane notes, stressed the "interrelationship of all aspects of art, culture and society" in the Werkbund manner. According to Frau Mia Seeger, Stuttgart, interview of April 28, 1973, *Die Form* never made money for its publishers, who regarded it as a prestige venture. On its importance for the history of design, cf. Lewis Mumford, *Technics and Civilization* (1934; reprinted New York, 1963), p. 456. Until Feb. 1926, *Die Form* served as the organ of the *Verband deutscher Kunstgewerbevereine*; the architectural emphasis became more pronounced after Riezler replaced Behrendt as editor in chief at the end of that year.

[41] Edited by Alexander Schwab, one of the Werkbund's most radical adherents. See Diethart Kerbs, "Alexander Schwab," *Werkbund-Archiv*, I, 159-67. Schwab's name does not appear on the Werkbund membership list for 1928, but his wife's does. (Dr. Hildegard Schwab-Felisch, an economist and follower of Friedrich Naumann).

[42] Stuttgart, 1927. Hilberseimer joined the Bauhaus in Dessau in 1928. A doctrinaire exponent of the *Neue Bauen*, he supplemented his work as architect and town planner with extensive journalistic activities.

nally, it spread the gospel of the *Neue Bauen* by arranging for well-known Werkbund personalities to travel from Berlin to all parts of Germany, addressing local Werkbund branches and other groups interested in learning more about the new architecture.[43]

Despite all these activities, it was the architectural exhibitions sponsored by the Werkbund that constituted its chief contribution to the *Neue Bauen*. The shift away from the arts and crafts to architecture led to a decision, in 1925, to organize a major building exhibition in Stuttgart devoted to the theme of contemporary living.[44] While a section of this exhibition was to display modern home furnishings, the plan outlined by the Württemberg Werkbund group in addition called for construction of a permanent housing estate on land owned by the city of Stuttgart. Consisting of a group of dwellings designed by progressive architects from Germany and abroad, this "Weissenhof" settlement was intended as a model development incorporating the latest technical, hygienic, and aesthetic improvements in domestic architecture.[45]

The Weissenhof scheme owed much to the initiative of Gustav Stotz, the energetic young executive director of the Württemberg Werkbund branch, who had worked since 1923 to strengthen the progressive tendencies within the association as a whole.[46] It was Stotz who originally recommended Mies van der Rohe as artistic director for the housing exhibition at Stuttgart, an appointment which proved to be a stepping stone to the vice-presidency of the

[43] Such lectures, regularly reported in the *Mitteilungen*, were sponsored both by Berlin headquarters and by the branches. For example, *DWB-M* Feb. 1927, April 1927. One of the most popular speakers on the Werkbund circuit at this time was Gropius.

[44] Resolution of the Werkbund annual meeting in Bremen, *DWB-M* No. 4, July 1925, p. 4.

[45] *DWB-M* April 1926.

[46] Stotz, when he joined the Werkbund in 1919, was manager of an art gallery in Stuttgart, the *Kunstausstellung Schaller*. An admirer of Gropius, he gave strong support to the Bauhaus when it ran into difficulties in Weimar. See the correspondence between Gropius and Stotz, *Bauhaus*, GN 2/79-80.

Werkbund.[47] Stotz and Mies together developed the exhibition program and selected the contributing artists. Eventually sixteen of Europe's leading modern architects designed some sixty dwellings for the Weissenhof site, ranging from single-family homes to entire apartment blocks. The chief foreign participants were Le Corbusier (France), Oud and Stam (Holland), Josef Frank (Austria), and Victor Bourgeois (Belgium). The German contributors, for the most part members of the *Ring*, included Mies himself, Gropius, Bruno Taut, Hans Scharoun, and Richard Döcker, as well as two Werkbund architects of the older generation, Peter Behrens and Hans Poelzig.[48]

The Werkbund in Berlin gave its unreserved support to the Stuttgart project, which also received subsidies from the recently established *Reichsforschungsgesellschaft für Wirtschaftlichkeit im Bau- und Wohnungswesen* (National Association for Economy in Housing and Construction). The latter reinforced the empirical-experimental bias of the Weissenhof, encouraging efforts to utilize new materials and cost-cutting techniques.[49] For a variety of reasons, however, it proved impossible to keep construction costs low, and critics could therefore deny that the Weissenhof structures provided models for inexpensive housing elsewhere as the exhibition's sponsors had hoped. Moreover, delays in completion of some of the buildings not only raised their cost but called in question the claim of the architects to have discovered more efficient methods of construction. The quality, comfort, and convenience of the buildings also left something to be desired, and while

[47] Frau Mia Seeger, Stuttgart, interview of April 28, 1973. Frau Seeger worked for the Werkbund, from 1925-28 in Stuttgart, and until 1932 in Berlin.

[48] For contemporary descriptions of the 1927 exhibition, see *Die Form*, II, Nos. 9 and 10 (1927), 257-328; and two Werkbund publications: *Bau und Wohnung* (Stuttgart, 1927) and Werner Gräff, *Innenräume* (Stuttgart, 1928).

[49] On the *Reichsforschungsgesellschaft*, Anna Teut, *Architektur im Dritten Reich 1933-1945* (Frankfurt, 1967), p. 53 [hereafter *Architektur*]; Benevolo, *History of Modern Architecture*, II, 449; Lane, *Architecture and Politics*, pp. 122-23, 164-65, 232-33.

this was not really surprising given their experimental character, it provided welcome ammunition for those hostile to the whole enterprise and wedded to traditional methods and forms.[50] Finally, although the participating architects differed in national origin, personality, and aesthetic views, they managed to create generally compatible structures characterized by a spare functionalism that friends of the *Neue Bauen* admired and its critics abhorred. The uniform appearance of the buildings as a group, achieved despite the fact that the exhibition's organizers had made no attempt to dictate stylistic conformity, gave rise to the view that the Werkbund sought to impose a rigid functionalist aesthetic on the nation.[51]

Paradoxically, one of the first and most profound critics of the Weissenhof was none other than the prewar apostle of functionalism, Hermann Muthesius. Muthesius, in a critique written on the eve of his death, welcomed the exhibition as a significant experiment, but argued that the solutions offered were not the product of functional considerations at all. Rather, they reflected a new formalism to which considerations of rationality, economy, and constructional requirements had been ruthlessly subordinated.[52] Thus at the very time when some of its opponents

[50] For an example of hostile criticism, see the articles on the exhibition by Felix Schuster in the *Schwäbische Merkur*, Sept. 3-Nov. 5, 1927 (Nos. 410, 434, 470, 482, 506, 518). Schuster taught at the Stuttgart Building Academy (*Höhere Bauschule*), a stronghold of preservationist sentiment and traditionalism. Cf. Wilhelm Kohlhaas, ed., *Chronik der Stadt Stuttgart 1919-1933* (Stuttgart, 1964), p. 254. See also the report on the findings of the *Reichsforschungsgesellschaft*'s Heating and Lighting Committee, which examined the Weissenhof dwellings and found them damp and costly to heat—or even unheatable. *Innen-Dekoration*, XL (June, 1929), Supplement.

[51] But Sharp, *Modern Architecture and Expressionism*, p. 82, points out that the selection of architects did contribute to the impression of unity. Thus Mies failed to invite Erich Mendelsohn, a leading exponent of Expressionism, and fell out with Häring, who withdrew soon after agreeing to participate.

[52] Posener, *Anfänge des Funktionalismus*, pp. 228-29. However, Heuss, in an obituary of Muthesius for the *Heimatdienst*, VII (1927), 379, stressed the continuity between Muthesius' functionalism and

deplored the Weissenhof's cold and alien functionalism, others were denouncing its alleged failure to conform to the demands of true *Sachlichkeit*.[53]

Despite its shortcomings and ambiguities, the 1927 Werkbund exhibition was an important event. With its associated displays, the Weissenhof attracted over half a million visitors. It established the reputation of Stuttgart as an exhibition center and of the Werkbund as a patron of the modern movement. By focusing public attention on the new architecture, it helped create a climate of opinion somewhat more favorable to further experimentation. Finally, it popularized the idea that exhibitions should incorporate permanent structures of genuine social utility. The Werkbund itself applied the Weissenhof pattern again in 1929 at Breslau. The exhibition of that year, on the theme of *"Wohnung und Werkraum"* (Home and Workplace), adopted certain features of the Stuttgart experiment while eliminating its more controversial aspects. In particular, the Werkbund took care on this occasion to employ only Silesian architects and artists, to conciliate the local artisans, and to emphasize the economics of home construction rather than matters of aesthetics or lifestyles. The result was a well-received exhibition that created exemplary solutions to limited problems while providing the city with much-needed new housing.[54]

the *Neue Sachlichkeit* as exemplified by the Weissenhof. Cf. also Arnold Whittick, "Deutscher Werkbund," *Encyclopedia of Modern Architecture*, p. 87. Moreover, Muthesius said enough good things about the exhibition in his review so that he could be cited as a protagonist of the Weissenhof, for example by Josef Popp, Obituary, *Kunstwart*, XXXI, No. 4 (Jan. 1928), 262-65.

[53] This charge is echoed by Walter Segal, "The neo-purist school of architecture," *Architectural Design*, XLII, No. 6 (1972), 344-45. Segal asserts that Le Corbusier and Gropius regarded themselves as functionalists, yet "decided critical issues in favour of form."

[54] See DWB, *Wohnung und Werkraum: Werkbund-Ausstellung in Breslau 1929* (Breslau, n.p., n.d.); and *Die Form*, IV, No. 13 (1929). Rading's plans for the exhibition were reported in *DWB-M* July 1928. Both the Weissenhof and Breslau dwellings, despite criticism

Thanks in good part to the stimulus of the Weissenhof and of the Werkbund's other efforts in its support, the *Neue Bauen* had made sufficient headway by 1929 to acquire a degree of respectability. Features associated with the new style, such as the flat roof and the extensive use of steel and glass, seeped into the architectural repertoire, while housing developments designed by innovative Werkbund architects began to modify the urban scene. The outstanding successes were due to Ernst May in Frankfurt and to Martin Wagner in Berlin, who, as that city's official architect, employed Bruno Taut, Scharoun, and Gropius, among others, on major projects.

At the same time, articles on modern architecture began to appear in formerly traditionalist periodicals, and books on contemporary living by such devotees of the *Neue Sachlichkeit* as Hilberseimer, Behrendt, Behne, and Bruno Taut found a ready market. One of the more successful "how to" books on interior decoration was the work of Wilhelm Lotz, after 1928 Riezler's chief assistant on *Die Form*. Lotz's handbook was published in a revised edition in 1930, testifying to growing popular interest in modern furnishings.[55]

Whereas in 1925 advocates of the *Neue Bauen* constituted a tiny avant-garde, by the end of the decade both supporters and critics had to admit that they were dealing with a movement capable of transforming the nation and setting a new standard to the world.[56] Despite doubts and

directed against their livability, were instantly snapped up by eager purchasers. Cf. F. H. Ehmcke, "Breslauer Werkbundtage" (1929), in Ehmcke, *Geordnetes und Gültiges*, pp. 11-16. The Weissenhof is still inhabited today, having withstood the passage of the years and periods of determined neglect in remarkable fashion.

[55] Wilhelm Lotz, *Wie richte ich meine Wohnung ein: Modern, gut, mit welchen Kosten?* (2nd rev. ed., Berlin, 1930). Lotz had worked for the Werkbund for a number of years, and in 1928 wrote a brief history of the association for publicity purposes: DWB, *Werkbundarbeit: Rückblick auf die Entwicklung des deutschen Werkbundes* von Dr. Wilhelm Lotz (Berlin, [1928]).

[56] Benevolo, *History of Modern Architecture*, II, 492-93. According to an American observer, Henry-Russell Hitchcock, only Germany

even open hostility from a faction within its own ranks, the Werkbund during these years managed to inspire a significant section of Germany's productive elite with a desire to recreate the architectural environment through modern technology, in order to meet the needs of contemporary man.

While the desire to evolve new forms for a new world guided much of the association's effort during the 1920's, Werkbund members, like Germans generally, differed in their response to the rapid transformations taking place in society. Some deplored the loss of traditional cultural values and concentrated on shoring up what remained of a vanishing world. Others, probably the majority, conceded the need to adapt principles and forms to contemporary requirements but wished to be modern without breaking the continuity between old and new. Only a minority seems actually to have welcomed the opportunities for creative reform afforded by a society freed at last from the dead hand of the past. Yet it was this last group that dominated the Werkbund between 1926 and 1930, secured support for its plans at well-attended annual meetings, and attracted new members to the association.

The leaders of the Werkbund strove to comprehend the implications of the vast changes under way and to play a part in shaping the culture of the new age, the *Neue Zeit*. Rejecting the widespread view that culture and style are fully determined by forces beyond the control of individuals, they felt it their duty to direct the forces of change into productive channels, and thus actually mold the society of the future.[57] In view of the importance given

could have produced an exhibition like the Weissenhof in 1927. Hitchcock concluded that the contributions of Gropius and Mies equalled the best work being done in France and Holland, the other centers of the new building. See his *Modern Architecture: Romanticism and Reintegration* (New York, 1929), pp. 195-97.

[57] Wilhelm Lotz, "Der Werkbundgedanke in seiner Bedeutung für Industrie and Handwerk," in "Erasmus" [Gotthilf Schenkel], *Geist der Gegenwart* (Stuttgart, 1928), pp. 279-329. This volume, in addition to Lotz's essay, contained pieces on the youth movement,

to the *Neue Bauen* by the Werkbund, it seems appropriate to illustrate the implications of this approach in the realm of domestic architecture.

While the conservatives sought semirural solutions for the housing problem, tried to stem the growth of the metropolis, and advocated the use of traditional building methods and materials, the Werkbund leaders after 1926 tended to be enthusiastic urbanites favoring an experimental approach to building. Even among the progressives, however, the majority seem to have taken a fairly narrow view of the architect's role. Since the time of the Expressionists, it had become almost a cliché to insist that the precondition for the *Neue Bauen* was the appearance of a new lifestyle (*Neues Wohnen*) and that this in turn depended on the evolution of a new type of man (*Neuer Mensch*).[58] If one believed that the new man already existed, and that it was the architect's duty to meet the needs of the masses in Germany's expanding cities, it was logical to conclude that the architect should find out what his contemporaries wanted, and then devise ways to create dwellings corresponding to these requirements.[59] It was this kind of reasoning that lay behind the original notion of *Neue Sachlichkeit* and inspired the work of organizations like the *Reichsforschungsgesellschaft*. In practice, however, most architects depended for patronage on the major municipalities that had to accommodate a swelling working-class population quickly, at lowest cost, and so made little effort to explore what the future tenants of

adult education, physical culture, contemporary music, painting, and architecture. It concluded with an essay by "Dr. Erasmus" entitled "Die neue Zeit, der neue Mensch und die neue Kultur."

[58] Fritz Wichert, "Die neue Baukunst," *Das neue Frankfurt* (1929) quoted in *Innen-Dekoration*, XL (1929), 375, 380. Wichert, director of the Art Academy in Frankfurt, worked in close collaboration with Ernst May.

[59] Thus Adolf Behne argued that true functionalism entailed the study of social relations, in order to establish people's actual wants and needs. Cf. Behne, *Neues Wohnen, Neues Bauen* (2nd ed., Leipzig, 1930), p. 34.

the huge housing developments felt about the *Neue Bauen*.[60]

A few Werkbund architects simply denied that it was the designer's task to serve people's present wants, and instead believed that architecture should be used to *create* a new lifestyle and, thereby, a new man. Functionalist and rationalist as to means, they were reformers at heart, and regarded the architect as an active instigator of social change. Thus Walter Gropius in 1929 worked out a project for a *Genossenschaftsstadt*, an urban cooperative to house 5,400 families, in which low rents would be achieved through the rationalization of daily life: common power, heating, and laundry facilities, and the joint purchase of supplies.[61] Similarly, Ferdinand Kramer, a former student at the Bauhaus and colleague of Ernst May in Frankfurt, called for an even greater change in lifestyles by advocating communal dining facilities.[62] Convinced that cooperation rather than competition should be the hallmark of the new era, these architects wished to foster a spirit of community (*Gemeinschaft*) by incorporating this principle into the living environment of the common man.[63]

It is striking that these apparently "socialist" solutions to the housing problem failed to meet with unanimous approval on the Left. Far from welcoming Gropius's and Kramer's proposals, Alexander Schwab, a former Spartacist and active Communist Party member, questioned the feasibility of maintaining communitarian outposts in a

[60] Occasionally, efforts were made to survey tenant opinion *after* people had moved into the new housing. Cf. Lane, *Architecture and Politics*, p. 246, n. 27 and n. 28.

[61] Alexander Schwab, "Ist die Genossenschaftsstadt möglich?" *Die Form*, IV, No. 11 (1929), 296-97.

[62] Ferdinand Kramer, "Die Wohnung für das Existenzminimum," *Die Form*, IV, No. 24 (1929), 647-49.

[63] Gropius had expounded his cooperative social ethic at the Werkbund annual meeting of 1927. Cf. *Frankfurter Zeitung*, No. 739, Oct. 5, 1927. Also, Egbert, *Social Radicalism and the Arts*, p. 653. Gropius's "socialism" affected both ends and means: he believed that the architect must work to strengthen the bonds of community, and also that architecture was essentially a social art that could be practiced best on the basis of cooperative teamwork.

predominantly capitalist environment and urged the architects to concentrate on the immediate issue, which was to devise ways of lowering construction costs. And Adolf Behne, who had joined the left-wing Independent Socialists in 1918, argued that it was wrong to force the workers to conform to the preconceptions of middle-class professional architects. While the Social Democratic press tended to favor the *Neue Bauen* and much of the new housing was actually financed by the Socialist trade unions, these critics were skeptical of the schemes of the middle-class radicals, regarding them both as utopian and as irrelevant to the needs of the working man.[64]

In any case, it was not only the radical architects who believed that the designer was responsible for the creation of a better society. Fritz Schumacher of Hamburg, anything but a revolutionary, repeatedly stressed that the architect must not only take actual needs into account, but must also be sensitive to social ideals as yet present only in embryo. Convinced of the overriding importance of good physical planning in creating a genuine mass culture, he urged the architect to look beyond his immediate task to the wider implications of his work.[65] Similarly Alfred Weber, addressing the Werkbund congress of 1928 at Munich, argued that the new architecture was significant primarily because it reflected the requirements of modern living as perceived by the architect, if not yet by the majority of his fellow countrymen.[66]

Even its advocates had to admit that the new building had produced homes that demanded a certain asceticism of their inhabitants, a willingness to dispense with cosiness, and on occasion, with privacy as well. What it offered instead was a clean, healthy environment that freed

[64] See Janos Frecot, "Adolf Behne," *Werkbund-Archiv*, 1 (1972), 81-83; and Kerbs, "Alexander Schwab," pp. 159-67. On the socialists and the *Neue Bauen*, Lane, *Architecture and Politics*, p. 104.

[65] "Kulturaufgaben nach dem Kriege," in Schumacher, *Zeitfragen der Architektur* (Jena, 1929), pp. 109f.

[66] DWB, *Reden der Münchner Tagung 1928*, Werkbundfragen, Flugschriften der 'Form' No. 1 (Berlin, 1928), pp. 10-20.

the individual for an active life outside the home and encouraged a purer spiritual state within its confines.[67] According to Lotz, modern man was already beginning to regard himself less as an isolated individual than as a member of the larger community, and was coming to recognize that the values created by the machine were better than those destroyed in the name of progress.[68] This "new man" would live happily in the homes designed by Werkbund architects, and would lead the way to a better future.

If much of the Werkbund's attention during the 1920's was absorbed by concern with the impact of social change on architecture and the reciprocal effect of the *Neue Bauen* on modern living and social values, the association also addressed itself to other facets of contemporary life. For example, the fact that most men spent over one-third of their time at their job led the Werkbund to reexamine the problem of the work environment. The theme of "Work and Life" was taken up at the Werkbund annual meeting of 1924 in Karlsruhe. Speaking in favor of mechanization, Hugo Borst, manager of the Bosch works in Stuttgart, tried to show that the application of modern production and management techniques would raise the productivity of labor and thus lower costs and raise wages. The new methods, popularly associated with the names of Henry Ford and Frederick Taylor, were described by Borst not as consequences of the much-feared "Americanization" of Europe but as the inevitable concomitants of a developing industrial system. Borst, himself a connoisseur of modern art, had to concede that culture had little place in the contemporary work environment, but he argued that the increased leisure made possible by modern industry would create the preconditions for cultural progress.[69]

[67] Wichert, "Die neue Baukunst," p. 380.
[68] "Der Deutsche Werkbund," DWB, *Wohnung und Werkraum*, p. 27.
[69] Hugo Borst, "Mechanisierte Industriearbeit, muss sie im Gegensatz zur freien Arbeit Mensch und Kultur gefährden?" in Hugo Borst and Willy Hellpach, *Das Problem der Industriearbeit* (Berlin,

The second speaker, Dr. Willy Hellpach, was considerably less sanguine about the cultural effects of industrialization. Hellpach, at the time Minister of Culture for Baden and a former professor of psychology at the Technical University in Karlsruhe, denied that work could be separated from the rest of life as Borst implied, and insisted that ways must be found to develop the work experience so that the worker might derive personal satisfaction from his labor within the setting of modern industry.[70] Borst had confidently predicted that future advances in psychology and physiology would produce better working conditions and communications within the factory, that greater leisure and improved educational and cultural facilities would result in an enriched popular culture, and that automation would eventually free man from subjection to the machine. Hellpach, on the contrary, doubted that better techniques or institutional arrangements would significantly improve the position of the average worker, until educational reforms had inculcated a new work ethic capable of overcoming the mechanistic and materialistic attitudes that had stripped work of all positive and human attributes.

It would seem that in 1924 Hellpach's views corresponded to the mood of the Werkbund as a whole better than did Borst's paean to progress. The general feeling seemed to be that the advance of industrialization was at best a necessary evil whose consequences would have to be mitigated through conscious effort if German values were to survive. Germany must seek a middle way, avoiding both the utilitarian materialism and cultural impoverishment of the United States and the dangers of Soviet-style revolutionary utopianism.[71]

1924), pp. 1-38. See also Günther von Pechmann's summary of the main speeches at Karlsruhe in *DWB-M* No. 6, Sept. 30, 1924, pp. 1-3.

[70] Willy Hellpach, "Die Erziehung der Arbeit," in Borst and Hellpach, *Das Problem der Industriearbeit*, pp. 39-70. Hellpach, a member of the DDP, was elected Minister President of Baden in 1924, and in 1925 was an unsuccessful candidate for the Reich presidency.

[71] Gustav Hartlaub, "Die Aufgabe," in *Ausstellung Typen neuer*

At the Bremen congress of 1925 controversial topics were avoided, to the disgust of some of the association's members. But in 1926, at Essen, the Werkbund once more organized its meeting around a significant theme, namely the relation of art and industry and the part that the Werkbund could play in bridging the growing gulf between them. Addressing the Essen meeting, Riemerschmid stressed the responsibilities of power and urged the captains of industry to adopt the Werkbund ethic. It was not enough, he insisted, to patronize the arts with the profits of industry. Such activities could in no way substitute for an adequate approach to everyday concerns. Businessmen, Riemerschmid argued, must make joy in work one of their primary goals and express their love for their fellows by creating a social climate free of class strife and self-seeking. Only on the basis of a new sense of community would solutions be found for the design problems of the age, including those of industrial architecture, in which adherence to functional simplicity would have to be combined with respect for all participants in the productive process.[72]

Subsequent speakers sought to blunt Riemerschmid's implied criticism by pointing out that modern industry had already made significant contributions to the creation of aesthetically pleasing contemporary forms. Nonetheless, the consensus seemed to be that engineering design could not be expected automatically to produce beauty of form. While functional things might be beautiful, utility alone did not ensure aesthetic merit, and it seemed that the artist-designer would once more have to insist on a bigger role in industry if the Werkbund ideal of a unified modern style was to be realized.[73]

Baukunst (Mannheim, 1925), p. 3. Also, Theodor Heuss, "Die Arbeit des Deutschen Werkbundes," *Badische Presse*, July 24, 1924, Werkbund supplement.

[72] Richard Riemerschmid, "Der Einfluss der Grossindustrie auf die Formung unserer Zeit," *Die Form*, I, No. 11 (1925-26), 231-32.

[73] Günther von Pechmann and Walter Riezler, in *DWB-M* July

The response of industry to the Werkbund's overtures, not surprisingly, was equivocal if not openly hostile. Riemerschmid's charge that industry lacked cultural concern provoked the countercharge that the Werkbund idealists failed to understand the real world. Their critique of industry was attributed in part to the insecurities of an intellectual class misunderstood by and increasingly estranged from a society in flux, and in part to gross ignorance of the difficulties under which German industry had to operate. Given the pressure to lower prices and costs, design considerations had to take second place to economics in the decision-making process.[74] The excellent reception given to the Werkbund congress could not obscure the fact that the big Ruhr industrialists resented the aspersions cast on them by the artists and remained reluctant to accept their rather patronizing counsel.

How then were the artists to gain influence over industrial design? Denied the leadership role demanded by Riemerschmid, their only alternative was to merge anonymously into a design team. A few Werkbund men, notably Gropius and one of his young Bauhaus disciples, Wilhelm Wagenfeld, were prepared to experiment with new methods of collaboration between artist and industry.[75] But the Werkbund as a whole did surprisingly little in the next few years to develop this theme. In general, the 1920's must be seen as a time of transition as far as the evolution of the modern industrial designer is concerned.

Factory design, too, commanded rather less attention in Werkbund circles than it had before the war. The association practically dropped the subject after the publi-

1926; and Walter Riezler, "Ford," *Die Form*, I, No. 9 (1925-26), 203-204.

[74] Unsigned report, "Industrie und Werkbund," *Kölnische Zeitung*, June 28, 1926; J. Wilden, "Der Werkbundgedanke in der rheinisch-westfälischen Industrie," *Kölnische Zeitung*, July 14, 1926, evening edition. Wilden was business manager of the Düsseldorf Chamber of Industry and Commerce.

[75] Wingler, *The Bauhaus*, p. 51; Wilhelm Wagenfeld, *Wesen und Gestalt der Dinge um uns* (Potsdam, 1948), p. 62.

cation in 1923 of Lindner and Steinmetz's *Ingenieurbauten*, although *Die Form* showed a continuing interest in the design problems of the transportation industry. Railways, ships, and automobiles, perhaps because they embodied the dynamic spirit of the age, seemed to exercise a fascination that factory architecture could not match. Not until 1929, at Breslau, did the Werkbund once more address itself to the issues raised at its meetings of 1924 and 1926, and promote the ideal of joy in work through the improvement of factory and office design.

In the interim, perhaps somewhat chastened by the failure of its attempt at Essen to effect a rapprochement with big business, the Werkbund turned once more to the problem of the crafts. At the annual meeting held in Mannheim in September 1927, it reexamined the role of the handicrafts in a predominantly industrial society. Pressures for a more positive relationship between Werkbund and *Handwerk* came from within, for many Werkbund members apparently felt that the association had embarked on a one-sided program inimical to the cultural values that *Handwerk* was still thought to represent. From the side of the crafts organizations, too, there were renewed efforts to form a working alliance with the Werkbund. Hans Meusch, the *Handwerk* spokesman who gave the main address at the Mannheim congress, urged the association to reconsider its boycott of the *Arbeitsgemeinschaft für Handwerkskultur*, arguing that recent modernizing tendencies within the handicraft movement had rendered it a fit ally for a progressive Werkbund. Meusch acknowledged that most artisans still distrusted the Werkbund and concluded that cooperation between Werkbund and *Handwerk* would be possible only if the former abandoned its elitist pretensions and entered into a partnership of equals, dedicated to service to the *Volk* community.[76]

[76] Hans Meusch, "Werkbund und Handwerk," *Die Form*, II, No. 11 (1927), 334-36. Meusch constantly employed the terms "Volkstum" and "Volksgemeinschaft" without defining them; and he failed to make concrete suggestions on how to achieve better relations between the Werkbund's artists and Germany's craftsmen.

Meusch's appeal had some effect. The Werkbund agreed to renew contacts with the *Arbeitsgemeinschaft für Handwerkskultur* and further indicated its sympathetic concern for the artisans by reelecting Wienbeck and co-opting Hans Meusch to its executive committee.[77] It also began once more to give greater emphasis to *Kunstgewerbe*, for example, by establishing a special committee to organize arts and crafts exhibitions abroad, in order to recapture the export markets lost to the German quality industries as a result of the war.[78] Meanwhile, in *Die Form* and other Werkbund publications, the art industries and crafts continued to hold their own, even when enthusiasm for the *Neue Bauen* was at its height.[79] For the Werkbund leaders, although convinced that the future belonged to industrial mass production, believed that there would always be a place for the small workshop in which skilled craftsmen, cooperating with Werkbund artists, would experiment to create new forms for hand or machine reproduction.[80] They also perceived that the products of *Kunsthandwerk* would continue to find a market, as bourgeois individualists with money to spare and the leisured international class indulged their taste for the unusual in order to escape the pressure toward uniformity characteristic of the modern world.[81]

Despite its efforts to define a modern role for the crafts, the Werkbund was unable to revive the close relationship

[77] *DWB-M* Oct. 1927.

[78] Members of the standing committee were Jäckh, Mies, Paul, and Erich Raemisch, at that time an industrialist in Krefeld, who played an important role in the Werkbund in the early 1930's. (See Ch. VIII, below.) *DWB-M* Nov. 1, 1928; H. Freytag, "Über deutsche Kulturpolitik im Ausland," *Deutsche Rundschau*, ccxx, No. 2 (1929), 106. Freytag, on the staff of the German Foreign Office, welcomed the expansion of Werkbund efforts in this area.

[79] For example, articles on metalwork, weaving, and ceramics, in *Die Form*, IV, No. 8 (1929).

[80] Walter Riezler, rejoinder to Hans Meusch at the 1927 annual meeting, *Die Form*, II, No. 11 (1927), 339-40; Wilhelm Lotz, comment on G. Hartlaub, "Handwerkskunst im Zeitalter der Maschine," *Die Form*, IV, No. 1 (1929), 15-17.

[81] Gustav Hartlaub, *Das Ewige Handwerk* (Berlin, 1931), p. 20.

with *Handwerk* that it had briefly enjoyed after the war. The main problem was its insistence on the primacy of the artist within the design process. Rejecting Meusch's plea for a genuine partnership, it continued to maintain that the artisan's duty was to serve as a skilled and willing executor of the artist's will. Moreover, it was determined to free *Handwerk*, in its own best interests, from what it regarded as the artificial primitivism of the folk arts enthusiasts. The latter, in 1927, were laying plans for a major folk arts exhibition to be held in Dresden in 1929 under the sponsorship of the *Reichskunstwart* and the *Arbeitsgemeinschaft für Handwerkskultur*. Redslob and his supporters regarded the revival of folk art as a progressive phenomenon, reflecting the desire of youth throughout the world to escape the overintellectualizing rationalism of the times.[82] The Werkbund, however, remained convinced that folk art was an anachronism and sought to legislate the contours of the new age by hastening its demise.[83] In order to push *Handwerk* towards standardized production and *Neue Sachlichkeit*, it tried to destroy Redslob's influence over the *Arbeitsgemeinschaft* and even pressed for his dismissal as *Reichskunstwart*.[84] When these moves failed and the *Arbeitsgemeinschaft* persisted in reaffirming its support for Redslob's *Volkskunstausstellung* in Dresden, the Werkbund proceeded to sabotage the exhibition, a step that ruled out any possibility of reconciliation between

[82] Letter from Redslob to Bruckmann, July 19, 1927, pp. 4-5, *BA*, Rep 301/443; in the same file, a memorandum dated Dec. 16, 1927 from an Austrian art expert and Werkbund member, signature illegible, supported Redslob by arguing that interest in "Volkskunst" was part of the "Geist der Zeit," of particular appeal to the young.

[83] Walter Riezler, *Die Form*, ii, No. 11, 337-42; Wilhelm Lotz, "Handwerk, Werkbund und Kultur: Das Für und Wider der Zusammenarbeit," *ibid.*, pp. 344-45.

[84] Cf. the memorandum of Aug. 8, 1927 from the Werkbund to the Minister of the Interior, dissociating itself from the *Reichskunstwart* and urging Redslob's dismissal on the grounds that he had failed to live up to his responsibilities and dissipated his energies on unworthy projects such as the Dresden *Volkskunstausstellung*. *BA*, Rep 301/443.

Werkbund and *Handwerk*, at least at the national level.[85]

By 1928, the Werkbund, inspired by its vision of the *Neue Zeit*, thus showed itself willing to combat elements that it believed had no rightful place in tomorrow's world, even if this meant estranging erstwhile supporters. Alfred Weber, addressing the Werkbund annual meeting of that year in Munich, appeared to be speaking for the majority of those present when he declared his support for modernity and his determination to break with tradition. Despite its ambiguities and dogmatism, his speech was much better received than the rebuttal by the art historian Wilhelm Pinder, who questioned the current tendency among proponents of the *Neue Bauen* to impose uniformity of style at the cost of individuality and artistic diversity.[86]

Again at Breslau in 1929, the Werkbund publicly affirmed its enthusiasm for the modern age by selecting Professor Friedrich Dessauer of Frankfurt as its chief speaker. Dessauer, author of a successful book entitled *Philosophie der Technik (The Philosophy of Technology)*, argued that technology, far from being destructive of higher values, was actually the main force in the modern world that freed man to be truly creative and therefore fully human. Convinced of the superiority of his own time over past ages, Dessauer answered the Spenglerians by confidently asserting that, as man achieved mastery over

<hr>

[85] Cancellation of the *Volkskunstausstellung* was announced in *DWB-M* May 1928. However, *völkisch* tendencies remained powerful within the Werkbund, notably in the Bremen group led by Ludwig Roselius. Cf. Hildegard Roselius, *Ludwig Roselius und sein kulturelles Werk* (Braunschweig, 1954), p. 58. *BA*, Rep 301/449 contains several letters supporting Redslob, including one from the president of the Austrian Werkbund of Nov. 25, 1927, and another from the *Deutscher Heimatbund Danzig*, Aug. 10, 1927. The latter is signed "Mit deutschem Gruss," the *völkisch*-National Socialist salutation.

[86] F. H. Ehmcke, report on the Munich meeting, *Kölnische Zeitung*, July 22, 1928. The text of both speeches was reprinted in DWB, *Reden der Münchner Tagung 1928*. Pinder, after 1933, became a spokesman for Nazi-*völkisch* ideals. Cf. Robert T. Taylor, *The Word in Stone: The Role of Architecture in the National Socialist Ideology* (Berkeley, 1974), pp. 83, 86, and *passim*.

the physical world, he would succeed in building a new society characterized by greater spirituality and beauty as well as knowledge. For technology, like art, was a product of the human intelligence, serving man's needs by injecting spirit and order into the world of nature.[87]

Dessauer's progressivism perfectly matched the mood of the Werkbund meeting that, on the day of his speech, approved plans for an exhibition dedicated to the *Neue Zeit*. For some years the Werkbund had been preparing a program for an international exhibition that would reassert Germany's leadership of the modern movement in the applied arts.[88] Suggested initially by Riemerschmid and approved by the general membership at Bremen in 1925, the scheme had subsequently been elaborated by Mies van der Rohe, but it was Jäckh who finally worked out the theoretical rationale of the exhibition and became its chief protagonist.[89] By the time Jäckh presented his plan to the Werkbund, the original idea for an exhibition of contemporary developments in the applied arts and architecture had yielded to a much more grandiose conception. Jäckh had in mind a novel type of exhibition that would survey all aspects of human thought and creativity.[90] Its

[87] For the text of Dessauer's talk, entitled, "Technik - Kultur - Kunst," see *Die Form*, IV, No. 18 (1929), 479-86. His *Die Philosophie der Technik* (Bonn, 1927), was in its second edition by 1928. Dessauer saw no conflict between technology and art, now that the era of *Neue Sachlichkeit* had dawned.

[88] Theodor Heuss, "Werkbund-Tagung," *Die Hilfe*, XXXIV, Aug. 1, 1928.

[89] Mies withdrew in favor of Jäckh in 1928, so as to devote himself wholeheartedly to the architectural exhibition planned for Berlin in 1931. See *Frankfurter Zeitung*, Aug. 6, 1928.

[90] For the original plan, cf. "Protokoll der Vorstands-und Ausschuss-Sitzung am 16. 10. 1926 in Berlin," pp. 1-2. Jäckh's version appeared as "Idee und Realisierung der Internationalen Werkbund-Ausstellung 'Die Neue Zeit' Köln 1932," in *Die Form*, IV, No. 15 (1929), 401-20. It is reproduced in Felix Schwarz and Frank Gloor, eds., '*Die Form.*' *Stimme des Deutschen Werkbundes 1925-1934* (Gütersloh, 1969), pp. 32-62 [hereafter *Stimme des Deutschen Werkbundes*]; and in part in Fischer, *Deutsche Werkbund*, pp. 258-62. In 1928, Jäckh had published a pamphlet entitled *Neudeutsche Ausstellungspolitik*, describing the new type of exhibition he envisaged. *DWB-M* Aug. 1928.

aim was to demonstrate the unity of the emerging modern world, to show what had been achieved so far, and, above all, to inculcate in every visitor the same faith in progress and enthusiasm for the future that inspired the efforts of the Werkbund itself.

Jäckh's extraordinary plan involved an elaborate cyclical arrangement, its seven subdivisions symbolizing the organic, almost mystical interrelationship of the parts. While it is hard to believe that the Werkbund members who approved it at Breslau fully understood the scheme, its blend of rationality and idealism, of technology worship and pseudospirituality, evidently touched a responsive chord. More important, the plan proved sufficiently palatable to win support from influential men in government and press. In the end, the Reich government, the *Reichstag*, and federal exhibition authorities, as well as the cities of Frankfurt, Stuttgart, and Mannheim gave their blessings to the idea of a major exhibition at Cologne, and agreed to coordinate their efforts under the over-all direction of Jäckh and the Werkbund.[91] Moreover, under the terms of an agreement with the newly formed International Exhibition Commission, the Reich government promised not to support another large-scale international exhibition on German soil for a decade.[92] This gave the Cologne exhibition international status, reinforcing the hope of its sponsors that it would encourage friendly cultural competition between nations and, in the spirit of Locarno, contribute to world peace.[93]

If Jäckh's scheme initially was well received, this was in large part because the program promised something

[91] Frankfurt agreed to subordinate its Goethe anniversary celebrations, planned for 1932, to the Werkbund exhibition, while Stuttgart and Mannheim reorganized their building programs to fit in with the Cologne venture. Only Berlin, where the Werkbund had originally hoped to hold the exhibition, refused to cooperate and instead proceeded with plans for its own building exhibition.

[92] *DWB-M* Dec. 1, 1928.

[93] Jäckh, in *DWB-M* July 1928; Reich Minister of the Interior Severing in *DWB-M* Nov. 15, 1928; and *DWB-M* Jan. 1, 1930, on the *Neue Zeit* exhibition and the spirit of Locarno.

for everybody. Architecture once again constituted the core of the exhibition: in Cologne alone, the plan called for the creation of numerous permanent structures, including a new university, housing estates, schools, and a market hall. Yet the *Neue Zeit* was not to be just another display of the *Neue Bauen*. Machine technology, transport, and such aspects of contemporary culture as music, dance, radio, and film were singled out for attention. The art industries, too, were allotted a place, as part of the new luxury made possible by a progressively expanding world economy, although they were not meant to dominate the 1932 Cologne exhibition as they had that of 1914.[94]

Finally, Jäckh, in order to demonstrate the all-embracing nature of the transformation of attitudes characteristic of the new era, planned a series of international scientific and philosophical congresses to be held in conjunction with the Werkbund exhibition.[95] His contention that the contemporary revolution found its fullest expression in the realm of philosophical, artistic, and scientific creativity won Jäckh the support of many on the Right who deplored the rationalistic and materialistic tendencies of the age; whereas the international character of the *Neue Zeit* proposal made it attractive to the socialists, who hoped that the Werkbund exhibition would help to bring about a new era of human solidarity and brotherhood.[96]

Although the Werkbund meetings of 1928 and 1929 unanimously approved the *Neue Zeit* plans, there were those who had misgivings about the scheme from the start. Some felt that an exhibition that tried to do so much would lose its impact, and therefore believed the Werkbund would

[94] Walter Riezler, "1932," *Die Form*, IV, No. 1 (1929), 1-3.

[95] In his "Neue Zeit" plan, Jäckh listed numerous German precursors and spokesmen of the new consciousness, including Nietzsche, Max Scheler, Ludwig Klages, Graf Keyserling, Karl Joël, Alfred Weber, C. H. Becker, Willy Hellpach, Ernst Kropp, and Friedrich Dessauer. Among non-Germans, he cited van de Velde, Moholy-Nagy, Ortega y Gasset, Guglielmo Ferrero, and H. G. Wells! Cf. Schwarz and Gloor, *Stimme des Deutschen Werkbundes*, pp. 45-48.

[96] See *Die Form*, IV, No. 22, 612-16, press comments from right-wing journals such as *Germania* and *Der Tag*, and a piece by Robert Breuer from the socialist *Vorwärts*.

do better to stick to its traditional areas of concern. Others wondered how the complex ideas broached by Jäckh could be rendered visually, in the context of an exhibition. More fundamentally, there was concern that the Werkbund was being presumptuous in its belief that it could predict the character of the coming age. Thus, it could be argued that the modern drama, music, and philosophy that Jäckh planned to include were highly unpopular and therefore unlikely to survive. On the other hand, the Werkbund leaders had themselves wondered whether *Kunstgewerbe* could hold its own in the world of the future; yet they now proposed to give it considerable prominence at Cologne. Arguing that they were living in a time of transition, some of Jäckh's critics therefore insisted that the "new age" was as yet too ill-defined to lend itself to summary treatment in an exhibition. Finally, doubts were expressed about the suitability of Jäckh's ideas and schemes for foreign consumption, for example by Dr. Vetter of Vienna who maintained that Jäckh was too typically *Boche* to be acceptable to the English and French, and that his main appeal would therefore be to German nationalists, neoconservative officials, and doctrinaire intellectuals, rather than to the international community of artists.[97]

None of the objections raised by Jäckh's critics posed a threat to the *Neue Zeit* until 1930, when the Depression brought the entire project into question. As the 1920's came to an end, the enthusiasm of the exhibition organizers proved infectious in Werkbund circles and beyond. The *Neue Zeit* Cologne 1932, scheduled to coincide with the association's twenty-fifth anniversary celebrations, promised to give visual expression to the emergence of a brave new world imbued with the Werkbund spirit and shaped according to its precepts.

[97] Letter from Vetter to Riezler, Jan. 4, 1930, in *BASK*, DWB III. For other criticisms, see, for example, Riemerschmid, in *Die Form*, IV, No. 5, 121; "Die neue Zeit," *Stadt-Anzeiger* (Cologne), Jan. 9, 1929. Frau Mia Seeger, Stuttgart, interview of April 28, 1973, commented on the doubts within the Werkbund about Jäckh's plan for the exhibition.

CHAPTER VIII

The Disintegration of the
Weimar Werkbund: 1930-1932

IN 1929, the Werkbund looked to the future with confidence. Although its membership remained just under 3,000, its architects, designers, and craftsmen held leading positions in many parts of the country.[1] Cities vied with each other for the privilege of playing host to the annual congresses, while the branch associations enjoyed good relations with municipal and state governments. Above all, the patronage of Reich authorities reinforced the Werkbund's prestige and made possible a wide-ranging program of exhibitions at home and abroad. If its leaders somewhat overestimated the degree of popular support for their progressive stance and failed to realize the extent to which concentration on the *Neue Bauen* had jeopardized good relations with the crafts and industry, they were nevertheless justified in believing that the years ahead would see a significant advance toward the realization of their goals. The new era—whose main outlines the Werkbund hoped to delineate at Cologne in 1932—promised to be one of peace and economic progress; and the association looked forward to playing a leading role in the cultural renaissance sure to follow.

Neither the Werkbund's progressive leaders nor their critics foresaw what the future actually held in store.

[1] The main centers of Werkbund strength during the 1920's were the Rhineland, Württemberg, and Bavaria, but there were also active branches in Dresden, Breslau, Bremen, and elsewhere. Berlin only formed a local association of its own in 1931. See *DWB-M* May 15 and July 15, 1931.

Instead of moving forward, the Werkbund, in the few years between 1929 and 1932, disintegrated as an effective cultural force. Under severe economic and political pressure, it lost all semblance of unity and eventually succumbed to hostile elements. Not the Werkbund, but the National Socialists with their own vision of the new age, were to mold the face of Germany for the next decade. To explain this abrupt decline in the Werkbund's fortunes, it is necessary to examine the effects of the Depression and of the politically exploited cultural reaction that throve during these years of economic adversity; but one must also take into account certain inbuilt weaknesses of ideology and structure. For it was the amplification, under stress, of flaws and tensions already present during the preceding period of public triumph that undermined the Werkbund's ability to respond effectively to external challenge. In this respect, as in many others, the history of the Werkbund parallels that of the Republic with which its fate was so closely linked.

The Depression, hitting Germany with full force in early 1930, not only put an end to the sustained economic growth on which the Werkbund had based its hopes; the virtual cessation of major construction, accompanied by rising unemployment among artisans and industrial workers, directly affected important sections of its membership.[2] As in the inflation years of the early 1920's, professional architects and decorators, industrial designers and craftsmen, academics and businessmen became absorbed in their personal struggles and accordingly less able—or willing—to support an association serving purely ideal ends.

From 1930 on, the Werkbund newsletter repeatedly called for prompt payment of dues and carried lists of

[2] Building construction had begun to decline in 1929; by August 1930, the unemployment rate among Berlin architects, engineers, and builders was 30%. In the autumn of 1931, the Reich building program was curtailed by decree of the Brüning government, and Prussia promulgated a two and one-half year moratorium on high-rise construction. Teut, *Architektur*, pp. 16-17 and 29-30.

members, "address unknown." With falling revenue from dues, the association was forced to curtail its activities. Thus in 1930 it still proved possible to hold two membership meetings: the major congress in Vienna in the summer and a special meeting in Stuttgart in October coinciding with the tenth anniversary of the Württemberg branch. But thereafter the Werkbund had to abandon the public meetings that had done so much to extend its influence throughout the country. At Vienna, it was decided that henceforth full-scale congresses would be held only every second year, but even this proved beyond the Werkbund's strength. An interim business meeting in Berlin in 1931, restricted to members, was poorly attended despite Lufthansa's offer of reduced rates for participants.[3] Plans for a full convention in either Dresden or Hamburg the following year came to nothing. In 1932, to mark its twenty-fifth anniversary, the Werkbund could afford only a relatively insignificant ceremony in the capital.[4]

Economic stringency also affected the Werkbund's publishing program. *Die Form* had to be cut back in September 1930 from biweekly to monthly publication, and on this basis struggled on to the end of 1932, when the arrangement between the Werkbund and the publisher, Reckendorf, was terminated.[5] Thereafter, it continued to appear as the organ of the Werkbund but no longer went automatically to all members. As Werkbund members had accounted for the bulk of *Die Form*'s readership, this dealt the journal a blow from which it never recovered.[6] Mean-

[3] *DWB-M* July 15, 1930; Nov. 15, 1930; July 15, 1931. In July 1931, half of those who attended the Berlin meeting were residents of the capital. By contrast, the meeting of the previous October in Stuttgart had attracted over two hundred members, including some from Königsberg, Breslau, Aachen, Vienna, and other distant cities.

[4] *DWB-M* Nov. 15, 1932; *Die Form*, VII, No. 11 (1932), 331-33; Adolph Donath, "Deutscher Werkbund—zu seinem fünfundzwanzigjährigen Bestehen," *Berliner Tageblatt*, Oct. 13, 1932.

[5] *DWB-M* Nov. 15, 1932. In November, Reckendorf still planned to publish *Die Form* independently of the Werkbund, but in December the journal, now under the sole editorship of the Werkbund's Wilhelm Lotz, was tranferred to a new printer.

[6] On the positive side, the decision to make subscription to *Die*

while, the series of *Werkbund-Bücher* came to an end in 1931 with Gustav Hartlaub's *Das Ewige Handwerk*. The association's subsequent inability to sponsor books further diminished its potential influence.[7]

In 1932, even after a move from the luxurious *Reckendorfhaus* to more modest premises, the Werkbund's income barely sufficed to cover the costs of its Berlin headquarters. There was nothing left over to finance new programs or to assist the branches as they struggled to maintain local and regional activities.[8] Members became ever more reluctant to pay dues when they realized that these would be absorbed by the essentially inactive Berlin office. Their resentment was compounded by the discovery, in 1931, that a staff member of long standing had embezzled large sums from Werkbund coffers.[9] Not only did this aggravate the financial situation; the bungling way in which Baur and the executive committee handled the scandal further damaged the image of Werkbund headquarters in the eyes of the membership at large.

The Werkbund's finances were also adversely affected by the drying up of public subsidies on which it had come to depend. As governments found themselves hard put to meet their payrolls, and the German taxpayer faced the prospect of subsidizing an ever growing army of unem-

Form optional made it possible to reduce Werkbund dues by nearly one-half. *DWB-M* Dec. 15, 1932.

[7] The *Bücher der Form* ceased to appear in 1928. In 1931, another Werkbund-Buch entitled *Eisen und Stahl* won a prize as one of the year's fifty most beautiful books. The firm of Reckendorf had served as Werkbund publisher since the early 1920's; its pavilion at the Cologne "Pressa" exhibition of 1928, designed by Riemerschmid, had featured a display of Werkbund publications as well as a selection of articles in current production approved by the Werkbund. Cf. Eckstein, "Idee," p. 16.

[8] *DWB-M* March 15, 1932.

[9] The culprit was a Herr Peiler who had worked for the Werkbund head office since the days of Wolf Dohrn. See letter from Jäckh to Bruckmann, Oct. 21, 1932, *BASK*, DWB III. Peiler failed to repay the sums involved even after his crime was discovered. The incident led to replacement of the honorary auditors by professionals in Oct. 1931. *DWB-M* Nov. 15, 1931.

ployed, there was understandable reluctance to allocate funds to support the pure and applied arts. Appeals to the government of Heinrich Brüning to relax its restrictive policies proved vain.[10] For a time, the Foreign Office continued to provide limited sums for international exhibitions. In 1930, under its auspices, Walter Gropius prepared a Werkbund display for the decorative arts exhibition in Paris, and Ludwig Hilberseimer organized a German section at the International Fair in Monza, Italy.[11] But in the following year, financial constraint forced the Reich to abandon all support for arts and crafts exhibitions.[12] As late as 1932, the Württemberg Werkbund branch managed to secure financial assistance from the city of Stuttgart and the Industrial Commission of the state of Württemberg for a display of quality home furnishings;[13] and the Viennese Werkbund, in the same year, completed a model housing estate of modest single-family dwellings.[14] But in

[10] See the text of a joint submission from a number of artistic and cultural groups to Chancellor Brüning, *DWB-M* Oct. 15, 1931. The Werkbund and the *Ring* were among the signatories. The government's intransigence delighted the critics of Weimar "Kulturpolitik," e.g., Hermann Schmitz, *Revolution der Gesinnung: Preussische Kulturpolitik und Volksgemeinschaft seit dem 9. November 1918* (Neubabelsberg, 1931), p. 197. Schmitz, who accused the Werkbund of having mixed politics with art, praised Brüning for confining himself to political matters.

[11] On the Paris exhibition, Wilhelm Lotz, "Ausstellung des Deutschen Werkbundes in Paris," *Die Form*, v, No. 11/12 (1930), 281-84; also press clippings in *Bauhaus*, GS 22, GN 28 and 29. On the Monza International Exhibition of Industrial Art, Wilhelm Lotz, "Unter der Lupe," *Die Form*, vi, No. 4 (1931), 154-55. See also report of the Werkbund exhibition committee, *DWB-M* Jan. 1, 1930.

[12] *DWB-M* Sept. 15, 1931; Abelein, *Die Kulturpolitik des Deutschen Reiches*, p. 127.

[13] *DWB-M* Dec. 15, 1931 and June 15, 1932; Wilhelm Lotz, "Werkbundausstellung 'Wohnbedarf' Stuttgart 1932," *Die Form*, vii, No. 7 (1932), 223-24. Printed on extremely poor paper, the catalogue of the *Wohnbedarf* exhibition perfectly exemplified the seriousness of the economic situation. The Stuttgart exhibition was the joint effort of the Austrian, Swiss, English (DIA), and German Werkbund groups in cooperation with the Reich government and the German Manufacturers' Association (RDI).

[14] *Die Form*, vii, No. 7 (1932), 201-22; Josef Frank, ed., *Die Internationale Werkbundsiedlung Wien 1932* (Vienna, 1932).

both these cases budget restrictions hampered exhibition planning, so that the results were in no way comparable to those achieved at the major Werkbund exhibitions of former years.

Worst of all, the Werkbund was forced to abandon its ambitious *Neue Zeit* exhibition. Originally scheduled for 1932, this project was first postponed and then shelved for the duration of the economic crisis. Neither Jäckh's persistence nor the unflagging enthusiasm of such influential backers as Cologne's mayor, Konrad Adenauer, could keep the scheme alive. Predicated on the availability of massive subsidies from industry and all levels of government, the *Neue Zeit* succumbed to the Depression.[15]

The Werkbund's desperate financial plight precipitated an organizational crisis. Irritated by the Berlin office's tendency to monopolize the association's shrinking revenues, the local groups in 1931 initiated moves to revise the constitution so as to give greater power to the branches.[16] Internal cohesion was further impaired by the break with *Die Form*, especially as the newsletter published in that journal had served as the last bond between head office and the membership when regular annual meetings were discontinued. From the end of 1932, the individual Werkbund member had nowhere to air his grievances, while the leadership had to resort to makeshift arrangements to communicate with him.

Yet if the Depression reinforced centrifugal tendencies within the Werkbund, economic causes alone cannot explain its sorry state at the end of 1932. In retrospect one can see that the unity of the association had already

[15] *DWB-M* April 15, 1930; Jan. 15, 1931; Nov. 15, 1931. As late as Oct. 1932, Jäckh still thought it worthwhile to publish an appendix to his background reading list for the exhibition. See *DWB-M* Oct. 15, 1932. A letter from Jäckh to Bruckmann, Oct. 21, 1932, *BASK*, DWB III, mentions that Adenauer had just paid the contribution he had promised some time before.

[16] *DWB-M* July 15, 1931. The Constitutional Committee consisted of Richard Lisker, Lotz, Mies, Poelzig, Lilly Reich, Paul Renner, Riezler, and a representative of the Austrian Werkbund.

begun to disintegrate some years before. The Weissenhof exhibition of 1927, which had appeared to inaugurate an era of triumphant modernism, had in fact evoked negative reactions that strengthened resistance to the progressive movement in German architecture and design, and led to disaffection within the Werkbund itself.[17] It is difficult to gauge how widespread the opposition to the *Neue Sachlichkeit* actually was in the mid-1920's, but we do know that disapproval of Werkbund support for the *Neue Bauen* led a number of former notables to resign from the association.

Among those who felt most strongly that the Werkbund under Bruckmann and Mies van der Rohe had ceased to represent the original Werkbund program was the architect Paul Schultze-Naumburg. After the war, Schultze-Naumburg abandoned hope that education might reverse the decline of German culture, and so drew away from the *Heimatschutz* and Werkbund movements. A convert to the racist views of Hans F. K. Günther, he began to propagate a racial theory of art, and to defend "Germanic" architecture by word and pen against the modernizers.[18] In 1925, two years before the Weissenhof alerted a wider public to the potential dangers of the modern movement, he sparked the reaction in an exchange with W. C. Behrendt on the theme of "tradition" in the pages of *Die Form*.[19]

Three years later, Schultze-Naumburg helped found an architectural association designed to counter the influential *Ring*. Called the *Block*, this group included several Werkbund members critical of the *Neue Bauen*, among them Fritz Schumacher of Hamburg, and Paul Bonatz and Paul Schmitthenner of the Technical University in Stuttgart,

[17] Eckstein, "Idee," p. 16; Teut, *Architektur*, p. 19.

[18] Lane, *Architecture and Politics*, pp. 136-45; Kratzsch, *Kunstwart und Dürerbund*, pp. 433-35. Also, Paul Schultze-Naumburg, *Kunst und Rasse* (Munich, 1927), and *Kampf um die Kunst* (Munich, 1932).

[19] *Die Form*, I, No. 10 (1925-26), 226-27; Hugo Häring, "Die Tradition, Schultze-Naumburg und wir," *Die Form*, I, No. 8 (1925-26), 180.

Schumacher, who withdrew from the *Block* in 1933 when he realized at last that it had become the mouthpiece of fanatics, remained a Werkbund member to the end.[20] But Bonatz and Schmitthenner, angered by the failure of Mies and Stotz to involve them in the Stuttgart exhibition, had abandoned the Werkbund by 1928, and the latter became an outspoken critic of both Werkbund and Weissenhof in the late 1920's.[21] In 1929, when Alfred Rosenberg, the leading theoretician of the National Socialist movement, founded the *Kampfbund für deutsche Kultur* (Fighting League for German Culture), the *Block* architects became active supporters, effecting an alliance that was to prove fatal to the Werkbund in the aftermath of the National Socialist revolution.[22]

Not all who disapproved of the Werkbund's progressive orientation during the late 1920's gave up their membership. Many preferred instead to fight from within, hoping to correct what they regarded as an unfortunate deviation from the association's principles. Thus Theodor Fischer, at the Werkbund congress in Munich in 1928, voiced his misgivings about the leadership's tendency to promote experimentation in architecture at the expense of such traditional Werkbund concerns as quality and joy in work.[23] In this, he spoke for all who failed to share the enthusiasm of Alfred Weber, Ernst Jäckh, or Walter Riezler

[20] See Schumacher, *Selbstgespräche*, pp. 109-10. On the *Block*, Lane, *Architecture and Politics*, p. 140; Teut, *Architektur*, pp. 19 and 29.

[21] Bonatz and Schmitthenner were already attacking Mies in 1926, and Bonatz apparently resigned from the Werkbund in 1927. See Library of Congress, Mies van der Rohe, Early Correspondence, 1921-1940 [hereafter *LC*] Container 3, 1926, letters from Mies to Adolf Rading/Breslau, and Adolf Meyer/Frankfurt, June 3, 1926; *LC*, 1927, Folder 1, contains a list of members of the Werkbund executive and board attached to minutes of a meeting of the architectural committee on Sept. 27, 1927, with a handwritten note next to Bonatz's name indicating his intention to resign. Unlike Schmitthenner, however, Bonatz continued to regard the Weissenhof as a necessary experiment. See Ch. IX, below.

[22] Lane, *Architecture and Politics*, pp. 148-52.

[23] "Schlusswort," DWB, *Reden der Münchner Tagung*, pp. 31-32.

for the more extreme manifestations of the modern spirit. In 1928, the critics were still in a minority and easily silenced, but by 1930 the level of dissent had risen sufficiently to pose a genuine threat to the progressive leadership. This was revealed at the special Stuttgart meeting of October, when speakers rose in turn to express disapproval of the Gropius-led Paris exhibition, of *Die Form* for its allegedly biased reporting of contemporary architecture, and of the Werkbund leaders for neglecting contacts with industry and the crafts in order to concentrate on the *Neue Bauen*.[24]

The fact that neither Mies van der Rohe nor Walter Gropius saw fit to attend the Stuttgart meeting at which they knew their policies would be criticized was taken as symptomatic of the executive committee's contempt for the views of ordinary members.[25] Much of the resentment that surfaced at Stuttgart stemmed from the feeling that the Werkbund was being run, and run badly, by an arrogant left-radical clique based in Berlin. But in the course of the Stuttgart debate it also became apparent that the Werkbund leaders once more faced a genuine change in the climate of opinion. Thus when Josef Frank raised the question "Was ist Modern?" (What is Modern?) at the Vienna Werkbund congress in June 1930, no one could provide a convincing answer.[26] The subsequent debate on this subject at Stuttgart in October, and in the pages of *Die Form*, showed that many who thought of themselves as progressives were not at all certain any longer that the

24 *DWB-M* Nov. 15, 1930, reported that thirty-five speakers had taken part in the debate. The most important contributions were summarized in "Die Ziele des Deutschen Werkbundes," *Die Form*, v, No. 23/24 (1930), 612-14. See also F. H. Ehmcke, "Die Stuttgarter Werkbundtagung 1930," memorandum, in Ehmcke, *Geordnetes und Gültiges*, pp. 38-40; G. Harbers, "Die Zukunft des deutschen Werkbundes," *Der Baumeister*, xxviii (Dec. 1930), B223-24; Peter Meyer, "Die Stuttgart Aussprache über die Ziele des Deutschen Werkbundes," *Frankfurter Zeitung*, Oct. 30, 1930.

25 Ehmcke, "Die Stuttgarter Werkbundtagung," pp. 38-39.

26 Josef Frank, "Was ist Modern?" *Die Form*, v, No. 15 (1930), 399-406.

Neue Sachlichkeit epitomized the spirit of the age. What the partisans of the modern movement regarded as practical solutions to current problems, expressive of the contemporary mood, their critics found cold and inhuman. To them it seemed that the Werkbund was encouraging a doctrinaire, mechanistic cult of modernity that failed to leave room for the spirit, the only source of true art.[27]

The functionalists therefore had to defend their position not only against traditionalism but also against a new irrationalism that stressed the importance of artistic individualism, valued diversity for its own sake, and encouraged creative spontaneity. The architect was no longer asked to model himself on the engineer with his utilitarian calculus; instead he was urged to learn from the innocent play of the child or the naive creative pleasure of the primitive craftsman.[28] Dissatisfied by the identification of art and technology that had inspired the Werkbund leadership since 1925, the avant-garde now preferred analogies from the realm of biology, and regarded the modern style as an "organic growth" that would create forms adapted to the needs of the unique individual or the social "organism."[29]

[27] See for example the review of Frank's talk by Peter Meyer of the Swiss Werkbund, "Der Deutsche Werkbund in Wien," *Neue Zürcher Zeitung*, July 8, 1930. Meyer, without succumbing to traditionalism, was nevertheless a leading critic of the German Werkbund's extreme modernism. See also Henry van de Velde, "Das Neue: Weshalb immer Neues" (1929), in van de Velde, *Zum neuen Stil* (Munich, 1955), pp. 227-35. Like Meyer, who regarded all dogma as fundamentally "unmodern," van de Velde noted that the new style was threatened not only by the reactionaries but by those who sought novelty for its own sake. Cf. Benevolo, *History of Modern Architecture*, II, 551-52.

[28] For example, Wilhelm Pinder, "Diskussionsrede," DWB, *Reden der Münchner Tagung*, pp. 21-31.

[29] A leading exponent of this so-called "organic functionalism" was Hugo Häring, secretary of the *Ring*. See Julius Posener, "Häring, Scharoun, Mies and Le Corbusier," in Posener, *From Schinkel to the Bauhaus*, pp. 33-41; and Heinrich Lauterbach and Jürgen Joedicke, eds., *Hugo Häring* (Stuttgart, 1965). Häring believed that mankind was about to enter an age of organic building under the leadership of the Nordic race. Meanwhile, F. H. Ehmcke, in an essay of 1933

Hans Poelzig, whose Stuttgart Werkbund address of 1919 had captured the mood of that day, once more summarized the avant-garde position in 1931. Addressing the *Bund deutscher Architekten* (BDA) he criticized the advocates of *Neue Sachlichkeit* for unthinkingly equating art with technology. Instead, Poelzig called for an artist's architecture that would go beyond rationalistic functionalism to reflect the spirit of the age as interpreted by the creative personality.[30] His approach seems to have appealed strongly to the younger generation of architects who were casting about for a new creed. Attracted to the folk arts and prepared to find virtue in traditional forms, youthful critics of the *Neue Bauen* after 1930 found themselves drawn into a sympathetic relationship with men of the pre-World War I generation like Poelzig or Tessenow. The architects of the intervening period—Gropius, the Taut brothers, Martin Wagner, Ernst May, Mies van der Rohe—they came to regard not as pioneers of a new era bravely throwing off the shackles of the past, but as establishment figures imposing an overly abstract, intellectualistic, even unnatural style on a hapless nation.[31]

It is difficult to estimate to what extent this change in aesthetic attitudes was due to the Great Depression. One

entitled "Gedanken zum neuen Bauen," *Geordnetes und Gültiges*, p. 61, warned against confusing technique with art, arguing that the former was a matter of reason (Verstand) whereas the latter constituted an organic amalgam of sentiment and soul ("Gefühl" and "Seele").

[30] For the text of Poelzig's speech, "Der Architekt," see Gaber, *Entwicklung*, pp. 227-51. For a summary, Heuss, *Poelzig*, pp. 148-54.

[31] Schmitz, *Revolution der Gesinnung*, p. 197 n.; Julius Posener, "Die Deutsche Abteilung in der Ausstellung der Société des artistes décoratifs français," *Die Baugilde*, XII, No. 11 (1930), 983, suggested that it was time to show the other side of Germany, her woods instead of machine guns, Salvisberg or Tessenow rather than Gropius. A pupil of Poelzig, Posener in 1936 described the Weimar Werkbund as dominated by "prophets of modernism" who used its extraordinary influence to encourage a style strongly at variance with the nation's taste. Cf. "L'architecture du IIIᵉ Reich," *L'Architecture d'Aujourd'hui*, VII, No. 4 (1936), 23-25. Also, Benevolo, *History of Modern Architecture*, II, 553.

might argue that just as Expressionism had yielded to *Neue Sachlichkeit*, so the latter was bound to be superseded in turn. Moreover, opposition to extreme functionalism had existed while the German economy was still flourishing. Yet the Depression did make a difference. For one thing, it encouraged the revival of many features of the Expressionist aesthetic, notably its romantic bias in favor of the handicrafts and rejection of the metropolis. As the Depression deepened, those who had all along condemned mechanization and the consequent "Americanization" of German society and culture felt their worst fears confirmed. In vain did Werkbund spokesmen like Lotz point out that the machine could not be held responsible for the failures of capitalism, and that modern technology would hold its own in any postcapitalist society, whether dominated by forces of the Left or of the Right.[32] Non-Communist critics of the "system," including young people whose material and spiritual aspirations had not yet been satisfied by 20th century capitalism, preferred to take Spengler rather than Dessauer as their prophet, and responded to the apparent breakdown of the economic order by espousing the cause of cultural reaction.[33] Even those unwilling to go this far found the enthusiasm of men like Jäckh for the *Neue Zeit* increasingly distasteful. As the situation of Germany continued to deteriorate, the feeling grew that, whereas change had indeed to be accepted, it should not be worshipped, nor used to justify the destruction of valuable elements in the traditional culture.[34]

[32] Wilhelm Lotz, "Um das Kunsthandwerk," *Die Form*, VI, No. 6 (1931), 238. On p. 240, Lotz insisted that "One must finally stop looking at *Handwerk* through rose-colored Meistersinger spectacles."

[33] Walter Riezler, "Drei Bücher über Technik," *Die Form*, VI, No. 11 (1931), 427-29, reviews three recent books on technology and culture by Dessauer, Spengler and a Catholic architect named Rudolf Schwarz. Riezler, rejecting both extremes, preferred to believe that modern technology, while incapable of creating higher values, might usefully be put into the service of spiritual and cultural goals.

[34] Paul Renner, "An die Vorstandsmitglieder des DWB," typescript circular letter, May 10, 1932, pp. 9-10, BASK, DWB III.

As men lost faith that the times would produce a worthy and harmonious modern style, they tended once more to favor an eclectic approach to design problems. Even those architects who still talked in functionalist terms now argued that true *Sachlichkeit* would produce a multiplicity of forms to meet the natural diversity of human needs.[35] In the realm of the decorative arts, the new mood reinforced the view of many within the Werkbund that self-conscious attempts to create a *Zeitstil* would merely produce ephemeral fashions.[36] Under their influence, the Werkbund began to play down the importance of stylistic innovation in favor of renewed emphasis on quality. It did not abandon its preference for functional forms but now insisted that modern times did not have a monopoly of simplicity and *Sachlichkeit*. Thus the *Neue Sammlung*, the modern design division of the Bavarian National Gallery, in 1931 mounted an exhibition dedicated to Eternal Forms (*Ewige Formen*), which sought to demonstrate the existence of a "tradition" of modern form by displaying functional objects from the past.[37] Moreover,

Renner, a well-known graphic artist whose advanced "Futura" type had recently been adopted for use in *Die Form*, charged that the Werkbund, by identifying itself with the slogan "Die Neue Zeit," had given the impression that it wished "to celebrate the triumph of the Machine, although this cannot always be equated with the triumph of humanity."

[35] E.g., Schumacher, *Stufen des Lebens*, pp. 384-85.

[36] Karl Rupflin, "Handwerk, höhere Schulen und Werkbund," *Die Form*, VI, No. 8 (1931), 281-84. Rupflin, a professor at the Art School in Augsburg, was elected to the Werkbund executive for a one-year term in Nov. 1932, presumably to represent the conservative *Handwerk* point of view. Cf. *DWB-M* Dec. 15, 1932.

[37] Wilhelm Lotz, "Ewige Formen—Neue Formen," *Die Form*, VI, No. 5 (1931), 161-66; Walter Riezler, "Ewig—Zeitlos," *ibid.*, pp. 167-74; Justus Bier, "Zur Ausstellung 'Ewige Formen,'" *ibid.*, pp. 175-76. Schaefer, *Roots of Modern Design*, refers to this as the "vernacular tradition." See also Klaus-Jürgen Sembach, *Into the Thirties: Style and Design 1927-1934* (London, 1972), p. 21. On the founding of the *Neue Sammlung*, R. von Delius, "Die Neue Sammlung in München," *Die Form*, I, No. 7 (1925-26), 154-55. Based on a collection donated by the Werkbund's *Münchner Bund*, the *Neue Sammlung* was—and has remained—extremely close to the Werkbund.

as experimentalism yielded to renewed appreciation of the intrinsic value of continuity, the older generation of Werkbund designers came back into favor. The twenty-fifth anniversary celebration of the Werkbund, in 1932, at which Poelzig, Schumacher, Riemerschmid, and Theodor Fischer were prominent, reflected this tendency to seek roots in the past even for essentially modern design phenomena.[38]

Given the prevailing mood of the early 1930's, it is no wonder that the Werkbund progressives, dedicated to the triumph of a new era based on science and technology, found it difficult to maintain their position of intellectual leadership. Their problems were compounded by attacks from men whose dissatisfaction stemmed from primarily economic grievances. Since the early 1920's there had been complaints from groups that felt their interests damaged by the new architecture. Handicraftsmen and decorative artists protested that the trend to unornamented form unfairly discriminated against their traditional skills. Similarly, stonecutters or men engaged in forestry and related trades saw the increasing use of steel, concrete, and glass as a direct threat to their livelihood. But so long as times were good, little could be done to mobilize such sentiments as an effective brake on the modern movement. For example, the Württemberg furniture manufacturers, already alarmed by the *Form ohne Ornament* exhibition of 1924, had become sufficiently organized by 1927 to secure the inclusion of some of their products in the home furnishings section of the Weissenhof exhibition; but local pressure was not strong enough at that time to prevent the showing of Marcel Breuer's steel chair and other experimental designs approved by the Bauhaus.[39] With the

[38] Much of the 1932 annual meeting was in fact devoted to re-examining the Werkbund "tradition." See *Die Form*, VII, No. 10 (1932), 297-324.

[39] Gropius expressed disgust with the concessions made to local interests by the exhibition directorate, in a speech reported by the *Schwäbische Merkur*, No. 474, Oct. 11, 1927. A copy of the protest

onset of the Depression, however, these interest groups, their situation further impaired, became increasingly vehement in their opposition to "Werkbund" functionalism. In alliance with members of the intellectual and artistic elite who were opposed to the modern movement on abstract aesthetic or patriotic grounds, the artisans systematically pressed their attack on the *Neue Bauen*. Pro-*Handwerk* elements accounted for much of the criticism directed against the Werkbund leadership at the Stuttgart meeting of 1930, and in the following year there were charges that Werkbund exhibitions abroad damaged the South German arts and crafts, because firms that failed to subscribe to the favored *Werkbundstil* lost sales and therefore had to curtail employment.[40] By 1932, Peter Bruckmann, touring the small cities of Württemberg during an electoral campaign for the *Landtag*, found the Werkbund everywhere identified as the enemy of *Handwerk*, and himself notorious because of his connection with it.[41] Clearly, the tolerance and good will that had initially enabled the Werkbund to mobilize considerable popular support for the new architecture had evaporated.

The Werkbund, if it wished to carry on its work, had to take into account the views of its critics. While maintaining that it had never intended to impose a uniform *Werkbundstil* and rebutting every charge made against it, the association after 1930 nevertheless began to make concessions. Thus, the *Werkbundsiedlung* of 1932 in Vienna turned its back on the intensive block-building of earlier public housing experiments and instead created a "semi-rural suburbia" more in line with middle-class tastes.[42] Even in Württemberg, that stronghold of Werkbund modernism, an exhibition scheduled for 1933 consciously

by the *Wirtschaftsverband der Deutschen Holzindustrie*, dated Sept. 20, 1927, can be found in *LC*, Container 3, 1927, Folder 1.

[40] Excerpt from the *München-Augsburger Abend-Zeitung*, in *Die Form*, VI, No. 2 (1931), 77.

[41] See Renner, "An die Vorstandsmitglieder des DWB," p. 9.

[42] Benevolo, *History of Modern Architecture*, II, 549.

set out to placate the irate forestry interests and carpenters of the region. By planning a modern housing estate on the *Kochenhof* in Stuttgart as part of this *Deutsches Holz für Hausbau und Wohnung* exhibition, the Werkbund re-affirmed its allegiance to progressive ideals. But the return to wood construction marked a break with an important feature of the *Neue Bauen*, its extensive use of glass and concrete in home building; and the selection of Hugo Häring, the exponent of "organic" architecture, to head the project, represented a repudiation of *Neue Sachlichkeit*.[43]

The economic crisis weakened the Werkbund financially, encouraged hostile aesthetic and intellectual elements, and exacerbated the opposition of certain interest groups. Nevertheless, the disintegration of the Weimar Werkbund can be understood only by considering the political environment. For the period 1930-1932 witnessed not just the collapse of the German economy, but an associated political upheaval from which no sector of the nation could remain aloof. Throughout the 1920's the Werkbund had prided itself on its political neutrality and had maintained an above-party stance. But after 1930, the line between culture and politics, never clearly drawn, was breached increasingly from both sides.

Perhaps the primary characteristic of German politics after 1930 was the tendency to extremism. As the Depression deepened, the initiative passed from the moderate center to the radicals of both Right and Left. National Socialists and Communists clashed in the streets and competed for the allegiance of the German voter in an apparently endless series of elections. The nation's cultural elite found it increasingly difficult to escape the process of political polarization. Especially among the young, ev-

[43] Eckstein, "Idee," p. 16. The intiative for this exhibition came from the radical Stuttgart architect and *Ring* member Richard Döcker. Cf. Lauterbach and Joedicke, *Hugo Häring*, p. 12. The retreat from functionalism in the early 1930's was reinforced by the demise (in 1931) of the *Reichsforschungsgesellschaft*. Teut, *Architektur*, pp. 53-54.

eryone seemed to be either a Nazi or a Communist.[44] Progressives loudly attacked their critics as cultural reactionaries; while the latter, spurred on by the National Socialists, accused the modernists of "cultural bolshevism." The absurdity of this process was recognized at the time only by a few, who strove in vain to maintain the distinction between art and politics:

> When they are in power, reactionary parties proscribe the revolutionary,
> religious parties the atheistic and immoral (naked)—
> and anticlerical parties the religious representations of Art.
> Parties of the middle always favor an art of the middle.
> Good art is anathema to every party
> Bad art is agreeable to all.[45]

Although the Werkbund's membership ran the gamut from Right to Left, as an association it stood near the center of the political spectrum. As a result, it proved vulnerable to attack from both extremes. The Communists and their allies deplored its failure to adopt the cause of the proletarian revolution. Debating with Riezler in *Die Form*, the Marxist Roger Ginsburger argued that the architect must cease to serve his former masters and throw in his lot with the working masses, suppressing all personal stylistic preferences to meet the material and psychological needs of the ill-housed majority. His position was similar to that put forward two years before by Alexander

[44] Renner, "An die Vorstandsmitglieder des DWB," p. 13. Cf. Albert Speer, *Inside the Third Reich* (New York, 1970), p. 14, on the polarization within the Institute of Technology in Berlin, where Poelzig allegedly attracted the small group of Communist architectural students while the National Socialists gravitated to Tessenow's seminar. In both instances, the process rested on a misconception: Poelzig was certainly no Communist, and Tessenow never joined the National Socialist party. In fact, both professors remained determinedly apolitical.

[45] Karl Scheffler, in *Kunst und Künstler*, xxxi (1932), 387. Scheffler published this as a doggerel intended "to be taught to school children"!

Schwab in his critique of Gropius's *Genossenschaftsstadt*, but Ginsburger put the case for a politically revolutionary Werkbund even more forcefully, citing the extreme unrest of the times in suport of his views.[46]

Of the two best-known Werkbund architects, Gropius and Mies van der Rohe, it was the latter who particularly aroused the ire of the Left. After all, Gropius, although he refused to identify with any political party, had consistently stressed the social responsibility of the artist.[47] By contrast, Mies's radicalism had been aesthetic rather than social even in the revolutionary postwar years. While Gropius addressed himself to the practical needs of his contemporaries, exploring the social implications first of *Handwerk* and then of the *Neue Sachlichkeit*, Mies concentrated on the formal aspects of design. The social, economic, and technical problems that absorbed the attention of his more radical colleagues. Mies regarded as "merely" practical and of secondary importance. Like other Werkbund idealists, he sought solutions in the realm of the spirit and preferred to keep his art severely divorced from "politics." Thus, in a speech at the Werkbund congress in Vienna in 1930, Mies insisted that the new era must be accepted as a fact independent of anyone's approval or disapprobation.[48] This essentially value-free approach to current controversies infuriated the politically committed, who concluded that Mies was simply advocating accept-

[46] "Zweckhaftigkeit und geistige Haltung, eine Diskussion zwischen Roger Ginsburger und Walter Riezler," *Die Form*, VI, No. 11 (1931), 431-36.

[47] See the exchange between Gropius and Tomás Maldonado, in *Ulm: Zeitschrift der Hochschule für Gestaltung*, No. 8/9 (1963), pp. 62-63, where Gropius insisted that he, not the Marxist Hannes Meyer, had brought social concern into the Bauhaus, but criticized Meyer for combining this with party politics. Also Herbert Hübner, "Die soziale Utopie des Bauhauses," inaugural dissertation, Westfälische Wilhelms-Universität Münster, 1963, pp. 57-59, 62-63 and 82.

[48] "Die Neue Zeit, Mies van der Rohe auf der Wiener Tagung des Deutschen Werkbundes," *Die Form*, V, No. 15 (1930), 405. In Mies's words, "Die Neue Zeit ist eine Tatsache; sie existiert ganz unabhängig davon, ob wir 'ja' oder 'nein' zu ihr sagen."

ance of the status quo. Actually, Mies had not intended to renounce the individual's right to judge his times and find them wanting, but he did maintain that the criteria for such judgment must be aesthetic and spiritual rather than utilitarian. His critics thus erred in accusing him of ethical neutrality, but correctly saw that Mies was prepared to approve any political regime that offered scope for artistic creativity.[49]

Mies's lack of social concern seemed confirmed by the nature of his architectural practice. His two most notable buildings of the period—the Barcelona exhibition pavilion of 1929 and a luxury villa, the *Haus Tugendhat* of 1930—undoubtedly deserve a place in histories of modern architecture, but they made no contribution to solving the problems regarded as urgent by the more socially-minded. Finally, his determination to separate art from politics manifested itself in 1930 when he took over the leadership of the Bauhaus from Hannes Meyer, a doctrinaire Marxist. By cleansing the school of the radical elements his predecessor had encouraged, Mies aroused the enmity of the left-wing students, who abhorred his apolitical orientation and the authoritarian methods he employed as Bauhaus director.[50]

To many on the Left, the Werkbund by 1932 appeared an association of useless aesthetes, out of touch with the German masses, and encouraging the dissipation of valuable talent on the design of luxuries. But this judgment was not the monopoly of the socialists. The extreme Right echoed essentially the same view when it charged the Werkbund with disregarding the wishes of the *Volk*. Both Left and Right deplored the elitism of the Werkbund leadership, which continued to advocate artistic innovation long after the "modern style" had ceased to be acceptable

[49] Mies concluded: "Denn Sinn und Recht jeder Zeit, also auch der neuen, liegt einzig und allein darin, dass sie dem Geist die Voraussetzung, die Existenzmöglichkeit bietet."

[50] Communist students at the Bauhaus were among Mies's most vociferous critics. Cf. *Bauhaus*, No. 3 (1930), quoted in Wingler, *The Bauhaus*, p. 170.

even to the majority of its own members.[51] In their defense, the Werkbund leaders argued that the association could in any case only hope for understanding from the cognoscenti, and that its influence in the long run would depend on its ability to convert the enlightened few.[52] As late as 1932, Theodor Fischer, undismayed by the Werkbund's unpopularity, warned that it must guard against compromising its ideals in a vain effort to curry favor with the masses.[53]

The Werkbund further revealed its elitism when it insisted that the *Neue Bauen* be judged by the creations of a Gropius or a Mies rather than by the more prolific if less exalted work of the merely talented; when it condemned most manufacturers of "contemporary" forms as unscrupulous entrepreneurs exploiting the work of the creative artist; when it tried to prevent the use of its name in conjunction with goods in mass production; or when, in the crafts, it confined its approval to the products of the few highly skilled artworkers while disdaining the bulk of handicraft output.[54] Given this aristocratic selec-

[51] Otto Neurath, "Die neue Zeit im Lichte der Zahlen," *Die Form*, v, No. 19/20 (1930), 532-34. Neurath, director of the Gesellschafts- und Wirtschaftsmuseum in Vienna, pointed out that if there were few who furnished their homes in the "modern" style, perhaps it was not modern after all! Unlike Jäckh and Lotz, he wanted the *Neue Zeit* exhibition to show current realities, rather than the preferences of a minority of would-be prophets.

[52] For example, Gropius, "My Conception of the Bauhaus Idea," *Scope of Total Architecture* (New York, 1955), p. 19. In retrospect, Gropius recognized that the advance of the new style in the 1920's had been too rapid, and that natural human inertia lay behind much of the resistance to it. Implied is the notion that the ordinary man, left to himself, will always slow the rate of innovation acceptable to the minority.

[53] As reported by Adolph Donath, "Der Werkbund-Gedanke," *Berliner Tageblatt*, Oct. 17, 1932.

[54] E.g., Walter Riezler, "Front 1932," *Die Form*, vii, No. 1 (1932), 1-4; and Poelzig, "Der Architekt," in Gaber, *Entwicklung*, p. 247. Poelzig here described talent as the greatest enemy of genius! Reproducing an advertisement for an iron stove in the "Werkbundstil" from the Technology Supplement of the *Berliner Tageblatt*, the editors of *Die Form* commented that no Werkbund style existed, only a Werkbund attitude ("Gesinnung"). But there is no doubt that

tivity, it is no wonder that the Werkbund by the 1930's found itself isolated from both industry and *Handwerk*.[55]

The Werkbund had clearly failed to solve the basic problem posed by the establishment of the democratic republic, namely how to reconcile intellectual and artistic leadership with the demands of a mass-based culture. When it became apparent at the onset of the Depression that the public rejected its ideals, the association at first welcomed the evolution of a more authoritarian regime in which public opinion would no longer play a predominant role.[56] Unfortunately, the Brüning government that in effect ended parliamentary government in Germany in 1930, concentrated on economic and political issues to the virtual exclusion of cultural matters, so that the Werkbund found itself forced to deal with an unsympathetic civil service just when its loss of support from other sources had rendered it more dependent than ever on bureaucratic favor. As far as the Reich government was concerned, there is no doubt that the Werkbund's influence reached its nadir during the Brüning years.

Unwilling to adopt either the Communist ideal of "proletarian culture" or the *völkisch* populism of the National Socialists, the Werkbund tried to maintain itself against pressure from the radicals of both Left and Right. In this, it relied in good part on the eloquent advocacy of Walter

they were pleased by this indirect recognition of Werkbund influence. Cf. *Die Form*, v, No. 1 (1930), 28.

[55] Renner, "An die Vorstandsmitglieder des DWB," pp. 10-11. Writing to Renner on April 21, 1932 (*BASK*, DWB III), Riezler told of the difficulties the Werkbund was having in converting big business. During the winter of 1930-1931, there were several meetings with representatives of the *Reichsverband der Deutschen Industrie*, but the only common ground seemed to be agreement on the value of Werkbund exhibitions. *DWB-M* Dec. 15, 1930 and Feb. 15, 1931.

[56] See Günther von Pechmann, "Der Qualitätsgedanke und die deutsche Wirtschaftspolitik," *Die Form*, VII, No. 11 (1932), 331. Pechmann was reporting as chairman of the Werkbund's consumer products committee, to the annual meeting, Berlin, Oct. 1932. On the link between modern architecture and the state, Benevolo, *History of Modern Architecture*, II, 498.

Riezler in *Die Form*. Against the political Left, Riezler insisted on the creative artist's right and duty to express his personal vision even at a time when the majority of his fellow citizens suffered extremes of economic deprivation. He refused to admit that either the artist as an individual or the Werkbund as a whole had a mission to overturn the social order, and argued that no blame could therefore attach to accepting patronage from capitalist sources. In defense of Mies's *Haus Tugendhat*, commissioned by a wealthy businessman, Riezler maintained that any work that made possible the realization of significant aesthetic concepts was to be welcomed in a period of gravely curtailed creative opportunities.[57]

The chief danger to the Werkbund came from the Right, however. Whereas the left-radical critics tended to be outsiders, the Werkbund harbored significant elements receptive to right-wing traditionalism or *völkisch* nationalism. These were the very groups to which the National Socialists directed most of their propaganda when they set out systematically to woo the intellectuals. Yet the National Socialist leaders were careful not to define the goals of their *Kulturpolitik* before 1933. Whether because they had not yet made up their minds or because they were reluctant to antagonize potential supporters, the Nazis for a time tolerated internal controversy on artistic questions. This made it possible for conservatives and modernists alike to cite National Socialist pronouncements to demonstrate that the movement basically supported their own views.[58]

The performance of Wilhelm Frick, National Socialist Minister of Culture in the Thuringian coalition govern-

[57] Walter Riezler, "Front 1932," *Die Form*, VII, No. 1 (1932), 1-4.
[58] Lane, *Architecture and Politics*, p. 152, notes that the National Socialist *Der Völkische Beobachter* contained many articles favorable to the *Neue Bauen* before 1930. On the other hand, Schultze-Naumburg and the *Block* had for some years linked National Socialism with cultural reaction. The *Block*, in 1932, published the first "National Socialist" architectural program, K. W. Straub's *Weder so noch so, Die Architektur im Dritten Reich* (Stuttgart, 1932). Cf. Teut, *Architektur*, pp. 19 and 62-64.

ment elected in 1930, seemed to prove that the Nazis were cultural reactionaries. Yet even after this demonstration of National Socialism in action, which involved the destruction of the Weimar *Bauhochschule* directed by Otto Bartning, a Werkbund observer could argue that Thuringia represented a special case, and that what had occurred in the philistine backwater of Weimar was unthinkable in Prussia or the Reich as a whole.[59]

If it was possible to disagree on what the Nazis stood for or on what they would do should they come to power at the federal level, after 1930 it was only too clear what they opposed. Led by Rosenberg's *Kampfbund für deutsche Kultur* and the *völkisch* news service, *Deutscher Kunstbericht*, the National Socialists posed as defenders of the nation against the "cultural bolsheviks," whom they accused of using modern art and architecture to corrupt the patriotism and morality of the German people.[60]

The charge of "cultural bolshevism" appealed to many conservatives unconnected with the Nazi party and even to men highly critical of its general program and methods.[61] It aroused prejudices common to all for whom the

[59] Justus Bier, "Zur Auflösung der Staatlichen Bauhochschule in Weimar," *Die Form*, v, No. 10 (1930), 269-74. The main beneficiary of Nazi policy on this occasion was Schultze-Naumburg, who took over the school and vented his wrath on all who had held even moderately progressive views.

[60] On the *Kampfbund*, see its *Mitteilungen*, I-III, Munich, 1929-1931. Also, Lane, *Architecture and Politics*, pp. 148-52; and Teut, *Architektur*, p. 21. On the *Deutsche Kunstbericht*, cf. the compilation of articles in Bettina Feistel-Rohmeder, *Im Terror des Kunstbolschewismus* (Karlsruhe, 1938), and Rave, *Kunstdiktatur im Dritten Reich*, pp. 14-15.

[61] An early reference to the Werkbund's "bolshevik" hatred of ornament appeared in a report by Hermann Heuss to a meeting of the Sächsische Landesstelle für Kunstgewerbe, in *DWB-M* No. 8, Nov. 28, 1924. For the effect of Nazi propaganda on at least one foreign observer, see S. H. Roberts, *The House that Hitler Built* (London, 1939), pp. 256-57. Roberts tells how during the Weimar years many poor children had been indoctrinated with "bolshevik ideas" in the schools, and how "cultural bolshevism" had invaded art, music, literary criticism, and history. He was prepared to believe that these tendencies were more destructive to Germany than the "superpatriotism of the Nazis."

negative consequences of cultural change outweighed the benefits of progress. Those who employed it gave little thought to fact or consistency, using it indiscriminately to denote whatever qualities they disliked in contemporary culture, including its alleged internationalism, anti-individualism, materialism, and immorality. As a slogan, it therefore proved an ideal tool for the National Socialists in their attempt to win over significant sections of Germany's intellectual and artistic community.

Those who used "cultural bolshevism" to attack the *Ring*, the Bauhaus, and the Werkbund itself set out to demonstrate that modern art, particularly the *Neue Bauen*, represented a Marxist-Jewish plot to destroy German culture. In the hands of such men as Schultze-Naumburg, Konrad Nonn of the Prussian Ministry of Finance's building division, and the Swiss architect Alexander Senger, who made a specialty of criticizing his more gifted compatriot Le Corbusier, this charge proved remarkably potent.[62] Yet their allegations could easily be controverted. Thus it is true that the *Ring*, denounced by the Nazis as a "Jewish-bolshevist architectural organization," contained a number of artistic and social radicals;[63] but it also included men like Behrens, Poelzig, and Tessenow who had been successful architects long before the hated November Revolution of 1918 and whose patriotism was above reproach. Moreover, although its members admired Le Corbusier as an architect, they could not justly be accused of subservience to his artistic influence. Nor did their interest in Russian architectural developments lead

[62] Lane, *Architecture and Politics*, pp. 133-45, shows that Schultze-Naumburg avoided specific references to bolshevism or anti-Semitism, confining himself to an apolitical racialist attack on the modern movement. Nonn joined the Nazi party around 1930, in order to get back at the Weimar progressives, who, he alleged, had secured his dismissal from the Ministry because of his attacks on the Bauhaus. When the National Socialists came to power, he was duly reinstated. *Ibid.*, pp. 81-82; and Teut, *Architektur*, pp. 135-36. Senger became a National Socialist in 1932 or 1933.

[63] See the quotation from *Der Völkische Beobachter*, in Lane, *Architecture and Politics*, p. 165.

the *Ring* architects to uncritical advocacy of the Soviet system. Far from seeking to undermine their own society or culture, these men generally prided themselves on their contributions to what they regarded as Germany's first truly national style.[64]

The Bauhaus, born of the 1918 revolution and dependent on republican governments to 1932, was vulnerable as a product of the hated Weimar system. Concerned with social questions from the start, between 1928 and 1930 it had come under Marxist control. However, by the time the Nazi-led campaign against the school reached its climax, Mies van der Rohe had successfully and ostentatiously cleansed it of every taint of "communism" and restored its apolitical character. If the Bauhaus engaged in "politics," it was only in response to external pressures that threatened its continued existence.[65] Nevertheless, the Nazis accused the Bauhaus of cultural bolshevism, for example referring to it as a "cathedral of Marxism" built like a synagogue.[66] With such slander, they succeeded in mobilizing the bourgeois parties and eventually secured the school's eviction from Dessau in 1932.[67]

As far as the Werkbund was concerned, one would have

[64] See the undated memorandum (circa 1934) by Hugo Häring, "Für die Wiedererweckung einer deutschen Baukultur," *Bauhaus*, GN 13/1/23-31. Häring systematically demolished the charges of Senger, Nonn, and others who denounced the *Neue Bauen* as cultural bolshevism. Also Lane, *Architecture and Politics*, p. 181.

[65] Walter Gropius, "The Idea of the Bauhaus," in Eckhard Neumann, ed., *Bauhaus and Bauhaus People* (New York, 1970), p. 16. Looking back at his diary for the period 1923-1928, Gropius estimated that 90% of the energies of all involved in the Bauhaus had gone into "countering national and local hostility, and only ten percent remained for actual creative work." On the "politics" of the Bauhaus, Hübner, "Die soziale Utopie des Bauhauses," pp. 138-42. Hübner stressed the school's link with the Republic, but one must bear in mind its roots in the Imperial period. Cf. Franciscono, *Walter Gropius*, pp. 13-70.

[66] Lane, *Architecture and Politics*, p. 162.

[67] According to Lang, *Das Bauhaus*, p. 143, in the final vote on the Bauhaus's fate in August 1932 the SPD abstained, and only the mayor of Dessau and the four Communist members of the City Council voted to keep the school.

thought that the association's position as defender of the national culture was unassailable and the social respectability of its leading members beyond question. The way in which the National Socialists nevertheless attempted to discredit it reveals much about their method of operation. In the first place, they accused the Werkbund of "internationalism." The Werkbund had indeed encouraged German artists and architects to regard themselves as participants in a movement that went beyond national boundaries, and had welcomed the establishment of similar groups abroad, hoping that one day a Werkbund "league of nations" would come into being. Moreover, by inviting foreigners to show their work at the Weissenhof and elsewhere, and by giving considerable space in *Die Form* to discussion of American, Russian, and other non-German developments, it sought to demonstrate the international character of the new era.[68] Yet the Werkbund never abandoned its strong commitment to the national cause. On the contrary, it was just because its leaders were so confident of the ability of their fellow countrymen that they did not hesitate to enter into an exchange of ideas with their peers in other lands.[69]

In fact, the deep-rooted nationalism of the pre-1914 Werkbund continued to reveal itself during the Weimar years, particularly in its foreign exhibition work. Motivated by the desire to restore the reputation of Germany as a leader of the modern movement and to counter the renewed threat of French cultural dominance, the Werkbund in 1925 had sought to ensure German participation at the first postwar international exhibition of the decorative arts in Paris. When the German government, aggrieved at receiving an invitation only at the last moment,

[68] *Die Form* carried reports in French and English on the Paris decorative arts exhibition of 1930, and as late as 1932 it featured articles on architecture in Italy, Russia, Austria, England, and the United States.

[69] E.g., Walter Riezler, in his introduction to *Das deutsche Kunstgewerbe im Jahr der grossen Pariser Ausstellung* (Berlin, 1926), p. 10, a report on the 1925 Monza exhibition.

resolved to boycott this event, the Werkbund supported its decision and instead helped to organize a small counterexhibition in the Italian city of Monza, near Milan.[70] There followed a series of government-sponsored exhibitions in countries from the United States to Brazil and Japan, which showed industrial products and crafts of modern design selected by the Werkbund.[71] For a time, the anti-French animus yielded to a spirit of friendly rivalry that enabled the Werkbund at last to show itself in Paris. But by the opening day of the international exhibition of 1930, the tide had turned once more, and predominantly nationalistic criteria were applied by critics of both countries in judging this first German exhibition in the French capital.

The Werkbund also furthered the national cause by stressing the importance of the borderlands and occupied territories, and by working to maintain German territorial unity. The Breslau congress and exhibition of 1929, under the patronage of Reich President Hindenburg himself, consciously directed the attention of West and South to the problems of the threatened East. True to the legacy of Friedrich Naumann, the Werkbund also advocated closer ties between Germany and Austria. The Vienna annual meeting of 1930 was designed to remind Germany and the world that these two countries were culturally one, even if a political or economic *Mitteleuropa* could not be attained; and from 1929 the Werkbund gave institutional expression to the principle of Austro-German cultural unity

[70] The Werkbund approved this abstention only with the greatest reluctance, and the controversy over German participation continued to rage for over a year. See especially "Protokoll der Vorstands-und Ausschuss-Sitzung am 27. Oktober 1924 . . . ," p. 2; *DWB-M* Dec. 28, 1924; Walter Riezler, "Deutschland und die Internationale Gewerbeausstellung in Monza," *Die Form*, I, No. 1 (1925-26), 11-13; memorandum by Bruno Paul, Aug. 6, 1925, *BA*. Rep 301/III; Fritz Hellwag, "öffentliche Kunstpflege, Deutscher Werkbund und Pariser Weltausstellung," *Kunstchronik und Kunstmarkt* (1925), pp. 382-85; and a reply in *DWB-M* Oct. 1925.

[71] Cf. Freytag, "Über deutsche Kulturpolitik im Ausland," pp. 97-109, and periodic reports in *Die Form*.

by arranging for dual membership in the Austrian and German Werkbund groups.[72] Thus while the Werkbund hoped that its ideals would in time find acceptance throughout the civilized world, at heart it remained a thoroughly German institution, concerned above all to preserve and extend the national culture in traditionally "German" lands.[73]

What really differentiated the Werkbund from its nationalist critics was its refusal to identify national with folk art. *Völkisch* advocates of Blood and Soil (*Blut und Boden*) could therefore charge it with preferring to look abroad for inspiration, or even back to the primitives, rather than drawing on the German folk heritage.[74] While its opponents attributed this tendency to the Werkbund's lack of patriotism, in fact it sprang from the association's deep commitment to the ideal of a unified national style, to which local and regional design traditions must be subordinated.

In their effort to tar the Werkbund with the "cultural bolshevik" brush, the Nazis also used the method of imputing guilt by association. Because the Werkbund had been closely linked with the Bauhaus from its inception and for a time took its cue from prominent *Ring* architects, it became an easy target for enemies of the *Neue Bauen*.[75] But to designate the Werkbund itself as "bolshevik" was simply ludicrous. While the association did include a few socialists and many idealists disdainful of

[72] *DWB-M* Nov. 1, 1929, reporting on an executive and board meeting of Oct. 15. A member of either group thereafter automatically became a member of the other. From Nov. 1929 to Sept. 1933, *Die Form* served as the organ of the Austrian as well as of the German Werkbund.

[73] See *DWB-M* June 1925, where the German Werkbund expressed satisfaction at the recent creation of a "Werkbund der Deutschen in der Tschechoslowakischen Republik."

[74] E.g., the memorandum of Dec. 16, 1927 from a Viennese Werkbund member, signature illegible, in *BA*, Rep 301/443.

[75] Almost without exception, the *Ring* architects attacked by name in *Der Völkische Beobachter* were influential members of the Werkbund. Lane, *Architecture and Politics*, p. 165.

profiteers and capitalists, on the whole it was ideologically much closer to the "German socialism" espoused by the Nazis than to any form of Marxism.[76] If its members thought of revolution at all, it was in terms of spiritual regeneration rather than overthrow of the existing social order.[77] In any case, individual Werkbund artists of all political persuasions were prepared to cooperate with private enterprise, and the association, albeit reluctantly and with little success, made repeated attempts to improve its contacts with the world of business.[78] Like the Bauhaus, it had shown itself willing to work with socialist governments, but this alone could hardly justify its condemnation as a "Marxist" tool. Similarly, although some Werkbund members looked to the U.S.S.R. for inspiration or even accepted opportunities offered by the Soviet regime for socially significant work, on the whole they remained convinced of German cultural superiority and regarded themselves as teachers rather than apprentices in the Russian context.[79]

National Socialist propagandists who used the term "cultural bolshevism" often gave vent simultaneously to their racialist anti-Semitism. The Werkbund counted not

[76] Paul Renner, *Kulturbolschewismus?* (Zürich, 1932), pp. 42-43. Renner claimed that the socialism of the Werkbund was "Prussian" rather than Russian. The notion of a peculiarly Prussian socialism was common among conservative intellectuals in the 1920's, and the National-Social idea espoused before the First World War by Friedrich Naumann continued to find adherents.

[77] The charge of cultural bolshevism in relation to Gropius and Mies is discussed by Egbert, *Social Radicalism and the Arts*, pp. 653 and 663-65. Cf. Hübner, "Die soziale Utopie des Bauhauses," p. 82.

[78] "Werkbund, Industrie und Handwerk," *DWB-M* Feb. 15, 1931.

[79] Walter Riezler, "Die Kluft," *Die Form*, VII, No. 2 (1932), 42-43. Riezler denied that the *Neue Bauen* had Russian roots, instead stressing the inspiration derived from capitalist Holland and America. Ernst May, Bruno Taut, and others who went to Russia to work under the auspices of the Soviet government, were soon disillusioned, because they found their creative efforts hampered by the growing bureaucratization of Russian cultural life. See Lane, *Architecture and Politics*, p. 103. Mendelsohn, *Letters of an Architect*, pp. 125-26, reports how Gropius returned from a visit to Leningrad early in 1933 horrified and shaken by what he had seen.

a single Jew among its prominent members, but so-called patriots, convinced that Jews and Marxists were conspiring to exclude nationally-minded artists from jobs and influence, condemned the Werkbund as an instrument of this conspiracy. In order to do so, they sometimes falsely accused Aryans of being Jews, for example Gustav Hartlaub of the Mannheim Art Gallery, whom they disliked for his support of modern art.[80] Peter Behrens they denounced as a cultural bolshevik because of his association with Walther Rathenau in the A.E.G., and with Einstein, Werfel, and other Jews in the "Circle of Friends of the Bauhaus." Behrens, that most socially conservative and patriotic of architects, was further charged with philo-Semitism by an aggrieved architectural assistant who in July 1932 claimed he had been dismissed from Behrens' Berlin office at the instigation of the office manager's Jewish wife solely on account of his National Socialist proclivities.[81]

The Werkbund also suffered through its link with the Jewish publishing firm of Hermann Reckendorf. As anti-Semitic pressure built up in 1932, this relationship became uncomfortable for both sides. Considerations of prudence may well have supplemented economic motives to induce the Werkbund to abandon its office in the *Reckendorfhaus* in April of that year; while the desire not to give unnecessary offense to the National Socialists motivated Reckendorf's decision to censor a strongly anti-Nazi article by Walter Riezler in August, which helped precipitate the final break between Reckendorf and the Werkbund.[82]

[80] Renner, *Kulturbolschewismus?*, pp. 13-15.

[81] On the "Circle of Friends of the Bauhaus," Egbert, *Social Radicalism and the Arts*, pp. 663-64. See the denunciation by Dr. Ing. Nonn, Sept. 1938 and the letter of July 1932 from the architectural assistant, both in the Berlin Document Center (BDC), Behrens file.

[82] In his draft (*BASK*, DWB III) for "Der Kampf um die deutsche Kultur," Riezler had placed the blame for the destruction of the Bauhaus squarely on the National Socialists. The published version in *Die Form*, VII, No. 10 (1932), 325-27 acknowledged that antag-

As the attacks on Reckendorf show, the Nazis were pre-
pared to resort to terror and intimidation to achieve their
aims. During this period, however, their primary empha-
sis was still on propaganda. In order to extend their in-
fluence they not only employed their own newspapers
and periodicals, but also made skillful use of front organi-
zations like the *Kampfbund für deutsche Kultur*. The
Kampfbund, founded by the National Socialists, did not
declare its affiliation openly nor require its members to
join the party, although anyone who spoke at a *Kampfbund*
meeting was introduced by a party member. This enabled
it to attract support from "unpolitical" members of the
academic and artistic community, some of whom even
regarded themselves as anti-Nazis.[83] After 1931, the
Kampfbund's efforts were supplemented by a special sec-
tion for architects and engineers, the *Kampfbund deut-
scher Architekten und Ingenieure* (KDAI), which joined in
the propaganda war against the New Architecture. As a
competitor to the BDA and the Werkbund for the alle-
giance of architects, the KDAI accelerated the polariza-
tion of the profession along ideological lines begun in the
late 1920's by the establishment of the *Block*.[84]

Finally, the Nazis employed the tactics of infiltration.
It is impossible to determine how many Werkbund mem-
bers actually joined the National Socialist party before
1933, but there is no doubt that the internal opposition
included clandestine Nazis and that many members were

onism to the Dessau Bauhaus was not confined to the Nazis. Cf.
BASK, DWB III, letter from Lotz to Riezler, Aug. 15, 1932. Recken-
dorf committed suicide in January 1933, according to information
received from Dr. G. B. von Hartmann, Berlin, letter of April 2,
1974. Reckendorf's successor as printer of *Die Form*, another Jewish
firm (W. & S. Loewenthal), was apparently forced in April 1933 to
sell out to an Aryan concern, Wendt und Matthes.

[83] Lane, *Architecture and Politics*, p. 255, n. 11. Fritz Schumacher,
Theodor Fischer, and Paul Bonatz were among those who addressed
Kampfbund meetings.

[84] *Ibid.*, p. 158. Other dissident conservative offshoots of the BDA
were *Der Bund* (Munich, 1927) and *Die Gruppe* (Dresden, 1932).
See Teut, *Architektur*, p. 29 n.

prepared to follow the party line in attacks on the non-Nazi leadership of the association. Among the most persistent was Johannes Knubel, chairman of the Werkbund's *Niederreinische Arbeitsgemeinschaft* (Lower Rhineland Branch), who from 1930 on did his best to make Werkbund policy conform to *Kampfbund* principles.[85]

As repeated electoral successes increased the likelihood of a National Socialist government, men concerned for their professional future found it expedient to ingratiate themselves with, or at least refrain from antagonizing, the nation's prospective rulers. Frick's dismissal of the entire staff of Bartning's *Bauhochschule* in Weimar in 1930, and closure of the Dessau *Bauhaus* in 1932, reinforced their insecurity, reducing many to such a state of terror and confusion that they could not think of effective countermoves. The Werkbund leadership, although divided on the best tactic to employ, eventually decided to "respond" to National Socialist pressures by adopting a wait-and-see approach. The executive secretary, Otto Baur, was in agreement with Mies, Jäckh, and Lotz that the Werkbund should maintain strict political neutrality while making concessions as required, in order to preserve the association's organizational viability. Against them, a small group of activists led by Walter Riezler and Paul Renner of Munich, argued that the best defense lay in attack, and that the Werkbund had either to mount a public campaign against the National Socialists or risk falling into oblivion.[86]

[85] *DWB-M* Nov. 15, 1930, shows Knubel pressing for revision of the contract with Reckendorf and advocating a dues-sharing arrangement between the branches and head office. His campaign against the Berlin leadership intensified in the early months of 1933. See Ch. IX, below.

[86] Walter Riezler, "Werkbundkrisis?" *Die Form*, VI, No. 1 (1931), 2; Renner, "An die Vorstandsmitglieder des DWB," p. 13. Renner, arguing for revitalization of the Werkbund, maintained that a strong association need not worry about any political party but would be able to command a respectful hearing even from the National Socialists. He outlined his reform proposals at several meetings of the Werkbund's inner council, as well as in two memoranda to members of the executive committee, dated April 12 and May 10, 1932, *BASK*, DWB III.

What separated the appeasers from the resisters was above all a different appraisal of Nazi prospects. Baur and Lotz had early come to terms with the idea that further efforts to weaken the Nazis would not prevent their victory but would merely destroy the Werkbund's ability to function effectively under a future National Socialist government.[87] Moreover, they were convinced that many of the younger Nazis rejected Schultze-Naumburg's cultural views. Encouraged by the fact that even Rosenberg on occasion had dissociated himself from the reactionary camp, the appeasers concluded that quiet persuasion might yet induce the Nazis to grant toleration to the modernists.[88]

By contrast, Riezler and Renner insisted that the Nazis had made their reactionary intentions all too clear, and that it was essential to expose their errors so that honorable men misled by their propaganda might yet be persuaded to abandon the cause before irreparable damage had been done.[89] By the summer of 1932, they could no longer disregard the possibility of a Nazi victory at the polls, but they refused to see it as a certainty and therefore continued their anti-Nazi activities. Renner's chief con-

[87] E.g., Lotz to Riezler, Aug. 15, 1932, *BASK*, DWB III.

[88] Thus Winfried Wendland, a young church architect, wrote a letter to the editor of the *Kampfbund Mitteilungen*, I, No. 5 (May 1929), in which he attacked Schultze-Naumburg and others who designated as "cultural bolshevik" any tendency they disliked. Wendland charged that the reactionary neoclassicism advocated by the generation of 1890 was a greater menace to German architecture than Le Corbusier, and put in a good word for such modern artists as Otto Bartning, singled out for his *Stahlkirche*, and Piscator, the radical theatrical designer. However, by 1934, in his book *Kunst und Nation*, Wendland had nothing but praise for Schultze-Naumburg and the *Kampfbund!* See Ch. IX, below. On Rosenberg, see his "Völkische Kunst," in *Der Völkische Beobachter*, May 19, 1932, reprinted in Rosenberg, *Blut und Ehre*, I (Munich, 1934), 198-200. In language that would have been entirely acceptable to most Werkbund members, Rosenberg here condemned *völkisch* artists hypnotized by the past, denounced the imitation of historic styles, and affirmed the right of the contemporary age to seek its own expression.

[89] Letter from Riezler to Lotz, Aug. 16, 1932, *BASK*, DWB III.

tribution was his pamphlet, *Kulturbolschewismus?*, which carefully analyzed the use made of this concept by the Nazis and countered every charge.[90] Riezler employed *Die Form* for the same purpose. In the lead essay of the 1931 volume he had argued the need to fight reaction openly and reaffirmed his dedication to the cause of progressive art.[91] Then in the summer of 1932 he wrote a fighting editorial, "Der Kampf um die deutsche Kultur," in which he openly linked the cultural reactionaries and anti-Semites with the National Socialists. Prevented by Reckendorf and the cautious Werkbund executive from printing this essay in the August issue, Riezler first threatened to resign but then agreed to publish a modified version that omitted specific references to the Nazi party. Even this less partisan piece, however, showed that Riezler, like Renner, realized that cultural questions could no longer be kept separate from politics, that antimodernism and racism were basic to National Socialism, and that it would therefore have to be fought as an absolute evil.[92]

Despite Renner and Riezler, the Werkbund executive remained determined not to antagonize the swelling National Socialist movement and did its best to restrain the interventionists. Mies himself argued for suppression, or at least postponement, of Riezler's "Kampf" article, despite the fact that it had been expressly designed to assist the Dessau Bauhaus in its fight for survival. In Mies's view, such "political" action would merely aggravate the school's difficulties, and goad the Nazis to take extreme

[90] Riezler reviewed Renner's pamphlet favorably in *Die Form*, VII, No. 5 (1932), 161-62. See also Lehmann-Haupt, *Art under a Dictatorship*, p. 67.

[91] "Werkbundkrisis?" *Die Form*, VI, No. 1 (1931), 2.

[92] *BASK*, DWB III, contains amended proofs of this article as well as a draft of the revised manuscript. A few months before, Riezler had still been content to confine his critique of the Nazis to their cultural views, apparently in the hope that they might abandon their reactionary art policy and adopt one more in keeping with their self-proclaimed revolutionary principles. Cf. "Front 1932," *Die Form*, VII, No. 1, 1-4.

measures.[93] Otto Baur seconded the efforts of Mies and Lotz by trying to persuade Riezler that the Werkbund simply could not afford to become known as an uncompromising foe of the Nazi party.[94] The result of this approach was to set the Werkbund on a course hardly distinguishable from National Socialism months before the Nazis actually controlled the power of the state.[95]

Even though better leadership might not have averted the final crisis of the Werkbund, the failure of the association's executive to rally support for an active program undoubtedly weakened it at its moment of greatest peril. By 1932 a power vacuum existed at the center.[96] Bruckmann was on the verge of retirement and Mies van der Rohe found himself largely preoccupied with Bauhaus affairs. At the same time, the Werkbund's loss of prestige made it impossible to persuade able men with established reputations to take on the leadership. For a time it looked as if Erich Raemisch, managing director of the Rayon Sales Bureau (*Kunstseide-Verkaufsbüro*) might be willing to replace Bruckmann. In October 1931, Dr. Raemisch accepted the second vice-presidency, agreeing to be groomed for the presidency and to share the management of Werkbund affairs with Mies until Bruckmann's planned with-

[93] Mies's views were reported to Riezler by Lotz, letter of Aug. 15, 1932, *BASK*, DWB III. By the time Riezler's article appeared, the Bauhaus had ceased to exist as a publicly supported institution. For a time, Mies continued to run it as a private school, in Berlin.

[94] Baur to Riezler, Sept. 5, 1932, *BASK*, DWB III.

[95] In a letter to the author, May 22, 1971, Lewis Mumford expressed the belief that a Nazi group had "gained control" of the Werkbund before 1933. One can see how the Werkbund leaders managed to convey this impression, although none of them apparently regarded themselves as National Socialists.

[96] The impression of chaos is confirmed by the typed transcript of a long meeting of the executive in Berlin, June 28, 1932, in *LC*, Container 3, 1932, Folder 2. Headed *Deutscher Werkbund 28. VI. 1932*, this 116-page document reveals strong enmities and resentments among the leaders of the association, and shows that many members were highly critical of the head office, which they accused of inefficiency and, above all, of failing to provide information and direction.

drawal the following year.[97] However, Mies was hardly ever in the office and Raemisch alternately intervened clumsily and absented himself for considerable periods, claiming pressure of business. As a result, Otto Baur was left to run the Werkbund virtually single-handed. Baur managed to get some help from Günther von Pechmann, now head of the *Staatliche Porzellanmanufaktur* in Berlin and president of the Berlin Werkbund branch; but this did little to improve the situation as Pechmann, a civil servant at heart, refused to take a firm stand on political issues.[98]

In September 1932, the situation became desperate. At this point Raemisch suddenly withdrew, leaving Jäckh and Pechmann as the only contenders for the presidency.[99] Instead of deciding between them at the annual meeting in October, the membership confined itself to electing Bruckmann as honorary president and referred the final decision to the executive committee.[100] Meeting on November 12, the latter, after several ballots and in the face of an organized opposition that now proposed Mies for the presidency, finally elected Jäckh. Poelzig accepted the first vice-presidency but Mies refused pressing invitations to serve as second vice-president and decided to withdraw completely from Werkbund affairs.[101]

[97] "Protokoll der Vorstandssitzung am 24. Oktober 1931. . . ."
[98] Renner, "An die Vorstandsmitglieder des DWB," p. 1, quotes a letter from Baur complaining of his sense of isolation.
[99] Letter from Raemisch to Mies, Sept. 29, 1932, *LC*, Container 3, 1932, Folder 1.
[100] *DWB-M* Nov. 15, 1932.
[101] *DWB-M* No. 1, Nov. 17, 1932. See letter from Poelzig to Mies, Nov. 22, 1932, expressing dismay at Mies's decision and defending Jäckh as the only man able to do what was needed. In his reply of Nov. 27, Mies reiterated his refusal to help. Both letters in *LC*, Container 3, Folder 1. Although he took no more part in the conduct of Werkbund affairs, Mies remained a member into 1934. *LC*, Container 4, 1934 contains his membership card for that year; 1933 has material related to an appeal Mies initiated, in May 1933, to a Werkbund "Court of Honor" against a National Socialist fellow member who had impugned his personal reputation. This "Court" exonerated him in Nov. 1933.

The Jäckh-Poelzig combination was not a strong one. Admittedly, Poelzig still inspired general respect and confidence; but Jäckh, the senior partner, was widely distrusted and feared as an ambitious schemer whose presidency would finally discredit the Werkbund. So intense was this feeling that the *Münchner Bund*, whose support was essential for Werkbund survival, nearly seceded in protest.[102] The only asset of the new team was Jäckh's confidence in his own ability to restore the association's unity and prestige by building on what remained of its reputation. Whether he could have achieved this will never be known, for his new course was deflected after only two months by Hitler's coming to power, an event that forced the Werkbund to recognize a truth that Jäckh had long appreciated, namely the primacy of politics.

[102] The opposition to Jäckh was spearheaded by Riezler, Renner, Pechmann, and Riemerschmid, all members of the *Münchner Bund*. Riezler at one point even suggested that Jäckh might be trying to *buy* his way into the presidency, by offering to make up the association's deficit! *LC*, Container 3, 1932, Folder 1, Riezler to Mies, Oct. 9, 1932. See also *GerN*, letter from Riemerschmid to Bruckmann, Nov. 7, 1932; and *BASK*, DWB III, *Münchner Bund* to Jäckh, Nov. 30, 1932. In the latter, the *Bund* explained the reasons for its stand, but then announced its decision to remain inside the Werkbund as a loyal opposition.

CHAPTER IX

The Werkbund and National Socialism

By the end of 1932, the Werkbund was virtually moribund. Ill-prepared to meet the challenge of National Socialism, it quickly fell victim to the Nazi revolution. As early as June 1933, it underwent the process of *Gleichschaltung* that brought it under National Socialist leadership. Then, in October 1934, it lost the last remnant of independence. Incorporated into the *Reichskammer der bildenden Künste* (Reich Chamber of the Visual Arts, *RdbK*), it struggled to maintain its identity, but soon vanished without trace, to be resurrected only after the destruction of the National Socialist regime.

The fact that the Werkbund ceased to exist as a private association during the Nazi years has made it easy to ignore the question of its relations with National Socialism. Werkbund chroniclers, like German historians generally, have been prone to treat the years 1933-1945 as if they marked a complete break in the continuity of German development. Only recently has the realization grown that to dismiss the Nazi era as a mere interregnum—however understandable in terms of the psychological needs of survivors of that traumatic time—involves serious distortion of the historical record. As far as the Werkbund is concerned, closer examination reveals that National Socialist elements had infiltrated the association well before 1933, that the National Socialist *Weltanschauung* incorporated features compatible with Werkbund principles, and that Werkbund ideas—and Werkbund men—continued to influence cultural policy in the Third Reich after the association

as such had ceased to exist. To give a true picture of the Werkbund's relationship with National Socialism, one must first of all reconstruct the chain of events that led to the organization's demise. But it is then necessary to carry the story further: to examine Werkbund ideas in relation to National Socialist ideology, and Nazi cultural policy after 1934 in the light of Werkbund principles.

At the beginning of 1933, even its most ardent supporters had to admit that the Werkbund was farther than ever from achieving its goals. Not only had the Depression reduced matters of taste to relative insignificance in the public mind. By once more putting a premium on low prices, it had produced further deterioration in the quality of German manufactures and design. With building construction declining sharply and public subsidies for cultural activities at an all-time low, the Werkbund shelved its plans for a major exhibition at Cologne. Meanwhile the forces of cultural reaction, carefully nurtured by the Nazi-led *Kampfbund für deutsche Kultur*, had brought the aesthetic experimentation of the 1920's to a halt. In his inaugural statement as editor in chief of *Die Form*, Wilhelm Lotz in early January 1933 had to confess that those concerned with the level of quality and design in the German applied arts could only mark time until the expected upswing in the economy prepared the ground for a revival of Werkbund activity.[1]

The appointment of Hitler as Chancellor on January 30, 1933 had surprisingly little immediate effect on the Werkbund. Theodor Heuss, at the time on the Werkbund executive committee, gloomily predicted that the politicization of Germany's cultural life would gain new impetus from the Nazi victory.[2] But if others shared his forebodings, they preferred to voice their fears in private. In general, even political opponents of National Socialism held fast to the view that the form of government bore no direct relation

[1] *Die Form*, VIII, No. 1 (1933), 2.
[2] Theodor Heuss, "Der Kampf um Poelzig," *Die Hilfe*, XXXIX, No. 3 (1933), 90-92.

to the level of a nation's culture, and that it might there-fore prove possible to reach a modus vivendi with the Nazi regime.[3]

This was the position of Ernst Jäckh, the Werkbund's new president. Jäckh thought of himself as politically neutral, a manipulator of contemporary forces rather than an advocate of any specific tendency.[4] Since November 1932, he had concentrated on securing his own position within the Werkbund and on reviving the authority of the central office in Berlin over the regional branches. At the same time, foreseeing the likelihood of a Nazi victory, he had initiated a program of judicious concessions to the *Kampfbund* faction within the association. The appoint-ment of Hitler at the end of January merely confirmed Jäckh's faith in the correctness of his policy.

Jäckh managed to sustain his optimism even when his tactics of appeasement failed to produce positive results during the first weeks of the Hitler regime. Thus, although the Nazi *Staatskommissar* for Württemberg excluded the Werkbund from the Stuttgart *Deutsches Holz* exhibition in March and turned the project over to the rival *Kampf-bund für deutsche Kultur*, Jäckh persisted in his efforts to cooperate with the new authorities.[5] Evidently, he still believed that he could steer the Werkbund successfully through the Nazi revolution, as he had through that of 1918-1919, and win a place for the association in the new Reich comparable to that which it had enjoyed in the Imperial and Weimar periods.

When the March elections and passage of the Enabling Act on March 23 confirmed National Socialist rule, Jäckh sprang into action. Going straight to the top, he secured

[3] Thus Fritz Schumacher commented that, in Hamburg, the Na-tional Socialist take-over passed ceremoniously. There were no violent incidents and all civil servants initially continued at their posts. Schumacher, *Selbstgespräche*, pp. 88-90.

[4] BDC, Jäckh file, copy of a letter from Jäckh to Johannes Knubel, Düsseldorf, May 1, 1933.

[5] *DWB-M* March 1933. For the subsequent fate of this exhibition, Lane, *Architecture and Politics*, p. 210; and Eckstein, "Idee," p. 16.

an interview with Hitler on April 1.[6] According to Jäckh, the future of the Werkbund was only one item dealt with in a wide-ranging discussion with the Chancellor. Hitler, influenced by the charges of "cultural bolshevism" that had been levelled against the Werkbund, refused to take a personal interest in its fate, but he arranged for Jäckh to pursue the matter further with Joseph Goebbels and Alfred Rosenberg.[7] There is no evidence that Goebbels and Jäckh ever discussed the Werkbund, although they did have dealings in connection with the *Hochschule für Politik*.[8] However, Jäckh saw Rosenberg on April 5 and emerged from the interview more confident than ever of the Werkbund's future. Rosenberg apparently agreed to Jäckh's suggestion that leaders of the *Kampfbund* and the Werkbund sit down together and work out a basis for cooperation in a series of "round-table" talks. Moreover, he gave Jäckh the impression that the National Socialists were prepared to back some of his pet projects, possibly even reviving the *Neue Zeit* exhibition as a summary of the new regime's first Four Year Plan![9]

[6] Jäckh, *Goldene Pflug*, p. 195; and Jäckh, *Weltsaat*, pp. 129-36. The main purpose of the interview seems to have been to arrange for the continuation of the *Hochschule für Politik*. In *Weltsaat*, p. 121, Jäckh claimed that he had already decided to leave Germany in the night of March 5, 1933, and that he emigrated in April (p. 124) or May (p. 146). However, Werkbund documents show that he was still active in Berlin during June and July 1933.

[7] Jäckh, *Goldene Pflug*, pp. 206-207. Jäckh, *Weltsaat*, pp. 130-36 includes a report on the conversation with Hitler, allegedly written in April 1933 although not published until 1942. The Werkbund is mentioned on p. 134. As regards the Werkbund, the substance of the conversation is summarized in a letter from Otto Baur to Richard Riemerschmid, April 5, 1933, in *GerN*; and also in "Rede von Stadtbaurat a. D. Martin Wagner Berlin im Deutschen Werkbund am 10.6.33," transcript of a meeting of the Werkbund executive and board in Berlin [hereafter *Wagner*]. I am indebted to Professor Wilhelm Wagenfeld of Stuttgart for making this document available to me. Cf. also *DWB-M* June 1933.

[8] Jäckh, *Weltsaat*, pp. 138-41.

[9] *GerN*, copy of a letter from Jäckh to Alfred Rosenberg, April 5, 1933, confirming the main points of the meeting. Although incomplete, this shows that Jäckh proposed convocation of a German congress for new quality work (*Neue Wertarbeit*), an indication

After his conversations with Hitler and Rosenberg, Jäckh redoubled his efforts to secure Werkbund cooperation with the *Kampfbund* at all levels. To do so, he had to overcome resistance within the association. For example Paul Bonatz, designated to replace Bruckmann as head of the Württemberg Werkbund group, refused to work on the *Deutsches Holz* exhibition under *Kampfbund* direction. Jäckh therefore was forced to circumvent him and deal directly with Schmitthenner, the local *Kampfbund* leader who believed it possible to reconcile "true" Werkbund principles with active participation in the National Socialist movement.[10] Likewise, the *Münchner Bund* found itself under pressure from head office to contact the local *Kampfbund* and co-opt leading Nazis into its executive committee. At the national level, too, Jäckh and Baur did what they could to suppress dissent. When Paul Renner, in charge of the German Graphics display about to open in Milan, began to quarrel with the new authorities, Baur urged Riemerschmid to restrain him. Far from achieving anything, Renner, by being awkward, would merely endanger the pro-Werkbund elements within the Foreign Office that were already under National Socialist pressure. Evidently, the head office still hoped that if Werkbund members refrained from rocking the boat, the Nazi leaders might in turn check their more radical supporters and adopt a responsible position on cultural questions.[11]

that he believed that Werkbund quality goals could be furthered through cooperation with the new regime. There is no mention of this interview in *Weltsaat*, where Jäckh wished to show that he had already made a clean break with the Nazi regime by this time.

[10] *GerN*, Baur to Riemerschmid, April 5, 1933; copy of a letter from Paul Bonatz to Jäckh, April 2, 1933. Schmitthenner, on the telephone, apparently indicated to Bonatz that he regarded the volte face in Werkbund policy with suspicion. Bonatz, for his part, would have preferred to exclude from the Württemberg Werkbund both the radical Richard Döcker and Schmitthenner, who at the time was determined to ride the crest of the Nazi wave. Schmitthenner's opportunism was also commented on by Martin Wagner, who referred to him as a "Konjunkturritter." Cf. *Wagner*, p. 4.

[11] *GerN*, Baur to Riemerschmid, April 5 and April 6, 1933.

Jäckh held to his course, even after considerable evidence had accumulated to show that no degree of acquiescence could save those whom the National Socialists distrusted. For example, Johannes Sievers, head of the cultural division in the Foreign Office and a long-time Werkbund supporter, agreed to attend the opening of the Milan exhibition in the company of two young Nazis—one in S.A. uniform—and watched silently while these outsiders induced the Italian government to exclude a number of "unsuitable" works by Werkbund members. Yet Sievers's apparent willingness to tolerate infringement of the authority of the Foreign Office, and to suffer personal humiliation did not save him from being pensioned off shortly thereafter.[12] Meanwhile, a number of prominent Werkbund personalities had met the same fate, among them Edwin Redslob, whom the new government forced into retirement as early as February 1933, simultaneously abolishing the *Reichskunstwart* office.[13] Redslob's dismissal was followed by a systematic purge of government-controlled art schools, universities, and museums in the course of which many Werkbund people lost their positions.[14]

As head of the private and nonpartisan *Hochschule für Politik*, Jäckh himself was at first immune from direct attack. However, the Werkbund's vice-president, Hans Poelzig, either resigned, or was dismissed, from the directorship of the Berlin United State Schools at the beginning of April.[15] It is hard to see how either Jäckh or Poelzig, by

[12] Rave, *Kunstdiktatur im Dritten Reich*, p. 27; letter from Gropius to Poelzig, June 15, 1933, *WB*, Poelzig papers.

[13] See Redslob, *Von Weimar nach Europa*, pp. 289-92. Redslob claimed he lost his job after publicly refusing to shake hands with Hitler. He survived the war on a quarter-pension plus limited income from free-lance journalism. After the war, he became first *Rektor* of the Free University in Berlin.

[14] Some of the architects and artists dismissed in consequence of the Law for the Reconstruction of the Civil Service, April 7, 1933, are listed by Teut, *Architektur*, p. 67 n.

[15] *GerN*, Baur to Riemerschmid, April 5, 1933, indicates that Poelzig resigned in protest against the dismissal of Gies, Hofer, Schlemmer, and others of his staff; but Teut, *Architektur*, p. 67 n.

this time, could have believed it possible to prevent the nazification of the Werkbund. Rather than resign forthwith, however, and recommend the association's dissolution, the Werkbund leaders set themselves the task of guiding the process of *Gleichschaltung*—coordination with National Socialist policy—so as to preserve as much as they could of the Werkbund's identity.[16]

Jäckh, in particular, insisted on maintaining the initiative in negotiations with the authorities. When the *Kampfbund* leadership continued to rebuff him, he attempted to regularize the Werkbund's position by turning for help, instead, to the Prussian Ministry of Culture.[17] Consultations with that Ministry led in June 1933 to a decision to ask the architects Carl Christoph Lörcher and Winfried Wendland—both National Socialists and members of the *Kampfbund*—to assume the leadership of the Werkbund.[18] This plan, based on Jäckh's recommendations, subsequently was approved at a crucial meeting of the Werkbund executive and board on June 10, 1933.[19]

Its acceptance forestalled an attempt by Johannes

lists him among those dismissed in consequence of the Civil Service Law of April 7. Heuss, *Poelzig*, pp. 157-58 sheds little light on the circumstances of Poelzig's withdrawal, which is not surprising as Heuss wrote in 1939! It is equally difficult to establish the exact sequence of events that led up to Jäckh's resignation from the directorship of the *Hochschule für Politik* later in April, and the subsequent restructuring of the school as a training establishment for National Socialist leaders. Cf. Jäckh, *Weltsaat*, pp. 138-41.

[16] According to *DWB-M* June 1933, Jäckh and Poelzig had already offered their resignations in March, presumably in order to make way for men more agreeable to the new regime, but they had evidently been persuaded to stay on.

[17] *GerN*, transcript of a telephone conversation of June 1, 1933, between Riemerschmid and Baur. Baur reported that Jäckh had not yet succeeded in arranging the talks with *Kampfbund* leaders authorized by Rosenberg in April.

[18] *GerN*, Schmitthenner to Riemerschmid, June 10, 1933, gives an account of the meeting in the Ministry of Culture. Schmitthenner claimed that he had proposed Riemerschmid to succeed Jäckh, whereas Jäckh had suggested Lörcher and Wendland. Schmitthenner, himself, had also been considered for the presidency.

[19] *DWB-M* June 1933.

Knubel of the Werkbund's *Arbeitsgemeinschaft Nieder-
rhein und Bergisch-Land* to oust Jäckh and Poelzig and
secure a complete merger of the Werkbund with the
Kampfbund für deutsche Kultur.[20] By skillful diplomacy,
Jäckh managed to transfer power "legally" to his Nazi
successors, to maintain the Werkbund's corporate identity
as a semiautonomous affiliate of the *Kampfbund*, and even
to secure a place for himself on the interim executive
committee, selected to advise the new Werkbund president
until the forthcoming membership meeting could complete
reorganization of the association.[21]

The quasi-legal character of the *Gleichschaltung*, which
accorded with the National Socialists' practice of traducing
legality where they could, made it easier for the Nazis
to consolidate their position, and the presence of Jäckh
and Riemerschmid on the interim executive probably had
the same effect. The non-Nazis found themselves associ-
ated with the first step taken by Lörcher, Wendland, and
Schmitthenner, namely, to require Werkbund members to
complete a *Fragebogen* (questionnaire) giving details of
their personal and occupational background and informa-

[20] *BA*, Kanzlei Rosenberg, NS 8/136, Johannes Knubel, "Deut-
scher Werkbund: Vorschläge einer Neuorganisation 1933," memor-
andum of April 27, 1933 to Hans Hinkel, then *Staatskommissar* in
the Prussian Ministry of Culture and a high official in the *Kampf-
bund*. Also, *BDC*, Jäckh file, copies of letters from Jäckh to Knubel,
May 1, 1933; and Knubel to Jäckh, May 3, 1933. According to
Wagner, pp. 1-2, Schultze-Naumburg had called for this solution
long before 1933.

[21] *Wagner*, p. 2, states that Jäckh, on the day before the vote,
had expressed his desire that the *Gleichschaltung* should take place
"im Rahmen der gesetzlichen Bestimmungen"–within the frame-
work of legality. Schmitthenner, writing to Riemerschmid on June
10, 1933 (*GerN*), said that Jäckh had pressed for his own inclusion
on the interim committee, whereas Riemerschmid owed his appoint-
ment to Schmitthenner. The distinction between the reorganization
proposed by Knubel and the solution arrived at by Jäckh was not
great. Teut, *Architektur*, p. 71 n. refers to the new arrangement as
de facto incorporation of the Werkbund into the *Kampfbund*. A
note, "Der neue Deutsche Werkbund," *Deutsche Kulturwacht*, No.
18 (1933), p. 15, mentions that the Werkbund, on June 10, agreed
to apply for membership in the *Kampfbund*.

tion on their political and religious affiliations and racial extraction. Aware that this might prove unpopular, Lörcher initially sought to disguise its purpose, which was to secure the exclusion from the Werkbund of "Marxists" and Jews.[22] Shortly thereafter, at the first—and only—full meeting of the interim executive committee on July 3, Lörcher proceeded to impose a National Socialist constitution on the Werkbund.[23] Stressing that he owed his position as Werkbund *Führer* to the National Socialist Minister of Culture in Berlin rather than to the wishes of the association's members, Lörcher boldly declared the Werkbund reconstituted on the basis of the *Führerprinzip* (leadership principle). To implement this change he decreed the formation of twelve new Werkbund districts, each with its own *Führer* appointed by himself, thus destroying at a stroke the existing branch groups.

Among the first district leaders chosen were Schmitthenner, to replace the somewhat obstreperous Bonatz in Stuttgart; and Riemerschmid, allowed to stay on as head of the *Münchner Bund*—now renamed the *Landesgruppe Bayern*—on condition that K. J. Fischer, the National Socialist president of the *Bund deutscher Architekten* in Munich and a *Kampfbund* activist, be co-opted to the executive committee. Lörcher made it clear that Jäckh's role would merely be to ease the transition from the old administration to the new, and would terminate at the next membership meeting.[24]

[22] A copy of the *Fragebogen* can be found in *GerN*. It is referred to in a letter from Baur to Riemerschmid, June 22, 1933. See also *GerN*, "Notizen zu der Werkbundbesprechung am 3. Juli 1933," p. 7, typescript of notes taken unofficially by Riemerschmid at a meeting of the interim executive [hereafter "Notizen"]. The approved minutes, published in *DWB-M* July 1933, differ somewhat from Riemerschmid's version, which is likely to be more accurate.

[23] That this was the only formal meeting of the group emerges from minutes of a meeting of the *Münchner Bund*, Feb. 6, 1934, *BASK*, DWB III. After July 3, 1933, Lörcher, Wendland, and Baur managed the Werkbund, occasionally advised by Schmitthenner and by the new Berlin district leader, Wilhelm Niemann.

[24] Riemerschmid, "Notizen." Bonatz, who appeared at the July 3 meeting as part of a Württemberg deputation, spoke up for the

Although those present on July 3 "unanimously" approved Lörcher's decision, it was not long before his dictatorial manner and arbitrary actions led to murmurs even among members of the inner circle. Schmitthenner and Riemerschmid had assumed that implementation of the *Führerprinzip* would give them increased authority. Instead, they found that Lörcher and Wendland seldom sought, and regularly disregarded, their advice.[25] Moreover, their hope that the new regime would reverse what they felt had been the excessive centralization of the Weimar Werkbund proved illusory. Although Lörcher at the July 3 meeting had expressly denied that he intended to concentrate all authority in Berlin, he soon began to impose his will on the districts and systematically appointed as local leaders men ready to render unquestioning obedience to directives from above.

One result was a confrontation between the Berlin leadership and the *Münchner Bund*. Within days after he had confirmed Riemerschmid in his post, Lörcher changed his mind and decided instead to install K. J. Fischer as district leader of Bavaria. When Riemerschmid refused to yield gracefully to Fischer, a man of no standing in local artistic circles, Lörcher simply expelled the recalcitrant *Münchner Bund* from the Werkbund.[26] Thereafter,

Weissenhof exhibition of 1927 and refused to cooperate on the Kochenhof project, but he nonetheless agreed to serve as Schmitthenner's deputy in the nazified Württemberg Werkbund.

[25] *GerN*, Baur to Riemerschmid, July 10, 1933; Schmitthenner to Riemerschmid, Aug. 10, 1933; Riemerschmid to Schmitthenner (copy), Aug. 18, 1933. These and other notes show that Schmitthenner's suggestions regarding personnel were systematically ignored, as was a proposal by Riemerschmid that Ernst Bertram of Cologne, a leading "conservative revolutionary," member of the Stefan George circle, be asked to address the forthcoming Werkbund annual meeting.

[26] *GerN*, Riemerschmid to Lörcher, July 17, 1933, and Lörcher to Riemerschmid, July 22, 1933. Riemerschmid on this occasion appealed to his notes of the July 3 meeting to prove that Lörcher had gone back on his word, but the latter insisted that Riemerschmid's appointment had always been intended as temporary. According to an unsigned appraisal of Fischer, dated Aug. 1, 1933, *GerN*, the

for a time, the *Landesgruppe Bayern* under Fischer represented the Werkbund in Munich, while the *Münchner Bund* struggled to maintain its independence by playing off the Prussian authorities against the Bavarian. Eventually, however, in February 1934, the *Bund* decided to disband rather than allow itself to be incorporated into the Munich Arts and Crafts Association (*Kunstgewerbeverein*).[27]

Lörcher's attacks on Riemerschmid, one of the Werkbund's most respected figures, alienated many who might otherwise have been prepared to collaborate. Even Schmitthenner was appalled and vainly tried to persuade Lörcher to reverse his decision on the grounds that Riemerschmid, apart from Jäckh, provided the only significant link between the old Werkbund and the new.[28] Riemerschmid himself, and his friend Pechmann, both of whom had wanted to believe that the Werkbund could be preserved and that Hitler was on their side, became disillusioned in the course of the summer and decided to stay away from the annual meeting scheduled for Würzburg in September. In their view, the world would be a better place without the Werkbund than with one run by Lörcher and Wendland.[29] Schmitthenner, despite misgivings and indignation

latter was a "geborene Hecht im Karpfenteich," possibly suited to the *BDA* but unworthy of the more select *Münchner Bund*, a man conspicuously lacking in artistic vision, judgment, and qualities of leadership. Riemerschmid appears to have sent this to Schmitthenner. For the expulsion of the *Münchner Bund*, GerN, Wendland to Riemerschmid, Sept. 22, 1933.

[27] GerN, Riemerschmid memorandum of Dec. 18, 1933, written for the information of his deputy in the *Münchner Bund*; also BASK, DWB III, report, "Mitgliederversammlung des Münchner Bundes am 6. Februar 1934."

[28] GerN, Schmitthenner to Lörcher, Sept. 8, 1933. At the same time, Schmitthenner intervened with Lörcher, at Riemerschmid's request, on behalf of Theodor Fischer whom the Werkbund *Führer* sought to prevent from addressing the forthcoming Städtebau-Tagung, and generally to discredit. Cf. Riemerschmid to Schmitthenner, Aug. 18, 1933.

[29] GerN, Riemerschmid to Pechmann, Sept. 21, 1933 and Pechmann to Riemerschmid, Sept. 22, 1933. Also, Riemerschmid to

at the treatment accorded Riemerschmid, did attend the Würzburg congress, accepted a position on the executive appointed there, and continued to serve as leader of the Württemberg district. His loyalty to the Nazi party, combined with faith in his own ability to influence the cultural policies of Germany's new rulers, presumably prevailed over his sense of solidarity with the man whom he acknowledged as his master and friend.[30]

Of the twenty-seven Werkbund leaders who voted in favor of *Gleichschaltung* on June 10, only seven were present at Würzburg in September, but this once again sufficed to give the proceedings a semblance of legality. At a special meeting on the eve of the general meeting, the executive committee resigned en bloc as it had promised to do in June.[31] The next day, the membership accepted the National Socialist leaders, constitution, and program by acclamation. Forewarned by the terms of the invitation to the meeting, which had indicated that no debate would be tolerated, those who strongly disapproved of the new course had for the most part preferred to

Schmitthenner, Sept. 11, 1933. One should contrast this with Lörcher's postwar account, in Thiersch, *Richard Riemerschmid*, p. 99, where he claimed to have worked with Riemerschmid even after the Würzburg meeting to save the Werkbund.

[30] *GerN*, Schmitthenner to Riemerschmid, Sept. 14, 1933. Here Schmitthenner indicated that he, too, would stay away from the Werkbund congress, if his advice to postpone it were rejected. It was, but he went. He may have been acting under *Kampfbund* orders. Cf. *BDC*, Schmitthenner file, Schmitthenner to Hans Hinkel, Aug. 12, 1933, which shows that he felt more committed at this time to the *Kampfbund* than to the Werkbund. The heads of the twelve new Werkbund districts are listed in *DWB-M* Nov. 1933.

[31] "Vorstands-und Ausschussitzung am 29. September 1933 . . . in Würzburg." Among those who absented themselves were Poelzig, Pechmann, Riemerschmid, and Jäckh, who by this time had emigrated to London. The seven members of the pre-Nazi executive present and voting were Otto Baur, Hugo Borst/Stuttgart, Theodor Heuss, Wilhelm Lotz, Karl Rupflin, Karl Schmidt/Hellerau, and Gustav Stotz. Lörcher failed to attend this meeting of the executive, having been unavoidably detained by a summons from Hitler's agricultural expert, Walther Darré!

absent themselves.[32] They were thus spared having to hear Lörcher denounce the former Werkbund leaders, assert that, in future, talent would count for less within the association than racial purity and political conformity, and spell out the revised Werkbund program with its emphasis on rural settlement and the handicrafts. Nor did they have to sanction the plan outlined by Wendland that imposed a disciplined organizational schema converting what had been a free association of creative individuals into an "S.A. of cultural action."[33]

Thus, in September 1933, the Werkbund formally became what it had been de facto since June—an integral part of the National Socialist movement, loosely affiliated with the *Kampfbund für deutsche Kultur* and subordinate to the conflicting jurisdictions of the Prussian Ministry of Culture and Goebbels' Propaganda Ministry. Lörcher and Wendland, who had been largely responsible for creating this ambiguous situation, as well as for alienating most of its ablest members, seem, after the September meeting, to have addressed themselves with some energy to the task of reviving the Werkbund's prestige. Wendland, in particular, worked to reverse the decline in membership and to ensure that the association became once again the chief agency in Germany for the encouragement of quality work. Initially, his efforts led to the recruitment of some new members, but it proved impossible to replace those who had withdrawn by men of equal ability, character, and dedication.[34]

[32] A copy of the Lörcher-Wendland invitation, sent on Sept. 1, 1933 to "all Werkbund members and friends," is in *LC*, Container 4, 1933. It included a tentative program for the Würzburg meeting, along with a statement of National Socialist plans for the Werkbund.

[33] "Der Werkbund des Dritten Reichs," *Neue Zürcher Zeitung*, Dec. 22, 1933. The revised constitution and a report of the Würzburg meeting appeared in *Die Form*, Oct. 1933, reprinted in Schwarz and Gloor, *Stimme des Deutschen Werkbundes*, pp. 100-109.

[34] "Rundschreiben an die Mitglieder des Deutschen Werkbundes," April 1934. According to DWB-M, in *Die Form*, IX, No. 4 (1934), 77 had joined since January of that year, among them Paul

Worse still, the Werkbund found its position threatened by a number of rivals. The *Kampfbund,* apparently resentful of its failure to secure the complete destruction of the Werkbund, tried in the course of 1934 to render it superfluous.[35] The Werkbund's claim to lead the movement for quality work was also challenged by the new *Reichsverband für deutsche Wertarbeit,* which tried to carry on the Werkbund program outside the framework of the Nazi-dominated association.[36] Eventually, the Werkbund managed to protect itself against the *Kampfbund* and other groups that infringed its monopoly, but it did so at the cost of losing the last vestige of its independence. The Werkbund had become affiliated in early 1934 with the new *Reichskulturkammer* (Reich Chamber of Culture) created by Goebbels as part of his campaign to wrest control of cultural policy from Alfred Rosenberg.[37] At that time, Goebbels denied any intention of "commanding" art, insisted that he had the greatest respect for creative genius, and promised to secure for German artists the liberty they needed to continue their work.[38] But it soon

Schultze-Naumburg. The following issue listed another 24 new members.

[35] Schmitthenner memorandum to the *Reichsleitung* of the *Kampfbund,* March 19, 1934, *BA,* NS 8/109; also *BDC,* Schmitthenner file, Schmitthenner to Hinkel, Sept. 13, 1933, inviting him and Rosenberg to attend the opening of the *Deutsches Holz* exhibition in Stuttgart as *Kampfbund* representatives.

[36] The *Reichsverband* had been founded by Peter Behrens and others in June 1930. Teut, *Architektur,* p. 375. By July 1933, Baur and Wendland regarded it as a real threat to the Werkbund, and appealed to the authorities to secure its suppression. Cf. *GerN,* Baur to Riemerschmid, July 7, 1933.

[37] See the report of a Werkbund executive meeting in Bremen, Jan. 1934, in *Die Form,* IX, No. 1 (1934). Also, *Innen-Dekoration,* XLV (March 1934), Supplement, vi. For the founding of the *Kulturkammer,* Josef Wulf, *Die Bildenden Künste im Dritten Reich* (Gütersloh, 1963), pp. 102-104. The conflict between Goebbels and Rosenberg is discussed in Lane, *Architecture and Politics,* pp. 175-84; and Hildegard Brenner, "Die Kunst im politischen Machtkampf der Jahre 1933/34," *Vierteljahrshefte für Zeitgeschichte,* X, No. 1 (1962), 12-42.

[38] See Wulf, *Bildenden Künste im Dritten Reich,* pp. 103-104.

became evident that the *Reichskulturkammer* constituted as great a threat to the Werkbund's freedom of action as did the *Kampfbund*. Indeed, when the *Reichskulturkammer* was restructured in late October 1934 along corporate lines, the Werkbund found itself absorbed into the section for the visual arts, the *RdbK*, and assigned precise tasks within that body.[39]

Meanwhile, the Werkbund's fortunes had continued to decline. By the time of the last annual meeting held in Königsberg in August 1934, the nominal membership had dropped from a high of around 3,000 in 1928 to a mere 1,500. Moreover, despite intensive advance publicity and the inducement of cheap fares on the national railways, less than fifty members chose to attend the Königsberg congress, and of these not one was an architect or craftsman active in the Weimar Werkbund. Only the name remained to link the new association with the old on the eve of its incorporation into the machinery of the state.[40] The *Gleichschaltung* of *Die Form* proceeded a little more slowly than that of the Werkbund itself, but by the beginning of 1934 it, too, had come completely under the domination of the National Socialists. Riezler had been forced to make concessions to Nazi pressure as early as 1932; his successor, Wilhelm Lotz, gradually limited the journal's architectural comment and tried to please the National Socialists by emphasizing the less controversial industrial arts and crafts. On the rare occasion when architecture

Goebbels' words were instantly seized upon by Werkbund men who wished to justify their collaboration with the new regime, e.g., Wilhelm Lotz, "Wird die Kultur diktiert?" *Die Form*, VIII, No. 12 (1933), 382-83.

[39] "An die Mitglieder des Deutschen Werkbundes," Nov. 8, 1934, mimeographed circular letter signed by Wendland, in *Bauhaus* GN 5/19/411-12. Also, a press release in the *Berliner Börsenzeitung*, Nov. 15, 1934.

[40] "Die 23. Tagung des Deutschen Werkbundes," *Frankfurter Zeitung*, Sept. 8, 1934. On preparations for the meeting, see *DWB-M* Feb. and April 1934; and *Die Form*, IX, No. 5 (1934), 158. Theme of the congress was the *Ostfrage*, the problem of Germany's eastern frontiers.

was featured, the work illustrated tended to be that of the Werkbund's new leaders and other National Socialists. In January 1934, Lotz was replaced by Friedrich Heiss, Wendland's brother-in-law, but the latter never had an opportunity to show what he could do. *Die Form*, having lost the majority of its readers, failed to maintain a regular schedule of publication and soon was forced out of existence.[41]

The Werkbund's exhibition activity likewise ground to a halt. The only exhibition of any significance after January 1933 was a photographic display, *Die Kamera*, organized by Wendland and Wilhelm Niemann. Originally scheduled for November 1933, this exhibition was shown in Stuttgart during March and April 1934 under the auspices of the Reich Ministry of Propaganda. Breaking with the principles that had inspired an earlier Werkbund photographic exhibition held in Stuttgart in 1929, *Die Kamera* displayed the work of amateurs side by side with that of professionals, and concentrated on the technical rather than the artistic aspect of the medium.[42] Nothing came of the bold exhibition program outlined by Wendland at a Werkbund meeting in January 1934.[43] A small show organized by Wendland himself was held in Berlin at the end of 1934, but despite the pretentious idealism of its title, "Deutsches Siedeln und Symbolisches Bauen" (Ger-

[41] Wendland, who had recommended Heiss (a civil service architect) to Hans Hinkel as a good National Socialist, subsequently had to apologize when it transpired that Heiss had lied about his party membership. Cf. *BDC*, Wendland file, letter from Wendland to Hinkel, May 2, 1936. *Die Form* appeared only intermittently in 1934, and a special issue on textile design promised for that year never appeared.

[42] *DWB-M* Aug. 1933-March 1934. On the 1929 exhibition, DWB, *Internationale Ausstellung des Deutschen Werkbundes 'Film und Foto'* (Stuttgart, 1929).

[43] "Von der Arbeitstagung des Bundesbeirates," *Die Form*, IX, No. 1 (1934), 31. Wendland announced plans for exhibitions in Frankfurt and Augsburg in 1934 and Düsseldorf in 1935, the latter on behalf of the *Reichskulturkammer*. Werkbund participation in the 1936 Olympics also came up for discussion.

man Settlements and Symbolic Architecture), it aroused a minimal response.[44]

By this time, Wendland was perhaps the only Werkbund member who still believed that the association could be restored to productive life. Lörcher, formally reappointed when the Werkbund became part of the *RdbK*, did nothing to further its aims, and either resigned or was relieved of his duties shortly thereafter. By May 1935, the Werkbund found itself without a director and lacked sufficient income from dues to pay the office staff.[45] Even at this late date, Wendland tried to retrieve the situation. His appeal to the Ministry of Propaganda may have led to the appointment of Hermann Gretsch of Stuttgart to head the Werkbund division of the *RdbK*, which he kept going, for a time, with the assistance of Otto Baur. But none of the programs originally projected, such as the creation of Werkbund-run retail outlets for quality goods, were ever realized.[46]

Meanwhile, the *RdbK* itself sank into relative obscurity. Welcomed at its inception by many architects who regarded it as the first step in a long-overdue corporate

[44] *Bauhaus* GN 5/19/410, invitation to the exhibition dated Nov. 8, 1934. Wagner, writing to Gropius on Nov. 28, referred to the exhibition as a "Leichenschändung," desecration of the corpse of the Werkbund, just incorporated into the *RdbK*. *Bauhaus*, GN 5/377ᵛ.

[45] *BDC*, Wendland file, letter from Wendland to Hinkel in the Ministry of Propaganda, May 25, 1935. Writing on Werkbund letterhead, Wendland blamed the situation on the inactivity of the president of the *RdbK*, Eugen Hönig, professor of architectural history at the Munich Art Academy and co-founder of the *Kampfbund deutscher Architekten und Ingenieure*. Lörcher, in Thiersch, *Richard Riemerschmid*, p. 99, claimed he had been forced to resign, but the circumstances are not clear.

[46] "Eingliederung des Deutschen Werkbundes in die Reichskammer der bildenden Künste," *Der Baumeister*, xxiii (Feb. 1935), Supplement 2, 28-29; *Die Baugilde*, No. 22, 1934, pp. 812-13. The latter described the main responsibilities of the Werkbund within the *RdbK*, mentioning exhibitions, propaganda for German quality work abroad, the raising of exports, lectures, and retail outlets. The last reference to the Werkbund in the National Socialist period seems to be the entry "Werkbund" in the supplement to *Wasmuths Lexikon der Baukunst* for 1937.

reorganization of their profession, it soon became hopelessly bureaucratized and incapable of providing inspired leadership. The very fact that all active architects, artists, and craftsmen had to join made it impossible to oversee the work of its members in order to maintain a reasonable standard. At the same time, it led to the neglect of the special needs of the creative elite formerly served by such voluntary associations as the *BDA* and the Werkbund itself. The small Werkbund division, alone, found that it could do little to uphold the principle of quality under these circumstances.[47]

In a propaganda leaflet published shortly after Hitler came to power, the Werkbund had confidently proclaimed that its greatest days lay ahead.[48] As late as December 1934, Poelzig, who had consistently backed Jäckh's policy of appeasement, still hoped that, with the right leader, the association might carve out a sphere that would link with its past and ensure an even greater tomorrow.[49] But by November 1934, when it was absorbed into the *RdbK*, the general feeling among old-time members was probably that voiced by Fritz Hellwag, who simply bade the Werkbund "farewell."[50] Some members who refused to recognize

[47] According to Teut, *Architektur*, p. 76, by 1936 no less than 16,000 architects, interior decorators, and landscape architects had joined the *RdbK*, compared with a *BDA* membership of 2,500 in 1932. Cf. also Winfried Wendland, "Kritische Anmerkungen zur Reichskammer der bildenden Künste," typescript memorandum of Jan. 29, 1936, *BDC*, Wendland file. Wendland claimed that the *RdbK*, instead of serving the artists, had come to feed on them, and complained of the lack of an effective corporatist policy ("Standespolitik").

[48] *Der Deutsche Werkbund, Was er Will—Seine Geschichte und Leistung—Seine Aufgaben von heute und morgen.* (Copy in the possession of Wilhelm Wagenfeld, Stuttgart). Quoting from this pamphlet, the *DWB-M* April 1933 declared: "Die grosse Zeit des Werkbundgedankens, die schöpferische Stunde der nationalen, die Welt gewinnenden Form hebt erst an." It should be recalled that Jäckh and Poelzig were at least nominally in charge of the Werkbund at this time.

[49] See Poelzig's response to a questionnaire survey of *Die Deutsche Bauzeitung*, Dec. 1934, quoted in Teut, *Architektur*, p. 163.

[50] "Abschied vom Werkbund," *Deutsche Allgemeine Zeitung*,

the Werkbund division in the *RdbK* as the legitimate successor to the Weimar association thereupon tried to resurrect it on a nonofficial basis, but nothing came of these efforts.[51] The true Werkbund, still very much alive in the minds of many, could not survive within the National Socialist state.

While it is plain in retrospect that the Jäckh-Poelzig policy could lead only to disaster, it should be remembered that at the decisive meeting on June 10, only three men had voted against their proposals, and of these only one, Martin Wagner, had systematically argued the case against voluntary *Gleichschaltung*. Wagner, whom the National Socialists had already dismissed from his post as Berlin's municipal architect, accurately predicted the debacle that would follow on the adoption of Jäckh's plan. Drawing attention to Lörcher's lack of leadership qualities, he also pointed out that either a drop in membership or an increase in activity would upset Jäckh's budget calculations and precipitate a financial crisis. Neither these practical objections nor Wagner's more fundamental protest against collaboration with the National Socialists swayed his listeners, however. The vote of 27 to 3 was declared unanimous at Jäckh's request, and the Werkbund promptly embarked on the downhill path Wagner had foreseen. The one concrete result of his outspokenness was that Wagner became the only Werkbund member to be expelled from the association as soon as its new leaders had consolidated their authority.[52]

Nov. 18, 1934. See also Wagner to Gropius, Nov. 28, 1934, *Bauhaus*, GN/5/377ᵛ; and Richard Döcker to Gropius, Dec. 18, 1934, *Bauhaus*, GN/5/47. Döcker mentioned that Lörcher was vexed because none of the old Werkbund people were any longer willing to cooperate.

[51] Wagner mentions one such initiative (involving Mies, Häring, and Wagenfeld) in a letter to Gropius, Nov. 28, 1934, *Bauhaus*, GN/5/377ᵛ. According to G. B. von Hartmann, Berlin, letter to the author April 2, 1974, later attempts to revive the Werkbund were made by Hermann Gretsch and Frau Mia Seeger of Stuttgart.

[52] *Bauhaus*, GN/13/2/61-2, letter from Gropius to Lörcher, Feb. 20, 1934, protesting Wagner's exclusion and declaring his refusal to attend further Werkbund meetings unless it was reversed. Wag-

One of Wagner's supporters on June 10 was the designer Wilhelm Wagenfeld, who a month before had denounced Jäckh's policy of appeasement, warning that collaboration with the *Kampfbund* would merely strengthen the latter as an instrument of cultural reaction at home and abroad.[53] At that time, Wagenfeld had attacked particularly the nationalist rhetoric of recent Werkbund publications and the abandonment of Renner's Futura type in favor of the traditional Gothic. As the executive committee had totally ignored his protests, it is not surprising that Wagenfeld decided to vote against Jäckh on June 10. It is harder to understand why this man, who in May 1933 had insisted on the duty to avoid compromise with the cultural reactionaries, continued to contribute to *Die Form* after the *Gleichschaltung* and agreed to chair a Werkbund committee on folk art and domestic crafts established at the Würzburg congress.[54]

The third man to cast a negative vote on June 10 was Gropius. A close friend of Wagner's, Gropius felt strongly enough to join him in walking out of the meeting and in resigning from the executive committee. Like Wagenfeld, however, he retained his Werkbund membership after the *Gleichschaltung*, although he abstained from public participation in the affairs of the association.

If the withdrawal of Gropius and Wagner failed to spark active resistance among their colleagues, the most probable explanation is that the only alternative to voluntary

ner had been the only member of the Prussian Academy of Arts to resign rather than meekly accept the expulsion of Heinrich Mann and Käthe Kollwitz on political grounds. He referred to this earlier act of resistance, which had cost him his job, in his speech to the Werkbund, *Wagner*, p. 1. Cf. Hildegard Brenner, ed., *Ende einer bürgerlichen Kunst-Institution* (Stuttgart, 1972), pp. 30-31; and Teut, *Architektur*, p. 119.

[53] See transcripts of letters from Wagenfeld to the "Vorstand des D.W.B.," May 14 and May 25, 1933, and the reply of May 23 by Otto Baur, in the possession of W. Wagenfeld, Stuttgart.

[54] *DWB-M* Nov. 1933; Wilhelm Wagenfeld, "Kulturelle Förderung der Heimindustrie, Denkschrift," *Die Form*, VIII, No. 12 (1933), 377-81.

Gleichschaltung was to disband forthwith. Wagner's suggestion that the association work out a positive program and then ask any Nazis who wished to join on the Werkbund's terms to do so, was utopian; at best, it would have delayed the absorption into the Nazi movement.[55] But in view of the clarity with which Wagner outlined the disastrous consequences of the decision to keep the Werkbund going under National Socialist leadership, one must at least try to establish why his warnings were ignored.

Some appear to have approved the Jäckh proposal because they hated to see the Knubels and Schultze-Naumburgs of the reactionary *Kampfbund* take over the Werkbund legacy without a fight. Others may have been afraid to vote against the National Socialists, dreading the personal consequences of such a step.[56] But in general those who acquiesced in the *Gleichschaltung* did so because they genuinely believed that the Werkbund could continue to serve the nation under National Socialist leadership. Prepared to discount the violent extremism of the Nazis in the early months as an aberration, they persuaded themselves that the "German Revolution" had passed its peak and that remaining conflicts on cultural issues could be resolved through rational discussion. This belief had led Jäckh to seek talks with the *Kampfbund* leaders in April, and at the end of 1933 it lay behind Riezler's decision to correspond with Wendland. In a lengthy exchange, Riezler tried to convince the Nazi Werkbund leaders that the Third Reich could only benefit by allying itself with the modern movement in the pure and applied

[55] *Wagner*, p. 7. Teut, *Architektur*, p. 20, mentions several groups that preferred to liquidate themselves rather than cooperate with the Nazis, among them the Bauhaus, the Bavarian Werkbund, and a Berlin association, the "Junge Architekten."

[56] G. B. von Hartmann, letter to the author April 2, 1974, stresses this motive. Perhaps the fact that Wagner had already lost his job in February freed him to speak out in June. All non-Nazis were vulnerable at this time, but it is unlikely that their stand on the relatively insignificant Werkbund issue would have materially affected their position vis-à-vis Germany's new rulers. Neither Gropius nor Wagenfeld suffered as a result of their negative vote.

arts, and by tolerating a degree of freedom to experiment and debate within the framework of the total state.[57] Thus despite their distaste for many aspects of National Socialism, Jäckh, Riezler, and others in the Werkbund, at first failed to grasp what Wagner spotted so unerringly: the basic incompatibility between National Socialism and the conditions of rationality and intellectual freedom essential for fruitful Werkbund work.

The fundamental discrepancy between the Werkbund ethos and Nazi ideology was partly obscured by the fact that many of the goals proclaimed by the National Socialists seemed to echo long-cherished Werkbund ideals. Even before the *Gleichschaltung*, the Werkbund under Jäckh tried to demonstrate that its espousal of "National Socialist" values antedated the birth of the Nazi movement. Thus, Werkbund propagandists thought it expedient to stress the nationalism of the association's founders, citing Hermann Muthesius and Friedrich Naumann, in particular, to prove that the Werkbund from its inception had identified itself with the national cause. The *Mitteilungen*, in April 1933, reproduced an essay from the *Werkbund-Korrespondenz* that praised Muthesius as a forerunner of *völkisch* nationalism and noted the resemblance between views expressed in his *Handelschochschule* speech of 1907 and recent statements on the political mission of the applied arts by Paul Schmitthenner.[58] Similarly, Theodor Heuss, who had voted for the *Gleichschaltung* on June 10, as late as October 1933 traced the National Socialists' demand for a "German" style back to Naumann, in an attempt to link the nazified association with its predecessor.[59]

[57] *BASK*, DWB III, Riezler to Wendland, Nov. 1, 1933, Nov. 29, 1933, Dec. 31, 1933, and Jan. 29, 1934; Wendland to Riezler, Nov. 8, 1933, Dec. 1, 1933, Jan. 18, 1934, and Feb. 8, 1934. These documents have now been printed in Fischer, *Deutsche Werkbund*, pp. 319-32.

[58] *DWB-M* April 1933, in *Die Form*, VIII, No. 4 (1933), 126.

[59] "Der Werkbund vor neuen Aufgaben," *Vossische Zeitung*, Oct. 6, 1933. Shortly before Hitler's advent to power, Heuss had published

If a liberal democrat like Heuss could see a connection between Werkbund nationalism and National Socialism, this was even easier for such conservatively oriented patriots as Hans Poelzig and Ludwig Roselius. When Poelzig first came under National Socialist pressure in January 1933, the Werkbund *Mitteilungen* defended him by stressing his love of country and cited Moeller van den Bruck— that "most perceptive propagandist of youthful nationalism"—in support.[60] Moeller had concluded his essay of 1916 on the Prussian style with an encomium to Poelzig, whom he regarded with some justice as the prototypical "conservative revolutionary." Like most to whom this label could be applied, Poelzig combined a patriotic revulsion against the Versailles settlement with rejection of "liberalism" and intellectualism. When the National Socialists had come to power, he did what he could to prove his loyalty despite repeated Nazi attacks on his person. Both in the Prussian Academy of Arts, of which he was vice-president, and in the Werkbund, he used his influence to avert direct confrontation between the National Socialists and their opponents.[61] He accepted extension of his professorship at the Berlin Institute of Technology in 1934, and only considered emigration seriously in November

an analysis of National Socialism, *Hitlers Weg* (Berlin, 1932) in which he dealt with Naumann's National-Social program in a passage on the roots of National Socialism (pp. 22-28). Although Heuss concluded that Naumann's ideas could not fairly be regarded as a source of Nazi ideology, he later regretted even having entertained the comparison. Cf. Eberhard Jäckel, introduction to the reprint of *Hitlers Weg* (Tübingen, 1968), xli.

[60] *DWB-M* Jan. 1933; Arthur Moeller van den Bruck, *Der Preussische Stil* (Munich, 1916); Heuss, *Poelzig*, pp. 13-14. The attacks of early January on Poelzig are described in Heuss, *Poelzig*, pp. 156-59, and Heuss, "Der Kampf um Poelzig," *Die Hilfe*, xxxix, No. 3 (1933), 90-92. At the time, a Werkbund submission to the Prussian Ministry of Culture still sufficed to shore up Poelzig's authority.

[61] Brenner, *Ende einer bürgerlichen Kunst-Institution*, p. 31. It was Poelzig who devised the formula that avoided a vote on the issue of whether Heinrich Mann and Kollwitz should be thrown out. The effect was to condone the Nazi expulsion of these two members of the Academy.

1935, by which time he had come to despair of Germany's future—and his own—under the Nazis.[62] Poelzig's absorption in his creative work, combined with an aversion to politics, kept him outside the National Socialist movement, but it also enabled him to condone Nazi control over national policy, as long as the sphere of culture remained relatively free from interference.

The position of Ludwig Roselius was somewhat different. This Bremen exporter, banker, and patron of the arts had long combined devotion to the Werkbund cause with efforts to promote the folk arts and crafts. Although he had rejected Hitler's personal appeal to join the Nazi party in 1922, Roselius already then had been deeply impressed by the future *Führer*, whom he regarded as a potential savior of the German nation.[63] A disciple of H. S. Chamberlain, Roselius found an outlet for his racialism during the Weimar years by fostering "Nordic" Expressionism, folk art, and Anglo-German cultural relations. He believed that the Nazis alone were capable of reversing the verdict of Versailles, approved of their outspoken anti-Communism, and—more surprisingly—of their anticapitalism. Most important, he managed to persuade himself that the National Socialists shared his strong cultural concern. Roselius thus had many reasons for welcoming the Nazi victory in 1933 and evidently saw no conflict between his own ideals and those proclaimed by the National Socialist party.[64] Filling the vacancy on the

[62] Heuss, *Poelzig*, p. 158. Poelzig died in 1936, shortly before taking up a post in Turkey arranged for him by Martin Wagner.

[63] Ludwig Roselius, *Briefe und Schriften zu Deutschlands Erneuerung* (Oldenburg, 1933), pp. 5-6. Stern, *Cultural Despair*, p. 292, notes the similar reaction of Moeller van den Bruck, who was approached by Hitler around the same time as Roselius.

[64] Roselius's *Briefe und Schriften* was dedicated to H. S. Chamberlain. Persuaded by the National Socialist victory that Germany was at last ready to listen to him, Roselius felt it appropriate in 1933 to reissue these nationalistic essays originally published in 1918. Cf. Roselius, *Ludwig Roselius und sein kulturelles Werk*, *passim*; and Conrads and Sperlich, *Fantastic Architecture*, p. 168, n. 89.

Werkbund executive committee created by the withdrawal of Riezler in the spring of 1933, Roselius proceeded to back Jäckh's proposals and accepted appointment as *Führer* of the association's *Gau Niedersachsen* after the Würzburg reorganization. Although, at Würzburg, he warned of the threat to artistic freedom implicit in certain Nazi statements, Roselius continued to serve the Werkbund until its demise, and the National Socialist state thereafter.[65]

In addition to nationalism, the Werkbund in 1933 placed renewed emphasis on another closely related facet of its original program, namely the notion of quality work. The first propaganda leaflet published after the Nazi seizure of power proclaimed that the association's primary goals remained the propagation of quality and the development of a new ethic of work.[66] A few months later Wendland explicitly defined the Werkbund's role in the Third Reich in terms of the concept of *Wertarbeit*—quality work—which he regarded as the principal contribution of the old association. In so doing he consciously turned his back on the formal and aesthetic experimentalism of recent years and sought to make the Werkbund once more the chief guardian of the quality ideal.[67]

The National Socialist leadership also adopted two other terms that had frequently been employed in Werkbund circles in earlier years: *Gesinnung* (ethos) and *Leistung* (achievement). Thus the new constitution stated that the first aim of the Werkbund would be to create and nurture a German *Werkgesinnung* rooted in the nation's cultural

[65] "V-A, Sept. 29, 1933"; Heuss, "Der Werkbund vor neuen Aufgaben"; *DWB-M* Nov. 1933. *BDC*, Roselius file, contains a curriculum vitae that shows that in April 1938 Roselius, although still not a party member, served as "Anwärter" and "förderndes Mitglied" of the SS. In 1935, he was a member of the *RdbK*'s governing council. Cf. *Wer ist's?* (1935).

[66] *Der Deutsche Werkbund, Was er will . . .* , p. 1 and *passim*. As in 1914, quality production was lauded particularly for the contribution it could make to Germany's attempt to dominate the markets of the world.

[67] "Der Deutsche Werkbund im neuen Reich," *Die Form*, VIII, No. 9 (1933), 257-58.

tradition; and the communiqué issued after the Würzburg meeting asserted that the association would strive to act in accordance with the principle of *Leistung* proclaimed by Adolf Hitler.[68] Qualität, Wertarbeit, Gesinnung, Leistung, were all words, rich in ethical connotations, that had played an important role in Werkbund propaganda before the Nazi era.[69] By using them, the National Socialist leadership evidently hoped to evoke a favorable response in members' breasts, especially among the more conservative, who agreed that the stylistic dogmatism of the late Weimar years had constituted a betrayal of the association's fundamental moral purpose. As one young architect observed at the time, the National Socialists cleverly pretended that the Werkbund was National Socialist in essence, that alien influence had diverted it from its original program, and that Hitler's revolution would restore its true character.[70]

Those who continued to believe that the Werkbund could function in the Third Reich rested their hopes on more than words. Thus a law of May 1933 for the protection of the national emblems—"Zum Schutz der nationalen Symbole"—was taken as proof that the Nazi leadership had identified itself with the Werkbund goal of quality and declared war on *Kitsch*.[71] This legislation, followed by an exhibition on the same theme at the Cologne Art Society, seemed to show that the National Socialist state intended to protect and propagate artistic standards. Such

[68] Clause 2 of the revised constitution; "Der Werkbund des Dritten Reichs," *Neue Zürcher Zeitung*, Dec. 22, 1933.

[69] Cf. the Werkbund brochure, *Der Deutsche Werkbund: Ziele und Arbeit* (Munich, n.d.) written around 1922 by Theodor Heuss, and cited in *Theodor Heuss: Der Mann, das Werk, die Zeit. Eine Ausstellung* (Stuttgart, 1967), p. 123. In his "Der Werkbund vor neuen Aufgaben," Heuss, writing about the Würzburg meeting in 1933, noted the connection between the aims of the Werkbund as outlined at that meeting and the association's original program: "Qualität und Leistung gegen charakterlosen Ramsch, Verantwortung, Ehrlichkeit in Stoffverwendung und Formausdruck, Bewusstsein der nationalen Bindung."

[70] Julius Posener, "L'Architecture du IIIe Reich," *L'Architecture d'Aujourd'hui*, VII, No. 4 (1936), 25.

[71] Gerd Ruhle, ed., *Das Dritte Reich*, 1 (Berlin, 1934), 95.

steps were ideally designed to reassure those who had feared that the National Socialist party, with its mass base, would pander to popular taste to the detriment of quality.[72]

During the early months of the regime, Nazi propaganda and policy thus seemed to reinforce what the Werkbund had long proclaimed, namely that true art and culture necessarily contain an aristocratic element at variance with mass opinion. There is evidence that the National Socialist movement attracted many creative artists precisely because it promised to save German culture from the dangers of a libertarian mass society. Not a few hoped that the National Socialists would return a measure of cultural leadership to the intellectual and artistic elite, so that the latter, exercising "Platonic guidance" in the name of the national community, might finally vanquish "bourgeois vulgarity."[73] On their way to power, the Nazis had found it expedient to pose as egalitarian defenders of the *Volk* against self-selected elite groups like the Werkbund. They had accused the Weimar authorities of using the power of the state to support or even dictate culture from above, and claimed that the Nazi revolution would bring art back into close contact with the people and thus, by implication, secure the victory of popular taste.[74] Once in power, however, the National Socialists for a time moderated the populist tone of their propaganda. In a bid for the support of Germany's cultural leaders they argued that every young artist had a patriotic duty to develop his

[72] Ernst Hopmann, "Fort mit dem nationalen Kitsch," *Die Form*, VIII, No. 8 (1933), 255. The exhibition in Cologne was sponsored jointly by the *Reichsverband bildender Künstler* and the *Kampfbund*. One of the declared aims of the *RdbK* was to fight against "das Pfuschertum und . . . die Kitschhändler." Ruhle, ed., *Das Dritte Reich*, II, 176.

[73] Fritz Ringer, review of G. Mosse, *Germans and Jews*, in *Journal of Modern History*, XLIV, No. 3 (1972), 176.

[74] For an example of antielitism, cf. Hermann Hass, *Sitte und Kultur im Nachkriegsdeutschland* (Hamburg, 1932). Also, letter from Wendland to Riezler, Jan. 18, 1934, accusing the Weimar Werkbund of having concerned itself exclusively with the interests of a small intellectual stratum, out of touch with the *Volk*.

personality. No longer was it demanded that the creative individual submerge himself in the *Volk*. Rather, his will would determine popular culture.[75] Such statements, paraphrasing sentiments often expressed by Werkbund propagandists in the past, served to allay many fears.

If the Nazis simultaneously proclaimed their aversion to liberal individualism and to political democracy, this did not automatically condemn them in Werkbund eyes. For whereas most Werkbund intellectuals insisted on creative freedom for themselves, many, including such staunch anti-Nazis as Riezler or Wagner, had long abandoned any faith they might once have had in liberal democracy as such. Riezler, an admirer of Fascist Italy since the early 1920's, was prepared in 1933 to recognize the right of the modern state to limit personal freedoms for the sake of the national community.[76] Had the Nazis been willing to suppress reactionary cultural tendencies and form an alliance with the artistic avant-garde, Riezler might possibly have acquiesced in their general policy. Similarly, Wagner acknowledged that he would be prepared under certain circumstances to espouse National Socialism, namely, if the new regime proved capable of ending mass unemployment.[77] Undoubtedly there were others in the Werkbund much readier to jettison liberal means if thereby they could secure valued national, cultural, or social ends. The conviction that strong government alone could solve the nation's problems had grown steadily throughout the last years of the Republic. Thus

[75] Thus Ernst Adolf Dreyer, ed., *Deutsche Kultur im neuen Reich* (Berlin, 1934), pp. 137-38: ". . . die Haltung des Einzelnen bestimmt das Gesicht der Masse." As in other areas, National Socialists concerned with the role of the artist in a mass society continually contradicted each other, but certain tendencies predominated at particular times.

[76] *BASK*, DWB III, Riezler to Wendland, Nov. 29, 1933. In 1925, Riezler had asserted that Italy was undergoing an impressive reformation, spiritual as well as economic. Cf. *Die Form*, I, No. 1 (1925-26), 13.

[77] *Wagner*, p. 7. Probably he felt confident that this day would never come!

architects urged governments to take an active part in urban and regional planning, while those concerned with the design of consumer goods, discouraged by the poor response from private industry, increasingly argued that the state should intervene to set and police standards of quality. Finally, in the realm of education, state regulation seemed to hold out the best hope for securing needed reforms and imposing a degree of uniformity on a nation-wide basis.[78] Given this state of mind, it is small wonder that even men like Riezler and Wagner questioned the universal validity of liberal principles.

While antidemocratic sentiment spread within the Werkbund after 1930 largely because of the Republic's failure to provide vigorous leadership in a time of national emergency, distrust of democracy had roots deep in the association's past. The Werkbund had always advocated giving strong-willed individuals full authority over its exhibitions, and expressed distaste for the notion that artistic matters should be decided by committee or in accordance with the will of a numerical majority. In the sphere of art education, it had argued that best results would be achieved in a school dominated by a single director able to exert personal authority over staff and students alike.[79] Consequently, some members could accept the Nazis' *Führerprinzip* without undue qualms. Riemerschmid and Schmitthenner positively welcomed its adoption by the Werkbund, believing that it would give the creative minority the recognition and influence largely denied them by Weimar society. And even Theodor Heuss argued that the principle's incorporation into the new constitution of

[78] Benevolo, *History of Modern Architecture*, II, 498-99. Pevsner, *Academies of Art* (1940), pp. 294-95, noted a European trend to totalitarianism and, while admitting that most progressive artists strongly opposed state interference, pointed out that the totalitarian state might indeed produce results unobtainable under a liberal regime.

[79] E.g., Paul Renner, "Werkbund und Erziehung," *Die Form*, VII, No. 11 (1932), 334. Also Pevsner, *Academies of Art*, p. 295, referring specifically to the Bauhaus.

September 1933 accorded with Werkbund tradition and merely formalized existing practice.[80]

The *Führerprinzip* proved relatively congenial to the Werkbund, but it would seem that Nazi racialism did not. Among the association's leaders, at least, there were no overt anti-Semites. Nevertheless, the majority signally failed to allow dislike of this aspect of National Socialist doctrine to culminate in outright resistance. Wagner, at the June 10 meeting, warned most eloquently that acceptance of the Jäckh-Poelzig plan would inevitably lead to "Aryanization" of the Werkbund, but he failed to move his colleagues. Not even by appealing to the authority of Martin Luther or by reminding his audience of the contribution Jewish artists like Max Liebermann had made to German culture could Wagner persuade the executive committee to reject cooperation with the Nazis—or at least to make collaboration conditional on a promise to exclude the "Aryan paragraph" from Werkbund affairs.[81] On the contrary, the Werkbund, under pressure from the *Kampfbund für deutsche Kultur*, became one of the first cultural organizations in Germany formally to exclude non-Aryans.[82] By September 1933, when the constitution embodying this principle was presented to the general membership at Würzburg, the time for effective protest had long passed. As Martin Wagner had foreseen, once the first step had been taken in the National Socialist direction, principled resistance to further Nazi demands proved impossible.[83]

[80] Heuss, "Der Werkbund vor neuen Aufgaben," *Vossische Zeitung*, Oct. 6, 1933.

[81] *Wagner*, p. 3. [82] Teut, *Architektur*, p. 70.

[83] When Jäckh tried to make Wagner drop the subject, the latter responded with an apt quotation from Goethe: "Das Erste steht uns frei, beim Zweiten sind wir Knechte." *Wagner*, p. 3. One wonders if general application of this dictum might not have changed the course of German history. In the case of Theodor Heuss, it would have entailed voting *against* the Enabling Act in March 1933, and backing Wagner at the June Werkbund meeting, instead of merely carrying on a futile, if valiant, rearguard action against racist dogma in *Die Hilfe* during 1934.

It may be that some who took the fateful first step in June did so because they hoped that reason would prevail on the Jewish question, as on others. In the first months after the seizure of power, Hitler and, even more, Goebbels, seemed to be pushing the racist extremists to one side. Thus Goebbels' protegé, Hans Hinkel, an important official in the Prussian Ministry for Science and Education and head of the *Kampfbund*'s Brandenburg branch, spoke out against *Radauantisemitismus* (rowdy anti-Semitism) and promised that Jewish artists in future would still be allowed to contribute to German culture; while the original constitution of the *Reichskulturkammer* permitted non-Aryans to become members.[84] Such instances of moderation made it easier for Werkbund members to avoid taking a stand on this issue. Moreover, although it is difficult to find evidence on this point, there were undoubtedly some who were not averse to discrimination against Jews. Even Wagner prefaced his attack on Nazi anti-Semitism with an admission that he believed Jews had come to exercise inordinate influence in certain areas of national life, notably the press, finance, and commerce. He did not object to the Nazis' proposals to limit Jewish preponderance, but only disliked the indiscriminate and violent methods with which they sought to achieve this goal.[85] One must conclude that whatever their personal feelings, the Werkbund leaders were not prepared in June 1933 to jeopardize the association's future by openly challenging the National Socialists on this matter.

Even the resistance of the three who voted against the *Gleichschaltung* was not motivated by concern for their Jewish compatriots, but stemmed primarily from the conviction that Jäckh's plan entailed capitulation to the forces

[84] Teut, *Architektur*, p. 66; Karl-Friedrich Schreiber et al., *Das Recht der Reichskulturkammer*, i (Berlin, 1934), 29. According to Teut, p. 70, non-Aryans were excluded from the Kulturkammer only in 1935, after passage of the Nürnberg racial laws.

[85] *Wagner*, p. 3. Wagner associated himself with Poelzig's view that leading Jews should themselves inaugurate a policy of voluntary restraint in certain areas of public life.

of cultural reaction.[86] Whereas some argued in June that Schultze-Naumburg's influence was already waning and that the Nazis were prepared to encourage healthy elements in the modern movement, the dissidents regarded Rosenberg's *Kampfbund* as an inveterate foe, incapable of conversion to progressive views, and certain in the end to impose its retrograde aims on the Werkbund.[87] As in the case of anti-Semitism, however, the majority on the executive either sympathized with *Kampfbund* policy or believed that, by working from within, the progressives could exert a moderating influence.

Within a year of the *Gleichschaltung* even the most optimistic had to admit that Wagner's gloomy prognostications had been only too accurate. As he had predicted, the Jäckh-Poelzig tactics of accommodation had proved to be poor strategy, leading not to the Werkbund's salvation but to its dissolution. Yet if it failed to maintain its independence, something of the Werkbund spirit continued to manifest itself in the Third Reich. Despite the destructive force of the National Socialist revolution that drove many former members into "inner" or physical emigration, a surprising number of Werkbund men managed to carry on their creative work under the auspices of the new regime. To complete the Werkbund's story, one must therefore look at those men and ideas that found a place in National Socialist Germany and, by so doing, maintained a degree of continuity through revolution, dictatorship, and total war.

By 1935, all that remained of the Werkbund was a small division within the *RdbK*, linked with the pre-Nazi-organization solely by the presence of Otto Baur as "Referent."[88]

[86] Gropius, earlier on, had displayed traces of anti-Semitism, according to Stressig, "Hohenhagen," pp. 469-70 and 506, n. 51. In 1934, however, he strongly defended Jewish rights against Lörcher and other National Socialists. Cf. *Bauhaus*, GN/13/3/72, letter from Lörcher to Gropius, Feb. 28, 1934, warning Gropius to desist from his interventions in favor of Jewish artists and architects.

[87] *Wagner*, pp. 1 and 5-6.

[88] *BDC*, Baur file, undated personnel record, lists Otto Baur as "Referent" in the "Abteilung deutscher Werkbund" of the *RdbK*.

Baur, a born bureaucrat, may well have felt more at home in the new setting than he had as executive secretary of the often fractious and faction-ridden Weimar Werkbund, but his scope for positive action was severely restricted. In the end, it proved impossible to propagate Werkbund ideals effectively within the limits set by the legalistically minded bureaucrats of the *Kulturkammer*.[89]

While the *RdbK* failed to provide an environment suited to the propagation of Werkbund views, a more promising alternative soon presented itself. In January 1934, Robert Ley created a division within his Labor Front dedicated to *Schönheit der Arbeit*–Beauty in Work–as a subsidiary of the "Strength Through Joy" movement. Like many Werkbund idealists, Ley believed in the need to "awaken joy in work and kindle in the worker the will to organize his working world in a beautiful and dignified and friendly manner," as an essential prerequisite for the rebirth of a true sense of community or *Gemeinschaft*, threatened by the advance of industrialization.[90] Given the similarity of goals, it is not surprising that the *Arbeitsfront* initiative was welcomed by some Werkbund members. Led by Albert Speer, soon to become Hitler's favorite architect, the *Amt Schönheit der Arbeit* systematically recruited former Werkbund men to carry out its programs.[91] The first step in cooperation between the new bureau and the Werkbund was a special issue of *Die Form*. Entitled *Schönheit der Arbeit*, this generously illustrated joint publication, devoted

[89] Heuss, "Notizen," p. 23, referred to Baur as "bereits als Regierungsrat geboren . . . der zuverlässige, zur eigenen Beruhigung und verborgenen Selbsterhöhung nörgelnde Bürokrat *in artibus*." According to an interview with Wilhelm Niemann, Feb. 2, 1974, recorded by Irmgard Tschich of the Deutsche Werkbund, Berlin, Baur died in the Allied raid that destroyed the Werkbund office on Nov. 23, 1944.

[90] Cf. Laurence van Zandt Moyer, "The Kraft durch Freude Movement in Nazi Germany, 1933-1937," Ph.D. Dissertation, Northwestern University, 1967, p. 11 and *passim*. Also, R. Ley, *Ein Volk erobert die Freude* (Berlin, 1937).

[91] Speer, *Inside the Third Reich*, p. 57; letter from Speer to the author, Oct. 26, 1971.

to the theme of the beautiful work environment, appeared early in 1935, in an edition of 13,000.

The hope that the Werkbund's journal would thereby recover its vitality proved illusory and this most lavish issue of *Die Form* was also its last. However in 1936, when the *Amt Schönheit der Arbeit* started its own periodical, one of its principal editors was none other than Wilhelm Lotz.[92] For several years thereafter, Lotz, who before 1933 had regarded himself as an opponent of National Socialism, found it possible to reconcile his political views with active collaboration on this and other government-sponsored propaganda publications of a cultural nature.[93] Meanwhile, an agreement signed in 1936 between the *RdbK* and the *Amt Schönheit der Arbeit* facilitated the cooperation of other Werkbund members with Speer's office.[94]

In addition to *Schönheit der Arbeit*, Ley's Labor Front spawned several other bureaus in which Werkbund ideas and Werkbund men could find a place. One of these, the *Reichsheimstättenamt* (Federal Homestead Office) explicitly acknowledged the pioneer contribution of the Werkbund when it initiated a program dedicated to *Schönheit des Wohnens* (Beauty in the Home). Looking ahead to the postwar era, the National Socialists in 1941 promised

[92] *Schönheit der Arbeit*, I, No. 1 (May, 1936), gives Lotz as "Schriftleiter und verantwortlich für die Bildgestaltung." By early 1939, he had been promoted to "Hauptschriftleiter." Wendland made extensive efforts to revive *Die Form*. See *BDC*, Wendland file, Wendland to Hans Hinkel, Aug. 22, 1935.

[93] Lotz defended the National Socialist Werkbund leadership, and Nazi cultural policy in general, in *Die Form*, VIII, No. 12 (1933), 382-83, and subsequently did a great deal of architectural reporting for the Nazis. Teut, *Architektur*, pp. 190-94 and 282. Lotz's fate remains a mystery. Wilhelm Niemann, interview of Feb. 2, 1974, claims he was shot by the Nazis in the Ordensburg Sonthofen during the war.

[94] See *Das Taschenbuch Schönheit der Arbeit*, ed. Anatol von Hübbenet (Berlin, 1938), with an introduction by Speer and a quotation from Hitler on the frontispiece: "Schönheit der Arbeit ist edelster Sozialismus," a sentiment with which few Werkbund members would have found fault.

to provide the ordinary German with the kind of domestic environment that Werkbund efforts had allegedly managed to secure only for Germany's upper classes.[95]

In the arts and crafts, the Nazis initially advocated the introduction of more *völkisch* and *heimatlich* elements, and sought to temper functionalist severity with human warmth by favoring the handicrafts over the machine.[96] However, National Socialist policy was ambivalent once more, as can be seen from the illustrated publication *Gestaltendes Handwerk* (Creative Handicrafts) produced by Hermann Gretsch in 1940 for the Labor Front's *Fachamt "Das Deutsche Handwerk."* This volume professed to delineate the cultural role of the artworker in *völkisch* terms, but, taken as a whole, text and illustrations emphasized the Werkbund ideals of simplicity, honesty, clarity, and unornamented form equally applicable to hand or machine production; and the book contained numerous references to problems of industrial design.[97] If the items shown, originally exhibited at the first international handicraft exhibition held in Berlin in 1938, failed to come up to the highest standards established by Werkbund designers in the years before 1933, the general level was certainly respectable and the designs remarkably free from ideological contamination.[98]

[95] Hermann Doerr, "Schönheit des Wohnens: ein politisches Problem," *Der soziale Wohnungsbau in Deutschland*, II (Berlin, 1941), in Teut, *Architektur*, pp. 285-86. Lehmann-Haupt, *Art under a Dictatorship*, p. 69, mentions a building division of the *Arbeitsfront*, and one devoted to the German crafts.

[96] Walter Passarge, *Deutsche Werkkunst der Gegenwart* (Berlin, 1937), p. 7.

[97] In an introduction to this volume, Rudolf Schäfer asserted: "Die volksnahe Gestaltung ist die Kulturaufgabe des Handwerks." But Gretsch's own inclination was towards industrial production of high-class designs. Cf. Theodor Heuss, *Hermann Gretsch: Industrielle Formgebung* (Berlin, 1941). Produced for the official *Kunst-Dienst*, this publication, which included objects designed in the pre-Nazi period, was pure Werkbund from beginning to end.

[98] For a critique of the exhibition on which the book was based, see Wilhelm Wagenfeld, "Über die Kunsterziehung in unserer Zeit," in Wagenfeld, *Wesen und Gestalt*, pp. 16-17. Lehmann-Haupt, *Art*

In any case, the National Socialists, conscious of the need to supply a mass market with inexpensive consumer goods, gradually relegated their *Handwerk* enthusiasm to second place. Hitler and Rosenberg made ever more frequent statements in favor of the machine, and even incorporated the once hated concept of *Sachlichkeit* into their propaganda. [99] This made it possible for government organizations, especially after 1940, to encourage innovative industrial design without betraying party doctrine. Meanwhile, private industry gave continued scope to designers trained during the 1920's, among them the former Bauhaus artist Wilhelm Wagenfeld whose superior prototypes for the Lausitzer glass works and other firms between 1934 and 1942 carried on the Werkbund tradition.[100]

With regard to quality, the Nazis tried to maintain minimum standards and even to raise the level of popular taste. In addition to taking measures against the manufacture of *Kitsch* exploiting National Socialist symbols, they published a catalogue of good designs in current production apparently modeled on the Werkbund's pioneering *Deutsches Warenbuch* of 1915, and sponsored numerous exhibitions to cultivate public sensibilities in matters of design.[101] Nevertheless, dissatisfaction with the state of the industrial arts is revealed in a government report of March 1942. Despite several years of a policy described

under a Dictatorship, pp. 135-36, analyzed it for its "National Socialist" content and concluded that the applied arts were relatively much more resistant to ideological and political pressure than were the fine arts. The fact that Hitler took little personal interest in the applied arts apart from architecture may have given them this partial immunity. Cf. Speer, *Inside the Third Reich*, p. 57.

[99] See Lane, *Architecture and Politics*, p. 189; and Taylor, *Word in Stone*, pp. 43-44.

[100] Wagenfeld's work during these years is summarized in *Wilhelm Wagenfeld: 50 Jahre Mitarbeit in Fabriken* (Cologne, 1973), exhibition catalogue.

[101] Lehmann-Haupt, *Art under a Dictatorship*, pp. 129-30. Called *Deutsche Warenkunde*, this Nazi successor to the Werkbund catalogue appeared in Berlin under the auspices of the *Kunst-Dienst* and with the blessing of Adolf Ziegler of the *RdbK*.

by Lehmann-Haupt as "Gestapo in the Gift Shop," the Nazis were no more able than the Werkbund had been to effect a revolution in taste.[102]

In the long run, politicization of the arts and crafts schools and the destruction of such pioneer institutions as the Weimar *Bauhochschule*, the Breslau Academy of Art, and the Bauhaus, would undoubtedly have lowered German design standards. However, the war intervened before such National Socialist "reforms" could do their worst, and one can argue that the deterioration in German *Kunstgewerbe* was due primarily to the war itself, which everywhere proved detrimental to the pursuit of quality.[103]

In architecture, too, the National Socialists failed to make a complete break with the past. Despite discrimination against such "cultural bolsheviks" as Gropius, May, Mies van der Rohe, and Bruno Taut, the new government could not dispense with the services of Werkbund men or those they had trained. While a few of the more conspicuous progressive architects found themselves unable to get party or government jobs, other Werkbund members, especially among the older generation, managed to secure significant public and private commissions. Thus Hitler chose as his favorite architect Paul Troost of Munich, who had belonged to the Werkbund before World War I and had achieved renown principally by designing interiors for luxury liners on the trans-Atlantic run. The fact that Troost had maintained his Werkbund membership during the 1920's was evidently not held against him by the new regime.[104]

[102] *Ibid.*, pp. 128-29, cites a report produced in 1942 by the Security Police (Sicherheits-Dienst).

[103] However, Wagenfeld, "Über die Kunsterziehung in unserer Zeit," pp. 16-17, claimed that the apprenticeship examinations, as early as 1935, had revealed the negative effects of National Socialist training. Although he blamed politicization and the downgrading of manual work during the war for further loss of skills and recognized that the war had also harmed the cause by rendering the crafts irrelevant, he insisted that the corruption of *Handwerk* had begun well before 1939.

[104] Troost, Riemerschmid, and Pankok were among the Werkbund artists who, during the 1920's, frequented the house of the Munich

After Troost's death, he was succeeded in Hitler's favor by the young Albert Speer. Speer's personal association with the Werkbund dated only from 1933, but was based on respect for its principles as he had been taught to understand them by Heinrich Tessenow, whom he greatly admired. This may help to explain why Speer, during the early years of the Third Reich, used his influence to secure employment and preferment for former Werkbund members.[105] Perhaps the most notable instance was that of Paul Bonatz of Stuttgart. Speer persuaded Hitler to withdraw his opposition to Bonatz, who had offended him by criticizing Troost's designs for the *Königsplatz* in Munich, and this made it possible for Bonatz to collaborate with Fritz Todt on the design of the *Autobahn* bridges.[106] In his work on the *Autobahnen*, Bonatz maintained a high technical and aesthetic standard, utilizing modern technology to meet contemporary needs in the best Werkbund tradition.

Two other Werkbund architects who secured major commissions in the Third Reich, Wilhelm Kreis and Peter Behrens, had done their freshest work during the Wilhelminian era and produced relatively little under the Weimar Republic. Unlike Bonatz, both were prepared, in late career, to design in the monumental pseudoclassical style favored by Hitler for public buildings.[107] Kreis, although president of the *BDA* from 1926 to 1933, had received few important assignments during those years. Un-

publisher Hugo Bruckmann, where Hitler, Rosenberg, Hess, and other prominent Nazis were favored guests. Cf. Karl Alexander von Müller, *Im Wandel einer Welt* (Munich, 1966), p. 299. The Bruckmanns, ardent nationalists and anti-Semites, did much to smooth Hitler's way in Munich society. See also Speer, *Inside the Third Reich*, p. 41.

[105] Speer, *Inside the Third Reich*, p. 145; letter from Speer to the author, Oct. 26, 1971.

[106] Teut, *Architektur*, pp. 297-307; Speer, *Inside the Third Reich*, p. 80; Bonatz, *Leben und Werk*, pp. 159-70. Through Speer's influence, Bonatz also secured a commission as architect for the Naval High Command. Cf. Speer, *Inside the Third Reich*, p. 144.

[107] Speer, *Inside the Third Reich*, p. 145; Benevolo, *History of Modern Architecture*, II, 552-55.

der the Nazis, he obtained several, including the task of designing war memorials in the heroic mode to commemorate German conquests in the East. His appointment to the presidency of the *RdbK* in 1943 confirmed the high esteem in which he was held by the National Socialists, and his acceptance of this honor demonstrated the extent to which he felt at home in the atmosphere of the Third Reich.[108]

Peter Behrens also made a successful adaptation to the Third Reich, in marked contrast to his illustrious pupils, Gropius and Mies van der Rohe. While the two younger men vainly sought work that would enable them to remain in Germany and were eventually forced to emigrate, Behrens voluntarily returned from Austria to Germany in 1936 and quickly moved into a prominent position.[109] Behrens' willingness to collaborate with the Hitler government lost him the friendship of some of his anti-Nazi acquaintances, but his success in securing the *Führer*'s favor also rendered him highly unpopular with the more idealistic National Socialists. Men who had backed the Nazi movement during the *Kampfzeit*, at some personal sacrifice, were incensed to find opportunists like Behrens profiting from their struggles.[110] Behrens' standing with the Nazi authorities must have been particularly galling to *Kampfbund* enthusiasts like Schultze-Naumburg, Schmitt-

[108] Hans Stephan, *Wilhelm Kreis* (Oldenburg, 1944), p. 10 and *passim*. Speer, in a foreword to this volume, noted that Kreis's career linked Bismarck's Reich with that of Adolf Hitler. See also Wilhelm Kreis, "Kriegermale des Ruhmes und der Ehre im Altertum und in unserer Zeit," *Bauwelt*, No. 11/12 (1943), in Teut, *Architektur*, pp. 222-26.

[109] Although Behrens had maintained an office in Berlin throughout the Weimar period, his main practice was in Vienna. Teut, *Architektur*, p. 180, terms him one of the leading architects of the Third Reich.

[110] Redslob, interview with the author Dec. 8, 1972, mentioned that although he had been a long-time friend and neighbor of Behrens, he came to shun him in the 1930's because of his pro-Nazi sympathies. On the other hand, the Behrens file in the *BDC* contains several denunciations of Behrens by National Socialists who regarded him as a philo-Semite and "cultural bolshevik."

henner, Lörcher, and Wendland, whose hopes for greater success under the new regime proved ill-founded. Hitler, who had a low opinion of Schultze-Naumburg's capabilities, refused to give that ardent proponent of racial art any major commissions.[111] Schmitthenner and Lörcher did not fare much better, and their dismissal from office in the *RdbK* in 1935 ended their hopes of helping to shape National Socialist architectural policy at the highest level.[112] Wendland, who had specialized in church architecture, for a time found employment with the "German Christian" church headed by the National Socialist *Reichsbischof* Ludwig Müller; but by the 1940's he too had been passed over and was reduced to appealing to Speer for work.[113]

Thus in the sphere of architecture one must conclude that political and ideological considerations played a lesser role than the arbitrary preferences of the *Führer* and his favored lieutenants. Not doctrinal purity but the possession of influential friends decided who should be allowed to build and who should not.[114] Hitler intervened personally on a number of occasions to secure the advancement of certain architects and the proscription of others. While Bonatz, Kreis, and Behrens among Werkbund members enjoyed government patronage, others of their generation,

[111] Speer, *Inside the Third Reich*, p. 64, asserts that Hitler thought Schultze-Naumburg good enough only for modest projects like the annex to the Nietzsche House in Weimar.

[112] On Schmitthenner's failure to secure official party contracts, see Rudolf Pfister, "Der 'Fall Schmitthenner,'" *Der Baumeister*, XLV (1948), 166-67. The Nazis failed to reward Schmitthenner although he had published a thoroughly National Socialist book, *Die Baukunst im Dritten Reich* (1934). Lörcher likewise failed to carve out a niche for himself, although as late as 1935 he loyally proclaimed that the people's architecture of the new Reich would have to be built by men imbued with faith in National Socialism. Cf. *Die Baugilde*, Jan. 10, 1935, pp. 1-2.

[113] Teut, *Architektur*, p. 241; *BDC*, Wendland file, letter from Wendland to Hinkel, Oct. 25, 1940.

[114] Speer, *Inside the Third Reich*, p. 43, states that Hitler's architectural preferences cannot be defined in ideological terms. Rather, the *Führer*'s stylistic judgments were arrived at pragmatically. The subject is discussed by Taylor, *Word In Stone*, Ch. II: "Adolf Hitler and Architecture."

equally eminent, were pushed aside. For example Theodor Fischer and Richard Riemerschmid, both past presidents of the Werkbund, were not only forced into early retirement but denied the honors due their age and achievement on direct orders from Hitler himself.[115] Another founding member of the Werkbund, Fritz Schumacher, compelled to relinquish his position as municipal architect in Hamburg in favor of a National Socialist, supported himself by free-lance journalism during the Hitler years, and died of malnutrition shortly after the war.[116] Meanwhile, many of the younger architects, unable to pursue their professional careers in Germany, chose exile rather than abandon their calling: Martin Wagner went to Turkey, Ernst May to East Africa, Bruno Taut to Japan, Gropius and Mies—with others—to the United States.

Werkbund artists, like the rest of their countrymen, thus differed widely in their responses to the trauma of National Socialism and suffered a variety of fates. The only generalization one can make with confidence is that there was no complete break in continuity during the Hitler years. The Third Reich, dependent on men whose professional careers had begun under the old regime, failed to develop a characteristically "National Socialist" architectural or decorative style.[117] The National Socialists were not given time to produce a new artistic generation, and one can only speculate whether the reforms in art education they initiated would have created a distinctive breed of designer in the long run. After all, the men who di-

[115] *BA*, "Reichsministerium für Volksaufklärung und Propaganda," R55/94 and 95. These files show that Hitler turned down the *Adlerschild* award for Fischer in 1937 because Fischer (like Bonatz) had opposed Troost's plans for the Munich Königsplatz. Hitler also decided against the Goethe Medal for Riemerschmid in 1943, overruling Speer.

[116] Bonatz, *Leben und Werk*, p. 102.

[117] The striking similarity of much German architecture of the 1930's to that produced in the Soviet Union, the United States, and Western Europe, should be noted in this connection. It gives support to the view that every age has its own style, which is only marginally affected by political and national differences.

rected the Nazi reforms were themselves products of the Weimar system, and even those who espoused reactionary ideas merely voiced views widely held in non-Nazi circles before 1933.

Moreover, some National Socialist educators adopted as their own certain "progressive" features of the art schools of the 1920's. Thus Robert Boettcher, put in charge of art education in 1936, favored a return to naturalism in drawing instruction and approved the copying of traditional motifs, in both these respects turning his back on the advances of the previous decade. But he did not abandon the child-oriented educational philosophy of the Weimar period and acknowledged his debt to the pioneers of the *Kunsterziehungsbewegung* with which the Werkbund had been closely associated from the start.[118] The Nazis for a time even seemed willing to learn from the much-persecuted Bauhaus. At first they tried to keep the school open, though admittedly on their own terms; and when this failed, they sought to carry over some of its methods and spirit into the *RdbK*.[119] In the end, regimentation did inhibit self-expression, and authoritarian discipline hampered individual creativity, but the defects of the art education

[118] Cf. Lehmann-Haupt, *Art under a Dictatorship*, pp. 173-79; and Alex Diehl, *Die Kunsterziehung im Dritten Reich* (Munich, 1969). On p. 300, Diehl cites Boettcher, along with Georg Kerschensteiner of the Werkbund, as among the few educators who consistently favored modern art.

[119] According to Gaber, *Entwicklung*, p. 126, Eugen Hönig, president of the *RdbK*, tried to preserve something of the Bauhaus spirit. On the closing of the Bauhaus, see Wingler, *The Bauhaus*, pp. 11, 181-89, and 558-65; Teut, *Architektur*, pp. 138-42; S. Moholy-Nagy, "The Diaspora," *Journal of the Society for Architectural Historians*, XXIV, No. 1 (1965), 24f. and rejoinder by Dearstyne and reply by Moholy-Nagy, XXIV, No. 3 (Oct. 1965), 254-56. According to Moholy-Nagy, Mies tried to keep the school open but was forced by the rest of the faculty to reject the Nazi conditions that would have made continuation possible. There is considerable evidence that Mies may indeed have been willing to cooperate with the National Socialists. Thus, he signed a pro-Hitler appeal circulated by Schultze-Naumburg in June 1933, and when he finally withdrew from the Prussian Academy of Arts in July 1937, on the eve of his emigration, he gratuitously concluded his letter of resignation with "Heil Hitler!" Cf. Brenner, *Ende einer bürgerlichen Kunst-Institution*, p. 145.

system were perhaps due less to a false educational phi-
losophy imposed on the schools by National Socialist ide-
ologists than to the corruption of these schools, along with
other national institutions, by the poisoned atmosphere of
the totalitarian state.

Despite their claims, it would seem therefore that the Na-
tional Socialists failed to effect a genuine revolution in the
applied arts or architecture. The pool of ideas on which
they drew had originated in the debates of the Weimar
period, and the men selected to implement them remained
wedded to prejudices and preconceptions acquired before
1933. The radical modernizers who had determined Werk-
bund policy for a time, had been forced onto the defensive
even before the Nazi seizure of power, and failed to sur-
vive the subsequent upheaval; but many other Werkbund
members either continued to pursue their careers as private
citizens or put their talents at the disposal of Germany's
new rulers. Indeed, certain aspects of the Werkbund pro-
gram secured greater government support in the Third
Reich than they had commanded in the Weimar years.
Whatever break in cultural continuity came as a result of
Hitler's victory occurred not in 1933, but during the war,
when the forces of destruction gained the upper hand and
brought all creative endeavor to a halt. It was the war,
rather than the National Socialist revolution, that—for a
time—undermined the Werkbund ideal of quality work
and rendered it impotent.

The National Socialist regime did not bring down the
final curtain on the Werkbund drama. As soon as the war
was over, survivors of the Weimar association began to
form new groups to carry on its work.[120] In 1947, a num-

[120] The first such group seems to have been established in Dresden,
in the Eastern zone, Aug. 1945, by Hans König, Will Grohmann,
and Stephan Hirzl, but it was soon forced to disband by the Rus-
sians. Cf. Naumann, ed., *Bauhaus and Bauhaus People*, p. 118.
König subsequently moved to the West and served as honorary chair-
man of the Werkbund in Württemberg-Baden, 1947-1964. In Sept.
1945, a group was established in Düsseldorf, which for some years
served as federal Werkbund headquarters.

ber of these local societies came together in West Germany to refound the *Deutsche Werkbund*, this time on a federal basis reflecting the decentralized political structure of postwar Germany.[121] With headquarters in Darmstadt, the Werkbund today is supported by grants from that city, from several *Länder* governments, and from the Federal Ministry of the Interior. It publishes its own journal, *Werk und Zeit*, and continues to uphold the cause of quality design. In recent years, it has broadened its traditional concerns by drawing attention to such major contemporary problems as environmental pollution and the need for comprehensive urban and regional planning. Under pressure from a "radical" faction, it has also begun to alter its methods, laying greater stress on careful research and on political action.[122]

The Werkbund has failed to achieve a position in postwar Germany comparable to that which it enjoyed under the Second Reich or the Weimar Republic, in large part because an increasing number of competitors have taken up aspects of its program. Moreover, as the older generation dies off, the personal ties that held the prewar association together and provided the impetus for its resurrection after 1945, will be broken. Only a conscious effort will enable the Werkbund to maintain the continuity of tradition that has made it unique. It is therefore significant that all elements in today's Werkbund, no matter how much their policy recommendations may differ, seek confirmation for their stand by appealing to the association's past, and consequently support the work of the *Werkbund-Archiv*, established to document its heritage.

Whether or not the Werkbund will succeed in maintaining its unity, developing an effective program adapted to contemporary needs, and attracting continued govern-

[121] Eckstein, "Idee," p. 17; Fischer, *Deutsche Werkbund*, p. 20.

[122] Cf. Arianna Giachi, "Die falsche Liebe zum Objekt," *Frankfurter Allgemeine Zeitung*, Feb. 22, 1974, p. 28; and a rebuttal by the Werkbund's president, Julius Posener, "Wie politisch darf der Deutsche Werkbund sein?" *Frankfurter Allgemeine Zeitung*, Sept. 4, 1974, p. 21.

ment support, are still open questions. But there is no doubt about the significance of its achievements to date. Much that we take for granted in art education, architecture and interior decoration, industrial design, and exhibition technique evolved under its aegis. Controversial elements in its early program have become the platitudes of today, and many industrial countries now have organizations modeled on the Werkbund and similarly dedicated to the propagation of quality design. As the German Werkbund faces the challenges of the present day, its members may take pride in the pioneer work accomplished by its illustrious predecessor and feel confident that many will continue to work in its spirit, in order to meet the design needs of contemporary man.

CONCLUSION

LOOKING back over the history of the Werkbund between 1907 and 1934, one is struck by the tenacity with which it pursued the artistic, cultural, and social aims outlined by its founders. Undaunted by war, revolution, and economic upheaval, its members sought ideological and organizational solutions to a wide range of questions on the borderline between culture and politics, questions significant not only for Germany but also for other societies in the throes of modernization.

On the whole, the Werkbund was perhaps more successful in pinpointing the crucial issues than in finding satisfactory answers; and it is important to recognize that its difficulties, although aggravated by external developments, stemmed in large part from ambiguities in its original program. A prime example is the association's aim of bringing art and industry into closer contact. This involved redefinition of the role of the artist in capitalist society, but in the process it soon became apparent that the Werkbund's desire to espouse the cause of economic progress ran counter to the antimaterialistic ethos of many members, who clung to the values associated with the elite culture of the preindustrial age. Werkbund members also had mixed feelings about modern technology, some affirming the formative power of the machine while others believed that only the human hand, guided by the creative spirit of the artist, could shape objects capable of giving joy to both maker and user. The Werkbund never resolved these contradictions, but instead shifted its emphasis from traditionalism to modernism and back in response to changing circumstances. In general, during times of prosperity and progress, it favored the mass production of

functionally designed standard goods, utilizing machine technology; whereas in periods of crisis, it reverted to concern with the unique and individual, and thus to a position closer to that of the Arts and Crafts movement out of which it had grown.[1] This uncertainty of aim hampered the association as it tried to convert German industry to the ideal of aesthetic quality, and, at the same time, to disabuse the artists of their aversion to the profit-oriented capitalist system.

A second difficulty arose when the Werkbund attempted to reconcile nationalism with the desire to be modern. Even before 1914, the longing for a "German style" came into conflict with the perception that a style adapted to the needs of contemporary man would know no national barriers. Here, too, the Werkbund never found a solution acceptable to all its members. During the few good years of the Weimar Republic, its progressive leadership generated support for the notion that Germany's avant-garde architects would enhance the international prestige of their country by originating a style suited to the requirements of modern industrial society. But this sophisticated amalgam of patriotism and internationalism failed to attract many of the Werkbund's own leading spirits, who either refused to recognize internationalism as an ingredient of the modern style, or allowed nationalistic sentiment to override their progressive inclinations. The conflict came to a head in 1930, on the occasion of the Paris exhibition of the decorative arts. Thereafter, the Werkbund majority increasingly came under the influence of men who advocated a "national" style, rooted in German tradition and uncontaminated by foreign influence. Likewise, the attempt of the Weimar Werkbund to promote a national culture that would both reflect and buttress the new-found unity of the democratic Republic, was undermined by defenders of regional diversity determined to reassert the values of local tradition against the "alien" ideals of Berlin. Efforts, in the name of modernity, to encourage an

[1] See Posener, "Der Deutsche Werkbund," p. 3.

artistic revolution from the center and from above, simply served to strengthen the alliance between particularism and cultural reaction that seriously impaired Werkbund effectiveness, even before the National Socialists came to power.[2]

A third issue on which the Werkbund failed to evolve a consistent position was the role of the creative minority in a democratic society. The vision of a mass polity organized on modern lines appealed strongly to Friedrich Naumann and other influential members of the early Werkbund, but when political democracy became a fact of German life in the first years after 1918, enthusiasm for it waned. Werkbund artists, in particular, continued to regard themselves as members of an elite whose main purpose was to shape the thinking while remolding the environment of the dominant classes in a hierarchically ordered society. The Werkbund did, of course, attempt to influence popular culture through the reform of education and by means of its extensive exhibition and publishing program. But for the most part, it relied on the power of example, insisting that forms acceptable at first only to the enlightened few would eventually diffuse to broader sections of society. This essentially elitist outlook led the Werkbund to neglect the rural and small-town population of Germany almost entirely, and discouraged sustained efforts to coordinate its activities with those of working-class cultural associations. Eventually, the Werkbund even chose to repudiate the support of the organized *Mittelstand*, when it became clear that the artisans and shopkeepers of the nation were not prepared to defer respectfully any longer to the cultural guidance of the artist-intellectuals who dominated Werkbund councils in the last years of the Republic.

[2] Not all advocates of decentralization were cultural reactionaries. An interesting case is Fritz Schumacher of Hamburg, who favored the use of traditional building materials, particularly the local brick, but combined this with a thoroughly modern (if not extreme) functionalism. Indeed, most Werkbund advocates of a unified national style were quite willing to permit a degree of regional diversity. Likewise, Werkbund "internationalists" were prepared to concede the value of national variations on the theme of the "modern style."

While the belief that art and culture are always the product of the exceptional few contributed to the failure of the Werkbund to reach a broad public, its tendency, in the late 1920's, to concentrate on stylistic innovation rather than overall design quality made it seem irrelevant as well to the mass of German producers. The majority of practicing architects, decorators, and designers, closely tied to the demands of the marketplace, felt increasingly alienated from the Werkbund avant-garde with its insistence on originality and excellence. By the time the pendulum within the Werkbund began to swing back to concern with quality in the more traditional sense, Germany was in the grip of the Depression, and the association found itself too weak and disunited to formulate a more popular program.

Of all the tensions built into the original Werkbund program, the most fateful involved the relationship between art and politics. Before 1914, the Werkbund's members believed that their combined efforts as private individuals would suffice to reform the spirit and quality of German work. Although dissatisfied with many aspects of contemporary life, they tended to remain determinedly apolitical.[3] Even the admirers of Friedrich Naumann, who recognized the need for social change as a prerequisite for cultural renewal, generally believed that they could attain their ends without becoming personally involved in party politics. Political action seemed an inferior pursuit, an unnecessary distraction from more important cultural tasks, something that might safely be left to others. At the same time, however, the Werkbund contained a faction eager to use the power of the state to realize the goals of the association. Muthesius and Jessen, as we have seen, worked

[3] On the "unpolitical German," see especially Fritz Stern, "The Political Consequences of the Unpolitical German," *History*, No. 3 (1960), pp. 104-34. In an essay of 1908 on "The Aesthete and Politics," Friedrich Naumann had analyzed this phenomenon and tried to persuade the artist-intellectuals to take politics seriously. One of his arguments was that politics was itself an art. However, he entirely failed to overcome their traditional indifference or even aversion to this facet of human endeavor, which exerted such a fascination on Naumann himself. Cf. Naumann, *Werke*, VI, 543-51.

within the system to effect reforms in the schools and mu-
seums of the nation, while Jäckh forged links between the
Werkbund and the Foreign Office, and secured massive
public subsidies for the 1914 Cologne exhibition. Finally,
during the war, the Werkbund put itself unreservedly at
the disposal of the Imperial authorities and willingly sub-
ordinated its cultural efforts to "political" purposes.

The revolution of 1918 forced the Werkbund to recon-
sider the relationship between culture and politics. For a
brief period, many Werkbund intellectuals and artists en-
tered into alliance with political parties of the socialist and
democratic Left, in order to implement their vision of a
new society. But by the early 1920's, when it became evi-
dent that the major parties could not be persuaded to adopt
their ideals, these men for the most part resumed their
apolitical stance. The association continued to act as a
pressure group and to draw heavily on the resources of
the Reich, but it abandoned attempts to win popular ap-
proval. Faced with a socialist movement largely unrespon-
sive to its cultural goals and a democratic center in de-
cline, the Werkbund turned its back both on party politics
and on the parliamentary process itself. Particularly after
1930, it tended to espouse the authoritarian idea of collab-
oration between independent cultural "experts" and en-
lightened civil servants, repudiating the democratic-revo-
lutionary model of a symbiosis between artist and *Volk*.

Unfortunately, it adopted this course just at a time when
the notion of the state as embodied in its administrative
elite was coming under attack from political associations
of both Left and Right that claimed to speak for "the peo-
ple." The Communist Party and, even more, the National
Socialist movement, exploited the economic crisis of the
early 1930's to undermine the little that remained of the
Weimar system, in the process threatening all individuals
and groups that had flourished under the aegis of the Re-
public. The Werkbund responded to the challenge of these
mass movements by insisting, with increasing desperation,
on the political neutrality of art. When the political threat

to their cultural values could no longer be denied, a brave handful tried to rally for a counterattack, but by then it proved too late to stem the tide of cultural reaction or to shore up the faltering democracy. Failing to spring to the Republic's defense in time, the Werkbund majority acquiesced in the destruction of the political order whose guarantee of intellectual and artistic freedom had made possible the brief flowering of "Weimar culture."

When Hitler came to power, the Werkbund once again sought to make a pact with the authorities. Its leaders, by consenting to the *Gleichschaltung*, demonstrated their willingness to participate in a system in which the state openly proclaimed its determination to dominate society and culture. Even after the destruction of the Werkbund by the National Socialists, many former members cooperated with Nazi artistic and cultural programs that seemed to incorporate Werkbund ideals, and welcomed any evidence that the National Socialist regime was prepared to use its power to further Werkbund aims and to serve the national interest. While there seem to have been relatively few who actually joined the Nazi party, a number were prepared to accept the Third Reich as the legitimate successor to the Second, and to acknowledge Hitler as a more fitting heir of William II than the democratic republic that had ended the Imperial reign.[4] Those who could not accept the primacy of politics inherent in totalitarian rule either left the country or withdrew from public life, but most Werkbund members, like the majority of their fellow countrymen, continued to exercise their talents and pursue their careers to the best of their ability. Denying to themselves and others that by so doing they were, in a sense, committing a political act, they strove with varying degrees of success to maintain a sphere of artistic and personal autonomy within the framework of the total state.

Although the tensions and difficulties I have described

[4] Teut, *Architektur*, p. 14, discusses the extent to which Hitler's artistic tastes and ambitions reflected those of the late Kaiser.

can be shown to derive in part from the particular nature and purposes of the Werkbund, they reflected the state of mind of German artists and intellectuals in general, as they sought to come to terms with the problems of a modernizing society. What is perhaps distinctive about the Werkbund is that its members did not allow their intellectual, ethical, or political perplexities to keep them from their work. Despite the lack of an agreed program based on a consistent ideology, the Werkbund contributed significantly to the national culture through three tumultuous decades, and managed to leave its mark on the face of 20th century Germany.

APPENDICES

APPENDIX I. The Werkbund Leadership

	President	First Vice-President	Second Vice-President
1908	Theodor Fischer	—	—
1909	Peter Bruckmann	Theodor Fischer	—
1912	" "	Hermann Muthesius	—
1916	" "	Hans Poelzig	—
1919	Hans Poelzig	—	—
1921	Richard Riemerschmid	Peter Bruckmann	—
1926	Peter Bruckmann	L. Mies van der Rohe	—
1930	" "	" " " " "	Ernst Jäckh
1931 (Oct.)	" "	" " " " "	Erich Raemisch
1932 (Nov.)	Ernst Jäckh	Hans Poelzig	—
1933 (Jun.)	Carl Ch. Lörcher	Winfried Wendland	—

Executive Secretary

1907-1910	Wolf Dohrn
1910-1911	Alfons Paquet
1912-1922	Ernst Jäckh
1922-1934	Otto Baur

APPENDIX II. Annual Meetings, 1908-1934

1908	Munich	1922	Augsburg and Munich
1909	Frankfurt	1923	Weimar
1910	Berlin	1924	Karlsruhe
1911	Dresden	1925	Bremen
1912	Vienna	1926	Essen
1913	Leipzig	1927	Mannheim and Stuttgart
1914	Cologne	1928	Munich
1915	—	1929	Breslau
1916	Bamberg	1930	Vienna
1917	—	1931	Berlin
1918	—	1932	Berlin
1919	Stuttgart	1933	Würzburg
1920	—	1934	Königsberg
1921	Munich		

APPENDIX III. Principal Werkbund Publishers

1908-1914	Eugen Diederichs, Jena
1915-1919	F. Bruckmann A.-G., Munich
1920-1932	Hermann Reckendorf, Berlin

Appendix IV. Membership

Year	Members	Year	Members
1908	492	1913	1,440
1909	731	1914	1,870
1910	843	1916	1,955
1911	922	1925	circa 2,200
1912	971	1929	circa 3,000

BIBLIOGRAPHY

BECAUSE of the wide range of materials used in preparing this history of the Werkbund, I have listed the primary sources under several headings. The reader desiring greater detail, especially regarding the sources of scarce documents, should refer to my "The German Werkbund," Ph.D. Dissertation, Queen's University, Kingston, Ontario (obtainable on microfiche from the National Library of Canada at Ottawa). Secondary works listed are those cited in the text or particularly helpful for an understanding of the period.

I. ARCHIVAL SOURCES

Bauhaus-Archiv. 1 Berlin 19, Schlossstrasse 1. [Cited as *Bauhaus*]. Contains the papers of *Walter Gropius,* founder of the Bauhaus, associated with the Werkbund from 1910. The

following files proved useful: GS 1, 2, 3, 4, 6, 10, 11, 15, 19, 21, 22; GN 1, 2, 3, 4, 5, 10, 13, 18, 22, 28, 29, 36. They yielded correspondence, newspaper clippings on Werkbund exhibitions, and internal Werkbund communications.
Bayerische Akademie der Schönen Künste. 8 Munich 22, Max-Joseph-Platz 3, Residenz. [Cited as *BASK*]. The Academy holds the papers of *Walter Riezler*, founder-member of the Werkbund and editor, from 1927 to 1932, of the Werkbund journal *Die Form.* Files DWB II and DWB III contain relevant documents and correspondence. DWB III includes materials related to changes in the Werkbund executive committee 1931-1932, and to Riezler's resignation from *Die Form,* as well as correspondence between Riezler and Winfried Wendland, Nazi deputy leader of the Werkbund, for the period November 1933 to February 1934.
Berlin Document Center. 1 Berlin 37, Wasserkaefersteig 1. [Cited as *BDC*]. Contains the personnel files of the Berlin branch of the *Reichskammer der bildenden Künste (RdbK)* to which many Werkbund members belonged after 1933. The files are arranged alphabetically under the names of individual members.
Bundesarchiv, Koblenz. [Cited as *BA*].
1. *Theodor Heuss* papers, 12/1
Especially useful were the files "Deutscher Werkbund Allgemeine Notizen 1919-1947," "Zeitungsartikel," and "Korrespondenz."
2. *Reichskunstwart*, Rep. 301
The official papers and correspondence of *Edwin Redslob,* 1920-1933. Relevant material is contained in Rep. 301/18, "Deutsche Gewerbeschau München 1922"; Rep. 301/110, "Deutscher Werkbund 1919-März 1923"; Rep. 301/111, "Deutscher Werkbund April 1923-1927"; and Rep. 301/443, "Deutsche Volkskunstausstellung Dresden 1929."
3. *Reichsministerium für Volksaufklärung und Propaganda,* R55
File R55 deals with awards and honors, and includes correspondence relating to possible honors for two prominent Werkbund members, Theodor Fischer and Richard Riemerschmid.
4. *Kanzlei Rosenberg*, NS 8
NS 8/109 consists of a report from Paul Schmitthenner to

leaders of the *Kampfbund für deutsche Kultur*, March 19, 1934. NS 8/126, fol. 1, Bd. 4 K 1930-1935 is a memorandum from J. Knubel of Düsseldorf to H. Hinkel at the Prussian Ministry of Culture, April 27, 1933, entitled "Deutscher Werkbund-Vorschläge zu einer Neuorganisation 1933."

Germanisches Nationalmuseum, Nürnberg. [Cited as *GerN*]. Contains the papers of *Richard Riemerschmid*, active in the German Werkbund and long head of its Bavarian branch, the *Münchner Bund*. When I consulted them, these papers were still being arranged and catalogued. Particularly useful were the files "Münchner Bund bis zur Auflösung 1934, Korrespondenz 1906-1934"; and "Zeitungsausschnitte Münchner Bund-Deutscher Werkbund 1914-34."

Karl-Ernst-Osthaus-Archiv, Hagen, Hochstrasse 73. [Cited as *KEO*]. An invaluable source for the study of the Werkbund before 1920, which I was unfortunately not able to visit personally. However, I was able to obtain copies of letters and Werkbund documents from the following files: A1846/17, DWB212, DWB270a, Kü 339, Kü 344, Kü 385.

Library of Congress, Washington, D.C. [Cited as *LC*]. The Manuscript Division holds the personal papers of *Ludwig Mies van der Rohe*, influential in the Weimar Werkbund. Containers 3 and 4 of the "Early Correspondence 1921-1940" are devoted to the Werkbund between 1924 and 1934.

Royal Institute of British Architects, Portland Place, London. [Cited as *RIBA*]. The Institute houses the archive of the British Design and Industries Association and the related H. H. Peach Correspondence. The following proved useful: DIA 122, 123, 128, 133; DIAP 1, 10, 16, 17, 21, 25-32, 35, 36, 39.

Werkbund-Archiv, Berlin. 1 Berlin 19, Schlosstrasse 1. [Cited as *WB*]. This growing archive has recently moved to the same premises as the Bauhaus-Archiv. It contains Werkbund publications and unpublished materials relating to the Werkbund movement, broadly defined. Included are some personal papers of *Hans Poelzig*, president of the Werkbund 1919-1920 and vice-president 1916-1919 and 1932-1933. The archive began to publish its own yearbook in 1972.

Werkbund-Archiv, Düsseldorf. [Cited as *WD*]. Assembled by the Deutscher Werkbund West-Nord, which gave me access to the comprehensive collection of Werkbund publications and

newspaper cuttings. The material in this archive was about to be transferred to the Berlin Werkbund-Archiv.

Deutscher Werkbund Bayern e. V. 8 Munich 23, Martiusstrasse 8. Although I obtained access to the *F. H. Ehmcke* papers at this address, I was unable to secure copies. Sebastian Müller made extensive use of this material in his study of the pre-1914 Werkbund, and the interested reader is referred to Müller's *Kunst und Industrie* (Munich, 1974).

II. INTERVIEWS AND PERSONAL COMMUNICATIONS

Hartmann, G. B. von. Berlin. Letter to the author dated April 2, 1974. In this and subsequent correspondence, Herr Dr. von Hartmann, executive secretary of the Deutscher Werkbund from 1964-1971, provided information regarding the fate of the Werkbund under National Socialism.

Mumford, Lewis. Amenia, New York. Letter to the author dated May 22, 1971. Professor Mumford was a close friend of W. C. Behrendt, editor of the Werkbund journal *Die Form* 1925-1926, and contributed to that publication during the 1920's. Among his Werkbund acquaintances in Germany was Fritz Schumacher, the city architect of Hamburg, who served as the model for "Dr. Hermann K." in Mumford's *Values for Survival* (New York, 1946).

Redslob, Edwin. Berlin. (Deceased, Jan. 1973). In a letter of Dec. 9, 1971 and a long interview on Dec. 8, 1972, Dr. Redslob commented on the many Werkbund personalities who had been his friends, and reminisced about his years as *Reichskunstwart*. His official papers are in the *Bundesarchiv*, Koblenz.

Seeger, Mia. Stuttgart. Letter of March 2, 1973 and interviews of April 25 and 28, 1973. Frau Seeger was associated with the Werkbund from 1924 to 1932, as secretary and exhibitions organizer. In the latter capacity, she helped prepare the Stuttgart Werkbund exhibitions of 1924 and 1927, and the Paris exhibition of 1930, among others. These assignments brought her into close contact with Gustav Stotz, Ludwig Mies van der Rohe, Walter Riezler, Walter Gropius, and many more Werkbund personalities. Her move from Stuttgart to the Werkbund head office in Berlin in 1928 brought her to the center of Werkbund affairs during a most lively period in the association's history.

Speer, Albert. Heidelberg. Letter of Oct. 26, 1971. Dr. Speer answered a number of questions relating to his associations with the Werkbund and the work of the National Socialist "Amt Schönheit der Arbeit," which he headed during the 1930's.

Wagenfeld, Wilhelm. Stuttgart. Interview of April 27, 1973. Professor Wagenfeld, associated with the Bauhaus in the 1920's and with the Werkbund in the early 1930's, is one of Germany's leading industrial designers. In addition to answering questions, he kindly gave me copies of a number of documents in his possession, among them a Werkbund propaganda pamphlet of 1933; the transcript of a speech by Martin Wagner to the executive committee of the Werkbund, June 10, 1933, opposing a motion to transform the Werkbund into a National Socialist organization; and correspondence of April and May 1933 between himself and the Werkbund head office.

III. Werkbund Publications 1907-1935

A. Internal Communications

1. Minutes and Reports of executive committee (*Vorstand*) meetings June 30, July 30, Oct. 18, 1919; April 23, July 19, Oct. 29, 1921; Jan. 21, Nov. 6, 1922; July 23, 1923; July 26, 1924; March 30, 1925; June 23, 1926; Oct. 24, 1931; June 28, 1932; July 3, 1933.

2. Minutes and Reports of joint meetings of the executive committee and board of directors (*Ausschuss*)
Oct. 25, 1920; May 11, 1921; Sept. 13, 1923; July 24, Oct. 27, 1924; June 20, Nov. 29, 1925; June 23, Oct. 16, 1926; July 5, 1928; Oct. 14, 1929; June 23, 1930; Oct. 14, 1932; June 10, Sept. 29, 1933.

3. Minutes of meetings of the head office staff (*Geschäftsführung*)
Nov. 30, 1920; April 12, 19 and 28, 1921.

4. Membership Lists (printed)
1907, 1908, 1910, 1912, 1913, 1925, 1928.

5. Constitutions (*Satzungen*)
1908, 1912, 1928, 1933.

6. Financial Reports
1917/18; 1918/19; 1924/25; 1929/30.

7. Newsletters (unpublished)

Werkbund-Korrespondenz Nr. 7, March 13, 1933.

Werkbund-Korrespondenz Nr. 17, Aug. 14, 1933.

"Rundschreiben des Führers des Deutschen Werkbundes Architekt BDA Dipl.-Ing. C. Ch. Lörcher an die Mitglieder des Werkbundes, insbesondere diejenigen, die Architekten sind," circa July 1933.

B. Periodicals and Serials

1. Published Newsletters

Mitteilungen des Deutschen Werkbundes. 1915-March 1920. Bimonthly. Berlin: Deutscher Werkbund.

Das Werk. Mitteilungen des Deutschen Werkbundes. April 1920-March 1921. Monthly. Berlin: Hermann Reckendorf.

Mitteilungen des Deutschen Werkbundes. June 1921.

"Mitteilungen des Deutschen Werkbundes," in *Die Form*, 1, Nos. 1-5. Jan. to Oct. 1922. Bimonthly.

Werkbund-Gedanken. Beiblatt zum *Stuttgarter Neues Tagblatt.* April 1924-Sept. 1925. Monthly.

"Mitteilungen des Deutschen Werkbundes," in *Die Form*, 1 (1925)-IX (1934). Monthly, except between 1929 and Sept. 1930 when *Die Form* appeared fortnightly.

2. *Gewerbliche Materialkunde.* Im Auftrage des Deutschen Werkbundes hrsg. von P. Krais, Stuttgart, I-II, 1910-1912.

I. *Die Hölzer*

II. *Die Schmuck-und Edelsteine* von Alfred Eppler

3. *Jahrbuch des Deutschen Werkbundes.* 6 vols. 1912-1920.

I. *Die Durchgeistigung der deutschen Arbeit.* Jena: Eugen Diederichs, 1912.

II. *Die Kunst in Industrie und Handel.* Jena: Eugen Diederichs, 1913.

III. *Der Verkehr.* Jena: Eugen Diederichs, 1914.

IV. *Deutsche Form im Kriegsjahr. Köln 1914.* Munich: F. Bruckmann, 1915.

V. *Kriegergräber im Felde und daheim.* Hrsg. im Einvernehmen mit der Heeresverwaltung. Munich: F. Bruckmann, 1917.

VI. *Handwerkliche Kunst in alter und neuer Zeit.* Berlin: Hermann Reckendorf, 1920.

4. *Die Form.* Monatsschrift für gestaltende Arbeit. 1922, 1, Nos. 1-5. Munich: Hermann Reckendorf.

5. *Die Form.* Zeitschrift für gestaltende Arbeit. Berlin, 1 (1925-26)-x, No. 7 (1935).

6. *Bücher der Form.* 6 vols. 1924-1928.

 I. Wolfgang Pfleiderer, ed. *Die Form ohne Ornament: Werkbundausstellung 1924.* Stuttgart: Deutsche Verlags-Anstalt, 1924.

 II. *Deutsche Wiederaufbauarbeit: Der Wiederaufbau in Stadt und Kreis Goldap durch Architekt Fritz Stopohl.* Stuttgart: Deutsche Verlags-Anstalt, 1925.

 III. *Gold und Silber.* Deutsche Goldschmiedearbeiten der Gegenwart. Hergestellt und mit einer Einleitung versehen von Wilhelm Lotz. Berlin: Hermann Reckendorf, 1926.

 IV. Walter Riezler, ed. *Das deutsche Kunstgewerbe im Jahr der grossen Pariser Ausstellung.* Bilder von der deutschen Abteilung der Internationalen Kunstgewerbe-Ausstellung in Monza, 1925. Berlin: Hermann Reckendorf, 1926.

 V. Ernst Kropp. *Wandlung der Form im XX. Jahrhundert.* Berlin: Hermann Reckendorf, 1926.

 VI. *Licht und Beleuchtung.* Lichttechnische Fragen unter Berücksichtigung der Bedürfnisse der Architektur. Hrsg. von Wilhelm Lotz unter Mitwirkung von E. R. Haberfeld, G. Laue, Ernst May, Walter Riezler, H. K. Rose. Berlin: Hermann Reckendorf, 1928.

C. Other Books and Pamphlets Published, Sponsored, or Commissioned by the Werkbund (see also Exhibition Catalogues, Section IV, below)

Borst, Hugo und Willy Hellpach. *Das Problem der Industriearbeit.* Zwei Vorträge gehalten auf der Sommertagung 1924 des Deutschen Werkbundes. Berlin: Julius Springer, 1924.

Deutscher Werkbund. *Leitsätze ausgearbeitet von dem Geschäftsführenden Ausschuss auf Grund der Gründungsversammlung des Bundes zu München am 5. und 6. Oktober 1907.* n.p., n.d.

————. *Erste Jahresversammlung.* Programm. n.p., 1908.

————. *Die Veredelung der gewerblichen Arbeit im Zusammenwirken von Kunst, Industrie und Handwerk.* Verhand-

lung des Deutschen Werkbundes zu München am 11. und 12. Juli 1908. Leipzig: R. Voigtländer, 1908.

Deutscher Werkbund. *1. Jahresbericht des Deutschen Werkbundes 1908/09.* n.p., n.d.

————. *Verhandlungsbericht der II. Jahresversammlung zu Frankfurt a. Main . . . vom 30 September bis 2. Oktober 1909.* n.p., n.d.

————. *2. Jahresbericht des Deutschen Werkbundes 1909/10.* n.p., n.d.

————. *Die Durchgeistigung der deutschen Arbeit.* Bericht über die 3. Jahresversammlung des DWB vom 10-12. Juni 1910. Jena: Eugen Diederichs, 1911.

————. *3. Jahresbericht des Deutschen Werkbundes 1910/11,* n.p., n.d.

————. *4. Jahresbericht des Deutschen Werkbundes 1911/12,* n.p., n.d.

————. *Zur fünften Tagung des Deutschen Werkbundes.* Wien, 6-9. Juni 1912. Vienna: Graphische Kunstanstalt Brüder Rosenbaum, n.d.

————. *Flugschriften über Echtfärberei, II.* and *Mustersammlung.* Hellerau, n.p., 1912.

————. *Hermann Muthesius: Die Werkbundarbeit der Zukunft und Aussprache darüber . . . Friedrich Naumann: Werkbund und Weltwirtschaft. Der Werkbundgedanke in den germanischen Ländern. . . .* 7. Jahresversammlung des Deutschen Werkbundes vom 2. bis 6. Juli 1914 in Köln. Jena: Eugen Diederichs, 1914.

————. *Kriegs-Wahrzeichen zum Benageln.* 69 Entwürfe aus einem Preiswettbewerb des Deutschen Werkbundes. Munich: F. Bruckmann, 1915.

————. *Englands Kunstindustrie und der Deutsche Werkbund.* Übersetzungen von Begründungs-und Werbeschriften der englischen Gesellschaft "Design and Industries Association." Munich: F. Bruckmann 1916.

————. *Das Haus der Freundschaft in Konstantinopel.* Ein Wettbewerb deutscher Architekten. Munich: F. Bruckmann, 1918.

————. *Deutscher Hausrat.* Eine Sammlung von zweckmässigen Entwürfen für die Einrichtung von Kleinwohnungen. Dresden: Oskar Laube, 1919.

————. *Erster deutscher Farbentag, auf der 9. Jahresversammlung des Deutschen Werkbundes in Stuttgart am 9. Sep-*

tember 1919. Berlin: Selbstverlag des Deutschen Werkbundes, n.d.

————. *Der Deutsche Werkbund, Ziele und Arbeit.* Munich: Universitätsdruckerei Wolf, [1922]. Apparently written by Theodor Heuss, although his name does not appear on it.

————. *Der Deutsche Werkbund.* Berlin, n.p., n.d. From internal evidence, this brochure written by Richard Riemerschmid can be dated 1927.

————. *Werkbundarbeit.* Rückblick auf die Entwicklung des Deutschen Werkbundes von Dr. Wilhelm Lotz. Berlin: Hermann Reckendorf, [1928].

————. *Reden der Münchener Tagung 1928 am 6. Juli 1928.* Werkbundfragen. Flugschriften der "Form" Nr. 1. Berlin: Hermann Reckendorf, 1928.

————. *Der Deutsche Werkbund. Was er will-seine Geschichte und Leistung-seine Aufgaben von heute und morgen.* Berlin: n.p., [spring 1933].

Dürerbund-Werkbund Genossenschaft. *Deutsches Warenbuch.* Kriegsausgabe. Text von Dr. Jos. Popp, München. Dresden-Hellerau: Im Selbstverlag, [1916].

Ehmcke, F. H. *Amtliche Graphik.* Flugschriften des Münchner Bund unter Mitwirkung des Deutschen Werkbundes. Munich: H. Bruckmann, 1918.

Hartlaub, Gustav Friedrich, ed. *Das ewige Handwerk im Kunstgewerbe der Gegenwart.* Werkbund-Buch. Berlin: Hermann Reckendorf, 1931.

Hilberseimer, Ludwig. *Internationale Neue Baukunst.* Im Auftrag des Deutschen Werkbundes. Die Baubücher, Bd. 2. Stuttgart: Julius Hoffmann, 1927.

Lindner, Werner, and Georg Steinmetz. *Die Ingenieurbauten in ihrer guten Gestaltung.* Deutscher Bund Heimatschutz und Deutscher Werkbund in Gemeinschaft mit dem Verein deutscher Ingenieure und der Deutschen Gesellschaft für Bauingenieurswesen. Berlin: E. Wasmuth, 1923.

Oelsen, Herbert, Freiherr von. *Tausend Jahre deutscher Plastik und Malerei.* Von Herbert, Freiherrn von Oelsen, Beauftragter des Deutschen Werkbundes. Berlin and Leipzig: Walter de Gruyter, 1934.

Riemerschmid, Richard. *Künstlerische Erziehungsfragen,* I. Flugschriften des Münchener Bundes, Erstes Heft. Munich: Georg Müller, 1917.

————. *Künstlerische Erziehungsfragen,* II. Flugschriften des

Münchener Bundes, Fünftes Heft. Munich: Hugo Bruck-
mann, 1919.

Scheffler, Karl. *Sittliche Diktatur, ein Aufruf an alle Deutschen.*
Herausgegeben vom Deutschen Werkbunde. Stuttgart and
Berlin: Deutsche Verlags-Anstalt, 1920.

Stahl, Fritz [Siegfried Lilienthal]. *Deutsche Form. Die Eigen-
werdung der deutschen Modeindustrie, eine nationale und
wirtschaftliche Notwendigkeit.* Flugschrift des Deutschen
Werkbundes. Berlin: E. Wasmuth, 1915.

Württembergische Arbeitsgemeinschaft des Deutschen Werk-
bunds. *10 Jahre Werkbundarbeit in Württemberg.* Stuttgart:
Tagblatt-Buckdruckerei, 1930.

IV. Exhibition Catalogues and Published Accounts of Exhibitions

Note. This section includes descriptive volumes published in
conjunction with or shortly after the exhibition. Arranged
chronologically, it includes Werkbund exhibitions and those
in which the Werkbund played an important role, either as an
association or through the participation of its members. See
also Section III. B, above.

Dresden 1906. *Das Deutsche Kunstgewerbe 1906.* III. Deutsche
Kunstgewerbe-Ausstellung Dresden, 1906. Hrsg. vom Direk-
torium der Ausstellung. Munich: F. Bruckmann, 1906.

Brussels 1910. *Deutschlands Raumkunst und Kunstgewerbe auf
der Weltausstellung zu Brussel 1910.* Vom Reichskommissar
autorisierte Ausgabe, hrsg. Robert Breuer. Stuttgart: Julius
Hoffmann, n.d.

Cologne 1914. *Deutsche Werkbund Ausstellung Cöln 1914.*
Offizieller Katalog. Cologne: Rudolf Mosse, 1914.

———. "Werkbundnummer hrsg. in Gemeinschaft mit der
Deutschen Werkbundausstellung Cöln 1914," *Illustrierte Zei-
tung,* Leipzig, CXLII, No. 3699, 1914. Includes contributions
by H. Muthesius, E. Jäckh, P. Bruckmann, H. van de Velde,
F. Naumann.

———. *Deutsche Werkkunst: Arbeiten deutscher und oester-
reichischer Künstler auf der 'Werkbund-Ausstellung' Cöln
am Rhein.* Hrsg. Alexander Koch. Darmstadt: Alexander
Koch, 1916.

London 1915. Great Britain, Board of Trade. *Exhibition of*

German and Austrian Articles Typifying Successful Design.
London: Board of Trade, 1915.

Munich 1922. *Das Neue Kunsthandwerk in Deutschland und
Oesterreich, unter Berücksichtigung der Deutschen Gewer-
beschau München 1922.* Von Alexander Koch. Darmstadt:
Alexander Koch, 1923.

Newark 1922. *The Applied Arts.* Newark, N.J.: Newark Mu-
seum Association, 1922.

Mannheim 1925-26. *Die Form. Ausstellung des deutschen
Werkbundes 30.XI.1925–3.I.1926.* Katalog. Mannheim: Kunst-
halle, 1925.

——. *Typen neuer Baukunst. Ausstellung 25. Oktober 1925-
3. Januar 1926.* Katalog. Mannheim: Kunsthalle, 1925.

Stuttgart 1927. Deutscher Werkbund. *Bau und Wohnung. Die
Bauten der Weissenhofsiedlung in Stuttgart errichtet 1927
nach Vorschlägen des Deutschen Werkbundes im Auftrag
der Stadt Stuttgart und im Rahmen der Werkbundausstel-
lung 'Die Wohnung'.* Stuttgart: Akad. Verlag. Dr. F. Wede-
kind, 1927.

——. *Innenräume: Räume und Inneneinrichtungsgegen-
stände aus der Werkbundausstellung 'Die Wohnung,' insbe-
sondere aus den Bauten der städtischen Weissenhofsiedlung
in Stuttgart.* Herausgegeben im Auftrage des Deutschen
Werkbunds von Werner Gräff. Stuttgart: Akad. Verlag Dr.
F. Wedekind, 1928.

Leipzig 1927. *Europäisches Kunstgewerbe 1927.* Berichte über
die Ausstellung Europäisches Kunstgewerbe 1927 im Städ-
tischen Kunstgewerbe-Museum zu Leipzig. Leipzig: E. A.
Seemann, 1928.

Cologne 1928. *Internationale Presse-Ausstellung: Pressa-Kul-
turschau am Rhein.* Berlin: Max Schroder, 1928.

Cologne 1929. *Ausstellungen Köln 1929.* Amtlicher Katalog
herausgegeben von der Ausstellungsleitung. Berlin: Her-
mann Reckendorf, 1929.

Breslau 1929. Deutscher Werkbund. *Wohnung und Werkraum:
Werkbund-Ausstellung in Breslau 1929, 15. Juni bis 15.
September.* Amtlicher Katalog. Breslau: n.p., n.d.

Stuttgart 1929. Deutscher Werkbund. *Internationale Ausstel-
lung des Deutschen Werkbunds 'Film und Foto'.* Stuttgart,
1929.

Vienna 1932. Frank, Josef., ed. *Die Internationale Werkbund-*

siedlung Wien 1932. Neues Bauen in der Welt, Bd. VI. Vienna: Anton Schroll, 1932.

Stuttgart 1932. *Werkbund-Ausstellung Wohnbedarf.* Katalog. Stuttgart: n.p., n.d.

V. COLLECTIONS OF DOCUMENTS

Baynes, Norman H., ed. *The Speeches of Adolf Hitler, April 1922-August 1939,* Vol. I. London: Royal Institute of International Affairs-Oxford University Press, 1942.

Brenner, Hildegard, ed. *Ende einer bürgerlichen Kunst-Institution. Die politische Formierung der Preussischen Akademie der Künste ab 1933. Eine Dokumentation.* Schriftenreihe der Vierteljahrshefte für Zeitgeschichte, No. 24. Stuttgart: Deutsche Verlags-Anstalt, 1972.

Conrads, Ulrich, ed. *Programme und Manifeste zur Architektur des 20. Jahrhunderts.* Ullstein Bauwelt Fundamente 1. Berlin: Ullstein, 1964.

Eckstein, Hans, ed. *50 Jahre Deutscher Werkbund.* Im Auftrag des Deutschen Werkbundes herausgegeben von der Landesgruppe Hessen. Frankfurt am Main: Alfred Metzner, 1958.

Hesse-Frielinghaus, Herta, ed. *Peter Behrens und Karl Ernst Osthaus.* Eine Dokumentation nach den Beständen des Osthaus-Archivs. Hagen: Karl-Ernst-Osthaus Museum, 1966.

Lauterbach, Heinrich and Jürgen Joedicke, eds. *Hugo Häring: Schriften, Entwürfe, Bauten.* Dokumente der modernen Architektur. Beiträge zur Interpretation und Dokumentation der Baukunst, No. 4 Stuttgart: Karl Krämer, 1965.

Pfankuch, Peter, ed. *Adolf Rading: Bauten, Entwürfe und Erlauterungen.* Schriftenreihe der Akademie der Künste. Berlin: Gebr. Mann, 1970.

Posener, Julius. *Anfänge des Funktionalismus: Von Arts and Crafts zum Deutschen Werkbund.* Bauwelt Fundamente 11. Berlin: Ullstein, 1964.

————. *Hans Poelzig. Gesammelte Schriften und Werke.* Schriftenreihe der Akademie der Künste, Band 6. Berlin: Gebr. Mann, [1970].

Schmidt, Diether, ed. *Manifeste 1905-1933.* Schriften deutscher Künstler des zwanzigsten Jahrhunderts, Band 1. Dresden: VEB Verlag der Kunst, [1964].

Schwarz, Felix and Frank Gloor, eds., *'Die Form.' Stimme des Deutschen Werkbundes 1925-1934.* Bauwelt Fundamente 24.

Gütersloh: Bertelsmann Fachverlag, Reinhard Mohn, 1969.

60 Jahre. Ein Almanach. Düsseldorf: Eugen Diederichs-Verlag, 1956.

Teut, Anna. *Architektur im Dritten Reich 1933-1945.* Bauwelt Fundamente 19. Frankfurt: Ullstein, 1967.

Wulf, Josef, ed. *Die Bildenden Künste im Dritten Reich. Eine Dokumentation.* Gütersloh: Sigbert Mohn, 1963.

VI. AUTOBIOGRAPHIES BY WERKBUND MEMBERS AND THEIR CONTEMPORARIES

Bonatz, Paul. *Leben und Bauen.* Stuttgart: Engelhornverlag Adolf Spemann, 1950.

Diederichs, Eugen. *Aus meinem Leben.* Sonderausgabe. Leipzig: Meiner, 1938. (First published 1927).

Heuss, Theodor. *Erinnerungen 1905-1933.* Tübingen: Rainer Wunderlich Verlag-Hermann Leins, 1963.

Jäckh, Ernst. *Der Goldene Pflug: Lebensernte eines Weltbürgers.* Stuttgart: Deutsche Verlags-Anstalt, 1954.

———. *Weltsaat: Erlebtes und Erstrebtes.* Stuttgart: Deutsche Verlags-Anstalt, 1960.

Man, Hendrick de. *Gegen den Strom. Memoiren eines Europäischen Sozialisten.* Stuttgart: Deutsche Verlags-Anstalt, 1953.

Muche, Georg. *Blickpunkt: Sturm, Dada, Bauhaus, Gegenwart.* Munich: Albert Langen, Georg Müller, 1961.

Müller, Karl Alexander von. *Mars und Venus: Erinnerungen 1914-1919.* Stuttgart: G. Kilpper, 1954.

———. *Im Wandel einer Welt: Erinnerungen, Bd.3, 1919-1932.* Hrsg. von Otto Alexander v. Müller. Munich: Süddeutsche Verlag, 1966.

Neumann, Eckhard, ed. *Bauhaus and Bauhaus People: Personal Opinions and Recollections of Former Bauhaus Members and Their Contemporaries.* New York: Van Nostrand Reinhold, 1970.

Ostwald, Wilhelm. *Lebenslinien: eine Selbstbiographie.* Part III. Berlin: Klasing, 1927.

Pechstein, Max. *Erinnerungen.* Wiesbaden: Limes, 1960.

Raabe, Paul, ed. *Expressionismus: Aufzeichnungen und Erinnerungen der Zeitgenossen.* Olten u. Freiburg i. Breisgau: Walter, 1965.

Redslob, Edwin. *Gestalt und Zeit: Begegnungen eines Lebens.* Munich: Albert Langen, Georg Müller, 1966.

————. *Von Weimar nach Europa: Erinnerungen.* Berlin: Haude & Spener, 1972.

Scheffler, Karl. *Die fetten und die mageren Jahre.* Munich: P. List, 1948.

Schumacher, Fritz. *Stufen des Lebens: Erinnerungen eines Baumeisters.* Stuttgart: Deutsche Verlags-Anstalt, 1935.

————. *Selbstgespräche: Erinnerungen und Betrachtungen.* Hamburg: A. Springer, 1949.

Seewald, Richard. *Der Mann von Gegenüber: Spiegelbild eines Lebens.* Munich: List, 1963.

Speer, Albert. *Inside the Third Reich: Memoirs.* New York: Macmillan, 1970. (First published in Germany as *Erinnerungen*, Ullstein, 1969).

Thiersch, Heinz, ed. *Wir fingen einfach an. Arbeiten und Aufsätze von Freunden und Schülern um Richard Riemerschmid zu dessen 85. Geburtstag.* Munich: Richard Pflaum, 1953.

Velde, Henry van de. *Geschichte meines Lebens.* Munich: R. Piper, 1962.

Wright, Frank Lloyd. *A Testament.* New York: Horizon Press, 1957.

VII. CONTEMPORARY NEWSPAPERS AND PERIODICALS
(Consulted for the years indicated)

L'Architecture d'Aujourd'hui. Boulogne (1930-1935)

Die Baugilde. Berlin (1930-1935)

Der Baumeister. Munich (1930-1935)

Dekorative Kunst. Munich (1911-1934. From 1929, entitled *Das Schöne Heim*).

Deutsche Kunst und Dekoration. Darmstadt (1918-1933)

Frankfurter Zeitung (1918-1925)

Die Hilfe. Berlin (1920-1927)

Innen-Dekoration. Darmstadt (1918, 1923-1934)

Jahrbuch der Deutschen Werkstätten. Raehnitz-Hellerau bei Dresden. (1928-1929)

Kampfbund für deutsche Kultur: Mitteilungen. Munich (1929-1931)

Kunst und Künstler. Berlin (1918-1933)

Kunstwart. (Various titles, including *Deutsche Zeitschrift, Kunstwart und Kulturwart*). Munich (1918-1931)

Die neue Rundschau. Berlin (1918-1925)
Schönheit der Arbeit. Berlin (1936-1939)

VIII. OTHER PRIMARY SOURCES

Avenarius, Ferdinand. "Deutsches Warenbuch." *Kunstwart,*
xxix, No. 1 (1915), 19-22 and No. 10 (1916), 121-25.
Bartning, Otto. *Die Stahlkirche.* New York: Copper and Brass
Research Association, 1930.
Bauer, Albert. "Die Basler Werkbund Ausstellung." *Innen-Dekor-
ation,* xxix (1918), 165-68.
Becker, C. H. *Kulturpolitische Aufgaben des Reiches.* Leipzig:
Quelle und Meyer, 1919.
Behne, Adolf. "Kritik des Werkbundes." *Die Tat,* ix, No. 1
(1917), 430-38.
———. "Werkbund." *Sozialistische Monatshefte,* xxvi, No. 1
(1920) 68-69.
———. "Kunst, Handwerk, Technik." *Die neue Rundschau,*
xxxiii, No. 10 (1922), 1021-37.
———. *1923: Der Moderne Zweckbau.* (Reprint of 1926 pub-
lication). Ullstein Bauwelt Fundamente 10. Berlin: Ullstein,
1964.
———. *Neues Wohnen, Neues Bauen.* Leipzig: Hesse &
Becker, 1930. (First published in 1927).
Behrendt, Walter Curt. "Die Deutsche Werkbund-Ausstellung
in Köln." *Kunst und Künstler,* xii (1914), 615-26.
———. "Zur Tagung des Deutschen Werkbundes in Stutt-
gart." *Kunst und Künstler,* xviii (1919-20), 90-91.
———. "Handwerk als Gesinnungsfrage." *Deutsche Allge-
meine Zeitung* (Berlin), Sept. 13, 1919.
———. *Der Kampf um den Stil in Kunstgewerbe und in der
Architektur.* Stuttgart: Deutsche Verlags-Anstalt, 1920.
———. "Die Schicksalsstunde des Deutschen Werkbundes."
Die Kornscheuer, ii, No. 5 (1921), 83-91.
———. "Der Deutsche Werkbund 1921. Ein Nachwort zur
Münchner Tagung." *Deutsche Allgemeine Zeitung* (Berlin),
June 2, 1921.
———. "Deutsche Gewerbeschau München 1922." *Kunst und
Künstler,* xxi (1922-23), 55-60.
———. "Die Zukunft des Werkbundes." *Deutsche Allgemeine
Zeitung* (Berlin), Sept. [20?], 1923. (Partially identified clip-
ping in *BA,* Rep 301/110.)

Behrendt, Walter Curt. *Der Sieg des Neuen Baustils.* Stuttgart: Akad. Verlag Dr. Fr. Wedekind, 1927.

————. *Modern Building: Its Nature, Problems and Forms.* New York: Harcourt, Brace, 1937.

Behrens, Peter. "Bund der Erneuerung." *Die neue Rundschau,* XXXI, No. 3 (1920), 1051-54.

Benz, Richard Edmund. *Ein Kulturprogramm. Die Notwendigkeit einer geistigen Verfassung.* Jena: Eugen Diederichs, 1920.

Best, Walter. *Kultur oder Bildung. Der Wert des Schöpferischen in der Gemeinschaft.* Würzburg: Konrad Triltsch, 1939.

Boettcher, Robert. *Kunst und Kunsterziehung im neuen Reich.* Breslau: Ferdinand Hirt, 1933.

Breuer, Robert. "Typus und Individualität. Zur Tagung des deutschen Werkbundes, Köln, 2.-4. Juli 1914." *Deutsche Kunst und Dekoration,* XXXIV, No. 11 (Aug. 1914), 378-87.

————. "Die Kölner Werkbund-Ausstellung, Mai-Oktober 1914." *Deutsche Kunst und Dekoration,* XXXIV, No. 12 (Sept. 1914), 417-36.

Brock, A. Clutton. *A Modern Creed of Work.* The fourth pamphlet of the Design and Industries Association. London: DIA, [1916].

Bruckmann, Peter. *Deutscher Werkbund und Industrie.* Von Hofrat P. Bruckmann, Heilbronn. Vortrag gehalten auf der sechsten Generalversammlung des Verbandes Württ. Industrieller zu Heilbronn a.N. am 18 Januar 1914. Sonderabdruck aus der "Württembergischen Industrie" Heft 2, Jahrgang 1914. Stuttgart: Stähle & Friede, 1914.

————. "Der deutsche Werkbund und seine Ausstellung in Köln." *März,* VIII, No. 2 (1914), 620-29.

Bund Deutscher Gelehrter und Künstler. *Um Deutschlands Zukunft.* Nos. 1-10. Berlin: Bund deutscher Gelehrter und Künstler, 1917-1921.

Bund der Erneuerung wirtschaftlicher Sitte und Verantwortung, Berlin. *Was soll ich tun?* Schriften, Nr. 1. Stuttgart: Deutsche Verlags-Anstalt, 1921.

David, Const. J. "Der Deutsche Werkbund und die Gewerbeschau München 1922." *Die Kornscheuer,* II, No. 5 (1921), 77-83.

Dessauer, Friedrich. *Philosophie der Technik: Das Problem der Realisierung.* Bonn: Friedrich Cohen, 1927.

Deutscher Bund Heimatschutz/Arbeitsgemeinschaft für Deutsche Handwerkskultur. *Schlichte deutsche Wohnmöbel.* Von Theda Behme, mit einem Beitrag 'Der Werkstoff und seine Verarbeitung' von Herbert Gericke. Munich: Georg D. W. Callwey, 1928.

Deutscher Museumsbund. *Die Kunstmuseen und das deutsche Volk.* Munich: K. Wolff, 1919.

Diederichs, Eugen. "Ferdinand Avenarius zum 60. Geburtstag." *Die Tat,* VIII, No. 9 (1916-17), 836f.

————. *Politik des Geistes.* Jena: Eugen Diederichs, 1920. (A collection of essays by Diederichs from *Die Tat,* 1915-1919).

————. *Selbstzeugnisse und Briefe von Zeitgenossen.* Düsseldorf: Diederichs, 1967.

Dietrich, Bernhard. "Die Ausfuhr von Qualitätsware und der internationale Musterschutz." *Weltwirtschaftliches Archiv,* II (1913), 52-68.

Donath, Adolph. "Deutscher Werkbund-zu seinem fünfundzwanzigjährigen Bestehen." *Berliner Tageblatt,* Oct. 13, 1932.

————. "Der Werkbund-Gedanke." *Berliner Tageblatt,* Oct. 17, 1932.

Dreyer, Ernst Adolf, ed. *Deutsche Kultur im Neuen Reich. Das grundlegende Volksbuch des deutschen Kulturneubaus über Wesen, Aufgabe und Ziel der Reichskulturkammer.* Berlin: Schlieffen, 1934.

Ehmcke, Fritz Hellmut. *Persönliches und Sachliches. Gesammelte Aufsätze und Arbeiten aus fünfundzwanzig Jahren.* Berlin: Hermann Reckendorf, 1928.

————. *Geordnetes und Gültiges. Gesammelte Aufsätze und Arbeiten aus den letzten 25 Jahren.* Munich: C. H. Beck'sche Verlagsbuchhandlung, 1955.

Eisler, Max. *Österreichische Werkkultur.* Hrsg. vom Österreichischen Werkbund. Vienna: Anton Schroll, 1916.

Emge, Carl August. *Die Idee des Bauhauses. Kunst und Wirklichkeit.* Berlin: Pan Verlag, Rolf Heise, 1924.

Encke, Fritz. "Nachklänge zur Kölner Werkbundausstellung 1914." *Gartenkunst* (1917), 109-15.

Engelhardt, W. von. "Nachklänge zur Kölner Werkbundausstellung 1914." *Gartenkunst* (1917), 115-21.

"Erasmus" [Gotthilf Schenkel]. *Geist der Gegenwart. Formen, Kräfte und Werte einer neuen deutschen Kultur.* Stuttgart: Stuttgarter Verlags-Institut, 1928.

Esswein, Hermann. "Zur Münchner Werkbund-Tagung." *Frankfurter Zeitung*, May 20, 1921.

————. "Die Deutsche Gewerbeschau München 1922." *Deutsche Kunst und Dekoration*, L (April-Sept. 1922), 277-82.

Feistel-Rohmeder, Bettina. *Im Terror des Kunstbolschewismus.* Urkundensammlung des "Deutschen Kunstberichtes" aus den Jahren 1927-33. Karlsruhe: C. F. Müller, 1938.

Felisch, Hildegard. "Zum Formproblem unserer Zeit." *Die Hilfe*, Sept. 15, 1926, 388-89.

Fischer, Eugen. "Die Ausstellung des Werkbundes in Köln." *Die Tat*, VI (1914-15), 530-33.

Freytag, Hans. "Über deutsche Kulturpolitik im Ausland." *Deutsche Rundschau*, CCXX, No. 2 (1929), 97-109.

Fries, Henry de, ed. *Frank Lloyd Wright: Aus dem Lebenswerke eines Architekten.* Berlin: Ernst Pollak, 1926.

Fritz, Gottlieb. *Volksbildungswesen.* 2nd ed. Berlin: B. G. Teubner, 1920.

Grautoff, Otto. *Die neue Kunst.* Die neue Welt, Sammlung gemeinverständlicher Schriften. Berlin: Siegismund, 1921.

Great Britain. Department of Overseas Trade. *Report on the Present Position and Tendencies of the Industrial Arts as indicated at the International Exhibition of Modern Decorative and Industrial Arts, Paris 1925.* London: Department of Overseas Trade, n.d.

Gretsch, Hermann. *Gestaltendes Handwerk.* Hrsg. Fachamt "Das deutsche Handwerk" in der Deutschen Arbeitsfront. Bearbeitet von Dr. Hermann Gretsch im Auftrag der Abteilung "Der Handwerker als Kulturträger." Stuttgart: Julius Hoffmann, 1940.

Grimme, Adolf. *Das neue Volk-der neue Staat.* Sieben Ansprachen. Berlin: Dietz, 1932.

Grohmann, Will. "Zehn Jahre Novembergruppe." *Kunst der Zeit*, III, Nos. 1-3, Sonderheft, 1-9.

Gropius, Walter. *Idee und Aufbau des Staatlichen Bauhauses Weimar.* Munich: Hursching am Amersee, Dietz Edzard, 1923.

————. *The New Architecture and the Bauhaus.* Trans. from the German by P. Morton Shand with an introduction by Frank Pick. London: Faber & Faber, 1935.

————. *Scope of Total Architecture.* World Perspectives

planned and edited by Ruth Nanda Anshen, Vol. III. New York: Harper & Brothers, 1955.

Haenisch, Konrad. *Die Not der geistigen Arbeiter.* Leipzig: Werner Klinkhardt, 1920.

———. *Neue Bahnen der Kulturpolitik. Aus der Reformpraxis der deutschen Republik.* Berlin: Buchhandlung Vorwärts, 1921.

Hamburg. Kunstgewerbeverein. *Hamburgische Werkkunst der Gegenwart.* Hamburg: Verlagsbuchhandlung Broschek, 1927.

Harbers, Guido. "Die Zukunft des Deutschen Werkbundes." *Der Baumeister,* XXVIII (Dec. 1930), Beilage, B223-24.

Hartmann, Alfred Georg. "Aufschwung." *Der Tag* (Berlin), Oct. 13, 1907.

Hass, Hermann. *Sitte und Kultur im Nachkriegsdeutschland.* Hamburg: Hanseatische Verlagsanstalt, 1932.

Heise, Carl Georg. "Die 25. Tagung des DWB, Königsberg." *Frankfurter Zeitung,* Sept. 8, 1934.

Hellwag, Fritz. "Die vierte Jahresversammlung des 'Deutschen Werkbundes,' Dresden." *Kunstgewerbeblatt,* N.F., XXII, No. 10 (1911), 197-200.

———. "Der Deutsche Werkbund und seine Künstler." *Kunstgewerbeblatt,* N.F., XXVII (1915-16), 21-24, 41-42, 61-62.

———. "Die Deutsche Werkbund-Ausstellung in Bern." *Innen-Dekoration,* XXIX (1918), 155-62.

———. "Zeitgeist und Werkbundarbeit." *Kunstwanderer* (Berlin), IX (March 1922), 318-20.

———. "Öffentliche Kunstpflege. Deutscher Werkbund und Pariser Weltausstellung." *Kunstchronik und Kunstmarkt* (Leipzig), 1925, 382-85.

———. "Abschied vom Deutschen Werkbund." *Deutsche Allgemeine Zeitung* (Berlin), Nov. 18, 1934.

Heuss, Theodor. "Gewerbekunst und Volkswirtschaft." *Preussische Jahrbücher,* CXLI (1910), 1-15.

———. "Der deutsche Werkbund in Wien." *Die Hilfe,* XVIII, No. 25 (1912), 400.

———. "Der deutsche Werkbund in Leipzig." *Der Kaufmann und das Leben* (Leipzig), VI (1913-14), 72-74.

———. "Wolf Dohrn." (Obituary). *März,* VIII, No. 1 (1914), 279.

———. "Der Werkbund in Köln." (Ausstellungsbericht). *März,* VIII, No. 2 (1914), 907-13.

Heuss, Theodor. "Ein englischer Werkbund." *Die Hilfe*, XXII (1916), 395.

————. "Werkbund-Ausstellung in Kopenhagen." *Deutsche Kunst und Dekoration*, XLIII (1918), 253-63.

————. "Probleme der Werkbundarbeit." *Der Friede*, I (1918-19), 617-19.

————. *Zwischen Gestern und Morgen*. Stuttgart: J. Engelhorns Nachf., 1919.

————. "Vom deutschen Werkbund." *Die Hilfe*, XXV (1919), 520-21.

————. "Luxussteuer und Qualitätsproduktion." *Vossische Zeitung* (Berlin), Sept. 3, 1919.

————. "Werkbundfragen nach dem Kriege." *Vivos Voco*, I (1919-20), 408-17.

————. "Haus Werkbund." *Frankfurter Messe-Zeitung*, May 14, 1921.

————. "Der Werkbund in München." *Berliner Börsenzeitung*, May 19, 1921.

————. "Der Werkbund in München." *Steglitzer Anzeiger*, May 19, 1921.

————. "Werkbund und Wiederaufbau." *Stuttgarter Neues Tagblatt*, June 2, 1921.

————. "Wertarbeit und Messe." *Die Hilfe*, Oct. 15, 1921, 461-62.

————. "Zeitstil und Volksstil." *Deutsche Kunst und Dekoration*, L (April 1922), 51-56.

————. "Die Freude an der Arbeit." *Der Bund* (Frankfurt a.M.), I (July 15, 1922), 20.

————. "Die Werkbundtagung in Augsburg." *Frankfurter Zeitung*, July 5, 1922.

————. "Deutsche Gewerbeschau," Parts 1 and 2. *Der Bund*, I (July 15, 1922), 57-58 and (July 21, 1922), 87-88.

————. "Der deutsche Werkbund in Weimar." *Frankfurter Zeitung*, Sept. 22, 1923.

————. "Bilanz von Weimar." *Stuttgarter Neues Tagblatt*, Beiblatt 'Werkbund-Gedanken,' Oct. 10, 1923.

————. "Die Arbeit des Deutschen Werkbundes." *Badische Presse*. Sonderbeilage 'Der Werkbund,' July 24, 1924.

————. Der Deutsche Werkbund in Bremen." *Württembergische Zeitung*, June 25, 1925.

————. "Staat, Wirtschaft und Kunst." *Stettiner Abendpost,* May 13, 1926.

————. "Zur Psychologie des Sozialismus." *Berliner Börsen-Courier,* May 23, 1926.

————. *Staat und Volk. Betrachtungen über Wirtschaft, Politik und Kultur.* Berlin: Deutsche Buch-Gemeinschaft, 1926.

————. "Hermann Muthesius." (Obituary). *Der Heimatdienst,* VII (1927), 379.

————. "Ziele und Wesen des Werkbundes." *Neue Badische Landeszeitung,* Sept. 28, 1927.

————. "Richard Riemerschmid." *Berliner Volkszeitung,* June 20, 1928.

————. "Werkbund-Tagung." *Die Hilfe,* XXXIV, No. 15, Aug. 1, 1928.

————. "Die Zeit und ihre Form." *Wille und Weg,* IV, No. 20 (1928-29), 506-9.

————. "Drei Architekten." *Die Hilfe,* XXXV (1929), 307-9.

————. *Robert Bosch.* Unter Mitwirkung von Theodor Bäuerle, Peter Bruckmann, Johannes Fischer, Hans Kneher, Otto Mezger. Stuttgart und Berlin: Deutsche Verlags-Anstalt, 1931.

————. *Hitlers Weg.* Eine Schrift aus dem Jahre 1932 neu herausgegeben und mit einer Einleitung versehen von Eberhard Jäckel. Tübingen: Rainer Wunderlich Verlag-Hermann Leins, 1949.

————. "Gleichschaltung des Geistes." *Die Hilfe,* XXXIX, No. 10 (May 20, 1933), 265-67.

————. "Randbemerkungen zur Kunstpolitik." *Die Hilfe,* XXXIX, No. 16 (1933), 422-47.

————. "Der Werkbund vor neuen Aufgaben." *Vossische Zeitung,* Oct. 6, 1933.

————. "Kunst und Macht." (Review of *Kunst und Macht* by Gottfried Benn). *Die Hilfe,* XL (1934), 579-80.

————. "Peter Bruckmann." *Frankfurter Zeitung,* March 5, 1937.

————. *Hans Poelzig. Bauten und Entwürfe. Das Lebensbild eines deutschen Baumeisters.* 3rd ed. Tübingen: Rainer Wunderlich 1955. (First published by Wasmuth, Berlin, 1939).

————. "Peter Behrens." (Obituary). *Die Hilfe,* XLVI (1940), 74-76.

Heuss, Theodor. "Fritz Hellwag." *Deutsche Allgemeine Zeitung* (Berlin), Nov. 6, 1941.

[————.] *Hermann Gretsch: Industrielle Formgebung.* Werkstattbericht des Kunstdienstes, H. 10. Berlin: Ulrich Riemerschmidt, 1941.

————. *Robert Bosch: Leben und Leistung.* Stuttgart: Rainer Wunderlich, 1946.

Hitchcock, Henry-Russell, Jr. *Modern Architecture: Romanticism and Reintegration.* New York: Payson & Clarke, 1929.

Hoeber, Fritz. "Architekturfragen." *Die neue Rundschau,* XXIX, No. 2 (1918), 1103-8.

————. "Rundschau: Revolutionierung des Kunstunterrichts." *Die neue Rundschau,* XXX, No. 1 (1919), 487-97.

————. "Über Werkbundarbeit und Volksbildung: Eine Kritik und ein Programm." *Die neue Rundschau,* XXXI, No. 7 (1920), 827-37.

Huebner, Friedrich Marcus. "Werkbund, Auswärtiges Amt und Kulturberichterstattung." *Die Kornscheuer,* II, No. 5 (1921), 91-94.

Jäckh, Ernst. "Deutsche Werkbundausstellung in Köln." Part I and II. *Kunstwart,* XXVII (1914), No. 18, 404-14, and No. 20, 137-40.

————. *Das Grössere Mitteleuropa. Ein Werkbund-Vortrag.* Flugschriften der "Deutschen Politik," Vol. 2 Weimar & Berlin: Deutsche Verlags-Gesellschaft, 1916.

Jeanneret, Ch.-E. [Le Corbusier]. *Étude sur le Mouvement d'Art Décoratif en Allemagne.* Chaux-de-Fonds: La Commission de l'École d'Art, 1912.

Joël, Karl. *Neue Weltkultur.* Leipzig: Kurt Wolff Verlag, 1915.

Kalkschmidt, Eugen. "Die vierte Tagung des deutschen Werkbundes." *Dekorative Kunst,* XIX (1911), 522-24.

Karlsruhe. Badische Kunstgewerbe-Verein. *Kunst und Handwerk am Oberrhein.* Jahrbuch des Badischen Kunstgewerbevereins und des Kunstgewerbeverein Pforzheim. Vol. 1. Karlsruhe: C. F. Müller, 1925.

Kessler, Harry Graf. *Tagebücher 1918-1937. Politik, Kunst und Gesellschaft der zwanziger Jahre.* Ed. Wolfgang Pfeiffer-Belli. Frankfurt: Insel-Verlag, 1961.

Kulka, Heinrich, ed. *Adolf Loos: Das Werk des Architekten.* Neues Bauen der Welt, Bd. 4. Vienna: Anton Schroll, 1931.

Kutzke, Georg. *Voraussetzungen zur künstlerischen Weltmis-*

sion der Deutschen. Schriften zur kommenden Volkskultur, Heft 1. Eisleben: Iso Verlag, Walter Probst, 1919.

[Langbehn, Julius]. *Rembrandt als Erzieher.* Von einem Deutschen. 14th ed. Leipzig: E. L. Hirschfeld, 1890.

Loos, Adolf. *Sämtliche Schriften in Zwei Bänden.* Vol. 1. Vienna: Herold, 1962.

Lotz, Wilhelm. "Kunstgewerbe und Kunst." *Dekorative Kunst,* XXXII (June 1924), 218-23.

———. "Das Ornament." *Dekorative Kunst,* XXXII (Aug. 1924), 264-72.

———. "Kunsthandwerk und Kunstindustrie." *Deutsche Kunst und Dekoration,* LV (Oct. 1924-March 1925), 73.

———. "Tagung des Deutschen Werkbundes in Essen." *Germania,* 1926, No. 94.

———. *Wie richte ich meine Wohnung ein: Modern, Gut, mit welchen Kosten?* 2. verbesserte und veränderte Auflage. Berlin: Hermann Reckendorf, 1930.

Lux, Joseph August. *Das neue Kunstgewerbe in Deutschland.* Leipzig: Klinkhardt & Biermann, 1908.

———. *Der Geschmack im Alltag: Ein Buch zur Pflege des Schönen.* Volks-Ausgabe. 2nd ed. Dresden: Gerhard Kühtmann, 1912.

Man, Hendrik de. *The Psychology of Socialism.* New York: Henry Holt, 1929.

Mendelsohn, Eric. *Letters of an Architect.* Ed. Oskar Beyer, with an introduction by Nikolaus Pevsner, trans. Geoffrey Strachan. London: Abelard-Schuman, 1967.

Meyer, Peter. *Moderne Architektur und Tradition.* Zürich: H. Ginsberger, 1928.

———. "Der Deutsche Werkbund in Wien." *Neue Zürcher Zeitung,* July 8, 1930.

———. "Die Stuttgart Aussprache über die Ziele des Deutschen Werkbundes." *Frankfurter Zeitung,* Oct. 30, 1930.

Moeller van den Bruck, Arthur. *Der Preussische Stil.* Mit einem Vorwort von Hans Schwarz. Neue Fassung. Breslau: Wilh. Gottl. Korn, 1931. First published in 1916 by R. Piper, Munich.

Morris, William. *Architecture, Industry and Wealth.* Collected Papers. London: Longmans, Green, 1902.

Muthesius, Hermann. *Das Englische Haus.* 3 vols. Berlin: Wasmuth, 1902.

Muthesius, Hermann. *Wirtschaftsformen im Kunstgewerbe. Vortrag geh. am 30. I. 1908 in der Volkswirtschaftlichen Gesellschaft in Berlin.* Volkswirtschaftliche Zeitfragen Nr. 233. Berlin: L. Simion, 1908.

————. *Kultur und Kunst. Gesammelte Aufsätze über künstlerische Fragen der Gegenwart.* 2nd ed. Jena: Eugen Diederichs, 1909. First edition, 1904.

————. *Die Werkbundarbeit der Zukunft (1914).* Neudruck. Schriftenreihe der Muthesius-Werkschule Kiel, Heft 7. Kiel: Muthesius-Werkschule, 1960.

————. *Die Zukunft der deutschen Form.* Der Deutsche Krieg, Heft 50. Stuttgart: Deutsche Verlags-Anstalt, 1915.

————. *Der Deutsche nach dem Kriege.* Weltkultur und Weltpolitik, Heft 4. Munich: Deutsche Verlags-Anstalt, 1915.

Nationalsozialistische Gemeinschaft "Kraft durch Freude." *Amt Schönheit der Arbeit. Erlasse, Anordnung, Aufrufe von Partei, Staat, und Wehrmacht über Schönheit der Arbeit.* Munich, 1937.

————. *Das Taschenbuch Schönheit der Arbeit.* Hrsg. Anatol von Hübbenet. Mit einer Einleitung von Professor Albert Speer. Berlin: Im Selbstverlag der deutschen Arbeitsfront, 1938.

Naumann, Friedrich. *Werke.* 6 vols. Cologne: Westdeutscher Verlag: 1964-1969.

Osthaus, Karl-Ernst. "Deutscher Werkbund." *Das hohe Ufer* (Hannover), I, No. 10 (Oct. 1919).

Ostwald, Wilhelm. *Farbenatlas.* Leipzig: Unesma, [1917].

Passarge, Walter. *Deutsche Werkkunst der Gegenwart.* Berlin: Rembrandt-Verlag, 1937.

Pazaurek, Gustav E. *Guter und schlechter Geschmack im Kunstgewerbe.* Stuttgart: Deutsche Verlags-Anstalt, 1912.

————. "Die Krise des Deutschen Werkbundes." *Schwäbische Merkur* (Stuttgart), Nov. 6, 1932.

Pechmann, Dr. Günther, Frhr. von. *Die Qualitätsarbeit: ein Handbuch für Industrielle, Kaufleute und Gewerbepolitiker.* Frankfurt: Frankfurter Sozietätsdruckerei, 1924.

Pevsner, Nikolaus. "Post-war Tendencies in German Art Schools." *Journal of the Royal Society of Arts,* LXXXIV (Jan. 17, 1936), 248-62.

Posener, Julius. "Die Deutsche Abteilung in der Ausstellung der Societé des artistes décoratifs français." *Die Baugilde,* XII, No. 11 (1930), 968-83.

————. "Hermann Muthesius." *Die Baugilde*, XIII, No. 21 (1931), 1639-43.

————. "L'Architecture du IIIᵉ Reich." *L'Architecture d'Aujourd'hui*, VII, No. 4 (1936), 9-47.

Rauecker, Dr. Bruno. "Die Proletarisierung der geistigen Arbeiter." *Die Hilfe*, April 29, 1920, 268-71.

————. "Die Entwicklung im Werkbund. Ein Rückblick auf dessen Tagung vom 11.-13. Mai in München." *Münchener Neueste Nachrichten*, May 20, 1921.

Redslob, Edwin. *Die Werbekraft der Qualität*. Vortrag auf der Leipziger Herbstmesse am 30. August 1920 . . . Berlin: Hermann Reckendorf, 1920.

————. "Der Werkbund in Baden." *Badische Presse* (Karlsruhe), July 19, 1924.

————. "Der Werkbund in Baden." *Badische Presse*. Sonderbeilage "Der Werkbund," July 24, 1924.

————. *Die künstlerische Formgebung des Reiches*. Berlin: Kunstarchiv, 1926.

Renner, Paul. *Kulturbolschewismus?* Zürich: Eugen Rentsch, 1932.

Richards, Charles R. *Art in Industry*. New York: Macmillan, 1929.

Riezler, Walter. *Die Kulturarbeit des Deutschen Werkbundes*. Weltkultur und Weltpolitik, Deutsche Folge, Heft 7. Munich: Deutsche Verlags-Anstalt, 1916.

————. "Qualitätsarbeit." *Die Kunst*, XXVI, No. 3 (1924), 71-72.

Roselius, Ludwig. *Briefe und Schriften zu Deutschlands Erneuerung*. Oldenburg: Gerhard Stalling, 1933.

Rosenberg, Alfred. *Blut und Ehre*. 2 vols. Munich: Zentralverlag der NSDAP, Frz. Eher Nachf., 1934-1936.

Rühlmann, Paul M. *Kulturpropaganda*. Berlin-Charlottenburg: Deutsche Verlagsgesellschaft für Politik und Geschichte, 1919.

Scheffauer, Herman George. "Hans Poelzig." *Architectural Review*, LIV (1923), 122-27.

Scheffler, Karl. *Die Zukunft der deutschen Kunst*. Berlin: Bruno Cassirer, 1919.

————. "Ein Arbeitsprogramm für den Deutschen Werkbund." *Kunst und Künstler*, XVII (1920), 43-52.

————. "Der Werkbund." *Kunst und Künstler*, XXXI (1932), 422.

Scheffler, Karl. *Der neue Mensch.* Leipzig: Insel-Verlag, 1932.

Schlemmer, Oskar. *Briefe und Tagebücher.* Hrsg. von Tut Schlemmer. Munich: Albert Langen, Georg Müller, [1958].

Schmidt, Paul F. "Werkbund-Krisis." *Der Cicerone* (Leipzig), VII, No. 21 (1919), 704-5.

Schmitz, Hermann. *Revolution der Gesinnung: Preussische Kulturpolitik und Volksgemeinschaft seit dem 9. November 1918.* Neubabelsberg: Im Selbstverlag des Verfassers, 1931.

Schrieber, Karl-Friedrich. *Die Reichskulturkammer. Organisation und Ziele der deutschen Kulturpolitik.* Berlin: Junker & Dünnhaupt. 1934.

Schultze-Naumburg, Paul. *Kunst und Rasse.* Munich: F. Lehmann, 1927.

———. *Kampf um die Kunst.* Nationalsozialistische Bibliothek. Heft 36. Munich: F. Eher, 1932.

Schumacher, Fritz. "Die Wiedereroberung harmonischer Kultur." *Kunstwart,* XXI, No. 8 (1908), 135-38.

———. *Kulturpolitik. Neue Streifzüge eines Architekten.* Jena: Eugen Diederichs, 1920.

———. *Zeitfragen der Architektur.* Jena: Eugen Diederichs, 1929.

Schuster, Felix. "Die Versuchssiedlung beim Schönblick." *Schwäbische Merkur,* Nos. 410, 434, 470, 482, 506. Sept. 3-Oct. 29, 1927.

———. "Rückblick auf die Wohnungsausstellung." *Schwäbische Merkur,* No. 518, Nov. 5, 1927.

Siemsen, Anna. *Politische Kunst und Kunstpolitik.* Jungsozialistische Schriftenreihe. Berlin: E. Laubsche, 1927.

Sombart, Werner. *Kunstgewerbe und Kultur.* Die Kultur, Heft VIII, Berlin: J. Knoblauch, 1908.

Sommer, P. K. *Kunst und Kunsterziehung. Quellen der Zersetzung und des Aufbaues.* Dortmund: W. Crüwell, 1935.

Spengler, Oswald. *Der Mensch und die Technik. Beitrag zu einer Philosophie des Lebens.* Munich: C. H. Beck'sche Verlags-Buchhandlung, 1931.

Stahl, Fritz. "Die Arbeit am Scheideweg?" *Berliner Tageblatt,* Aug. 8, 1924.

Stern, Norbert. *Die Weltpolitik der Weltmode.* Der deutsche Krieg, Heft 30/31. Stuttgart: Deutsche Verlags-Anstalt, 1915.

Stotz, Gustav. "Die Krise des Deutschen Werkbundes." *Schwäbische Merkur,* No. 266, Beilage. Nov. 12, 1932.

Straub, K. W. *Weder so noch so: die Architektur im Dritten Reich.* Stuttgart: Akademische Verlag Dr. F. Wedekind, 1932.

Sutter, Otto W. "Das Haus Werkbund." *Stuttgarter Neues Tagblatt.* Beiblatt "Werkbund-Gedanken" No. 1, Jan. 17, 1924.

Taut, Bruno. *Die Stadtkrone.* Jena: Eugen Diederichs, 1919.

————. *Modern Architecture.* London: The Studio Ltd., 1929.

Tessenow, Heinrich. *Handwerk und Kleinstadt.* Berlin: Bruno Cassirer, 1919.

Velde, Henry van de. *Kunstgewerbliche Laienpredigten.* 2 vols. Leipzig: Hermann Seemann Nachfolger, 1902.

————. *Essays.* Leipzig: Insel-Verlag, 1910.

————. "Paris und das Europäische Kunstgewerbe." *Die neue Rundschau,* XXXVI, No. 2 (1925), 1074-80.

————. *Zum neuen Stil.* Aus seinen Schriften ausgewählt von H. Curjel. Munich: R. Piper, 1955.

Waentig, Heinrich. *Wirtschaft und Kunst: eine Untersuchung über Geschichte und Theorie der modernen Kunstgewerbebewegung.* Jena: Gustav Fischer, 1909.

Wagenfeld, Wilhelm. *Wesen und Gestalt der Dinge um uns.* Potsdam: E. Stichnote, 1948.

Weber, Alfred. "Die Bedeutung der geistigen Führer in Deutschland." *Die neue Rundschau,* XXIX, No. 10 (1918), 1249-68.

Weigert, Hans. *Die Kunst von heute als Spiegel der Zeit.* Leipzig: E. A. Seemann, 1934.

Wendland, Winfried. *Kunst und Nation. Ziel und Wege der Kunst im neuen Deutschland.* Berlin: Reimar Hobbing, 1934.

Westheim, Paul. "Woher und wohin? Eine Betrachtung." *Dekorative Kunst,* XXII (1914), 303-12.

————. "Von der Gesinnung in Architektur und Kunstgewerbe." *Dekorative Kunst,* XXIV (1915-16), 181-87.

————. "Reichskunstwart." *Frankfurter Zeitung,* Jan. 14, 1920.

————. *Für und wider.* Potsdam: Gustav Kiepenheuer, 1923.

————, ed. *Künstlerbekenntnisse: Briefe-Tagebuchblätter-Betrachtungen heutiger Künstler.* Berlin: Propyläen Verlag, [1923].

Whitaker, C. H. "Work-Pleasure. The remarkable exhibition at Cologne." *American Institute of Architects Journal,* II (1914), 420-32.

Wilden, Josef. "Der Werkbund-Gedanke in der rheinisch-westfälischen Industrie." *Kölnische Zeitung,* July 14, 1926.

Wolf, Georg Jacob. "Der Deutsche Werkbund und die Werk-

bund-Ausstellung in Köln." *Dekorative Kunst*, XXII (1913-14), 529-51.

Wolf, Georg Jacob. "Vom deutschen Werkbund." *Dekorative Kunst*, XXIII (1915-16), 163-66.

———. "Handwerkliche Kunst." *Dekorative Kunst*, XXIX, No. 3. Beilage, Dec. 1920.

———. "Deutsche Gewerbeschau." *Dekorative Kunst*, XXX (July 1922), 225-47.

Wolfer, Oskar. "Die Werkbundausstellung 'Die Form' in Stuttgart." *Dekorative Kunst*, XXXIII (1925), 20.

———. "Die Werkbundausstellung 'Die Wohnung' in Stuttgart 1927." *Die Kunst*, LVIII (1928), 33-36 and 57-68.

Zucker, Paul. "Architektur." *Die neue Rundschau*, XXXIII (1922), 1209-19.

IX. SECONDARY WORKS

A. Works of Reference

Bode, Ingrid. *Die Autobiographien zur deutschen Literatur, Kunst und Musik 1900-1965.* Stuttgart: Metzler, 1966.

Boveri, Margret. *Theodor Heuss. Die Literarische Gestalt.* Stuttgart: Vorwerk-Verlag, 1954.

Encyclopedia of Modern Architecture. Gerd Hatje, General Editor. London: Thames and Hudson, 1971.

Handwörterbuch der Kommunal-Wissenschaften. 4 vols. Jena: Gustav Fischer, 1924-.

Herzog, Fritz. *Die Kunstzeitschriften der Nachkriegszeit: eine Darstellung der deutschen Zeitschriften für bildende Kunst von der Zeit des Expressionismus bis zur Neuen Sachlichkeit.* Berlin: Rudolf Lorentz, 1940.

London. Historical Manuscripts Commission. *Design & Industries Association and H. H. Peach.* A bibliography of printed publications and correspondence at the Royal Institute of British Architects, compiled by R. A. Storey and T.W.M. Jaine. London: Historical Manuscripts Commission, 1972.

Meyers Lexikon. Leipzig, 1925.

Milatz, Alfred. *Friedrich-Naumann Bibliographie.* Düsseldorf: Droste-Verlag, 1957.

Münz, Dr. Ludwig, ed. *Führer durch die Behörden und Organisationen.* Berlin: Weidmannsche Buchhandlung, 1936.

Ruhle, Gerd., ed. *Das Dritte Reich.* 6 vols. Berlin: Hummel-verlag, 1934-39.

Schreiber, Dr. Karl-Friedrich, et al. *Das Recht der Reichs-kulturkammer.* I. Berlin: Walter de Gruyter, 1943.

Sharp, Dennis. *Sources of Modern Architecture. A Bibliography.* Architectural Association Papers II. London: Architectural Association, 1967.

Sperlings Zeitschriften und Zeitungs Adressbuch. 1931.

Stockhorst, Erich. *Fünftausend Köpfe: Wer war was im Dritten Reich.* Bruchsal, Baden: Blick und Bild Verlag, 1967.

Thieme, Ulrich und Felix Becker. *Allgemeines Lexikon der bildenden Künst von der Antike bis zur Gegenwart.* Leipzig.

Verzeichnis der schriftlichen Nachlässe in deutschen Archiven und Bibliotheken. 2 vols. Boppard am Rhein: Harold Boldt, 1969, 1971.

Wasmuths Lexikon der Baukunst. 4 vols. and Supplement. Berlin, 1929-37.

Wer ist's? 9th and 10th editions. Berlin: Hermann Degener, 1928 and 1935.

B. Exhibition Catalogues

Berlin. Akademie der Künste. *Poelzig, Endell, Moll und die Breslauer Kunstakademie 1911-1932.* Exhibition and catalogue prepared by Heinrich Lauterbach, 1965.

———. *Hans Scharoun.* Exhibition and catalogue prepared by Heinrich Lauterbach, 1967.

Cologne. Kunstgewerbemuseum. *Wilhelm Wagenfeld: 50 Jahre Mitarbeit in Fabriken.* Exhibition, Oct.-Dec. 1973. Catalogue prepared by Carl-Wolfgang Schümann. Cologne: Kölnische Verlagsdruckerei, 1973.

Hannover. Kestner-Museum. *Kunsthandwerk im Umbruch: Jugendstil und zwanziger Jahre.* Bildkatalog 232, Band XI. Prepared by Christel Mosel, 1971.

———. Kunstverein. *Die Zwanziger Jahre in Hannover: Bildende Kunst, Literatur, Theater, Tanz, Architectur 1916-1933.* Katalog. Exhibition, Aug. 12-Sept. 30, 1962.

Munich. Die neue Sammlung. *Zwischen Kunst und Industrie: der Deutsche Werkbund.* Exhibition prepared by G. B. von Hartmann and Wend Fischer. Munich: Die neue Sammlung, 1975.

Stuttgart. Landesgewerbeamt Baden-Württemberg. *Wilhelm Wagenfeld, vom Bauhaus in die Industrie.* Exhibition, May 1965.

————. Theodor Heuss Archiv. *Theodor Heuss: der Mann, das Werk, die Zeit: eine Ausstellung.* Catalogue of an exhibition prepared for the Schiller-Nationalmuseum Marbach a.N., May 5-Oct. 31, 1967, by E. Pikart and Dirk Mende.

C. Books, Essays, Articles, and Dissertations

Abelein, Manfred. *Die Kulturpolitik des Deutschen Reiches und der Bundesrepublik Deutschland.* Cologne: Westdeutscher Verlag, 1968.

Adolphi, R. "Grundlegung für eine kritische Darstellung der deutschen auswärtigen Kulturpolitik in den Jahren 1919-1933." Diss. Phil. Hamburg, 1941 (typescript).

A.E.G., Berlin. *Peter Behrens. 50 Jahre Gestaltung in der Industrie.* Bearbeitet von Hermann Lanzke. Berlin: A.E.G., 1958.

Banham, Reyner. *Theory and Design in the First Machine Age.* London: The Architectural Press, 1972 (first published in 1960).

Behne, Adolf. *Entartete Kunst.* Berlin: C. Habel, 1946.

Behr, Hermann. *Die goldenen zwanziger Jahre.* Hamburg: Hammerich und Lesser, 1964.

Benevolo, Leonardo. *History of Modern Architecture.* 2 vols. London: Routledge and Kegan Paul, 1971.

Blake, Peter. *Mies van der Rohe: Architecture and Structure.* Harmondsworth, Middlesex: Penguin Books, 1966.

Bøe, Alf. *From Gothic Revival to Functional Form: a Study in Victorian Theories of Design.* Oslo Studies in English, No. 6. Oslo: Oslo University Press, 1957.

Bott, Hans, ed. *Begegnungen mit Theodor Heuss.* Tübingen: Rainer Wunderlich Verlag-Hermann Leins, 1954.

Bowen, Ralph H. *German Theories of the Corporative State with Special Reference to the Period 1870-1919.* New York: McGraw-Hill, 1947.

Brenner, Hildegard. "Die Kunst im politischen Machtkampf der Jahre 1933/34." *Vierteljahreshefte für Zeitgeschichte,* x, No. 1 (1962), 17-42.

————. *Die Kunstpolitik des Nationalsozialismus.* Hamburg: Rowolt, 1963.

————. "Art in the Political Power Struggle of 1933 and 1934." *Republic to Reich: the Making of the Nazi Revolution.* Ten Essays, ed. Hajo Holborn. Vintage Paperback. New York: Random House, 1973.

Broermann, Herbert. *Der Kunstwart in seiner Eigenart: Entwicklung und Bedeutung.* Munich: Georg D. W. Callwey, 1934.

Conrads, Ulrich and Hans G. Sperlich. *Fantastic Architecture.* Tr. C. C. & G. R. Collins. London: The Architectural Press, 1963 (first published in Stuttgart, 1960).

Conze, Werner. "Friedrich Naumann. Grundlagen und Ansatz seiner Politik in der national-sozialen Zeit (1895 bis 1903)." *Schicksalswege deutscher Vergangenheit.* Ed. W. Hubatsch. Düsseldorf: Droste-Verlag, 1950.

Cremers, P. J. *Peter Behrens: sein Werk von 1909 bis zur Gegenwart.* Essen: G. D. Baedeker, 1928.

Diehl, Alex. *Die Kunsterziehung im Dritten Reich: Geschichte und Analyse.* Dissertation, Ludwig-Maximilian-Universität. Munich: private printing, 1969.

Doede, Werner. *Berlin: Kunst und Künstler seit 1870. Anfänge und Entwicklungen.* Recklinghausen: A. Bongers, 1961.

Düding, Dieter. *Der Nationalsoziale Verein, 1896-1903.* Munich: Oldenbourg, 1972.

Eckstein, Hans. "Idee und Geschichte des Deutschen Werkbundes 1907-1957." *50 Jahre Deutscher Werkbund.* Im Auftrage des Deutschen Werkbundes herausgegeben von der Landesgruppe Hessen, bearbeitet von Hans Eckstein. Frankfurt am Main: Alfred Metzner, 1958.

————. "Werkbund 1933." *Werk und Zeit,* 2 (1976).

Egbert, Donald Drew. "The Idea of 'Avant-Garde' in Art and Politics." *American Historical Review,* LXXIII, No. 2 (1967-68), 339-66.

————. *Social Radicalism and the Arts. Western Europe, A Cultural History from the French Revolution to 1968.* New York: Alfred A. Knopf, 1970.

Eksteins, Modris. *Theodor Heuss und die Weimarer Republik: ein Beitrag zur Geschichte des deutschen Liberalismus.* Stuttgart: Ernst Klett, 1969.

Fahrner, Rudolph, ed. *Paul Thiersch. Leben und Werk.* Berlin: Gebr. Mann, 1970.

Ferebee, Ann. *A History of Design from the Victorian Era*

to the Present: A Survey of the Modern Style in Architecture, Interior Design, Industrial Design, Graphic Design and Photography. New York: Van Nostrand Reinhold, 1970.

Fischer, Wend. *Bau-Raum-Gerät. Die Kunst des 20. Jahrhunderts.* Ed. Georg Heise. Munich: R. Piper, 1957.

Flittner, Andreas, ed. *Deutsches Geistesleben und Nationalsozialismus. Eine Vortragsreihe der Universität Tübingen.* Tübingen: Rainer Wunderlich Verlag-Hermann Leins, 1965.

Franciscono, Marcel. *Walter Gropius and the Creation of the Bauhaus in Weimar. The Ideals and Artistic Theories of its Founding Years.* Urbana, Ill.: University of Illinois Press, 1971.

Frecot, Janos. "Adolf Behne." *Werkbundarchiv,* I (1972), 81-116.

Gaber, Bernhard. *Die Entwicklung des Berufstandes der freischaffenden Architekten.* Essen: Richard Bacht, 1966.

Gasman, Daniel. *The Scientific Origins of National Socialism: Social Darwinism in Ernst Haeckel and the German Monist League.* London: Macdonald, 1971.

Gay, Peter. *Weimar Culture: the Outsider as Insider.* New York: Harper & Row, 1968.

Giedion, Sigfried. *Walter Gropius, Work and Teamwork.* New York: Reinhold Publishing Corporation, 1954.

––––––. *Space, Time and Architecture. The Growth of a New Tradition.* 5th ed. revised and enlarged. Cambridge, Mass.: Harvard University Press, 1967 (first published in 1941).

Greenberg, Allan Carl. "Artists and the Weimar Republic: Dada and the Bauhaus, 1917-1925." Ph.D. dissertation, University of Illinois, 1967 (microfilm).

Grimme, Adolf and Wilhelm Zilius, eds. *Kulturverwaltung der zwanziger Jahre. Alte Dokumente und neue Beiträge.* Stuttgart: W. Kohlhammer, 1961.

Grohmann, Will. *Bildende Kunst und Architektur. Zwischen den beiden Kriegen.* Dritter Band. Berlin: Suhrkamp, 1953.

Gropius, Walter. Untitled note. *Architectural Review,* CXXXIV, No. 797 (July 1963), 6.

Grote, Ludwig, ed. *Historismus und bildende Kunst.* Vorträge und Diskussion im Oktober 1963 in München und Schloss Anif. Munich: Prestel, 1965.

Hale, Oran J. *The Great Illusion 1900-1914.* The Rise of

Modern Europe Series, ed. W. Langer. Harper Torchbooks. New York: Harper & Row, 1971.

Hammacher, A. M. *Le Monde de Henry van de Velde*. Anvers: Edition Fonds Mercator, 1967.

Hauser, Arnold. *The Social History of Art, IV: Naturalism, Impressionism, The Film Age*. London: Routledge & Kegan Paul, 1968.

Hellack, Georg. "Architektur und bildende Kunst als Mittel nationalsozialistischer Propaganda." *Publizistik*, v (1960), 77-95.

Hess, Jürgen C. *Theodor Heuss vor 1933. Ein Beitrag zur Geschichte des demokratischen Denkens in Deutschland*. Kieler Historische Studien, Band 20. Stuttgart: Ernst Klett, 1973.

Heuss, Theodor. "Was ist Qualität?" in Theodor Heuss, *Die Grossen Reden: Der Humanist*. Tübingen: Rainer Wunderlich Verlag-Hermann Leins, 1965.

—————. "Notizen und Exkurse zur Geschichte des Deutschen Werkbundes." *50 Jahre Deutscher Werkbund*. Im Auftrage des Deutschen Werkbundes herausgegeban von der Landesgruppe Hessen, bearbeitet von Hans Eckstein. Frankfurt am Main: Alfred Metzner, 1958.

Hoeber, Fritz. *Peter Behrens*. Munich: G. Müller and E. Rentsch, 1913.

Holborn, Hajo. *A History of Modern Germany 1840-1945*. New York: Alfred A. Knopf, 1969.

Hübner, Herbert. "Die soziale Utopie des Bauhauses: ein Beitrag zur Wissenssoziologie in der bildenden Kunst." Inaugural-Dissertation, Westfälische Wilhelms-Universität zu Münster, 1963.

Hüter, Karl-Heinz. *Henry van de Velde. Sein Werk bis zum Ende seiner Tätigkeit in Deutschland*. Schriften zur Kunstgeschichte, Heft 9. Berlin: Akademie-Verlag, 1967.

Jackson, Holbrook. *The Eighteen Nineties: a Review of Art and Ideas at the Close of the Nineteenth Century*. New York: Mitchell Kennerley, 1914.

Jaeger, Hans. *Unternehmer in der deutschen Politik (1890-1918)*. Bonner Historische Forschungen, Band 30, Bonn: Ludwig Röhrsheid, 1967.

Jencks, Charles. *Modern Movements in Architecture*. Harmondsworth, Middlesex: Penguin Books, 1973.

Kerbs, Diethart. "Alexander Schwab." *Werkbundarchiv*, 1 (1972), 159-67.

Kliemann, Helga. *Die Novembergruppe*. Berlin: Gebr. Mann, 1969.

Kohlhaas, Wilhelm, ed. *Chronik der Stadt Stuttgart 1918-1933*. Veröffentlichungen des Archivs der Stadt Stuttgart, Band 17. Stuttgart: Ernst Klett, 1964.

Kratzsch, Gerhard. *Kunstwart und Dürerbund: ein Beitrag zur Geschichte der Gebildeten im Zeitalter des Imperialismus*. Göttingen: Vandenhoeck & Ruprecht, 1969.

Kroeber, A. L. and Clyde Kluckholn. *Culture: A Critical Review of Concepts and Definitions*. Vintage Books. New York: Random House, 1952.

Kubinsky, Mihály. *Adolf Loos*. Berlin: Henschelverlag, 1970.

Kurucz, Jenö. *Struktur und Funktion der Intelligenz während der Weimarer Republik*. Cologne: G. Grote, 1967.

Lane, Barbara Miller. *Architecture and Politics in Germany 1918-1945*. Cambridge, Mass.: Harvard University Press, 1968.

——. "Nazi Ideology: Some unfinished Business." *Central European History*, VII, No. 1 (March 1974), 3-30.

Lang, Lothar. *Das Bauhaus 1919-1933: Idee und Wirklichkeit*. Studienreihe angewandte Kunst-Neuzeit, Bd. 2. 2nd ed. Berlin: Zentralinstitut für Formgestaltung, 1966.

Langmaack, Gerhard. *Fritz Schumacher*. Hamburg: Hans Christians, 1964.

Lebovics, Hermann. *Social Conservatism and the Middle Class in Germany, 1914-1933*. Princeton: Princeton University Press, 1969.

Lehmann-Haupt, Hellmut. *Art Under a Dictatorship*. New York: Oxford University Press, 1954.

Lewis, Beth I. *George Grosz: Art and Politics in the Weimar Republic*. Madison, Wis.: University of Wisconsin Press, 1971.

Lindahl, Göran. "Von der Zukunftskathedrale bis zur Wohnmaschine. Deutsche Architektur und Architekturdebatte nach dem ersten Weltkriege." *Idea and Form. Figura*: Uppsala Studies in the History of Art, N.S., 1 (1959), 226-82.

MacCarthy, Fiona. *All Things Bright and Beautiful: Design in Britain 1830 to Today*. London: George Allen & Unwin, 1972.

Macdonald, Stuart. *The History and Philosophy of Art Education*. London: University of London Press, 1970.

Maldonado, Thomás. Exchange with Walter Gropius, in *Ulm. Zeitschrift der Hochschule für Gestaltung*. 8/9 (1963), 62-73.

Masur, Gerhard. *Imperial Germany*. New York: Basic Books, 1971.

Moholy-Nagy, Sibyl. "The Diaspora." *Journal of the Society for Architectural Historians*, XXIV, No. 1 (March 1965), 24f. and rejoinder by Dearstyne and reply by Moholy-Nagy, XXIV, No. 3 (Oct. 1965), 254-56.

Mosse, George L. *The Crisis of German Ideology: Intellectual Origins of the Third Reich*. London: Weidenfeld & Nicolson, 1970. (First published in 1964).

————. *Germans and Jews: The Right, the Left and the Search for a 'Third Force' in Pre-Nazi Germany*. New York: Howard Fertig, 1970.

Moyer, Laurence van Zandt. "The Kraft durch Freude Movement in Nazi Germany, 1933-1939." Ph.D. dissertation, Northwestern University, Illinois, 1967 (microfilm).

Müller, Sebastian. "Industrialisierung und Funktionalisierung der Kunst. Deutscher Werkbund zwischen 1907 und 1914." Diss. Phil. Bochum, Kunstgeschichtliches Institut der Ruhr-Universität, 1969 (typescript).

————. "Das Deutsche Museum für Kunst in Handel und Gewerbe." *Karl-Ernst Osthaus: Leben und Werk*. Ed. Herta Hesse-Frielinghaus. Recklinghausen: A. Bongers, 1970.

————. *Kunst und Industrie: Ideologie und Organisation des Funktionalismus in der Architektur*. Kunstwissenschaftliche Untersuchungen des Ulmer Vereins für Kunstwissenschaft, 2. Munich: Carl Hanser, 1974.

Münz, Ludwig and Gustav Kunstler. *Adolf Loos: Pioneer of Modern Architecture*. New York: Frederick A. Praeger, 1966.

Mumford, Lewis. *Technics and Civilization*. Harbinger Books. New York: Harcourt, Brace & World, 1963 (first published in 1934).

————. *The Culture of Cities*. London: Secker and Warburg, 1945 (first published in 1938).

————. *Values for Survival: Essays, Addresses and Letters*

on Politics and Education. New York: Harcourt, Brace, 1946.

Naylor, Gillian. *The Arts and Crafts Movement: a Study of its Sources, Ideals and Influence on Design Theory.* London: Studio Vista, 1971.

Pachter, Henry M. "The Intellectuals and the State of Weimar." *Social Research,* XXXIX, No. 2 (Summer 1972), 228-53.

Paul, Jacques. "German Neo-Classicism and the Modern Movement." *Architectural Review,* CLII (Sept. 1972), 176-80.

Pevsner, Nikolaus. *Academies of Art, Past and Present.* Cambridge: Cambridge University Press, 1940.

————. *Pioneers of Modern Design from William Morris to Walter Gropius.* 3rd rev. ed. Harmondsworth, Middlesex: Penguin Books, 1960 (first published in 1936).

————. "Finsterlin and some others." *Architectural Review,* CXXXII (July-Dec. 1962), 353-57.

————. "Gropius and van de Velde." *Architectural Review,* CXXXIII, No. 793 (1963), 165-68.

————. *The Sources of Modern Architecture and Design.* London: Thames & Hudson, 1968.

————. *Studies in Art, Architecture and Design.* Vol. II: *Victorian and After.* London: Thames & Hudson, 1968.

Pfister, Rudolf. "Der 'Fall Schmitthenner.'" *Der Baumeister,* XLV (1948), 166-67.

————. *Theodor Fischer: Leben und Wirken eines deutschen Baumeisters.* Munich: Georg D. W. Callwey, 1968.

Picht, Werner R. *Das Schicksal der Volksbildung in Deutschland.* 2nd ed. Berlin: Georg Westermann, 1950.

Pinson, Koppel S. *Modern Germany.* 2nd ed. New York: Macmillan, 1966.

Posener, Julius. "Hermann Muthesius." *Architects' Year Book,* No. 10 (1962), 45-61.

————. "Poelzig." *Architectural Review,* CXXXIII (June 1963), 401-5.

————. "Der Deutsche Werkbund." *Werk und Zeit Texte.* Beilage Heft 5, May 1970.

————. *From Schinkel to the Bauhaus.* London: Lund Humphries for the Architectural Association, 1972.

Pross, Harry. *Literatur und Politik: Geschichte und Pro-*

gramme der politisch-literarischen Zeitschriften im deutschen Sprachgebiet seit 1870. Olten: Walter, 1963.

Rave, Paul Ortwin. *Kunstdiktatur im Dritten Reich.* Hamburg: Gebr. Mann, 1949.

Read, Herbert. *Art and Industry: The Principles of Industrial Design.* 4th rev. ed. London: Faber & Faber, 1966.

Reilly, Paul. "The Challenge of Pop." *Architectural Review,* CXLII (July-Dec. 1967), 255-57.

Reinisch, Leonhard, ed. *Die Zeit ohne Eigenschaften: eine Bilanz der zwanziger Jahre.* Stuttgart: W. Kohlhammer, 1961.

Riewerts, Theodor. "Die Entwicklung des Kunstgewerbes seit der Mitte des 19. Jahrhunderts." *Geschichte des Kunstgewerbes aller Zeiten und Völker,* VI., ed. H. Th. Bossert. Berlin: Ernst Wasmuth, 1935.

Roberts, S. H. *The House that Hitler Built.* 11th ed. London: Methuen, 1939.

Rohde, Georg, et al. *Edwin Redslob zum 70. Geburtstag: eine Festgabe.* Berlin: E. Blaschker, 1955.

Roselius, Hildegard. *Ludwig Roselius und sein kulturelles Werk.* Braunschweig: Georg Westermann, 1954.

Rossow, Walter. "Werkbundarbeit damals und heute." *'Die Form,' Stimme des Deutschen Werkbundes 1925-1934.* Ed. Felix Schwarz and Frank Gloor. Gütersloh: Bertelsmann Fachverlag Reinhard Mohn, 1969.

Roters, Eberhard. *Painters of the Bauhaus.* New York: Frederick A. Praeger, 1969.

Sauer, Wolfgang. "Weimar Culture: Experiments in Modernism." *Social Research,* XXXIX, No. 2 (Summer 1972), 254-84.

Schaefer, Herwin. *The Roots of Modern Design: Functional Tradition in the 19th Century.* London: Studio Vista, 1970.

Scheidig, Walther. *Weimar Crafts of the Bauhaus, 1919-1924: an Early Experiment in Industrial Design.* London: Studio Vista, 1967.

Schnaidt, Claude. *Hannes Meyer, Bauten, Projekte und Schriften.* London: Alec Tiranti, 1965.

Schwierskott, Joachim. *Arthur Moeller van den Bruck und der revolutionäre Nationalismus in der Weimarer Republik.* Göttingen: Musterschmidt-Verlag, 1962.

Segal, Walter. "About Taut." *Architectural Review,* CLI (1972), 25-27.

————. "The neo-purist school of Architecture." *Architectural Design*, XLII, No. 6 (1972), 344-45.

————. "Scharoun." *Architectural Review*, CLIII, No. 912 (1973), 98-102.

Seling, Helmut, ed. *Jugendstil: Der Weg ins 20. Jahrhundert.* Heidelberg: Keysersche Verlagsbuchhandlung, 1959.

Selz, Peter and Mildred Constantine, eds. *Art Nouveau: Art and Design at the Turn of the Century.* New York: The Museum of Modern Art, 1959.

Sembach, Klaus-Jürgen. *Into the Thirties. Style and Design 1927-1934.* Trans. Judith Filson. London: Thames & Hudson, 1972.

Sharp, Dennis. *Modern Architecture and Expressionism.* London: Longmans, Green, 1966.

Simon, Klaus. *Die württembergischen Demokraten: ihre Stellung und Arbeit im Parteien-und Verfassungssystem in Württemberg und im Deutschen Reich 1890-1920.* Stuttgart: W. Kohlhammer, 1969.

Sperlich, Hans-Günter. "Grau ist heller als schwarz, zur Geschichte einer Gesinnungsgemeinschaft (Werkbund)." *Baukunst und Werkform* (1956), 577-603.

Stephan, Hans. *Wilhelm Kreis.* Geleitwort von Reichsminister Albert Speer, Oldenburg: Gerh. Stallung, 1944.

Stern, Fritz. "The Political Consequences of the Unpolitical German." *History*, No. 3 (1960), 104-34.

————. *The Politics of Cultural Despair: A Study in the Rise of the Germanic Ideology.* New York: Doubleday Anchor Books, 1965 (first published in 1961).

Sternberger, Dolf. *Über den Jugendstil und andere Essays.* Hamburg: Classen, 1956.

Stolper, Gustav, Karl Häuser, and Knut Borchardt. *The German Economy 1870 to the Present.* New York: Harcourt Brace & World, 1967.

Strauss und Torney-Diederichs, Lulu von. *Eugen Diederichs: Leben und Werk.* Jena: Eugen Diederichs, 1936.

Stressig, Peter. "Hohenhagen-Experimentierfeld modernen Bauens." *Karl-Ernst Osthaus: Leben und Werk.* Ed. Herta Hesse-Frielinghaus. Recklinghausen: A. Bongers, 1971.

Struve, Walter. *Elites against Democracy: Leadership Ideals in Bourgeois Political Thought in Germany, 1890-1933.* Princeton: Princeton University Press, 1973.

Stuttgart. Technische Hochschule. *Die Technische Hochschule Stuttgart 1954. Bericht zum 125-jährigen Bestehen.* Stuttgart, 1954.

Stuttgarter Zeitung. *Die zwanziger Jahre in Stuttgart: Eine Dokumentation.* Stuttgart: Turmhaus-Druckerei, 1962.

Taylor, Robert R. *The Word in Stone: The Role of Architecture in the National Socialist Ideology.* Berkeley: University of California Press, 1974.

Teirlink, Herman. *Henry van de Velde.* Monographies de l'Art Belge. Brussels: Elsevier, 1959.

Weber, Gert. *Kunsterziehung gestern, heute, morgen auch.* Ravensburg: O. Maier, 1964.

Welchert, Hans-Heinrich. *Theodor Heuss: Ein Lebensbild.* Bonn: Athenäum-Verlag, 1953.

Wende, E. *Ch. H. Becker: Mensch und Politiker. Ein biographischer Beitrag zur Kulturgeschichte der Weimarer Republik.* Stuttgart: Deutsche Verlags-Anstalt, 1959.

Werner, Bruno E. *Die zwanziger Jahre: von Morgens bis Mitternachts.* Munich: F. Bruckmann, 1962.

Whittick, Arnold. *European Architecture in the Twentieth Century.* 2 vols. London: Crosby Lockwood & Son, 1950.

Willett, John. *Expressionism.* World University Library. London: Weidenfeld & Nicolson, 1970.

Wingler, Hans Maria. *Das Bauhaus, 1919-1933: Weimar, Dessau, Berlin.* Bramsche: Gebr. Rasch, 1962.

————. *The Bauhaus: Weimar, Dessau, Berlin, Chicago.* Ed. Joseph Stein. Cambridge, Mass.: MIT Press, 1969.

Winkler, Heinrich August. *Mittelstand, Demokratie und Nationalsozialismus: Die politische Entwicklung von Handwerk und Kleinhandel in der Weimarer Republik.* Cologne: Kiepenheuer & Witsch, 1972.

Wright, Olgivanna Lloyd. *Frank Lloyd Wright: His Life, His Work, His Words.* New York: Horizon Press, 1966.

Ziegler, Theobald. *Die geistigen und sozialen Strömungen Deutschlands im neunzehnten Jahrhundert.* 7th ed. Berlin: Bondi, 1921.

INDEX

Library of Congress Cataloging in Publication Data

Campbell, Joan, 1929-
 The German Werkbund.

 Bibliography: p.
 Includes index.
 1. Deutscher Werkbund. 2. Art industries and trade—
Germany. I. Title.
NK951.C35 745'.06'243 77-71974
ISBN 0-691-05250-6